Wisdom With
Understanding
is Better
Than Rubies

Lurine Karon Greenberg
Fine Arts Collection

THE ARTIST AND THE WARRIOR

THE ARTIST AND THE WARRIOR

MILITARY HISTORY THROUGH THE EYES OF THE MASTERS

THEODORE K. RABB

YALE UNIVERSITY PRESS
NEW HAVEN AND LONDON

For information about this and other Yale University Press publications, please contact:
U.S. Office: sales.press@yale.edu www.yalebooks.com
Europe Office: sales@yaleup.co.uk www.yalebooks.co.uk

Set in Minion by IDSUK (DataConnection) Ltd
Printed in China through Worldprint

Library of Congress Cataloging-in-Publication Data

Rabb, Theodore K.
 The artist and the warrior : military history through the eyes of the masters / Theodore K. Rabb.
 p. cm.
 ISBN 978-0-300-12637-2 (cl : alk. paper)
 1. War in art. I. Title.
 N8260.R33 2011
 704.9'4935502—dc23
 2011030917

This publication is made possible in part by a subvention from the Barr Ferree Foundation Fund for Publications, Princeton University.

A catalogue record for this book is available from the British Library.

10 9 8 7 6 5 4 3 2 1

For Tamar

Contents

List of Figures *viii*

Acknowledgments *xiv*

Foreword: Boundaries *xv*

Chapter One The Ancient World: Assyria and Greece 1

Chapter Two Rome and the Middle Ages 22

Chapter Three A New Vigor: War and Art in Feudal Japan 49

Chapter Four The Persistence of Tradition in the Early Renaissance 57

Chapter Five Traditions Transformed: The Sixteenth and Seventeenth Centuries 79

Chapter Six War as Decoration: Suleyman, Palladio, and Akbar 126

Chapter Seven David Versus Goya 148

Chapter Eight The Pity of War: Modern Times 166

Afterword: Film *204*

Bibliography *212*
Index *217*

Figures

		page
1	Stone relief from Nineveh, Assyria, detail: camel, seventh century BCE (British Museum, London. © The Trustees at the British Museum)	8
2	Stone relief from Nineveh, Assyria, detail: Elamite troops, seventh century BCE (British Museum, London. akg-images)	9
3	Stone relief from Nineveh, Assyria, detail: scaling the walls of Hamanu, seventh century BCE (British Museum, London. © The Trustees at the British Museum)	10
4	Stone relief from Nineveh, Assyria, detail: Assurbanipal in his chariot, seventh century BCE (British Museum London. akg-images/Erich Lessing)	11
5	Douris, cup, detail: Eos and Memnon, 480s BCE (Louvre G115, Louvre Museum, Paris. © RMN/Hervé Lewandoski)	13
6	Douris, cup, detail: Menelaus and Paris, 480s BCE (Louvre G115, Louvre Museum, Paris. © RMN/Hervé Lewandoski)	14
7	Douris, cup, detail: Ajax and Hector, 480s BCE (Louvre G115, Louvre Museum, Paris. © RMN/Hervé Lewandoski)	15
8	Alexander Mosaic, second century BCE (Archaeological Museum, Naples. Photo by Magrippa)	18–19
9	Augustus of Prima Porta, early first century CE (Vatican City Museums. Photo Scala, Florence)	25
10	Augustus of Prima Porta, detail: breastplate, early first century CE (Vatican City Museums. Photo Scala, Florence)	26
11	Equestrian statue of Marcus Aurelius, 176 CE (Capitoline Museum, Rome. Archivio Fotografico del Musei Capitolini)	27
12	Trajan's Column, detail: Danuvius, 113 CE (Trajan's Forum, Rome. Plate by Conrad Cichorius)	30

13 Trajan's Column, detail: siege, 113 CE (Trajan's Forum, Rome. Plate
 by Conrad Cichorius) 31

14 Trajan's Column, detail: boats, 113 CE (Trajan's Forum, Rome. Plate
 by Conrad Cichorius) 32

15 Trajan's Column, detail: Danube bridge, 113 CE (Trajan's Forum,
 Rome. Plate by Conrad Cichorius) 32

16 St. Gall, *Book of Maccabees I*: siege, *c.* 900 CE (Leiden Codex Perizoni
 F.17: fol. 17 v, University Library, Leiden) 40

17 St. Gall, *Book of Maccabees I*: battle at river, *c.* 900 CE (Leiden Codex
 Perizoni F.17: fol. 22 r, University Library, Leiden) 40

18 St. Gall, *Book of Maccabees I:* battle, *c.* 900 CE (Leiden Codex Perizoni
 F.17: fols. 45 v–46 r, University Library, Leiden) 41

19 Bayeux Tapestry, detail: Halley's Comet and Harold's coronation,
 eleventh century (Museum of the Tapestry, Bayeux. By special
 permission of the City of Bayeux) 45

20 Bayeux Tapestry, detail: Norman invasion boats, eleventh century
 (Museum of the Tapestry, Bayeux. By special permission of the City
 of Bayeux) 46

21 Bayeux Tapestry, detail: death of Harold, eleventh century (Museum
 of the Tapestry, Bayeux. By special permission of the City of Bayeux) 47

22 *Heiji Monogatari Emaki*, detail: rushing crowd, late thirteenth
 century (Museum of Fine Arts, Boston. Photo © 2011 Museum of
 Fine Arts, Boston) 53

23 *Heiji Monogatari Emaki*, detail: palace fire, late thirteenth century
 (Museum of Fine Arts, Boston. Photo © 2011 Museum of Fine Arts,
 Boston) 54

24 *Heiji Monogatari Emaki*, detail: emperor's carriage, late thirteenth
 century (Museum of Fine Arts, Boston. Photo © 2011 Museum of
 Fine Arts, Boston) 55

25 Donatello, *Gattamelata*, 1453 (Piazza del Santo, Padua. akg-images) 61

26 Donatello, *David*, 1440s (Bargello Museum, Florence. Photo Scala,
 Florence – courtesy of the Ministero Beni e Att. Culturali) 63

27 Paolo Uccello, *Battle of San Romano*, I: Niccolò da Tolentino, *c.* 1450
 (National Gallery, London. © National Gallery, London) 65

28 Paolo Uccello, *Battle of San Romano*, II: Bernardino della Carda, *c.*
 1450 (Uffizi Gallery, Florence. Galleria degli Uffizi, Florence, Italy/
 Alinari/The Bridgemen Art Library) 66

29 Paolo Uccello, *Battle of San Romano*, III: Micheletto da Cotignola, *c.*
 1450 (Louvre Museum, Paris. RMN/Jean-Gilles Berizzi) 67

30 Andrea del Verrocchio, *Colleoni*, 1495 (Campo Santi Giovanni e Paolo, Venice. Photo Scala, Florence) 72

31 Piero della Francesca, *The Battle between Constantine and Maxentius*, detail, 1450s (Basilica of San Francesco, Arezzo. Photo Scala, Florence – courtesy of the Ministero Beni e Att. Culturali) 75

32 Piero della Francesca, *Pala Montefeltro, c.* 1473 (Brera Art Gallery, Milan. Photo Scala, Florence – courtsey of the Ministero Beni e Att. Culturali) 76

33 Pedro Berruguete, *Federico da Montefeltro with his son Guidobaldo, c.* 1480 (National Gallery of the Marches, Urbino. Photo Scala, Florence – courtesy of the Misistero Beni e Att. Culturali) 77

34 Pieter Brueghel the Elder, *The Blind Leading the Blind*, 1568 (Capodimonte Museum, Naples/Giraudon/The Bridgeman Art Library) 88

35 Pieter Brueghel the Elder, *Massacre of the Innocents, c.* 1567 (Kunsthistorisches Museum, Vienna) 89

36 Pieter Brueghel the Elder, *Massacre of the Innocents*, detail, *c.* 1567 (Royal Collection © 2011, Her Majesty Queen Elizabeth II) 90

37 Titian, *Allegory of the Battle of Lepanto*, 1575 (Prado Museum, Madrid. Photo © Boltin Picture Library/The Bridgeman Art Library) 95

38 Artemisia Gentileschi, *Judith Slaying Holofernes, c.* 1612 (Capodimonte Museum, Naples. Photo Scala, Florence – courtesy of the Ministero Beni e Att. Culturali) 100

39 Artemisia Gentileschi, *Judith and her Maidservant, c.* 1612 (Pitti Palace, Florence. Photo Scala, Florence – courtesy of the Ministero Beni e Att. Culturali) 101

40 Jacques Callot, *Siege of Breda*, 1628–29 (Rosenwald Collection. Image courtesy of National Gallery of Art, Washington) 104

41 Jacques Callot, *The Siege of La Rochelle*, 1628–31 (Courtesy of the Grunwald Centre for the Graphic Arts, UCLA Hammer Museum) 104

42 Jacques Callot, *The Miseries of War: The Hanging*, 1633 (Art Gallery of New South Wales) 105

43 Jacques Callot, *The Miseries of War: Plundering a Large Farmhouse*, 1633 (Art Gallery of New South Wales) 105

44 Jacques Callot, *The Miseries of War: Plundering and Burning a Village*, 1633 (Art Gallery of New South Wales) 106

45 Diego Velázquez, *The Surrender of Breda*, 1635 (Prado Museum, Madrid/Giraudon/The Bridgeman Art Library) 109

46 Diego Velázquez, *Mars, c.* 1640 (Prado Museum, Madrid. White
 Images Scala, Florence) 111

47 Peter Paul Rubens, *Allegory of Peace and War*, 1629–30 (National
 Gallery, London. © National Gallery, London) 112

48 Peter Paul Rubens, *The Horrors of War*, 1638 (Pitti Palace, Florence.
 Photo Scala, Florence – courtesy of the Ministero Beni e Att.
 Culturali) 113

49 Jacob Duck, *Interior with Soldiers and Women, c.* 1650 (J. Paul Getty
 Museum, Los Angeles) 116

50 Philips Wouwermans, *Cavalry Making a Sortie from a Fort on a Hill*,
 1646 (National Gallery, London. © National Gallery, London) 116

51 Hendrick Terbrugghen, *Sleeping Mars*, 1629 (Centraal Museum,
 Utrecht. CMU/Ernst Moritz) 117

52 Titian, *The Emperor Charles V on Horseback in Mühlberg*, 1548
 (Prado Museum, Madrid. The Bridgeman Art Library) 119

53 Sébastien Bourdon, *Queen Christina of Sweden on Horseback*, 1653
 (Prado Museum, Madrid. The Bridgeman Art Library) 120

54 Diego Velázquez, *Prince Baltasar Carlos on Horseback*, 1634–35
 (Prado Museum, Madrid/Giraudan/The Bridgeman Art Library) 121

55 Anthony Van Dyck, *Charles I on Horseback*, 1637–38 (National
 Gallery, London. © National Gallery, London) 122

56 Anthony Van Dyck, *Charles I at the Hunt*, 1635 (Louvre Museum,
 Paris. © RMN/Christian Jean) 123

57 Hyacinthe Rigaud, *Louis XIV*, 1701 (Châteaux of Versailles and
 Trianon. © RMN (Château de Versailles)/Daniel Arnaudet/Gérard
 Blot) 124

58 *Süleymanname*: Mohács I, *c.* 1560 (fol. 220a, Topkapi Palace Museum,
 Istanbull. bpk) 130

59 *Süleymanname*: Mohács II, *c.* 1560 (fol. 219b, Topkapi Palace
 Museum, Istanbul. bpk) 131

60 Andrea Palladio, ed., *Polybius's Histories*, cavalry formation, 1570s
 (plate 1: 293.g.20 © The British Library Board. All rights reserved) 136

61 Andrea Palladio, ed., *Caesar's Commentaries*, battle formation, 1575
 (plate 27. Centro Internazionale di Studi di Architettura, A. Palladio,
 Venice) 136

62 Andrea Palladio, ed., *Polybius's Histories*, siege layout, 1575 (plate 37:
 293.g.20. © The British Library Board. All rights reserved) 137

63 Battista Della Valle, *Vallo*, battle formation, 1539 (book 3, p. 37 v. Su
 concessione della Biblioteca civica Bertoliana di Vicenza) 138

64 Andrea Palladio, *Four Books of Architecture*, Villa Mocenigo, 1570
 (Vol. II, plate 66. Leonardo Mocenigo's villa. Centro Internationale
 di Studi di Architettura, A. Palladio, Venice) 139

65 *Akbarnama*: Siege of Ranthambore panorama, 1590s (Victoria and
 Albert Museum, London. © V&A Images – All rights reserved) 144

66 *Akbarnama*: Last stages of siege of Ranthambore, 1590s (Victoria
 and Albert Museum, London. © V&A Images – All rights reserved) 145

67 *Akbarnama*: Entry of Akbar into Ranthambore, 1590s (Victoria and
 Albert Museum, London. © V&A Images – All rights reserved) 146

68 Charles Le Brun, *The Decision for War, c.* 1680 (Hall of Mirrors,
 Versailles. Chateau de Versailles, France/Giraudon/The Bridgeman
 Art Library) 151

69 Jacques-Louis David, *Bonaparte Crossing the Great St. Bernard Pass*,
 nineteenth-century (Army Museum, Les Invalides. White Images/Scala,
 Florence) 157

70 Francisco Goya, *The Second of May 1808*, 1814 (Prado Museum,
 Madrid) 161

71 Francisco Goya, *The Disasters of War: And They Are Like Wild
 Beasts*, 1820s, published 1863 (© The Trustees of the British Museum) 162

72 Francisco Goya, *The Disasters of War: Barbarians!* 1820s, published
 1863 (© The Trustees of the British Museum) 162

73 Francisco Goya, *The Third of May 1808*, 1814 (Prado Museum,
 Madrid) 164

74 Mathew Brady, *Robert E. Lee*, 1865 (US National Archives, 111–B–
 1564) 173

75 Mathew Brady (photo by Alexander Gardner), *On the Antietam
 Battlefield*, 1862 (Library of Congress) 173

76 Mathew Brady (photo by Alexander Gardner), *Confederate Dead
 Gathered for Burial*, 1862 174

77 Mathew Brady (photo by Alexander Gardner), *President Abraham
 Lincoln and his Generals After Antietam*, 1862 (US National Archives,
 111–B–2933) 175

78 Edouard Manet, *Execution of the Emperor Maximilian*, 1867
 (Museum of Fine Arts, Boston. Photo © 2011 Museum of Fine Arts,
 Boston) 178

79 Edouard Manet, *Execution of the Emperor Maximilian*, 1868–69
 (Kunsthalle, Mannheim. bpk/Lutz Braun) 179

80 Edouard Manet, *Civil War*, 1871 (Image courtesy of National Gallery
 of Art, Washington) 180

81 Honoré Daumier, *The Empire Means Peace*, 1870 (Auckland Art Gallery Toi o Tamaki, purchased 1981) 181

82 Edouard Manet, *The Barricade*, 1871 (Museum of Fine Arts, Budapest) 181

83 Edouard Manet, *Rue Mosnier Decorated with Flags*, 1878 (J. Paul Getty Museum, Los Angeles) 182

84 John Singer Sargent, *A Street in Arras*, 1918 (Imperial War Museum, London) 185

85 John Singer Sargent, *A Wrecked Tank*, 1918 (Imperial War Museum, London) 186

86 John Singer Sargent, *Crashed Aeroplane*, 1918 (Imperial War Museum, London) 186

87 John Singer Sargent, *Gassed*, 1919 (Imperial War Museum, London) 188–89

88 Christopher Nevinson, *Paths of Glory*, 1917 (Imperial War Museum, London) 190

89 Otto Dix, *Card Players*, 1920 (National Gallery, Berlin. bpk/ Nationalgalerie, SMB, Verein der Freunde der Nationalgalerie/Jörg P. Anders. © DACS 2011) 192

90 Edwin Lutyens, *Cenotaph*, 1920 (Whitehall, London) 195

91 Edwin Lutyens, *Memorial to the Missing of the Somme*, 1932 (Thiepval, France) © Eye Ubiquitous / Alamy 197

92 Pablo Picasso, *Guernica*, 1937 (National Museum of Reina Sofia, Madrid). The Bridgeman Art Library © Succession Picasso/DACS, London 2011 201

93 Sergei Eisenstein, *Alexander Nevsky*, 1938: still (Mosfilm/The Kobal Collection) 206

94 Akira Kurosawa, *The Seven Samurai*, 1954: still (Toho/Cowboy/ Photofest. © Toho Company Ltd 208

95 Stanley Kubrick, *Paths of Glory*, 1957: still (Ronald Grant Film Archive) 210

Acknowledgments

I have discussed the ideas in this book with many friends and colleagues over the years, but I owe a special debt to the two editors/publishers, Robert Cowley and Byron Hollinshead, who started me on this path in the pages of *Military History Quarterly*. A number of the sections of this book started out as contributions to that magazine.

Since then, I have been grateful, in particular, to those who have been willing to give advice about, or comment on, parts of the draft manuscript: Guido Beltramini, Edward Champlin, Rosemary Crill, Peter Horne, David Howell, James Marrow, Arno Mayer, James McPherson, Philip Nord, Desmond Pitcher, Bernard Pucker, P. Adams Sitney, Susan Stronge and the two reviewers of the manuscript for the publisher. Their advice has been invaluable, as has the encouragement of Robert Baldock at the Yale University Press; the work on the illustrations by his assistant, Rachael Lonsdale, and the sharp eye of the copyeditor, Beth Humphries; the keen eye of the designer, Stephen Kent; and the attention to detail, at the final stages, of Candida Brazil and Tami Halliday.

I must also record my appreciation to the Barr Ferree Foundation fund for Publications at Princeton University, whose generous support for the costs of the illustrations helped make this publication possible.

For the debt I owe my wife, the dedicatee of this book, no expression of gratitude can be adequate.

For permission to quote lines from the poem 'Musée des Beaux Arts' by W. H. Auden the author and publishers gratefully acknowledge Faber and Faber and Random House Inc.

Foreword
Boundaries

One can hardly imagine two human undertakings less alike than war and the visual arts. The warrior is accustomed to a regular diet of physical danger, brute force, speedy action with little reflection, outdoor effort regardless of the weather, and a harsh disregard for human life – all in the company of many like-minded comrades. The artist, by contrast, tends to enjoy calm surroundings, the slow development of ideas, a mainly indoor existence, and, working alone, the effort to represent or reflect upon the human condition. A favorite contrast during the Renaissance was between the active and the contemplative life, and the warrior and the artist seem to embody the distinction. Yet the two pursuits have been so fundamental to every society known to history – indeed, both are so universal that they are often regarded as innate to humanity – that they have never fully remained apart. If it is true that the poor are always with us, then so too are war and art. What this book seeks to explore is what happens when such profoundly different instincts come into contact.

Overwhelmingly, this is a one-way street. There are not too many instances of art shaping war. For the few Leonardos who tried their hand at fortifications or military engineering (even in his case, to no great effect) there have been tens of thousands of influences going the other way. In the pages that follow, therefore, the basic question will be: how have artists responded to war? Given the latter's omnipresence in human history, it has been a constant inspiration, provoking responses both for and against. The boundless variety of those responses is the chief focus of this book.

One way of organizing this welter of creativity might be to arrange the works in categories, a kind of Linnaean table of species. The problem with that approach, however, is that there are only three distinct, major groupings: the attempt to create a visual record, such as Jacques Callot's enormous, multi-sheet bird's-eye

engravings of massive sieges; the celebration of battle, of which a notable example is the so-called Alexander Mosaic from Pompeii; or the denunciation of war, embodied by Goya's *The Third of May 1808* or Picasso's *Guernica*. Discussions of exemplars of each category would soon become repetitive. An alternative might be to give an account of the most famous conflicts of the past, and then to survey the art that they inspired. The trouble here would be the huge disparity in the quality of the works that different wars have prompted. It is not easy, for example, to identify notable artistic achievements that are associated with the Peloponnesian War or the Crusades.

My prime interest, instead, is in the visual images that, while not necessarily masterpieces in everyone's eyes, stand for this author as notable landmarks in the history of art. In other words, I am looking for paintings, sculptures, and related forms of expression that I believe deserve close attention for their own sake, and that happen to share the subject matter of warfare. The prime criterion for selection, in other words, will be, not the act of the warrior, but the act of the artist. Nor do I seek comprehensive coverage. Choice has to be personal, and I have therefore emphasized only those works that I consider remarkable artistic achievements. Space alone would dictate such selectivity. That is not to say, however, that other responses to conflict are ignored. Especially in Chapters 5 and 8, but also elsewhere, I discuss artistic activities and individual images that occupy an important place in my story, even if they do not receive the attention I have given to those I regard as masterpieces. This approach, I should add, reverses the one taken by Flavio Febbraro and Burkhard Schwetje in their recent *How to Read World History in Art* (New York, 2010). For them it is the event that matters, and they find works to document that focus. Thus, the Crimean War represents the year 1853, and it is made vivid by a painting by Henri Philippoteaux whose excellence is in its recording of a scene rather than its artistic achievement. My concern is more with the art than the event.

One other criterion needs to be mentioned. As a specialist in European history, I will be taking the large majority of my subjects from the Western tradition. All cultures have produced images that would be relevant to this account, and indeed I have included a few from non-Western societies, not only to broaden the range but also to underline the universality of the themes artists embraced. The main emphasis, however, is on the West, covering military action and artistic production from Assyria to Guernica.

These boundaries have seemed necessary if a gigantic subject is to be manageable. I also leave to others the theoretical implications of the theme. "Theory" has become a common concern of humanities scholarship, and deference to the "cultural turn" in the study of history means that image and perception sometimes

loom larger than the matter being perceived. In addition, questions of definition have come to the fore, leading to statements like "war in art is not war but art". This, in turn, has required further elaborations of theoretical premises (in an article about images of war) along the lines of "artistic images are mental constructs", "reality too is a construct", "the perception of reality is also a construct" and "such mental constructs are determined by cultural circumstances." It may be that what follows could provide material for this type of interpretive excursus, but my preference will be to keep as close to the evidence as possible.

To sweep through nearly three millennia is to invite another issue. Clearly, this is not an enterprise of primary research. I have made sure to see at first hand the works I discuss, but I have not explored the sources that surround them, relying instead on the findings of experts in these various fields. Yet such a survey has a purpose, both for the general reader who may be interested in the subject, and for the scholarship of the future. To take an analogy from the arts, this book is meant to serve as the underdrawing which prepares the way for a painting's more detailed elaborations. Specific cases within the wider subject have already attracted scholarly attention in recent years, but there has been no attempt to depict the larger contours of the theme. That is what this book seeks to provide, both as an end in itself and as a template for further scholarship in more narrowly defined areas.

What must be emphasized is that the book's broader view refers only to the way artists themselves responded to military conflict. There will be no attempt to offer general assessments of how warfare impinges on visual culture – how it affects patrons, how it changes markets, or how it either deters or stimulates the production of art. To tackle such questions one must explore the creation of images in their broadest context. One must see how much was being produced, how it was sold or supported, and how numbers as well as subject matter fluctuated in response to outside events. Such studies are important, for they can explain the background out of which a masterpiece emerges. My interest, however, is in individual works. Although it will be necessary to understand the nature and effects of warfare at the time they were created, the discussion of those subjects is intended strictly as scene-setting. It is true that the dramatic shifts in the conduct of armies over the centuries require regular overviews of changing military practices, and that these take up as much as a third of some chapters. Yet such excursions are unavoidable if there are to be adequate contexts for the exploration of an artist's purpose or the meaning of a particular work. The latter remains the ultimate objective.

If, in this undertaking, the force of various traditions and influences is acknowledged, that is not to diminish the originality or creativity of the exemplars who

receive close attention. The soldiers I discuss may appear as undifferentiated people who happened to engage in various forms of fighting over the centuries; but those who responded to their battles with masterpieces each had distinctive qualities. Though both "Artist" and "Warrior" in my title are categories, it is the achievements of individual artists that give structure to this book.

The Ancient World
ASSYRIA AND GREECE

Creating a Heroic Past

Every culture devises accounts of its origins, and most such stories give pride of place to military exploits. The ways that victories are won by ancestors may vary widely, but somewhere in the past there has nearly always been a decisive triumph, a moment to celebrate as the start of independence, of a new unity, or even of self-identification. It takes a while in the Bible before one gets to the Exodus, but when it arrives, it is heralded by the annihilation of a great army. For the Greeks, the beacon was the destruction of Troy; for the Romans, the conquest of the Latins by Aeneas and the rise to overwhelming power that followed.

In all three of these cases, the accounts of origins that embody the stories are literary masterpieces, written many centuries later but instinctively shaping legends and memories into a form that will have meaning for their listeners and readers. Whether or not one accepts the historicity of the tales, their emphases tell us a great deal about the audiences they served. War is omnipresent, but in many guises.

For the Greeks battle was an opportunity for heroism and immortality. The *Iliad* is a stirring narrative of national unity, as fiercely independent cities, rulers and soldiers combined forces for over a decade in pursuit of a common goal. But it is also an unwavering tribute to military might and to the many paths that lead to victory; above all, it is a paean to the virtues of muscular bravery. When the story continues in the *Odyssey*, even the leader noted for wiliness rather than strength, Odysseus himself, achieves his final success with brute force as he alone proves capable of bending his massive bow. Physical prowess is the key to an immortal name. According to one story, the epitome of such prowess, Achilles, was willing to die young if he could win eternal glory as the greatest of warriors.

The Hebrews, by contrast, saw all victories as the result solely of God's favor. When they fought the Amalekites, for instance, they won only as long as Moses, following divine instruction, was able to hold his hands aloft (Exodus 17). Even more revealing was the song that was sung following the obliteration of Pharaoh's army (Exodus 15):

> I will sing unto the Lord, for he hath triumphed gloriously: the horse and his rider hath he thrown into the sea. . . . The Lord is a man of war: . . . Pharaoh's chariots and his host hath he cast into the sea: his chosen captains also are drowned in the Red Sea. . . . Thy right hand, O Lord, is become glorious in power: thy right hand, O Lord, hath dashed in pieces the enemy.

The Greeks might have agreed that the denizens of Mount Olympus decided long-term outcomes, but when heroes took center stage gods moved to the background.

In Rome the story of origins was more complicated, reflected in two magisterial accounts: Virgil's *Aeneid* and Livy's *History*. Unlike the Greek and Hebrew accounts, whose date of composition and authorship remain obscure, these celebrations of a victorious tradition can be identified with specific writers and a golden age of literature around the reign of the first emperor, Augustus. For citizens of patriotic bent, these were glorious times, as a conquering Rome bestrode the entire Mediterranean world. Given this context, the emphasis on military triumph in both Virgil and Livy is hardly surprising. Yet the two writers were not unlike their Greek and Hebrew counterparts in that they were giving shape to oral traditions, legendary tales, and memories of an unrecoverable past. And despite the obvious consequences of the contrast between poetry and history, and the different narratives Virgil and Livy presented, the underlying focus on the heroic remained the same.

As with the Hebrew Bible, both accounts begin long before there is an opportunity for the battles that will define a distinctive people. Not until Virgil's epic poem is more than half over, in Book VII, does Aeneas reach the mouth of the Tiber. And he arrives as a defeated Trojan, at the end of a journey filled with distractions, detours, and the buffeting of the gods. Only in the very last pages of the poem does he emerge as a military hero, his victory over Turnus obviously the first of a long line of triumphs that will define Rome and her history.

Livy, on the other hand, starts with Romulus and Remus. But as the years pass, it is again and again the ability to defeat rivals and enemies that sets the Romans apart. The first hero, Horatius, holding a bridge against huge odds, is reminiscent of the Spartans at Thermopylae, and it is his valor that enables him to escape the normal consequences of murdering his sister. From then on, the *History* is largely

a catalog of the wars by which Rome won the empire that was her distinctive achievement.

Thus, at the very start of the celebration of identity that has marked the West, a central feature – both in reality and in cultural artifact – has been the looming presence of battle. But what kind of war was it, and what kind of art did it provoke?

The Armies of Assyria and Greece

Strife has always stalked human societies, and its more organized companion, war, was never far behind. Whether it be the Trojan War or the events recounted in the Bible, these were the themes that resonated. One of the first biblical stories describes Cain killing Abel, and it is not too long before we hear of Pharaoh's army or of David killing Goliath. The demand for valor, cunning, and strength on the battlefield is unavoidable.

From the earliest days of recorded history one could see that conquest and empire-building would always accompany humanity's instinct to live in permanent settlements. No sooner were the most ancient sedentary societies established than they encountered neighbors, and soon thereafter the relationships between neighboring communities had deteriorated into armed conflict. It is a pattern visible in all the prehistoric centers of civilization and nowhere more clearly than in the Fertile Crescent, today's Middle East. The agricultural richness of Mesopotamia – the area washed by the Tigris and Euphrates rivers – encouraged the building of some of mankind's oldest communities. Yet the relatively short distances and easy interchange between these primitive towns and cities soon led to the rivalries and conflicts that have been perennials ever since.

What is relevant to our concerns is that we can glimpse so many other features of society even as warfare arose. Wherever we find evidence of our most distant settled ancestors, we discover legal and political systems, religious beliefs, and (especially striking) artistic works. Although the purposes of the artworks that have survived from prehistoric times – wall and cave paintings, pottery, carvings in different materials, and other relics – are often difficult to decipher, their aesthetic power is inescapable.

That the earliest artistic reminders of our ancestors precede any evidence of warfare may well be because they date from the Paleolithic age, well before the discovery of seeds in the Neolithic period (starting around 6000 BCE), the development that made long-term settlement possible. Moreover, the creative urge seems to have adapted readily to the needs of more permanent communities. We have found, for example, astonishingly colorful and varied mosaics that were designed for house walls during the so-called Uruk period (beginning in the

fourth millennium BCE) in Mesopotamia. In both the Fertile Crescent and Egypt we can, for the first time, associate artistic traditions with a settled culture.

Yet there was a fundamental difference between these two ancient Middle Eastern regions. Along the Nile there developed a coherent, unified civilization, surrounded by desert and thus rarely threatened, with an artistic vision whose continuities in style and subject matter can be traced across the centuries. No such stability was achieved in the more variegated and vulnerable terrain around the Tigris and Euphrates. Regularly disturbed by aggression, upheaval, and invasion, the people of Mesopotamia took conflict and war for granted. Unlike the Egyptians in the last three millennia before the birth of Christ, they repeatedly experienced the rise and fall of cities, dynasties, tribes, and empires. Their art, as a consequence, was more diverse and also more concerned with heroics and war, especially in the kingdom that, more than any other, came to be known for its fierceness and its military prowess: the Assyrian Empire.

The Assyrians assembled the most feared army of the ancient world, whose tortures were recorded in countless inscriptions and whose cruelties were featured in the Bible. It was the Assyrians who captured and scattered the so-called ten lost tribes of Israel in the eighth century BCE, a conquest that was but one of many, and it was their monarch, Sennacherib, who in 2 Chronicles boasted about all the "nations that my fathers utterly destroyed".

Ruled by other cities until the nineteenth century BCE, the residents of the town of Assur on the Tigris had then gained their independence, and over the next thousand years had sought to extend their rule beyond Assur. For a millennium, however, these Assyrians went through periods of loss as well as advance. Not until the ninth century BCE did their mixed record give way to a sudden surge of relentless expansion, when a succession of able rulers created an army set apart from the other armies of the ancient world by its discipline as well as its ruthlessness. By the seventh century BCE they had made Assyria the largest and most powerful state in the world, controlling the Fertile Crescent, including the eastern shore of the Mediterranean, Cyprus, and most of Egypt. For nearly three hundred years, from the early ninth until the late seventh centuries BCE, this was the most effective military machine of the age.

Successful military ventures in antiquity, as in all ages, rested on discipline, well thought out strategy and tactics, and effective leadership. Weapons and armor may have changed over the centuries, but the crucial elements in most victories were the same from the first days of warfare: surprise, superior numbers, battlefield bravery, and decisive generalship. For centuries the Assyrians were able to outdo their neighbors in all these respects, and thus to establish themselves as a major military power – the first notable conqueror of a large territorial empire in history.

Central to their success was the fearsomeness of their troops. Some estimates have suggested that their army may have amounted to 120,000 men, though it is hard to imagine how a body of that size could have been sustained over lengthy campaigns. We do know that at the height of their power, the Assyrians controlled most of what is now called the Middle East, an area of thousands of square miles. They had created the first standing army; that is, a force that did not disband at harvest time to allow farmers to return to their crops. They had created a formidable weapon in the mounted archer pair: two horsemen who rode together, one of whom shot arrows (probably at an effective distance of some 100 yards) while the other held both sets of reins so as to keep the horses on course. Their armies could travel as far as 30 miles in a single day, and they were renowned for the ferocity of their charges to break up enemy lines. They were also masters of siege works; pioneers in the building of roads to speed communications; and conquerors known for their merciless treatment of enemies. That this was a formidable fighting machine cannot be doubted. Its few failures, such as the abortive siege of Jerusalem in 701 BCE, brought to an end by an outbreak of cholera, did little to mar its aura of invincibility. That the empire succumbed in the end was largely the result of excessive ambition: the attempt to control too wide an area, which became vulnerable to the inroads of local rivals.

The foundation on which the Assyrian army was built, and indeed the chief protagonist throughout these centuries, was the infantry. The invention of the stirrup was far in the future; as a result, although a man on a horse could add speed and menace to an attack, he was not sufficiently stable to make the cavalry the major striking force they were to become. Chariots also added a fearsome punch to an advance, and were an essential component of Assyrian tactics. At the same time, archers could disrupt enemy formations, and elephants served as means of clearing pathways. But the key to any victory was the foot soldier, protected by helmet, body armor, and shield, and carrying weapons that ranged from a dagger or a club to a sword or a spear.

It was a significant moment, for instance, in the rise of the Greeks – who formed the next redoubtable army of ancient times – that a crucial stage in the battle of Marathon (490 BCE) was reached when Persian archers sent a rain of arrows at the advancing Athenian troops. To the dismay of the Persian army, the Greeks were able to fend off the arrows with their shields and their body armor, and to keep advancing. Their discipline, a product of both training and determination to defend their homeland, enabled them to keep moving forward until they drove their enemies from the field. Their status as the first Greek army to overcome a Persian force, moreover, made them seem particularly heroic – a milestone that made the battle loom far larger to the Greeks than it did to the

Persians. For the latter, the regret may have been that their cavalry had just left the field, which made the two armies evenly matched, but for the Greeks the outcome was a testament to organization and, above all, bravery. Like their predecessors in Mesopotamia, the Athenian soldiers were organized in phalanxes: rectangular formations a few rows deep, with spears for offense and a wall of shields for defense. Though the formation is associated particularly with the Greeks, who used its maneuvers, including a charge on the run, to great effect, variations had existed among the Assyrians and other Mesopotamians for centuries.

Tactics in these years were relatively simple: the aim was to keep one's force intact, maintain a steadily advancing line, seek to outflank one's foe, avoid encirclement, and disrupt the opposing formation, either with a daring move or with relentless pressure, until the enemy's lines collapsed and fled the field. The essence of strategy was no more complicated: fight from advantage, whether by assembling greater numbers, by finding favorable terrain, or by catching the enemy unawares at a crucial moment. Amidst all the intangibles, such as resoluteness or cohesiveness, though, one stood out: reputation. The Greeks trembled before Marathon precisely because they had never defeated a Persian army. After their victory, however, their belief in themselves and the fear they aroused in their enemies began to grow.

The Spartans, in particular, became the epitome of military prowess, especially after their remarkable stand at Thermopylae in 480 BCE, when 300 Spartans led a force of around a thousand soldiers in holding off for three days a Persian army at least fifty times as large. It was no wonder that, a century later, when Cyrus, prince of Persia, sought to take over the throne from his brother, he should have wanted an army of Greek soldiers for his campaign. They did in fact win the crucial battle for him in Persia, but since he was killed, his insurrection collapsed. The heroism that followed, the extraordinary march of 10,000 Greek soldiers to friendly territory on the Black Sea, which involved crossing the mountains of Asia Minor in winter, was immortalized by one of their commanders, Xenophon. His book, the *Anabasis*, sealed the Greek soldiers' reputation for toughness and was an inspiration for their most spectacular general, less than a century later: Alexander the Great, who became the most successful warrior of the ancient world. Though broken up at his death in 323 BCE, the empire he created extended eastward all the way to India, and set a mark for rapid military success that has never been surpassed.

Although the Greeks are the oldest Western culture from whom we have extensive celebrations of the qualities of the soldier, they were by no means the first to have produced an artistic masterpiece inspired by war. For that we must return to the Assyrians.

The Stones of Nineveh

Though there may have been earlier representations of war and its effects, the first masterpieces to take up that theme were the huge stone carvings produced by the Assyrians. Amongst the finest of these sculptures are those unearthed in the city of Nineveh and currently on display in the British Museum.

The last of the great Assyrian empire-builders was the grandson of the Sennacherib who is mentioned in the Book of Chronicles: Assurbanipal, who ruled from approximately 668 to 627 BCE. Expanding the territories he inherited to the south-east, he brought under his control the kingdom of Elam, at the head of the Persian Gulf, sacking its principal cities, Susa (the site of the biblical Book of Esther) and Hamanu. To the south, he captured the ancient city of Babylon, soon to be the chief power in the region but now allied with the Elamites. And he undertook two campaigns as far away as Egypt.

In contrast to his predecessors as conquerors, however, Assurbanipal is remembered more for his patronage of learning and the arts than for his wars. He transformed his capital, Nineveh – the city of the Book of Jonah, on the east bank of the Tigris, across from the present-day Iraqi city of Mosul – into a major intellectual and artistic center. He assembled an impressive library of cuneiform tablets (one of our chief sources for the history of the region); he embellished the palace built by his grandfather; and he constructed a new, lavishly decorated palace of his own.

It is fortunate for us that one of the principal art forms Assurbanipal promoted was the carving of scenes into huge stone panels to adorn his walls, for these remained largely intact when Nineveh fell into ruin. The survival of the panels (together with much free-standing stone statuary) in sufficient quantities to allow us to reconstruct the visual impact of Assyrian art is entirely due to the materials of which they were made. The French and English archeologists who found the tablets in the mid-nineteenth century and sent them back to the Louvre and the British Museum recognized at once the importance of their discoveries. During the past 150 years, they have come to be regarded as among the first major achievements of the sculptor's craft.

Divided into wide strips, or registers, from top to bottom, the panels depict scenes and narratives that are filled with revealing details of the life of the Assyrians, from their jewelry and clothing to their primitive siege machines, weapons, and buildings. The reliefs were not deeply incised and can be seen as a kind of halfway point between sculpture and wall-painting. There was little attempt to create the three-dimensional effects that a few centuries later were to set Greek reliefs apart from all that had come before. And the traces of paint that have survived indicate that they were originally bright with color. It seems likely

that the principal artist drew outlines on the stone, and then teams of artisans cut, polished, and painted the surface to create the finished works.

That their theme is triumphalism is no surprise, for the panels were commissioned by a conqueror. There are a few idyllic scenes set in gardens after victory and much attention to another violent subject, hunting, but the main subject matter of Assurbanipal's panels is war. And we learn a great deal here about the way it was conducted. A scene from a fight with Arabs, for example, documents in vivid detail the Assyrians' superiority. Although two Arabs sit on a galloping camel – wonderfully captured in stone – they wear no body armor and use simple bows, whereas their enemy, outfitted with chest armor and shields, uses the powerful composite bow that was a far more effective weapon (see fig. 1). The Assyrians may have had the first large army equipped with iron weapons, and it was their arms and tight discipline that enabled them to defeat more mobile enemies, such as the Arabs on the camel.

Equally vivid is the record of Assurbanipal's victories over one of his most formidable opponents, the Elamites. The scene is set on the top register, which shows the peaceful gardens of Nineveh. Below, however, on three registers, a powerful enemy prepares for battle and marches forth to make war. We can tell

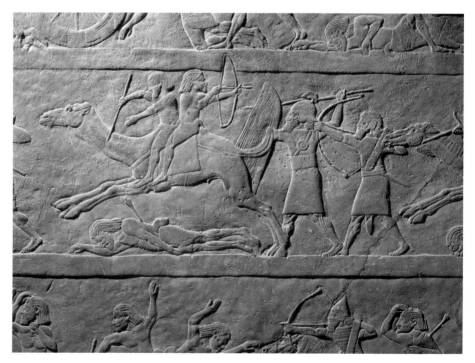

1 Camel from the Assyrian stone relief. The Arabs, with long hair, used pairs of soldiers on camels: one controlled the camel while the second shot arrows to the rear. The distinctive Assyrians, with armor, helmets, and trimmed beards, used the much larger composite bow. A dead Arab lies on the ground.

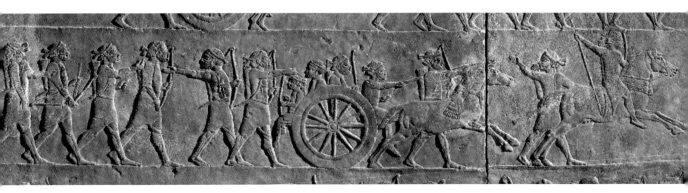

that these are Elamites from their characteristic headbands knotted at the back and also from the prominence of bowmen among their troops. It was the Elamites' reliance on long-distance fighting by archers and spear-throwers that put them at a disadvantage in their clashes with the Assyrians, because they were never able to prevail in the decisive, close-combat stages of a battle. Yet they are shown as redoubtable opponents, with soldiers marching in step, chariots filled to the brim, and splendid horses, elegantly attired and beautifully depicted (see fig. 2). What the panels make clear, though, is that in the end the Elamite archers and chariots were no match for the Assyrians.

Assurbanipal had defeated the Elamites once, and when they revolted around 650 BCE he decided to destroy their cities. The first to fall, in 648, was Hamanu. The top register of the commemorative panel shows the siege in dramatic detail. The Assyrians, in their distinctive headdress, climb a long ladder toward the top of a wall with crenelated battlements – the inner of two walls that ring the city. They advance with spears, shields, and arrows against the Elamite archers, and one of them has already climbed over the wall. On the ground below, other Assyrians turn their shields upward to protect themselves as they chip away at the fortifications. Around them lie the corpses of Elamites who have fallen to their death from the walls above (see fig. 3).

In the next scene, the city is razed, as the cuneiform inscription tells us: "The city of Hamanu, a royal city of Elam, I besieged and captured; I carried off its spoil, wrecked, destroyed, and burned it with fire." With flames rising from the towers and the gatehouse, men with tools resembling pickaxes, crowbars, and other means of demolition tear down the fortifications. Stones and timbers fall to the ground, and the tops of the walls are already uneven. Below, on a slope leading from Hamanu's gate, soldiers and prisoners carry off the loot, including caldrons and an elaborate chair that may have been a throne. A final demonstration of

2 Elamite troops from the Assyrian stone relief. The Elamite army, with its characteristic headgear, knotted at the back, marches out to war. It makes an impressive sight, with a sturdy chariot and fine weapons and horses, so that there will be no doubt that the Assyrians have overcome a formidable foe.

3 Scaling the walls of Hamanu from the Assyrian stone relief. With their archers already on the battlements, having climbed the ladder, the Assyrians assault the fortifications of Hamanu. Defenders' bodies are falling to the ground, to join their dead comrades, while the besiegers defend against missiles with upturned shields.

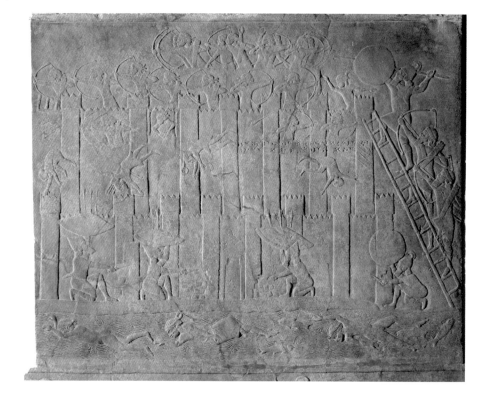

Assyrian might is a depiction of a river choked with the bodies of the defeated soldiers. The victorious Assurbanipal, standing in his chariot, presides over the scene. Nobody who saw this panel could doubt the ruthlessness or efficacy of Assyrian war-making.

Yet the panels are not just a record of events; they are also a work of art. Thus their designer could not resist adding, in his portrayal of the siege, a few elegant shrubs to decorate the slope below the walls. And the final touch, after the city has been captured, is a relaxed scene following the battle. The soldiers have laid their arms aside to eat, drink, and chat; one, on the far right, has to remain on guard, but even he, it seems, receives food from a woman who is one of the few smiling figures in this warrior's world.

The interest in nature is also apparent in a panel that begins, at the top, with the fall of Susa the year after Hamanu was captured. Bodies, weapons, and even a chariot mingle with the fish in the nearby river. After one of his victories, Assurbanipal exulted that a river was choked with corpses for three days, and one can see the theme repeated here. With success assured, Assurbanipal receives the booty in the next three registers. At the top is the river, now peaceful and

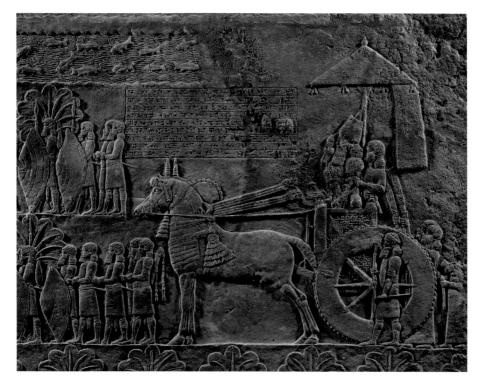

4 Assurbanipal from the Assyrian stone relief. The Assyrian king and commander, Assurbanipal, stands in his covered chariot. Even without his crown-cum-helmet, he is taller than the servants around him. Because it is shown out of scale, extending to three horizontal registers, the chariot is much larger than its surroundings, and Assurbanipal dominates the scene.

filled only with fish. Further down, amid graceful palm trees, the spoils are delivered to the king as he stands in his chariot, a moment that is magnified so that it extends across all three registers. Here is the conqueror himself, his face sharply portrayed, surrounded by servants and guards, looking steadfastly forward past a magnificent horse (see fig. 4). It is an image of the heroic commander that was to be echoed countless times during the ages that followed, though rarely again with the simple grandeur that these anonymous artists were able to achieve.

The Arts of Greece

When we enter the Greek world, attitudes toward war become more nuanced. A principal theme of Thucydides' history of the Peloponnesian War is the folly of excessive military ambition. Athens is laid low by the very quest for empire that had fueled Assyrian expansion. In the dialog between the Athenians and the Melians, Thucydides lays out the pride that comes before the fall. "The strong do what they can," says the Athenian representative, "and the weak suffer what they must." Right and justice have nothing to do with it.

Such uneasiness notwithstanding, there was general agreement that valor in battle was one of the supreme individual virtues. That was the lesson of the *Iliad*, and it was also taken up by the visual arts. As with the Assyrians, we are fortunate that Greek artists used materials that have survived across the centuries. Our two exemplars are objects made of ceramic and of stone.

First is a drinking cup 4½ inches high and 10½ inches in diameter, now in the Louvre, that was made by the potter Kalliades and painted by Douris, probably in the 480s BCE. We are at last in an age when artists are identified (both signed the cup), though we know little further about them. The potter has the same name as a companion of Odysseus, but is otherwise unknown. The painter is less obscure, because he has left behind over forty works that he signed, and dozens more that have been attributed to him. Given the survival rate of Greek pottery, it has been estimated that he produced thousands of pieces in his lifetime. Douris was an Athenian who worked mainly on cups made by others, though we know of some which he made himself. The potters with whom he collaborated, and the shifts in his style, have made it possible to suggest stages in his career. Beyond that, however, all is speculation. What is beyond question is that he was one of the master painters of his age.

The cup known as Louvre G115 shows three moments from the Trojan War. On the interior, inside an elegantly decorated border, is a scene of the pathos that accompanies battle. The goddess Eos, her wings flaring above her, carries the lifeless body of her son Memnon. He had come with an Ethiopian army to help the Trojans, but he had been killed by Achilles. Eos pleaded with Zeus to allow her to recover the body, and he agreed. The dead boy, arms hanging limply, is picked up by his mother, who stares fixedly at him. He is naked, as was customary for warriors, but she is in an elaborately pleated long gown. We see Memnon's wounds and, what is especially noteworthy, inside his arms and legs the bones of the skeleton he soon will be (see fig. 5). The fate that awaits the dead has rarely been so pointedly shown. It was said that Eos's tears created dew, but Douris has avoided any distraction from his central theme of finality and grief.

On the exterior of the cup are two scenes of individual combat between a Greek and a Trojan recorded by Homer: Menelaus vs Paris and Ajax vs Hector. In Book III of the *Iliad*, Menelaus, king of Sparta, challenges Paris, whose abduction of the king's wife Helen has caused the war, to a duel, with Helen to go to the winner. Menelaus wins, but before he can kill Paris the two goddesses who protect the Trojan, Aphrodite and Athena, spirit him away inside the walls of Troy, and the war continues. The hero here is clearly Menelaus, as one would expect in a Greek work of art. His sword drawn, and his shield dominating the center of the picture, he pursues Paris, who looks backward as he flees the field. But Aphrodite, holding

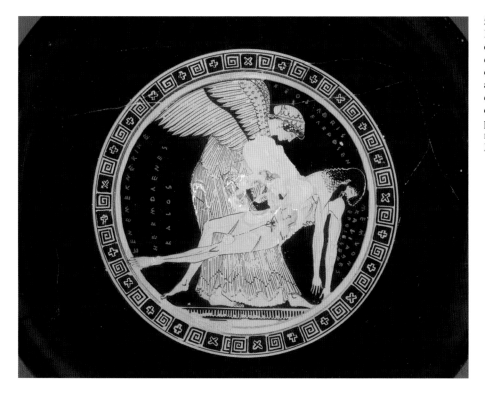

5 Eos and Memnon from the Douris cup. Though damaged, the inside of this cup reveals Douris's ability to capture the pathos that is the aftermath of conflict. Eos carries her dead son in a composition that eerily prefigures the many later representations of the Virgin Mary with the dead Christ.

a flower on the left, and Athena, holding a bow on the right, are about to inter-vene. One sees the sinews in the arms (and legs) of the warriors, in contrast to the delicate arms of the goddesses. But the clothes of all the protagonists are evoked in equal detail (see fig. 6). And the decorations suggest pleatings, armor, and drapery that vary from character to character. Douris is not merely illustrating Homer's verse, or showing us the contrast between men and women; he is giving a military scene a grace and a style that complement and enhance the action.

The final painting on the cup also celebrates a Greek hero, Ajax, who in Book VII of the *Iliad* took on Hector in single combat. Ajax prevailed, wounding Hector with his spear and knocking him to the ground with a large stone, but Hector struggled on until Zeus (who favored the Trojan) called a halt to the fight. Here Douris, while remaining true to his purpose of documenting a famous event, gives his artistic instincts especially free range. Behind Ajax, on the left, stands his protector, Athena, spear in hand. To the right, behind Hector, stands Apollo, bow in hand, to look after his charge. Balancing one another, the gods raise their free hands; both are dressed in flowing, pleated robes; and behind them are similar flower decorations. The heart of the action, however, is in the middle, where Ajax has just wounded Hector with his spear and hurled the huge stone that is bringing his antagonist to the

6 Menelaus and Paris from the Douris cup. The encounter between pursuer and pursued is a basic theme in the depiction of battle. Here Menelaus, the wronged husband of Helen of Troy, is about to avenge himself on Paris when the goddess Aphrodite, her arm raised, intervenes to protect her protégé.

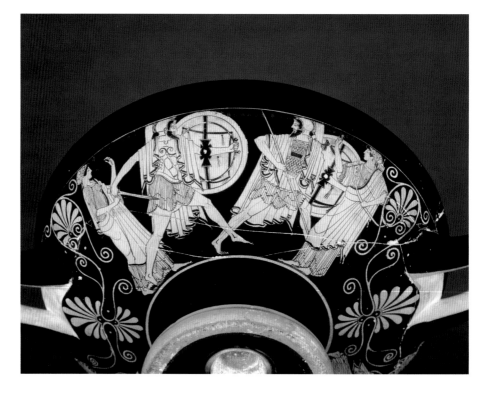

ground. Hector, wearing only a helmet and a scabbard, is about to fall down, his knee bent under him, while Ajax, in a uniform like Menelaus', seems about to strike again. Most arresting, however, is the shield that occupies the center of the picture. Greek shields were round, but with everything else going on in the painting Douris had no space for Ajax to have a shield that looked like Menelaus'. Instead, by a trick of perspective, he made it seem oval so that it would fit into the central area. And the odd, three-pronged stone had to be shaped accordingly (see fig. 7). It is an astonishing example of the artistic imagination trumping what might otherwise have been a straightforward depiction of heroism and war.

The Alexander Mosaic

The most famous Greek warrior was Alexander the Great, who set the standard against whom every general in history has been measured, and usually found wanting. No other commander has come close to the astonishing record of victory and conquest that unfolded in less than ten years, from 334 to 325 BCE, when his army overran empires and kingdoms from the Mediterranean to the Indian Ocean, from the Danube to the Ganges. Nor have the personal qualities that

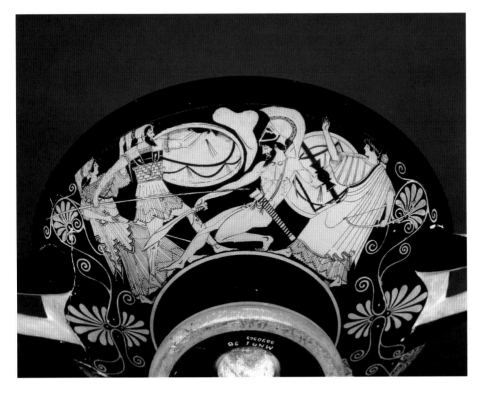

7 Ajax and Hector from the Douris cup. A strangely shaped boulder hurled by Ajax fells Hector, who still holds his shield and his wickedly curved sword. Alongside the sense of violence, though, one has to admire the elegance of the gestures and such touches as the pleats in the clothing.

made these successes possible – the tactical and strategic genius that Alexander displayed, not to mention his bravery in battle – ever been equaled.

The centerpiece of his relentless advance through Asia – the campaign that made him seem invincible and laid the foundation for his further success – was the destruction of the rich and powerful Persian Empire, ruled by Darius III. Over the course of four years, from 334 to 331, Alexander subdued a domain that stretched from Palestine to India, despite having to contend with armies and resources that completely overshadowed his force of 40,000 or so soldiers. This was a triumph that must have given the Greeks particular pleasure, because Persia was the ancient enemy. Darius' ancestors, Darius I and Xerxes, had twice invaded the Greek mainland from Asia Minor, only to be stopped by the legendary Greek victories at Marathon, Salamis, and Plataea. Now the tide flowed in the other direction, and Alexander exacted the ultimate revenge: the extinction of the Achaemenid dynasty that had ruled Persia for more than two centuries.

It took three battles to topple the empire: Granicus in 334, Issus in 333, and Gaugamela in 331. These have remained Alexander's most famous triumphs, textbook examples of tactical acumen, discipline, and personal courage overcoming daunting odds. On each field the Greeks and Macedonians were

outnumbered; in each case they faced an army that had prepared a strong defensive position (with the advantage in two of the battles, Granicus and Issus, of high ground and a river barrier); and each time there were desperate moments redeemed by determination, valor, and the shrewd identification and exploitation of weaknesses.

At the river Granicus, where Alexander encountered the Persians for the first time after crossing into Asia Minor, he himself, highly visible in brilliant armor and with great plumes on his helmet, transformed a dangerous stalemate by leading a decisive charge across the torrent and up the far bank into the midst of the enemy. The Persians hoped to kill him in the melee that followed, and the best account of the battle reports that he broke his lance in the fighting. Taking a new one from Demaratus of Corinth, so the account tells us, "Alexander with Demaratus' spear, seeing Mithridates the son-in-law of Darius spurring at him, charged out against him, and felled Mithridates. As he did so, Rhoisakes rode at him, and struck him on the head," removing part of his helmet, but Alexander killed him, too. Inspired by their leader, the cavalry surged forward and routed the Persian army.

The following year at Issus, in the very southernmost pocket of what is now Turkey, Alexander encountered Darius himself. The Persians were once again strongly in place, in the hills overlooking a coastal plain, and massed behind a line of stakes along the bank of the Pinarus River, which bisected the plain. This time the Persians advanced. Their right flank, at the edge of the sea, began to push back the Greeks' left flank. At the center, where Darius dominated the scene from a magnificent chariot, the Greek infantry made little progress and was in danger of being outflanked. But on the right Alexander led his cavalry, despite arrows raining down from the hills, in a stunning forward surge that he was then able to turn in order to threaten the Persians' center. Panicking, Darius decided to flee the field. Legend has it that Alexander was closing in on him, and that he was saved only by a friend who threw himself in the way of a deadly lance thrust. In fact, Darius escaped at the first hint of danger, and his premature flight caused disarray and the defeat of his army.

It was another two years before Alexander felt ready to move toward the heart of the empire by crossing the Tigris River. Nearby, at Gaugamela, in today's northern Iraq, he delivered the *coup de grâce*. Darius decided to make his stand in a broad plain, where there was room for his vastly superior numbers, his fifteen elephants, and an array of 200 armored chariots, which he hoped to drive right through the vaunted Greek phalanx. But it was not to be. Once again, the early maneuvers went the Persians' way. They withstood and then threw back the advance of the outnumbered troops in the Greeks' center and left, and soon

threatened to outflank them. Meanwhile, however, the chariots, which attacked Alexander's right flank, were cut to pieces by his more maneuverable cavalry. And the advance of the chariots left a gap, near Darius himself, in the Persians' center. This Alexander exploited with an unexpected and fearsome assault. As before, Darius fled, and his army fell apart, never to be reconstituted. Within a year, the emperor himself was assassinated.

The road to India was now open and, until his death seven years later, Alexander dominated the centers of ancient civilization. But he was no mere warrior. Tutored by Aristotle himself, he was also famed as a patron of the arts. His court artist, Apelles, was said to have been the greatest painter of antiquity. According to one story, Alexander acknowledged the supremacy of the artist, even over himself, by picking up a brush that Apelles dropped while he was painting a portrait. It is one of the great losses of Western culture that none of Apelles's work, or indeed any of the art that Alexander patronized, has survived. But there is one magnificent celebration of his triumphs that, though damaged, has a lineage that takes us back to his reign and offers a precious glimpse of the aesthetic values that surrounded history's greatest warrior.

On October 24th, 1831, the excavators of Pompeii found in the volcanic dust of Vesuvius, where it had been buried 1,750 years earlier, an enormous mosaic. Measuring about 10½ feet by 18 feet and containing some four million individual pieces, it remains the largest single mosaic picture in existence. Appropriately, it had decorated the most splendid building in Pompeii, known today as the House of the Faun. Probably made in a Sicilian workshop in the late second century BCE, it seems to have been based on a famous Greek painting completed two centuries earlier – that is, either during or just after Alexander's lifetime. Because of the accuracy of the depiction of costumes and weapons, scholars have concluded that the original painter must have been a contemporary. Various candidates have been suggested, including Apelles himself, but it seems safe to claim only that the artist was an undoubted master and that he probably completed the picture around 320 BCE.

What is so unusual about the mosaic is how it captures, in this very different medium, the sense of movement, the emotions, and even the indistinct background that must have marked the original (see fig. 8). And it is a complex story that it conveys. As its most incisive interpreter, Bernard Andreae, argues, it is nothing less than an evocation, in one scene, of all three of Alexander's victories over the Persians.

On the left, in splendid armor decorated with a fearsome Gorgon head, and riding his famous horse Bucephalus, is Alexander, lance in hand. He has just killed the Persian in front of him, who vainly tries to hold back the lance that pierces his

8 The Alexander Mosaic, even while incorporating meticulous details such as the Gorgon's head on Alexander's breastplate, manages to suggest the destruction and fear of battle. The gesture of the fleeing Darius, and the elegant spiral of the spears, focus attention on the victorious commander.

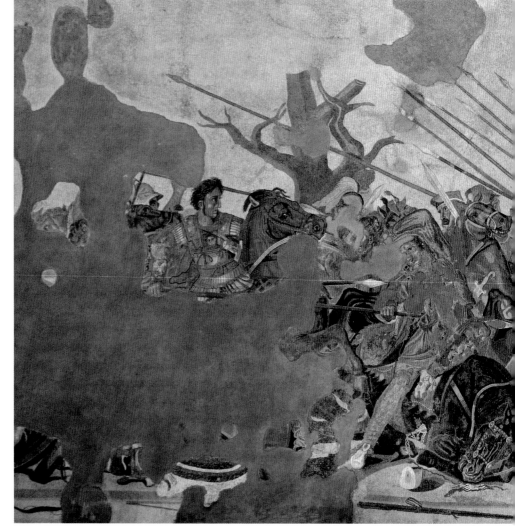

body. The victim sits astride a magnificent but dead horse that conveys all the pathos and destruction of battle. To the right a fearful warrior, turning his horse to flee, looks back on the scene. Behind him, dominating the picture, is Darius himself in his chariot. His driver is whipping his horses to speed from the battle, while the emperor looks back and reaches out in a despairing gesture to his slain warrior. But there is clearly no longer any hope, as all the Persian troops join his chariot in retreat.

 The movement and drama the mosaic captures, and the color and detail of its artistry – down to the highlights in the pupils of the protagonists' eyes – have won

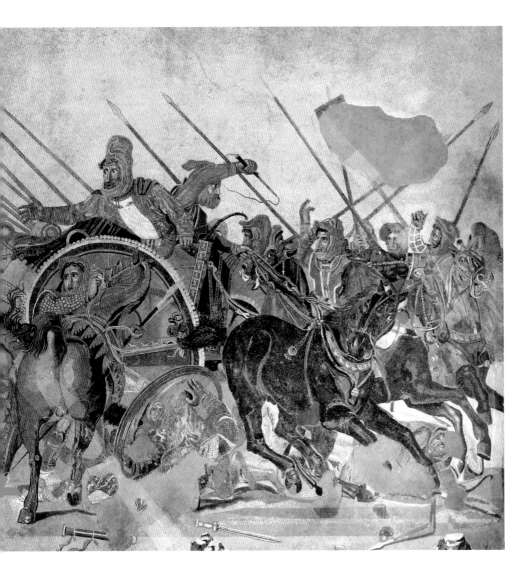

it recognition as one of the supreme achievements of ancient art. The German poet Goethe was deeply affected when he saw it, soon after its rediscovery, and it is among the chief attractions of the Archeological Museum in Naples, to which it was moved for safe keeping. Its appeal, moreover, is enhanced by the long-standing assumption that the portrait of the figure on the left may be the closest we can come to what Alexander actually looked like, since its pedigree goes back to his lifetime. This identification is reinforced by Andreae's suggestion that the events in the mosaic might have been intended as a composite tribute to the conqueror's three most renowned victories.

We can tell from the headgear and clothing that Alexander is fighting the Persians, and since Darius is escaping the onslaught in his chariot, this could be either Issus or Gaugamela. But the fact that Alexander is not wearing the plumed helmet for which he was famous suggests the strike by Rhoisakes at Granicus, which smashed the helmet. And since the only record of his killing specific Persians comes from that battle, his lance thrust through the body of the horseman could also be seen as a reference to his derring-do at Granicus. The horseman he is killing may, in turn, echo the story of the Persian who reputedly saved Darius at Issus when Alexander was in hot pursuit – a moment highlighted by the agonized reaching-out in the mosaic. If, then, the scene seeks to evoke no one battle, we might conclude that the flight of Darius and his troops also recalls the conclusive rout at Gaugamela.

Whatever the particular references the artist intended, we are undoubtedly witnessing a powerful moment from the Persian campaign – a moment so skillfully constructed that the hero, Alexander, can be set amidst the chaos of battle, while the enemy, Darius, can take on a prominence that, in the end, only emphasizes the magnitude of his defeat. The dominant figure in the elegant chariot succumbs to the warrior on horseback (yet another recollection of what happened at Gaugamela); indeed, the entire scene has a sweep and a grandeur that recall the subject it celebrates. For the trio of victories was Alexander's own masterpiece: they formed the most brilliant of a world conqueror's many brilliant campaigns, and in the Sicilian mosaic they found a worthy counterpart in the realm of art.

Signs of Change

From the evidence that has survived, it is apparent that the artists of these earliest centuries of recorded history found different ways of responding to warfare. The Assyrians, while concerned to convey a sense of accuracy in their depictions – hence the care with clothing, and such details as bushes and trees – were above all intent on recollecting great events. In works commissioned by their king himself, they evoked the most memorable scenes from the military triumphs that the elite clearly regarded as the glory of their realm.

In the hands of the Greeks, there were notable shifts of emphasis. Of major importance – and indeed essential to the depiction of war thereafter – was the emergence of the individual warrior as a central subject for the artist. With bravery and success on the battlefield elevated to the highest rank of human accomplishments – even Socrates was admired as a soldier – it was no surprise that the exploits of heroic figures should have featured so prominently in works

of art. Once the figure of a specific combatant became the focus, however, the possibilities widened for the creative spirit. Now it was not so much the collective achievement as the character of the warrior that came into view. Naturally, his bravery and skill inspired the highest respect, but there was also room for other considerations.

First was the role of the gods in human affairs. In the end, the outcome of a fight was determined by forces beyond the antagonists' control. There was no doubt about the heroism of Ajax, but behind him stood Athena. And though Menelaus was sufficiently fierce for Paris to require protection from two goddesses – Aphrodite (whom he had chosen as the fairest of deities) and Athena (whom Menelaus had offended) – this divine intervention did ensure that the Greek would be unable to destroy his enemy. The warrior, in other words, had to be seen in context.

The other new element was a recognition of the loss caused by warfare. In Assyria one saw the defeated, but they appeared mainly as the unavoidable accompaniment of victory. The latter was the main theme. But the grief of Eos was something else. She (no less than Hecuba in Homer's epic) was the embodiment of the terrible price that warfare exacted. Nor was the agony of defeat absent from the Alexander Mosaic. The balance was still heavily weighted toward the heroic, but at least the other side of the equation had put in an appearance. It was to be many centuries before that concern became more salient in the arts, for one sees little change in values either in Rome or, despite the rise of Christianity, in the Middle Ages. Yet that small modification of the emphasis on war's glory would eventually blossom into a transformation of the image of battle in the visual arts.

Rome and the Middle Ages

Rome at War

The most powerful and long-lasting military machine of antiquity was that of Rome, conqueror of the largest of the ancient Mediterranean empires. The Romans' success was a result of their going further than any of their predecessors in developing a state's military capacity. Theirs, for example, was the first full-time, large-scale salaried army. A legionnaire signed up, usually in his early twenties, for a term of service that normally ran for twenty-five years. There was heavy reliance on careful organization, on drilling, on discipline, and on weapons training to shape a fighting force that chalked up an astonishing record of conquest and victory for over half a millennium. At its broadest extent the Roman Empire reached from northern England to Persia, including all of the territory south of the Danube and west of the Rhine. The number of men under arms reached six figures, held together by the prized ideals of obedience, personal courage, and devotion to the *patria*, the fatherland. Like all successful warriors, though, they could also be ruthless. To describe one of their campaigns, their most acute historian, Tacitus, needed just four words: *solitudinem facient, pacem appellant*, usually translated as "they made a desert, and called it peace."

The central unit of the army was the legion, consisting of some 5,000 citizen-soldiers (less than 10 percent of whom were cavalry), who were committed to long-term service. They developed the sense of unity and camaraderie that was essential to their success, but it should be noted that, though they were the heart of the army, they often did not supply the majority of its soldiers. For they were always accompanied by non-citizen auxiliary soldiers, drawn from allies or conquered areas and consisting mainly of light infantry (rather than the legion's heavily armed infantry). These auxiliaries provided the bulk of the cavalry and all

the archers in a fighting force. They took responsibility for some of the empire's garrisons; and they sometimes had more men on the field than the legionnaires. Still, the core of Rome's military might was its legions, which not only formed the best-disciplined force of the time but were also able to share their fellow citizens' conviction that the ultimate glory of their state was defined by the triumphs of its armies.

There was much else that contributed to the Romans' conquests. They marshaled their economic resources effectively so as to ensure that their troops received the ample and regular supplies and equipment they needed. It has been estimated that there may have been as many as 400–600 servants attached to each legion, responsible for looking after baggage and providing food for the men and fodder for the animals. Logistics, too, were a matter of constant concern. In the building of camps, the planning of marches, and the attention to the organization and technical support that kept an army always at the ready, the Romans had no equals. Their roads remain famous to this day, and the relics of the camps they built for their troops have been a treasure trove for archeologists. Modern place names like Chester (an English town whose name derives from the Latin *castra*, camp) are living testimony to the presence of the legions.

With modern techniques, it has even been possible to reconstruct the order of march of a Roman army. The Westphalia site of the famous disaster in the year 9 CE, for instance the so-called battle of the Teutoburg Forest – when three legions were wiped out in a prolonged ambush by German tribes – has yielded extensive information about the equipment and the arrangement of the troops as they crossed difficult territory east of the Rhine. That the river became the empire's border thereafter is an indication of the extent of the disaster; for the historian and archeologist, however, the remains that survive in the marshes and forests of Westphalia enable us to appreciate the scale and complexity of Rome's military capacity, even at a distance of nearly a thousand miles from home.

Perhaps the most important single innovation associated with the Romans is their recognition of the importance of technology both in improving battlefield weapons and in the preparations for war. Nothing like their system of roads and bridges had been seen before in the ancient world. There were many reasons for this focus on communications, but the need to smooth the way for large bodies of men on the march was certainly one of them. And the mastery of digging and building, essential to the creation of defenses and forts, as well as the key to siege warfare, was exceptional. The Romans' skills as engineers were central to the successes they achieved in many realms, and nowhere more tellingly than in their pursuit of military power. It is no surprise that many of the scenes that give us

glimpses of the life of the soldier seem to celebrate the talents in construction work and other practical duties that set the legions apart.

The Image of the Warrior: Augustus and Marcus Aurelius

Given the importance to Roman society of bravery and success in war, the treatment of these subjects was a significant element in the arts. The opening words of the epic poem that helped define the city's history, Virgil's *Aeneid*, are *Arma virumque cano*, "Of Arms and the Man I sing". Unfortunately, there are no good surviving examples of what was probably the most common genre to address this theme in the visual arts, the Triumphal Painting. Meant to commemorate major conflicts, these depictions of scenes from campaigns and, above all, of the triumphal processions that honored victorious commanders and their armies, began to appear as early as the fourth century BCE. Sadly, however, our knowledge of the Triumphal Paintings now depends largely on written records. One of the most famous, by Josephus, describes a painting of the sack of Jerusalem that was the climax of Titus' Judean campaign in 70 CE. It showed, he says, "a happy country laid waste," the dead and the captives, and the fires that destroyed the city. "The workmanship," he adds, was so "magnificent and lively" that even those who were not there could see exactly what happened. Paint, though, is the most fragile of media, and, as with the Greeks and Assyrians, we have to look to other materials to see how artists envisioned warfare. Titus' conquest and subsequent triumphal procession, for example, remain visibly recorded only in the stone frieze on the arch near the Forum in Rome that was erected after his death by his brother and successor, Domitian, to honor his victory.

It is to the durable materials stone and metal, therefore, that we must turn if we are to see how Roman artists responded to warfare. Three masterworks, in particular, will suggest how they viewed the nature and the implications of the armed conflict that dominated their society. All three come from the imperial age, when the empire was at its peak, and when the Greek-dominated styles of the so-called Hellenistic era following the death of Alexander the Great gave way to a distinctive Roman vision.

The first two, though separated by nearly two centuries, are portraits of emperors: a marble statue of Augustus, usually referred to as the Augustus of Prima Porta, from the name of the villa, owned by his widow Livia, where it was found in 1863; and a bronze equestrian sculpture of Marcus Aurelius. The Augustus is believed to be a copy of a bronze version, now lost, that the Senate commissioned for a public space in his honor around 20 BCE; the Marcus Aurelius was erected in central Rome in the year 176 CE. There is a major difference

between the two statues, in that Augustus is shown as a warrior in armor whereas Marcus Aurelius, wearing a simple toga, does not appear in military garb. In both cases, however, the image came to be seen as an emperor in heroic pose. It may be that only the Augustus was intended as such, but that does not prevent us from linking these two examples as idealized representations of the valor that was regarded, both by contemporaries and in later centuries, as the epitome of Roman virtue.

The Augustus is a little over six feet high, and he is shown in a pose that marks him as a military leader. Not only is he dressed in elaborately decorated armor, but he raises his arm in the gesture of allocution (*adlocutio*), which identifies him at the moment when he is addressing his troops, usually on the eve of battle (see fig. 9). So potent was this gesture that it remained an emblem of imperious assertiveness until it was adapted for the Nazi salute in the twentieth century. In his left hand he carries the consular baton which, like the drapery across his lower torso, was a symbol of command. The small child riding a dolphin at his feet is Cupid, to emphasize Augustus' reputed descent from Venus, and hence his divinity. The latter is reinforced when we realize that, as in traditional figures of the ancient gods, his feet are bare.

With his calm, far-seeing look, Augustus seems to embody all the qualities the Romans most admired. He is powerful yet relaxed, at ease with his heroic and even divine status, and focused on his role as a commander. To underline his status and achievements, the figures embossed on his breastplate refer both to his heavenly connections and to his achievements on behalf of Rome (see fig. 10). At the top is Caelus, the god of the sky, spreading the cape of the heavens over all; below him Sol, the sun god, drives the four-horse chariot that carries the sun across the sky each day. This scene may well be so prominent because it connects with the emperor's patron deity, Apollo, who was often thought of as a sun god. Apollo himself we see with his lyre at the bottom left. On the two shoulders of the breastplate are sphinxes, associated with Egypt and thus with the defeat of Antony and Cleopatra at the battle of Actium in 31 BCE that made Augustus supreme in Rome. And in the center is the moment that symbolized his skills as a diplomat – an aspect of his rule that was much touted and a source of immense pride – when the Parthians, who had previously defeated

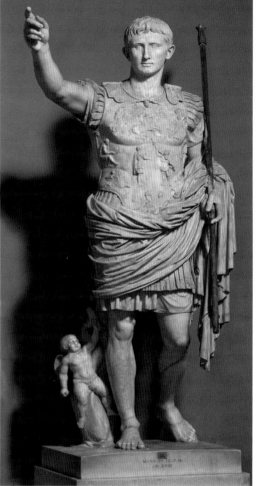

9 Augustus of Prima Porta. Few leaders have earned as potent a reputation as the emperor Augustus. Successful in war, he also transformed the government of Rome and presided over a cultural golden age. Yet his most famous portrait is as a warrior – supremely confident in a gesture of command.

10 Augustus of Prima Porta, detail, breastplate. Though it would have required expert assistance to decipher, the symbolism of the decorations of the breastplate manages to pay tribute to the emperor's god-like status, to his own deity, Apollo, and to his mastery of both war and peace.

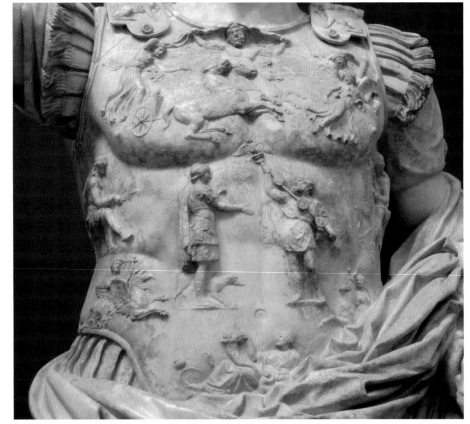

two Roman armies, agreed to return the battle standards they had captured. Since Rome's representative on that occasion was Tiberius, the emperor who succeeded Augustus and may well have commissioned this statue, the scene could have been intended as a way of legitimizing the succession.

As a whole, however, what was carved into the marble was a combination of the most prized virtues of the day: the disciplined commander who was victorious in battle, a master of peace, and divine. This last was a Roman addition. The Greek heroes, remembered from a distant time, had had connections with the gods, but this was a living contemporary who shared their immortality. For all this complexity, the artist was able to create both a coherent portrait and one that emphasized how essential, amidst Augustus' many attributes, was his distinction as a warrior.

Nearly two hundred years later, another emperor was honored with a public statue, once again in a pose that was to be influential for centuries to come. Marcus Aurelius had also gained fame on the battlefield. Indeed, most of his reign

(161–180 CE) was taken up with warfare, and he himself led armies in campaigns in northern Italy and along the empire's Danube frontier. Moving on from the model set by Augustus, the Romans had elevated their emperors even further by presenting them on horseback. Marcus Aurelius was by no means the first to be shown in this way, but the other statues were melted down in subsequent centuries so that their valuable bronze could be reused in coins and decorations. That he survived was solely the result of the mistaken belief, during the Middle Ages, that this statue was of Constantine the Great, Rome's first Christian emperor, who lived more than a century later.

Because of the horse, the sculpture is much bigger than the Augustus. It is nearly 11 feet high, and Marcus Aurelius himself is larger than life size – especially disproportionate in comparison with his horse (see fig. 11). This time there is no

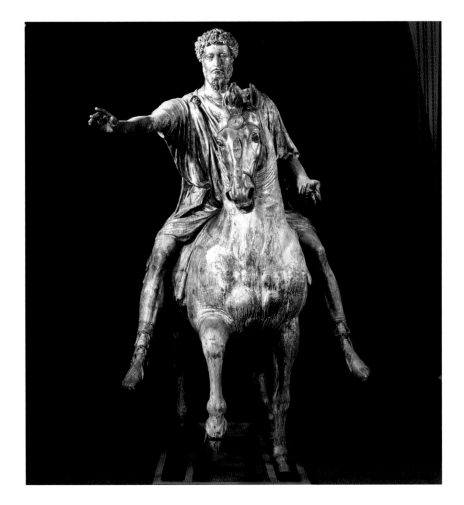

11 Statue of Marcus Aurelius. It was by luck that this bronze of Emperor Marcus Aurelius survived, yet it became the model for depictions of heroic leaders for centuries. If they wanted themselves shown at their most commanding, this is how they would appear, as grandiose figures on horseback.

armor, but there can be little doubt that this is a representation of power. The emperor may have been a notable writer, famous as an exponent of the philosophy of Stoicism, but of that side of his life there is no evidence here. He holds his right arm up in the same gesture we saw in the Augustus, and it is possible that his right hand once held the baton of command. There is evidence, moreover, that there once lay, below the horse's raised hoof, the figure of a bound captive, to whom the raised arm may have indicated either clemency or superiority. Given that this "allocution" gesture was associated with military command, however, it makes sense to regard the sculpture, even in the absence of armor, as a tribute to the conqueror as well as the wise ruler. The calm features, moreover, make Marcus Aurelius an emperor who embodies the undisturbed might of imperial Rome. His pose became a potent inspiration for portrayals of warriors in subsequent centuries.

When, in the Renaissance, artists wanted to show a leader at his most magnificent, it was on horseback, as a great commander, that he appeared. In the sixteenth century, Michelangelo was to make the equestrian Marcus Aurelius the focal point of the square he designed at the summit of the Capitoline Hill in Rome. By then, the statue had already served as a model for military men and for princes, but in the years that followed the homage proliferated. It became almost conventional, if you were a king or a general, even as late as the twentieth century, to have yourself shown (whether in armor or not) astride a splendid horse. Few images created by a Roman artist were to have as long and fruitful a life as this depiction of the ultimate heroic figure.

Trajan's Column

Our third example from Rome takes us into a different realm, to a masterpiece without precedent in form or structure that remains a marvel to this day: Trajan's Column. Nothing in history could have prepared Romans for this prodigious feat of engineering as well as art, which was completed in the year 113 CE. There had been engraved obelisks before, and huge pillars, but this structure, almost 100 feet high, and raised on top of a base 25 feet high, was not just physically imposing; it was decorated to a degree of elaboration not previously seen. Constructed out of twenty huge drums made of marble, each of them nearly 12 feet wide and weighing some 40 tons, it was covered by a frieze that was over 600 feet long and curved around the column twenty-three times. This immense carving describes Trajan's two victorious wars against the Dacians by creating 157 distinct scenes and over 2,500 individual figures. What is especially striking, where we are concerned, is that it conveys almost every aspect of the warfare of the time. Moreover, although we are now able to study the details through casts and photographs of the frieze,

astonishingly enough, it was not intended to be seen, since it rises far too high to allow anyone at ground level, or even on ladders, to make out what is going on. Its episodes are in fact taken from the *Commentarii*, Trajan's own history of the wars, and thus one must regard it both as an illustration of his written account and (because of its size and invisibility) as a symbolic tribute to his success as a commander.

There is no space here to follow the full story told by the frieze, but even a few of the scenes reveal the great skills of the artists who commemorated Trajan's campaigns. One has to say "artists," because although the designer of the column was a brilliant sculptor, architect, and engineer named Apollodorus of Damascus, the execution must have been the work of many hands. Apollodorus was a protégé of Trajan, the builder (as we shall see) of a bridge over the Danube and another in Spain. In addition, he built the houses and baths of the area in central Rome known as Trajan's Forum, where the column was erected; he designed triumphal arches for the emperor; and he was possibly the architect of the final version of the city's most famous surviving building, the Pantheon. This last, however, was not completed until the reign of Trajan's successor, Hadrian, whom, so it was later said, Apollodorus offended and by whom he was executed around 130 CE. Whether that story is true or not – and scholars are divided on the issue – Apollodorus would not have been the last creative figure to run foul of the politically powerful. Yet it seems especially poignant that such might have been the fate of the man whom it would be easy to consider the greatest artist in the history of ancient Rome.

The frieze tells the story of two wars that Trajan fought (in 101–102 and 105–106 CE) across the Danube border to punish the troublesome kingdom of Dacia (modern-day Romania) and its ruler, Decebalus. It starts at the base, with the preparations for the first campaign. In an early scene, barges are loaded from a fortified village on the banks of the Danube. Soon, however, through an arch in the walls of a city, the legions begin to march forth, crossing the Danube on a bridge of boats and watched by the river god, Danuvius (see fig. 12). Trajan himself appears fifty-nine times on the column. Near the beginning, for instance, while sacrifices are offered for good fortune and trumpeters sound, Trajan (on a platform above the action, as is often the case) points out to two of his officers a strange sight: a man in a loincloth, holding a sieve, who has fallen off a mule. Scholars have assumed that this little episode was regarded as a good omen, but it remains one of many fascinating but unexplained details in the frieze. Later, Trajan addresses the legions with the classic allocution gesture we saw in the Augustus statue (and echoed by Marcus Aurelius); this is a pose that he adopts more than once, and in these scenes it seems to have been the signal to launch an attack.

12 Trajan's Column, Danuvius. The largest figure on Trajan's Column is Danuvius, a river god who watches the Roman legions going off to war. As they depart, they cross his river, the Danube, on a beautifully rendered bridge that we can see is built on boats.

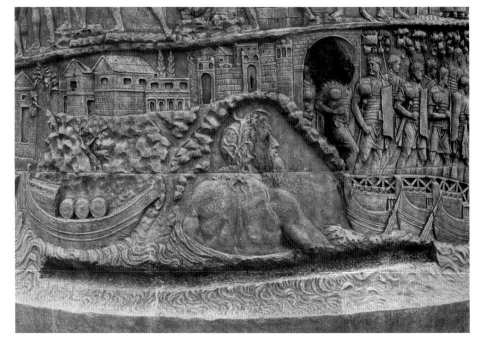

The mastery of gesture, combined with the determination to convey a sense of the day-to-day events of the campaign, is epitomized in an episode when a Dacian prisoner is brought before the emperor. Trajan stands taller than those around him, and behind him are the auxiliary soldiers who are always carefully distinguished, by their uniforms, from the legionnaires. In front of him, bearded, disheveled, hands held behind him and knee bent in supplication, is the Dacian whom he is interrogating. Another auxiliary holds the man's arms and his head. This is a pregnant moment, but Apollodorus is not about to waste an entire scene on this one confrontation. In the background, we see legionnaires hard at work at the tasks that must have been almost constant during the campaign: building and repairing fortifications.

At last, we come to an actual battle. As Jupiter hurls a thunderbolt at them, the Dacians advance, though behind the front line they already tend to their wounded. Almost hidden among trees, their king, the bearded Decebalus, wearing a crown, observes the action. That the artist could add a little touch like this is an indication of his determination to present, not just conflict, but also the human details that illuminate a long, difficult, and relentless campaign. And it is not only open battle that we see. In one of the scenes, a fortified city, its walls defended by auxiliaries holding shields and hurling rocks, is besieged by Dacians, including an archer and two soldiers holding a battering ram (see fig. 13). Responding to the attack, Trajan, prominently at the helm of his flagship, heads out to join the fight,

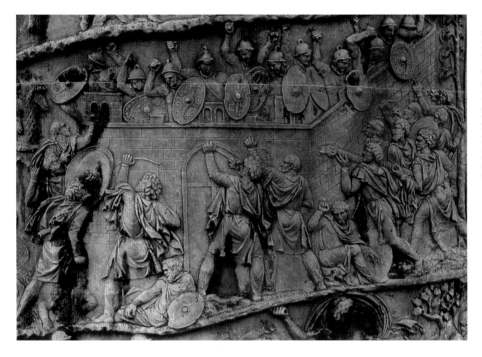

13 Trajan's Column, siege. In an echo of the Assyrian siege, Roman auxiliaries defend a town against Dacians, who attack with bows, slingshot, and battering ram. Since Dacians were bearded, the clean-shaven attacker may have been a Roman deserter. Below the edge of the frieze Jupiter hurls a thunderbolt, part of a battle scene on a lower register.

leading a fleet propelled by oarsmen pulling the ships through the Danube (see fig. 14).

In the end, the Dacians are pushed back, and we see them retreating on horse-back, wearing their characteristic helmets and armor. One archer turns back to shoot at the Romans; another lies on the ground; a third, wounded, is falling off his horse. There is no triumphalism here: just a cool recording of the aftermath of battle. And a few scenes later, as the legions parade their banners before the emperor, we see in the background the prison where captured Dacians are kept. Not that battle is the only topic at hand. In one scene, legionnaires are hard at work digging the moat and building the walls of a fortified encampment, while a few of their number keep a lookout from nearby hills. The sheer variety of the subject matter is astonishing. A few panels later, we are presented with the rough seas that Trajan described when soldiers were brought by oarsmen across the Adriatic. As the troops reach landfall, the waiting allies sacrifice a bull in thanks.

Soon thereafter, the emperor enters a captured city on horseback, to be greeted by the inhabitants hailing his approach. He also attends the ceremony when the bridge Apollodorus built across the Danube is dedicated. Both legionnaires carrying their banners and auxiliaries are in attendance; in the background we see the bridge itself; and standing behind the emperor, according to tradition, is Apollodorus himself (see fig. 15). Trajan pours an offering on to an altar, and it is

14 Trajan's Column, boats. When the Romans head for battle, Trajan leads the way as the helmsman, holding the rudder in the lower boat as they cross the Danube. This close-up shows the edge of the circular drums that make up the column and also the borders of the frieze.

15 Trajan's Column, Danube bridge. Trajan pours a libation on an altar and a bull is led to slaughter in the ceremony inaugurating the Danube bridge, whose huge piers we see in the background. Its architect, Apollodorus, is believed to be the man immediately behind Trajan.

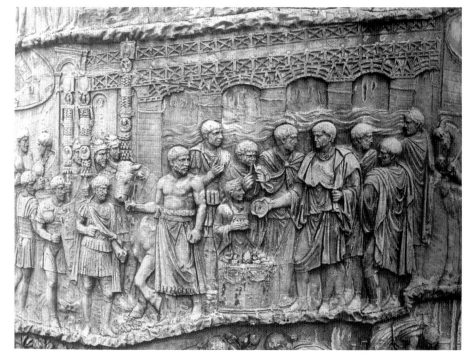

in this same religious role that we see him, a few scenes later, at a ceremony where he again pours a libation on to an altar. Now, however, he is inside an encampment, and he wears the veil that was the mark of Rome's high priest (the *pontifex maximus*). Outside, a pig, a ram, and a bull are led forward as a prelude to the sacred moment when all three are sacrificed to Mars, the god of war, in order to purify the newly conquered land. Completing the picture is a set of musicians playing the various instruments that accompanied the ceremony.

As the wars come to an end, the artist's gaze remains unflinching. The severed heads of defeated troops are brought to the emperor; Dacian priests or officials pass around, from a large bowl, what is probably the poison for a mass suicide, whose dying and dead victims are off to the side. And then, near the conclusion of the frieze, we find the crowned Decebalus under a tree. He has drawn the long knife with which he will slit his own throat, while a number of Roman soldiers try to stop him. But it was not enough for Apollodorus to document yet one more episode in the long story. What sets him apart as an artist of human understanding as well as supreme skill is the figure above Decebalus. It is a Roman soldier who, seeing that he has failed in the effort to forestall the suicide, puts his hand to his forehead in despair. And then, in a final scene, we see the Dacian civilians fleeing their homes: the refugees who are the ultimate casualties of the conflict.

The treatment is unblinking, and its many details amount to an artistic response to warfare that manages to convey celebration as well as reportage, compassion as well as power. It displays the importance of religious belief even as it emphasizes the necessity of endless toil. And it gives a sense of the many settings in which a campaign unfolds, neither romanticizing nor downplaying the way that men both fight and die.

The Era of the Knight

During the European Middle Ages, the scale of war shrank, and its pursuit lost the vast organization and discipline that had marked the Roman era. It was no less omnipresent, and no less bitterly fought. But the elaborate state bureaucracy that could keep tens of thousands of soldiers permanently in the field had gone, and in its absence the nature of military conflict changed. As the center of Roman power shifted eastward, to the new capital of Constantinople, and as western Europe, in the wake of this shift, became an area of fragmented political authority, with many isolated areas, it became inevitable that combat, too, would be transformed.

During the thousand years between the fall of Rome and the invention of gunpowder – which was to usher in another new kind of battle – fighting in the

West was conducted in a variety of ways. In the early centuries the principal cause of conflict was the massive wave of migration from the east. Some of those on the move, like the Lombards, the Goths, or the confederation of tribes known as the Franks, had been living in what is now Germany and eastern Europe. In a number of regions, their homes were near the border of Roman lands, and their penetration of the empire was a gradual process. In many cases, however, particularly with those who came from Asia, like the Huns, the rampaging newcomers mounted direct invasions. And the assaults came not only from Germany and the east. In the eighth century Muslim armies came from the south, conquered the Iberian Peninsula, and advanced into the center of France. Soon thereafter eyes had to turn north, where, coming by sea from Scandinavia, Viking warriors not only plundered but also founded settlements as far apart as Dublin and Kiev. No town or territory which their ships could reach remained immune, and for nearly three hundred years their military prowess was feared in places as scattered as Paris, Sicily, and Constantinople itself.

The response to these invasions was largely ineffectual until, in the eighth century, the Franks began to consolidate a large kingdom in the heart of western Europe. Their counter-offensive, emanating from the Rhineland, halted the Muslim advance in the south, regained control of France, made inroads into Italy, and pushed eastward into Germany. The Franks' successes, embodied in the figure of Charlemagne, inaugurated a new era of warfare, in which battles involved settled but hostile neighbors rather than scattered communities resisting marauding invaders. It was this more organized form of warfare that dominated Europe's Middle Ages. Though the scale never matched Roman combat, and the methods were very different, the memory of Rome's achievements remained a powerful example for centuries. By having himself crowned in Rome, Charlemagne sought, at least in part, to reclaim the title of Augustus, and as late as Charles V in the sixteenth century the belief in what was now regarded as a Holy Roman Empire had not entirely disappeared.

That it was "Holy" marked another basic change that was to affect the nature of war. The Middle Ages witnessed the rise of Christianity, and although this was a faith that advocated meekness and turning the other cheek, it added its own elements to the long history of military conflict. For example, the monasteries that were havens of spirituality in a disordered world could not escape the mayhem that sometimes surrounded them. They were often built as fortified enclaves, and their monks, as we shall see, were only too aware of the combat outside their walls. In addition, churchmen were often notable warriors, and even when they were not on the battlefield, their beliefs became a major new stimulus to military action. From the late eleventh century, when the first Crusade was launched, until the

second half of the seventeenth century, a repeated purpose of warfare was to impose a form of Christian belief on those who were regarded as unbelievers. It was this new goal, which aroused fiercer passions than did the efforts to expand territory or authority characteristic of earlier times, that added a third and final new dimension to the warfare of the age.

In the waging of actual battles, the transformation was no less notable. For this was the great age of cavalry warfare, when mounted knights epitomized armed conflict. Why this should have been so, and what limits these warriors faced, have been much debated by historians of the Middle Ages. One theory had it that the invention of the stirrup – developed in Asia, probably China, and widely adopted in Europe during the seventh and eighth centuries – made fighting on horseback far more effective. The double stirrup (an earlier version, on just one side, had served mainly as a help in mounting a horse), in combination with the heavy saddle to which it was attached, and the pommel in front, gave the rider a new stability, especially when wielding sword or lance, that he could exploit in battle. The latest thinking suggests that this may have been the case in a conflict between knights, but does not explain the prominence assigned to the horseman, as opposed to the infantryman or the archer, in medieval battles from the eighth to the fifteenth centuries. For that explanation historians have begun to look at social and economic conditions.

What set the elite apart in medieval Europe, as well as its wealth, was the special role it came to play in the organization of what became, in contrast to the structured rule of the Roman Empire, a relatively fragmented society. Since castles were the safest refuges in areas where political authority was still local, their lords, who dominated the surrounding countryside, were the only people who had the resources to own a horse and equip a fully clad knight. Their dependents, and the peasants who tilled their lands, might serve in their entourage, but their own role, as the equestrians who led the forces on the battlefield, was unique, and one for which they trained from an early age. Tournaments at which they could practice their talents honed their skills; a cult of nobleideals – chivalry – arose to validate their special privileges, their authority, and their aristocratic status; and religious ceremonies were devised to give ultimate justification to the violence that they wreaked. The mystique that surrounded the knight was thus religious as well as social, and put him at the heart of the web of obligations, responsibilities, and political and economic relationships – usually summed up as feudalism – that formed medieval society.

Those larger conditions, however, cannot alone explain the dominant role of cavalry during these centuries. For a body of infantry, organized as a defensive unit, could hold its own against mounted soldiers, because horses refuse to charge

into a closely packed group of men. Indeed, knights had to dismount if infantry held their ground, and continue their assault with hand weapons. But in an age of limited resources, few leaders could assemble the numbers or provide the training that would have put a substantial and disciplined infantry force in the field. It did happen, and archers could also disrupt a charge because horses lacked the armor of a knight. At some battles, therefore, the infantry did prevail; but in general the central feature of open battle in the Middle Ages was the charge of a line of knights. It was a terrifying sight, which, if it sent opponents into flight, had dire consequences, for the cavalry's speed meant that pursuit could wreak havoc on disorganized troops.

Since the charging knight, hurtling forward at a speed of some 20 miles an hour, with lance fixed or ax, sword, or flail waving, was so fearsome a sight, it was no wonder that he remained for centuries the decisive figure around whom military tactics in the open field revolved. He was the heart of any assault, and it was his valor and skill that defined the ideal of the medieval warrior. That was the case even though war took other forms in these centuries. In particular the siege, where a cavalryman was useless, was essential to military strategy. Here the conflict came down to a contest between the redoubtable fortifications that architects, masons, and engineers created – especially the elaborately constructed and defended castles of great lords and the massive walls that were built around towns – and the siege weapons that were used against them. Nor, as we have seen, were foot soldiers, though poorly armed and usually drummed into service by their social overlords, an unimportant presence on the battlefield. Nevertheless, it was the man in armor on horseback who became the exemplar of the warrior, the only soldier who could fully express the military ideals of the age.

What brought that dominance to an end in the fourteenth and fifteenth centuries was, first, the resort to the pike, especially by the Swiss. A line of pikemen, with weapons fixed, could stop cavalry in their tracks. In addition, the English longbow, with a range of 100 yards or more and shot at a rate of ten arrows a minute, could decimate their ranks. It was to counter this danger that iron plate armor (often weighing at least 50 pounds), as opposed to the lighter and more vulnerable mail armor of connected rings that had been common in earlier periods, came into use. By this time, however, in the 1300s and 1400s, the age of the knight was drawing to a close and the age of gunpowder was about to begin.

Because of the withering of strong, centralized political authority, commissions for depictions of warfare waned during the Middle Ages. The Church was now the chief patron of all forms of expression, and even when monarchs such as Charlemagne had cultural interests, they were more intent on celebrating the faith than the battlefield. Most knights were illiterate (though Charlemagne himself

could read, it seems unlikely that he could write), and those secular patrons who did have cultural ambitions often had to turn, for the production of art, to monks in their scriptoria; to the builders, sculptors, and decorators of churches; or eventually, in the later years of the Middle Ages, to the working artists who, though rarely identified, were to pave the way for the independence and expansiveness of the arts in the Renaissance. One other important change in this period was that the survival of materials other than stone, ceramic, or metal began to improve, and indeed it was on parchment and in cloth that the most memorable medieval representations of warfare were created.

The Maccabees of St. Gall

There are plenty of battle scenes in manuscripts, and even some in stained-glass windows. They reflect the practices of the day – knights on horseback, foot soldiers, archers, and sieges – and on occasion they purport to show contemporary events, such as Crusaders besieging Jerusalem. In these cases, however, and in the majority of the pictures, it is the religious rather than the military purpose that holds sway. Indeed, in many instances, the scene that is shown is taken from a story in the Bible. The remarkable Maciejowski Bible, for example, produced in Paris in the mid-thirteenth century, is filled with minutely detailed paintings of events in the Old Testament. The miniatures present the Israelite army, for instance, as a contemporary force. Its knights slice enemies in two, its foot soldiers use catapults and ladders as they besiege walled towns, and its archers aim at defenders. Since this is a holy book, the artist can idealize warfare as fought in a sacred cause. Of the many such documents, however, perhaps the most unexpected is a manuscript produced 350 years before the Maciejowski Bible. It is a copy of the First Book of Maccabees that was illuminated in the great Benedictine Abbey of St. Gall in Switzerland at some time in the ninth and early-tenth centuries. Unlike the Maciejowski Bible, which covers many subjects, this manuscript focuses almost exclusively on warfare, and – at least in the West – seems to have been the first extended visual treatment of this theme since antiquity.

The First Book of Maccabees, a Hebrew text that is usually regarded as an apocryphal book (that is, not part of the official canon) of the Old Testament, was written at the beginning of the first century BCE. It tells the story of Judea, the home of the Israelites, following the death of Alexander the Great. The Seleucid Empire, centered in Babylonia, was one of the successor states that had arisen after Alexander died, and it controlled Judea from the late fourth century BCE onward. But in the second century its ruler, Antiochus IV Epiphanes, sought to forbid Jewish religious practices, and the result was a revolt that lasted for forty years,

beginning in 174 BCE, during which an Israelite state was established in Judea that lasted until the Roman conquest in the next century. Naturally, this came to be seen as a heroic time, and the family that led the revolt, the Maccabees, were celebrated in a number of accounts, including the Hebrew First Book of Maccabees and others written in Greek, Arabic, and Syriac. To this day, the festival of Hannukah remains in the Jewish calendar to commemorate their victories.

A monk working in the scriptorium of St. Gall who was interested in showing soldiers in action would have found the history of the Maccabees an ideal subject for illustration. Virtually every chapter recounts the events of a long-drawn-out war, and thus offers far more opportunities for military scenes than another famous manuscript produced in these years at St. Gall, the so-called Golden Psalter, which has similar, but far fewer, battle scenes in connection with the wars of King David. That the subject may have been on the minds of these monks is not surprising. The monastery was a rich and powerful fortress that dominated the surrounding area, and it was a favorite target of a tribe from Siberia that was rampaging through Europe in the tenth century: the Magyars, ancestors of the modern Hungarians and Finns. The Magyars operated mainly in central Europe, but they ranged as far as France in the west and Italy in the south, and between 924 and 933 they repeatedly threatened St. Gall. They never captured the Abbey, whose territory went on to become an independent polity and eventually one of the cantons in the Swiss Confederation. But the danger they posed was direct, and just before a determined assault by the Magyars in 926 all the manuscripts in the monastery, including the Book of Maccabees, were moved for safe keeping to a nearby Benedictine house, the Abbey of Reichenau. This was situated on an island in the middle of Lake Constance, and thus safe from the land-based Magyars. Scholars have suggested that some of the paintings were not completed until after the transfer, but the consensus seems to be that the work was far advanced by 926. We can never know who the monks were who produced it, but their ability to suggest the nature of battle from their sheltered position inside monastic walls makes theirs a unique contribution to the many-sided story of artists' reactions to war.

The book is not long – just over 900 verses. Yet in that space there are thirty full-page miniatures. Given the tangential importance of the book itself to any Christian spiritual mission, one almost has to conclude that it provided an excuse for the depiction of warfare. Ten of the miniatures, in particular, offer vivid and dramatic evocations of the combat that swirled around the Abbey of St. Gall.

The first miniature shows two scenes. Below, Antiochus gives the order to march forth, and above him we see the first onslaught of the siege: archers shoot

their elegant arrows, knights with raised shields charge, soldiers with their shields man the defenses (probably of Jerusalem), and at the foot of the formidable walls lies the first Seleucid (Magyar?) casualty. The decorations on the shields, especially the brilliant colors, are a trademark of the artist(s). On the reverse, with the decorated domes of Jerusalem (St. Gall?) behind them, large contingents of the Israelite army watch Mattathias, the patriarch of the Maccabee clan, perform two executions: he beheads a captured enemy commander, and he kills one of the Jews who has accepted the Seleucid decree to abandon Jewish practices and is holding the unclean epitome of such faithlessness – a strikingly lively pig.

A few folios later, we come to the first open field battle. We have reached the fourth chapter, and Judah Maccabee, the son of Mattathias (who has now died) sets out at the head of an army. As the text notes: "So they joined battle, and the heathen being discomfited fled into the plain. Howbeit all the hindmost of them were slain with the sword: for they pursued them . . .". And that is what we see on a verso page. As the soldiers on the right, looking behind them, begin to flee, the knights on the left advance. Casualties, some upside down, fall off horses; others rear back; horses collapse; and an abandoned shield lies on the ground. A central figure, perhaps Judah himself, accounts for more than one victim. The scene conveys, in a few strokes, both calamity and victory. Moreover, the story continues on the recto page opposite. On the upper half the charge and the rout continue; the casualties cascade down the page; and in the lower half the triumphant Israelites celebrate. It was said that "they sung a song of thanksgiving," but in the drawing they also wave long, thin fronds in a kind of victory dance.

Following his victory, Judah recaptured Jerusalem. The Book of Maccabees says merely that the Temple had been defiled and that Judah cleansed it, but the artist clearly knew his Old Testament, and although he himself must have been surrounded by holy statuary, he has Judah perform this task by tearing down small sculptures that were obviously intended to represent idols. But even this scene occupies only half of a page; above it, we are treated once again to knights charging at defended walls – presumably Jerusalem just before it fell (see fig. 16). A few folios later, to change gear, the miniature shows the scene, described in Maccabees chapter 5, when Judah relieved an Israelite city and a siege failed. Now the troops are fleeing the walls and succumbing as knights charge out of the city's gate. And on the facing page we have the scene described a few verses later, when Judah won a victory by being the first to cross a brook. One again we see the advancing and retreating knights, and the casualties among the defeated, but this time a body of water bisects the battlefield (see fig. 17). The text, in other words, has given the artist the chance to show his versatility by incorporating the terrain that is described in the passage.

16 St. Gall, *Maccabees*, siege. This illumination serves a double purpose. Above, the knights in armor besiege the city, with spears suggesting the many others we cannot see. The shields on both sides add a blaze of color. Below, Judah casts down the idols that had defiled the Temple.

17 St. Gall, *Maccabees*, battle at river. Some of the Assyrians have turned tail and are fleeing to the right; one, his helmet flying, has fallen off his horse; another is dead. The triumphant Israelite army, its numbers suggested by helmets and spears, crosses the river in hot pursuit.

As he moves into chapter 6, the painter shows another failed siege, this time by Antiochus himself, and again an evocation of city walls and knights charging and retreating. But a few folios later he has the chance to try something new, for the book describes the appearance of elephants on the battlefield. Though he can never have seen the animal, the artist rises to the occasion, and in particular pays tribute to the heroism of a soldier named Eleazar who crept under an elephant and killed it with his spear. Its collapse, which crushed Eleazar to death, is left to the imagination, but the artist's loyalty to the text – despite the exotic intrusion that took him far from tenth-century Switzerland – is unimpeachable.

There is a final masterpiece to come. In the only two-page spread that is meant to be seen as such, we have another battle (see fig. 18). This time the Israelite knights on the left are charging ahead with lances at the ready. Below them, casualties already lie on the ground. And on the facing page, above further casualties, is a body of knights in full retreat. Some look backwards, and one even holds his lance to the rear. But there can be no doubt that these are two halves of the same picture. The artist has transcended his usual one-page illumination to create a scene of violent action, triumph, and fear. That he should have created such a vision of war from the secluded vantage point of a remote monastery makes his manuscript a unique contribution to the history of this theme.

18 St. Gall, *Maccabees*, battle. This double-page illumination offers a vivid contrast between the fleeing Assyrians on the right, looking fearfully backwards, and the advancing Israelites on the left, spears raised for attack. Yet there are also casualties from both sides, poignantly shown on the ground below.

The Bayeux Tapestry

The most sustained treatment of medieval warfare in a work of art is also one of the most famous objects of the age: the Bayeux Tapestry. Though there are many other illustrations of combat from these centuries (notably, over three hundred years later, in manuscripts of Jean Froissart's History of France), none has the range or the evocative power of this unique creation. Technically, it is not a tapestry (where the design is embroidered into the fabric itself), but rather a linen strip embroidered in wool thread. Still, it is as a tapestry that it is known, and indeed as a kind of medieval counterpart to Trajan's Column. It is less than half the length of that frieze – a little more than 230 feet long and nearly 20 inches wide, with just over seventy scenes in successive frames, showing some 600 men and women – but it is very different as a form of communication. It was designed, first, to hang on a church wall and thus be visible to its audience; second, to tell a story outlined in a caption that runs overhead; and third, to offer decorative touches, glimpses of the life of the time, and related images, not in the main frames themselves, but in borders that run above and below them for their entire length. The tapestry also has an advantage over the column in that the colors of the threads have given the scenes a brightness and even a glitter that are not available in marble.

The tapestry was commissioned by a powerful warrior-bishop, Odo of Bayeux, to be hung in the new cathedral (dedicated in 1077) that was being built in his diocesan city. It is impossible to know who designed or sewed it, though one can guess that here, for the first time in our survey, we have women among the artists, since they would have been particularly adept with needle and thread. All we can say with relative assurance (though this, too, has been challenged) is that it was produced in a workshop in Canterbury, the chief city of the county, Kent, where Odo became a major landowner following the victory that the tapestry commemorates, the battle of Hastings.

The evocation of specific battles and wars had been standard practice since at least the time of the Assyrians, but no single work had ever been before – nor was ever again – so meticulous in dealing with the conflict itself and with its causes. What is unusual about the battle of Hastings in 1066 is that in one stroke it altered the course of history. A favorite genre of historical writing once was the description of decisive battles that changed the world. In such lists Hastings always figured, because its consequences were so immediate, so obvious, and so far-reaching, reshaping the development of English politics and society more profoundly than any other single event in that nation's history. For the result was the creation of a new system of law, a new demographic mix (as Normans flooded

into Anglo-Saxon territory), a new social and political structure, and a new rich-
ness of the spoken language.

The origins of the battle lay in the volatile politics of eleventh-century Europe.
This was the last phase of the age of Viking voyages and settlements. By this time
the Norsemen had established themselves as a major presence in lands as far apart
as Iceland and the Ukraine. Regions closer to their home, notably the north-east
of England and the north of France, had seen successive waves of these deter-
mined intruders, who had come not only to plunder but also to build their own
communities in fertile lands. The so-called Danelaw, an area of Danish coloniza-
tion, covered almost half of modern England's terrain, and the very words
"Norman" and "Normandy" derived from "Norseman."

As a result, the Anglo-Saxons who dominated the south and west of England
were caught in a vise between the Norsemen to their north and east, and those
who were in Normandy, across the Channel to the south. In geopolitical terms, it
must have seemed merely a matter of time before the expansive Viking communi-
ties swallowed up this last unoccupied enclave in their sweep through the mari-
time areas of western Europe. As the saintly Anglo-Saxon king Edward the
Confessor reached advanced age in the 1060s without an heir, the pressures on
English leaders grew ever more intense.

Edward himself, the grandson of a duke of Normandy, had spent much of his
youth in Normandy, spoke what linguists call Old French, and found the Normans
more congenial than the powerful Saxon nobles who dominated his realm. For
much of his life, moreover, England's principal ruler had been the Danish king
Canute – famous in legend for having ordered the waves of an incoming tide to
stop advancing – and Edward had succeeded in 1042 only because Canute's line
had petered out. Not till 1051 did he manage to dislodge the Saxon nobles, led by
Godwin, earl of Wessex, and install a large Norman presence at his court. It was
at this time, too, that he probably promised the succession to his cousin, William,
the duke of Normandy. In 1052, however, Godwin regained his position and
expelled the Normans from the court.

Godwin himself died in 1053, and over the next decade his oldest son, Harold,
moved into position to take over the throne after Edward's death. The most prob-
able heir, Edward's nephew, died in mysterious circumstances, and Harold gradu-
ally strengthened his position among England's nobles. In 1064, however, while
crossing the Channel on a mission to France, he was driven off course, detained
by a local lord, and rescued by William, who apparently required the Englishman
to acknowledge, under oath, the Norman's claim to Edward's throne. But when
Edward died in January 1066, Harold claimed the crown for himself, and imme-
diately faced retribution from abroad.

William began assembling an invasion force, but so too did another candidate, Harold Hardrada, king of Norway, who asserted a right of succession that went back to Canute. By late summer the Norwegian had landed in northern England, and on September 20th he defeated an English force near York. Harold raced northward to meet him and on September 25th destroyed the invading army at a battle where Hardrada was killed. This was an immense stroke of luck for William, who thus had a major rival removed from the scene, and who at this very moment was finally ready, as contrary winds eased, to cross the Channel. Indeed, the Normans were able to land on the south coast of England on September 28th unopposed, because Harold and his army were 250 miles away to the north.

Over the next sixteen days Harold and his men, battle-weary, had to march south and regroup to face this new threat. The Normans had built a small fortification near the coast, and here the issue was decided on October 14th. In the words of the one English account, the invaders

> constructed a castle at the town of Hastings. This was told to King Harold, and he then collected a large army, and met William at the grey apple tree, and William came upon him unexpectedly, before his army was arrayed. Even so, the king fought with William very bravely with the men who would stand by him, and there was much slaughter on both sides. King Harold was slain there, . . . and many good men, and the Frenchmen had possession of the place of slaughter, as God granted to them for the people's sins.

Too much proved to be in William's favor to leave the outcome in doubt: he attacked the Saxons before they were quite ready; they found themselves hemmed into a narrow space; his own men were far more rested and fresh; he was able to isolate Saxon detachments by luring them forward with feigned retreats; and above all Harold himself was killed.

This is the story that Bishop Odo of Bayeux, one of the most important captains in William's army, had the tapestry present. Thanks to the talents of its creators, it did far more than recount the events themselves: it gave glimpses of topics as diverse as naval architecture, Norman armor, banquets, banners, shields, Aesop's Fables, shrines, and the animal life of the day. These graceful touches are what make the tapestry much more than a chronicle, and helped establish its reputation as one of the finest artistic endeavors of medieval Europe.

The principal figures, appropriately, are Harold and William, though Odo also, as one might expect, gets special mentions. The narrative begins with the origins of the conflict, when Edward sends Harold on his mission to France. We follow the party across the Channel, witness his capture by one of William's vassals, and

then see the release arranged by the duke himself. There follow idyllic scenes as Harold, usually depicted with a fine mustache, is entertained by William and joins him in a brief campaign into Brittany, after which, in one of the work's climactic scenes, Harold swears his oath of homage to William. At this point, nearly halfway into the tapestry, we have seen boats, horses, hounds, hawks, and peacocks, a dwarf, the newly built monastery at Mont-Saint-Michel, the palaces (and thrones) of both Edward and William, and splendid decorations such as figures from the zodiac and the Aesopian fable of the raven and the fox. We have also learned that Harold is a splendid knight who, even though he is to break his oath, is clearly a worthy opponent for William.

In the sequence that follows, which takes up about the middle third of the tapestry, Edward dies, Harold accepts the crown, and William organizes his invasion. This being a devout age, the presence of the divine is never far away. The hand of God emerges out of a cloud to point at Edward's funeral, and when Harold breaks his oath by having himself crowned, the symbolism intensifies. In the same scene, Halley's Comet appears, as it did just a few months after the coronation, and the caption tells us "These men marvel at the star" (see fig. 19). Harold recognized the apparition as an evil omen, a point that the tapestry emphasized by showing a ghostly invasion fleet in the border below – a forecast of the assault that was now inevitable. From this point on, the focus on the Normans intensifies as they assemble their force and transport an army (some 7,000 men), horses, arms, and provisions across the Channel (see fig. 20). There is no hint of the Norwegian

19 Bayeux Tapestry, comet. As Harold, clearly marked, ascends the throne, a group of onlookers points up at Halley's Comet, which has appeared in the sky. They are amazed by the star, the label says. Below, empty ghost ships foretell the disaster that this omen portends.

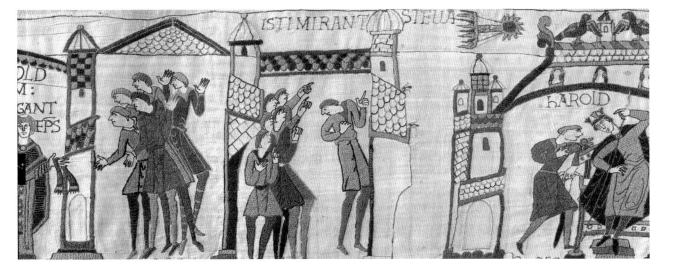

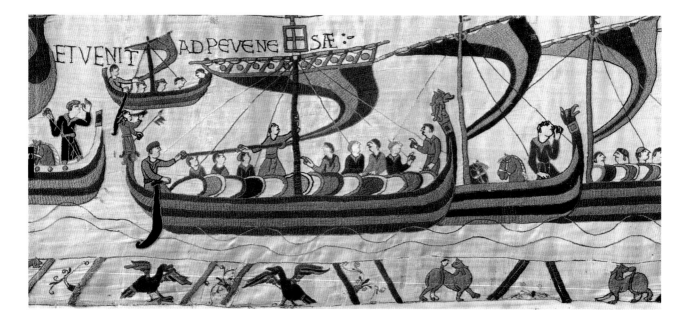

20 Bayeux Tapestry, boats. The characteristic Viking boats, with their carved prows, bring the Norman invaders, as the label says, to Pevensey on England's coast. We see a helmsman with his rudder, two horses, soldiers with their shields, and below, fantastic animals in a decorative border.

invasion; William's men simply make the crossing, settle in, and construct their fortifications unopposed. Odo now makes his appearance, saying grace at a meal and joining in a council of war. But the tapestry tempers these scenes of vigor and advance with the pathos of war, as soldiers burn a house and a woman and child have to flee. Finally, news arrives of Harold's approach, and the last quarter or so of the tapestry describes the battle of Hastings itself.

This is the culmination of the entire work, powerful and immediate in its cavalry charges, dead knights, collapsing horses, and assaults on isolated detachments of soldiers. What is extraordinary is the detailed description of combat, which is another link with Trajan's Column and something that sets both these works apart from the other masterpieces in this book. We see mounted knights (their feet firmly in their stirrups) wielding a variety of weapons – swords, clubs, lances, axes – some with shields, some without, some charging, others fighting to their rear. There are also bodies of infantry, surrounded by their shields; archers with their bows; arrows in the air and bouncing off shields; and even dismounted knights engaged with their opponents. Odo figures prominently, but the action eventually centers on a break in the English line, an attack on Harold's bodyguards, and then – in the penultimate and most famous scene – the death of Harold himself. The legend that he was killed by an arrow in his eye arose because the knight under the word "Haroldo" in the caption is pulling an arrow out of his

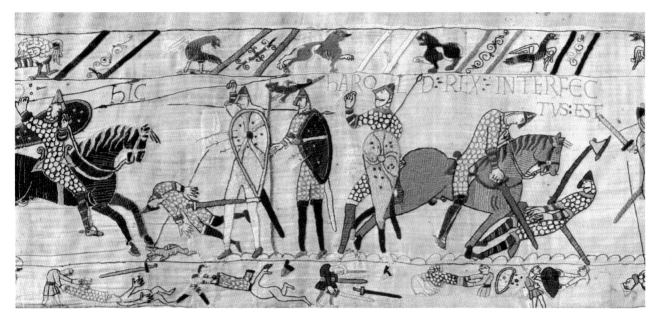

helmet, near his eye. But the king lies to his left, felled by the sword of a mounted knight, his own ax falling out of his grasp (see fig. 21).

Even as the tapestry gives life to the fundamental features of the age – the dominance of the knight, the reverence for oaths, the admiration for bravery and honor – it does so with a lightness of touch that makes it endearing as well as stirring. A besieged duke escapes from his castle by sliding down a rope; Harold, his fine mustache unmistakable, rescues two soldiers from quicksand by grabbing the hand of one and carrying the other on his back; a workman fixes a weather-vane on the newly completed Westminster Abbey as Edward's funeral procession approaches; and horses' heads peep over the edge of the splendidly decorated Viking boats of William's invasion fleet. We see war and death, but they take place in a world that still goes about its business. For those who designed the scenes, as well as those who executed them, it may have been important to exalt William, compliment Odo, and pay respect to Harold, but they also had a joy in everyday life and an appreciation for color, display, storytelling, and aesthetic pleasure that make the tapestry, like Virgil's *Aeneid*, far more than an account of conquest and valor, of arms and the man.

<p style="text-align:center">* * *</p>

Odo of Bayeux was no monarch or ruler, which makes him unusual among the identifiable people we have encountered in the long line of patrons who made

21 Bayeux Tapestry, death of Harold. The label says "Harold is killed". The battle is over, and in the border below a man is having his coat of mail armor removed. Harold himself lies on the ground, his axe and sword at his side.

possible the art depicting warfare. Yet he was not unusual in that every work we have seen so far – except perhaps the St. Gall manuscript – was produced because a non-artist wanted it made and had the means to pay for it. Even the monk in the scriptorium may have had his subject chosen by a superior. As a result, there is a certain consistency of tone that persists for nearly two thousand years, from Assyria to Bayeux. For all the occasional expressions of pity or pathos; the suggestions of distress and despair; or the digressions into matters of practicality or faith; the basic theme was always the honor that was the warrior's final reward. Even the rise of Christianity did not alter that fundamental aspiration. But the theme's long monopoly was ultimately to be breached when new values arose in the Renaissance. As we shall see, it retained its power for a long time, and in fact survived a changing aesthetic for centuries. But eventually artists gained an independence and a determination to convey individual views that was not visible before. As we enter the age of gunpowder, a gradual transformation began which, after a slow start, overtook art as well as war.

A New Vigor

WAR AND ART IN FEUDAL JAPAN

The Warrior Society

One of the consequences of the universality of warfare has been the persistence of the warrior society. Unlike forms of political organization that have given pride of place to priests, to the rich, to the well-trained, to the well-born, or to the masses (and all of these have arisen at some point in history), those that elevate the soldier are built on an acceptance of military skill and force as the basis of authority. In many respects, despite the importance of the Church, the feudal system that arose during the European Middle Ages rested on such foundations. The lord was, almost by definition, a knight, and his power over the communities he ruled derived from his prowess on the battlefield. A web of duties and obligations may have reinforced his status, but the system ultimately stood or fell on the capacity to make war. It is no surprise, therefore, that when a similar structure of social hierarchy arose in Japan in the twelfth century (lasting for some seven centuries), historians came to call it feudalism. Thus, in his authoritative *History of Japan*, George Sansom calls the chapter on this period "The Feudal State." There were of course many differences from the European model: for instance, there was no powerful Church, nor any of the territorial/linguistic divisions or the distinct kingdoms. But the central equation of military and political authority was at the heart of both feudalisms.

This is not to say that the warrior ethos has been the same in all places and times. The glorification of bravery alone has often been tempered by admiration for other skills, such as a wily sense of tactics, or by a belief that valor deserves respect only because it serves a higher purpose – the Crusader fighting for Christian goals, or the Prussian officer combining discipline with courtesy and gentlemanly honor. In the end, though, it was skill in wreaking violence that set

rulers apart from ruled in these societies. The defeated might denounce tyranny or savagery, but success depended on proficiency in war. And in art, literature, and various forms of propaganda, the depiction of war was infused with a color and a heroism that swept other values aside.

For all the examples of the genre we have seen thus far, though, none can compare in vividness or seething, dramatic activity with a scroll that was produced in Japan in the thirteenth century. Experience of a warrior society may have been necessary for the creation of so powerful an image of the reality of battle, but there were many other such polities – Sparta is the obvious example – that produced nothing comparable. And in this case we encounter an artist whose mastery of the depiction of physical reality, perspective, and motion combined to fashion a sweeping, tumultuous image of war. First, however, we need to understand the context for the episode that is the subject of the scroll.

Upheaval in Japan

The fundamental change that brought Japan into its "feudal" period took place in the second half of the twelfth century. For the previous hundred years or so, the country's political system had revolved around a practice that has been called "cloister government." This began in 1086, when the reigning emperor, Shirakawa Tennō, decided to abdicate. He had succeeded his father in 1072, but found himself overwhelmed by the ceremonial and family obligations that increasingly were demanded of him. Unable to devote the sustained time he felt was necessary to exercise his authority, he took the dramatic step of abdicating. The titular role was assumed by his young son, and he himself took holy orders, which included cutting his hair and wearing the robes of a Buddhist monk. He then moved into a private palace that provided him with the sanctuary of a religious house. For the next seventy years he and his grandson, Toba Tennō (who followed his grand-father's footsteps after his death in 1129), ruled Japan from their cloisters. They established an effective administrative and judicial center for the country; presided over a brilliant aristocratic culture; cultivated refined tastes and arts to a degree that has earned their period comparisons with golden ages in Persia, India, and Charlemagne's Europe; and set so distinctive a stamp on their country that they are now regarded as the last powerful emperors in Japanese history.

Yet the system began to fall apart in the 1150s. Because of economic and land-holding changes, the emperors no longer had the financial independence they once enjoyed. At the same time, a newly powerful warrior class was emerging. Japan's population had been growing during the previous two centuries, and as it expanded into new areas there was an increased demand for border defenses and

the protection of land claims. Responding to this need, two great warrior clans had crystallized: the Taira and the Minamoto, both of whom were themselves descendants of emperors. It was not difficult for them to take advantage of the withdrawal of the emperors into cloister government, and during these decades, as the historian George Sansom noted, "the power of the military families was rising with inexorable speed." It was only a matter of time before their rivalry, linked to the possibility of controlling the court, completed the erosion of imperial authority.

The opportunity came in the late 1150s, following the death of Toba. The emperor at the time, Go-Shirakawa, retired to the cloister in 1158, leaving his sixteen-year-old son, Nijō, as titular emperor. One of the old-line aristocrats, Fujiwara Yorinaga, scion of a family that had dominated the court for centuries, had been excluded from power when Go-Shirakawa won the support of both the Taira and the Minamoto clans. Seeking to restore the traditional forms, he had managed to persuade some of the Minamoto clan to back a coup, but he had been defeated and killed in 1156. This, though, was the beginning of a series of insurrections that soon widened into full-scale civil war. Out of that civil war would emerge the warrior society that was to govern Japan for centuries to come.

As in most internecine conflicts, the course of events was confusing, and marked by dramatic changes of fortune. One of the episodes, the Heiji Uprising (named after this period in Japanese history), seemed merely another chapter in a grim story of carnage and reprisal. It deserves our attention, however, because its long-term consequence was that it inspired a remarkable work of art.

The slaughter began after the death of Yorinaga. His supporters, the Minamoto, were the first victims. Their chieftain, Minamoto Tameyoshi, was condemned to death, and a wave of executions, unknown for more than three centuries, signaled an ominous new taste for blood at the seat of power. Deeply resentful, Tameyoshi's son, Minamoto Yoshitomo, bided his time until, late in 1159, Taira Kiyomori, the leader of the rival Taira clan (which gained power when Yorinaga died), left the capital of Kyoto on a pilgrimage. On December 9th, taking advantage of Kiyomori's absence, Yoshitomo struck. Gathering some five hundred soldiers, he seized the cloistered emperor Go-Shirakawa, burned down the Sanjō Palace where he lived, and took him to the nearby Great Palace, the residence of the titular Emperor Nijō, Go-Shirakawa's son. There the two emperors were held captive while the Minamoto and their allies began to take over the government.

This was the Heiji Uprising, an event that, as it turned out, merely accelerated the rise of the warrior class. For it failed. In less than three weeks, both prisoners managed to escape; Kiyomori returned with his own troops; and the uprising was viciously crushed. Yoshitomo fled, but was soon killed, not long after killing one of his own sons to prevent him from falling into enemy hands. Although another son

was publicly decapitated, Kiyomori allowed the remaining sons to live – a fatal concession, as the Taira were to discover. Leniency would be seen as weakness in the new warrior society, a shift in attitude that was demonstrated by the most ruthless of Yoshitomo's sons, Minamoto Yoritomo, who eventually regained power for his clan and then, to establish his own position, hounded his surviving brothers to death.

In the meantime, for twenty-one years until his death in 1181, Kiyomori was the effective ruler of Japan. He was an unusual transitional figure who displayed the taste and elegance of his aristocratic predecessors even as he represented the warrior class from which he came. All the while, however, the Minamoto were waiting for the chance to overthrow their rivals. They were already gathering troops before Kiyomori died, and over the next decade they defeated the armies and navies of the Taira clan in a bitter civil war that eradicated all threats that the Taira might have posed. Merciless and unrelenting, toward potential rivals in his own family as well as his enemies, Yoritomo was in full command of court and country by 1189. Three years later he took the title of shogun (essentially, commander-in-chief) and set in place a system that was to last for nearly seven hundred years. While the emperor in Kyoto was the nominal ruler, Yoritomo and his heirs as shogun created a capital in Kamakura that controlled a feudal regime dominated by great warrior families.

For all the betrayals, the humiliations, and the callous ambitions that marked these events, they were so decisive in the transformation of Japanese society that they soon took on legendary and heroic proportions. Celebrated in literature and art, the events' protagonists have become some of the most famous figures of medieval times.

Naturally, too, the Heiji Uprising, though ultimately a failure, was of particular interest, since it was led by the Minamoto clan, which eventually played a leading role in the shogunate. The striking images already began to appear in the late twelfth century, reaching a climax in the work of an amazingly versatile painter, active in the thirteenth century, who produced three scrolls depicting the main events of the Heiji Uprising. Called the Heiji Monogatari Emaki (the Illustrated Tale of the Heiji Era), the scrolls achieve a liveliness, a realism of representation, and a power of visual depiction and composition that cannot be found in any of the manuscript illustrations or paintings in the Europe of the time, or indeed in any of the depictions of warfare that have survived from antiquity or the Middle Ages.

The *Heiji Monogatari Emaki*

To tell the full story of the Uprising and its repression, the artist required three paper scrolls. It is the first, devoted to the assault on the Sanjō Palace, that concerns

us here, because its subject clearly is a military action. The other two scrolls document the folly of the insurrection and its grim aftermath, but they are not to the same degree representations of warfare. It is worth noting, though, that all three scrolls would have been curled up for storage, and unrolled on a table only occasionally for their owner to study or admire. The process may have rubbed off some of the paint, but the minimal exposure to light has kept the colors brilliantly alive. The very freshness of the work enhances one's admiration for the painter and calligrapher (for the story is also told in words at the beginning and end of each scroll). This was one of the great masters of the age, equally at home in conceiving an overall vision of the Heiji Uprising and in riveting our attention on its details.

The scroll depicting the opening event of the Heiji Uprising, the burning of the Sanjō Palace and the capture of the cloistered emperor Go-Shirakawa, is over 22 feet long and more than 16 inches tall. Its narrative moves from right to left, and it begins with two running figures, one of whom is shading his eyes as he looks intently ahead. From the outset, the viewer is driven to the left to follow the action. Ahead of the running figures a carriage hurtles along, pulled by a bullock that in its haste knocks a man to the ground. And immediately in front is a horde of people – courtiers and warriors, galloping horsemen, eager runners, passengers in carriages drawn by bullocks, others turned around in their haste – rushing forward in a headlong display of speed (see fig. 22). They whip their bullocks, some fall down and are crushed underfoot in the chaos, and many shade their eyes as they stare in astonishment or point ahead. It is a feast of splendid animals

22 Heiji Scroll, rushing crowd. In the rush to see what is happening at the palace, the crowds hurtle forward. But in their haste, carriages are destroyed, bullocks and people fall to the ground, and anxious figures look both backward and forward as they seek friends or information amidst the chaos.

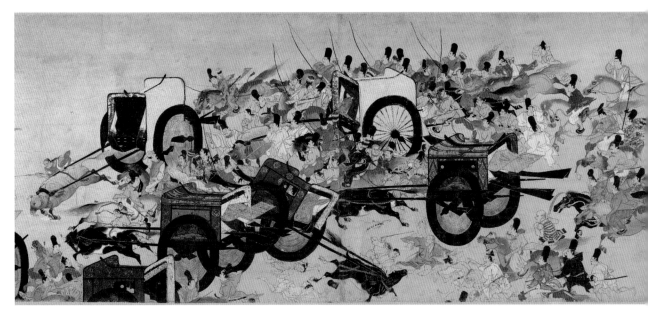

and colorful humans dashing across the scene, all of whom serve to build suspense. For a reader would typically unroll only a shoulder-length width of the scroll at a time, and as one follows the crowd one is forced to ask: What is it that these people are rushing to see?

We discover, at last, that they are heading for the wall of a compound, which slices diagonally across the scroll, and along which a group of riders is moving, presumably toward a gate. When we look across the wall, we encounter another turbulent scene. We are now between the outer and inner walls of the palace compound, where a large crowd has gathered, listening to a man who stands on two men's shoulders at the inner wall. He has climbed up, one assumes, to get a better view over the wall, and is explaining to his audience what is happening just out of sight. It is obviously a shocking tale that he tells, met by looks of amazement and anxiety. Even as one admires the painter's narrative gifts, though, one is made aware of his aesthetic interests, because he gives us glimpses of many of the listeners through the branches and foliage of a grove of elegant trees in the compound. But already we can guess what lies in store. For the inner wall turns across the bottom of the scroll, allowing us to look inside a wing of the palace, where a group of women is gathered. Near them a warrior with a huge halberd is about to hack at a man who has fallen to the floor.

The next scene (see fig. 23). is the heart of the scroll: an astounding, bravura depiction of the flames and the smoke that have brought the crowd scurrying to

23 Heiji Scroll, palace fire. The centerpiece of the scroll is the scene at the palace. The savagery of the soldiers as they kill helpless men and women is overshadowed by the billowing flames and smoke of the building as it is burned to the ground.

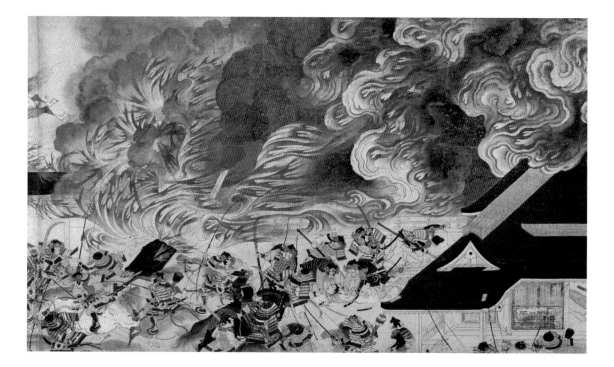

the palace The exultant Minamoto troops, with their bows and arrows, their halberds, and their swords charge across the palace compound, slaughtering the defenders – one of whom is being decapitated, while others lie dead on the ground, with splotches of blood all around. A soldier is even searching for more victims in the narrow space between the veranda and the ground. Above this turmoil, the flames and smoke of the burning palace billow up to the sky in a swirl of orange, white, and black. Then, as we move out of the far gate of the palace, we see yet more troops, driving forward past a small group of quiet women. That we are watching the outcome of a fierce assault is underlined by two foot soldiers who carry huge spears, with wicked-looking curved serrated blades on which are impaled the heads of butchered enemies. They are part of a large entourage of cavalry and foot soldiers, old and young, weapons drawn, pushing forward as they escort the carriage of the captured emperor (with curtains drawn) to the Great Palace a short distance away (see fig. 24).

The momentum forces our eyes ever onward across the scroll. But even as we are swept along by the forward movement we can relish the elegance of the artist's conception. In this final large grouping, especially, one notices the huge bows that the archers carry, their silhouettes regularly punctuating the scene and creating lines and diagonals that catch the eye. The vibrant costumes, animals, and settings adhere to a color scheme of oranges, greens, and blacks that gives the entire scroll cohesion and unity. And at the very front, as we approach the end of the scroll, is the most magnificent figure of them all. Though he is preceded by an archer, his

24 Heiji Scroll, emperor's carriage. Their mission accomplished, the troops race away from the palace with their prize, the closed carriage holding the emperor. Fiercely brandishing swords, halberds, and bows, they nevertheless create a brilliant spectacle with the rich colors of their clothes and the splendor of their horses.

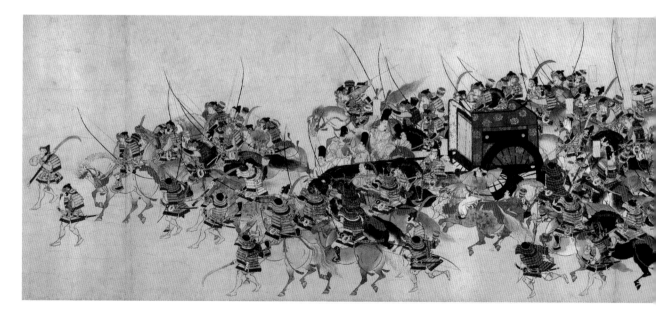

bow at the ready, this is probably Minamoto Yoshitomo himself. The commander of the soldiers is set apart, alone, triumphant, and astride a majestic rearing horse. The animal, pitch black, seems to share its rider's jubilation, and helps make this vignette a fitting climax for the story the scroll has told.

The overwhelming impression is of the immense vigor that is displayed both by the combatants and by the artist. Moreover, everything that happens takes on a crystalline clarity and comprehensibility because it is viewed as a sharply etched tableau from above. This vantage point, which centuries later was to help transform Western art, not only helps provide a sense of recognizable perspective and three-dimensionality, but also permits an attention to detail that enlivens every scene – a sharpness that is heightened by the absence of shading and shadows that was characteristic of the Japanese painting of this period. As a result, even though the scroll teems with some three hundred people and over seventy horses, each one is distinctive. It is impossible to study the scroll and not be struck by the lucidity of the artist's command of his subject. And the larger purpose is also apparent. One may notice a sober reminder of the destruction of war in the flames and bodies that interrupt the flowing action and the display of military energy. Yet the main impact of the scroll is its demonstration that art can invest even the most pitiful and squalid events with a drama and a grandeur that make their perpetrators, however brutal, seem splendid and superb.

The Persistence of Tradition in the Early Renaissance

Gunpowder

The discovery of gunpowder's destructive power, and its earliest application to warfare in the West during the fourteenth and fifteenth centuries, marked the beginning of a major military, political, and social revolution. Yet it took a long time for these transformations to make their presence felt. Exactly when the new kind of weapon first appeared remains unclear, but primitive cannon were certainly being built in Europe by the mid-fourteenth century. By the late 1370s there is evidence of their use in battle by the Venetians, whose enormous, state-of-the-art arsenal was probably the most efficient weapons factory of its age. Nevertheless, it was many decades before firearms began to play a decisive role in battle (early examples are at Castillon in 1453 and at Ravenna in 1512). It took time, in other words, before they began to win recognition as a force that altered fundamentally the way that warfare was waged – and thus how it was conceived.

The basic problem was technological. It was easy to see how devastating the effects of a gunpowder explosion could be. Less self-evident was a mechanism for channeling the blast so as to damage the intended target. Given the potent and unpredictable force that could be unleashed, a detonation was likely to be as dangerous to the shooter as to his victim. From earliest days, therefore, the aim was to construct a hollow tube out of metal that was thick and strong enough to contain the eruption yet could give direction to whatever projectile was launched out of the tube by an explosion. Thus was born the cannon. It was fairly straight-forward to understand the principle, but far more difficult to build a cannon that worked, because large-scale metalwork was a tricky endeavor in these centuries. For special patrons, beautiful decorations could be devised, but practical require-ments such as the standardization of dimensions, proved to be unattainable.

Casting the massive blocks of iron into regular, smooth shapes was simply beyond the skills available in fourteenth- and fifteenth-century Europe.

What craftsmen could produce was a long barrel, closed at one end, where, through a small hole, a flame or hot wire could be touched to a small clump of gunpowder that had been packed into the cannon. If a missile was placed in front of that gunpowder, the resultant explosion (assuming it did not destroy the entire contraption) would send it hurtling out of the barrel towards its objective. The trouble was that, given existing manufacturing methods, it was impossible to guarantee the size either of the barrel or of the missile. The cooling and hardening of hot metal was not a precise process, nor was the fashioning of cannonballs. In the early days, some of these were even made of stone, chiseled until they fit into the barrel; also favored were large, long, arrow-like objects. It does not take much insight to realize that as an ungainly projectile like this flew along a barrel it bounced off the sides and eventually emerged flying off at an angle that nobody could control. Where it would land was anyone's guess.

Engineers did begin to add nasty accessories to increase the damage cannon could cause. They attached chains to the balls that flailed viciously as they descended; they used grapeshot – small metal pellets – to spread the maiming zone of each blast; and they tried to add fire to the impact of their projectiles. Nevertheless, the effects of these devices remained limited. Cannon used in sieges were enormously heavy, usually weighing thousands of pounds, and difficult to move. Smaller ones were tried in battles, but they had little impact, and if the action shifted, they were often left behind. In most cases, therefore, it was the noise and the smoke of the new weapons, rather than their effectiveness at mowing down enemies, that changed the nature of combat. They could be terrifying, but for more than a century they made neither the knight nor the archer obsolete.

That did not happen until the sixteenth century, when the handgun, after decades as a heavy and awkward adjunct to the bow, at last began to have a significant impact on the battlefield, and when gunpowder charges ended the invulnerability to siege assault of massive walls. But those shifts in tactics and mentality lay in the future. Indeed, if one seeks to prove how minimal the impact of the new technology was, one need but look to the visual arts. For the fifteenth century, the first age of gunpowder in the West, was also the very time when the new aesthetic we associate with the Renaissance was being formed. What is striking is that, although new ways of telling a story or representing the world were being devised by the inventive artists of this brilliantly creative period, they did not see the need – despite their many innovations – to depart from the heroic tradition when treating the theme of warfare.

Donatello's *David*

The Renaissance in the arts is commonly thought to begin with the generation of three colleagues, all of whom were active in Florence in the first third of the fifteenth century: the sculptor Donatello (who is our concern here), and his friends Masaccio, a painter, and Brunelleschi, an architect. All three traveled to Rome to study the ancients and to bring to their fields of endeavor the qualities that, according to the program put forward some half a century earlier by their fellow Florentine, the poet and moralist Petrarch, were essential to the well-led life. Petrarch had argued that the Romans were models of virtue, and had urged his contemporaries to seek to emulate them. Out of this prescription there gradually emerged a backward-looking revolution in ideas and taste, as the effort to imitate antiquity came to transform first Italian and then all of European culture.

In the realm of sculpture the pioneer in this revival was Donatello, born in Florence around 1386. The power, the emotion, the focus on humanity, and the realism that he brought to his work left all who followed in his debt. Given the situation in which he lived, moreover, the world of the warrior soon presented itself as a natural subject. For we need to remember that the Florentines of the fourteenth century regarded the changes and enthusiasms that engulfed their city primarily as matters of civic pride – reflections of their determination to demonstrate their superiority over rival cities and principalities. The great dome Brunelleschi built over their cathedral, for example, was but the climax of more than a century of construction, one of whose aims was to create a building significantly larger and more impressive than the famous cathedral in nearby Siena.

Nor were the rivalries confined to bricks or canvas. The almost constant state of warfare in Italy between the late fourteenth and the mid-fifteenth centuries expressed and intensified the competitiveness, and in addition contributed to the hothouse atmosphere, the clash of ideas, that some historians have seen as the seedbed of the Renaissance itself. Ironically, though, the battlefield was one arena where the Florentines did not excel. In 1402, for instance, they found themselves mortally threatened by a prince who was amongst the most effective military commanders of the age, Giangaleazzo Visconti, duke of Milan.

Giangaleazzo was one of the most fearsome rulers of Renaissance Italy. In Machiavelli's apt description, he became "duke of Milan by treachery, [and] sought to make himself king of Italy by force." He had become master of Lombardy, the broad northern plain of the Italian peninsula, in the 1380s, and his next target was to the south: Tuscany, the hilly region centered on Florence. War broke out in 1390, and over the next twelve years Giangaleazzo drew an ever more menacing vise around his target. He captured Perugia, Pisa, and Siena, and in the summer of 1402 completed the circle by conquering the city of Bologna. At this

bleak moment fate intervened. Giangaleazzo died unexpectedly, and with his departure the threat to Tuscany dissolved. Within four years Florence herself had taken over the city of Pisa.

But the danger from Milan did not vanish. Twenty years later Giangaleazzo's son and heir, Filippo Maria Visconti, resumed his father's conquests. He was advancing toward Tuscany's eastern border when Florence, fearing renewed encirclement, declared war in 1423. Once again, the Florentines did not shine on the battlefield, and after two years became so "alarmed" (in Machiavelli's words), and so "reduced to despondency by their frequent losses," that they sought an alliance with Venice. That formidable republic, hoping to make its own territorial gains at the expense of the Visconti, joined the war and quickly turned the momentum against Milan. As before, Florence was saved by an outside force, and this time was able to make peace without loss in 1428.

It was either during the last years of this second conflict, or possibly in the years that followed (the date remains uncertain), that Florence's most famous sculptor, the forty-year-old Donatello, was commissioned – probably by the Medici family – to depict the biblical figure of David. He was a logical choice for the subject, because the statue that had first made him famous, some decades earlier, was a *David* that he had begun in 1408. Carved in marble for the still unfinished cathedral, it had aroused such admiration that in 1416 the city's ruling council ordered it moved to a position of unique prominence – to the central building of Florence's government, the Palazzo Vecchio. What is significant for our purposes is that Donatello was now asked to modify the statue before it left the cathedral workshop. Even though David's identifying attribute, the head of Goliath, lay at his feet, he had been portrayed carrying a scroll, which emphasized his role as both psalmist and prophet. By the time the statue was installed in the Palazzo Vecchio, however, Donatello had removed the scroll and replaced it with a sling. It may also have been at this juncture that a Latin inscription was added: "To those who bravely fight for the fatherland the gods will give aid even against the most terrible enemies." *David* had come to stand for Florence's courage in the face of mighty adversaries.

But that did not exhaust the sculpture's symbolic meanings. Donatello by this time was forging close ties with Florence's humanists – the scholars and publicists who were followers of Petrarch and who were insisting that moral improvement came from a quite specific imitation of models from antiquity. What was necessary was to unite two commitments: the contemplative, which was the effort to emulate the intellectual and cultural ideals of ancient Rome; and the active, which required a devotion to public service. It may well have been the humanists who suggested that David, the perfect combination of the contemplative and the active (the psalmist and the warrior) should serve as the patriotic embodiment of the city – a

monument worthy of the Palazzo Vecchio. Even more likely is the assumption that the humanists, learned students of antiquity, suggested one of the statue's most striking features, the wreath of amaranthus that crowns *David*'s head. It must have been a scholar steeped in the stories of Greece and Rome who pointed out that this constantly re-flowering plant was not only an attribute of ancient heroes – ever fresh, it covered Achilles's grave to keep his memory alive – but had been described by the Roman scholar Pliny as a flower whose beauty was always reborn. Pliny's word was *renasci*; ours is renascent. Thus did *David* become the symbol of Florence, of valor, and of rebirth (Renaissance) all in one. The aesthetic may have been new, but the purpose of glorifying warfare could not have been more traditional.

There were three other major sculptures by Donatello that served the same aim. In one, he went back to the prototype we saw in the statue of Marcus Aurelius in order to celebrate one of the most famous soldiers of the age, a successful commander of mercenaries known as Gattamelata. Cast in bronze, he was shown in armor astride a splendid horse, and placed on a pedestal more than 25 feet high at the side of the cathedral in Padua (see fig. 25). In another, near the end of his

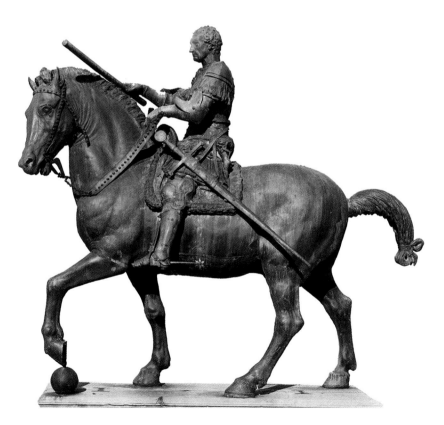

25 Donatello, *Gattamelata*. The *condottiere* Erasmo da Narni was known as *Gattamelata* – "the honeyed cat." His equestrian portrait by Donatello transformed the genre. There had been sculptures of horsemen before, but this one, inspired by the Marcus Aurelius statue, created a defining image of the heroic warrior.

career, he showed the Israelite heroine Judith – a symbol of courage in wartime whom we will encounter again – raising a sword as she decapitates an enemy general, Holofernes. She stands to this day in Florence's main square, the Piazza della Signoria. But Donatello made the most explicit reference to the battles of his time in the third of these sculptures, when he returned to the theme of the young David.

This second *David* has become one of the defining images of Renaissance art. Together with the treatment of the subject by Michelangelo some seventy years later – a statue deeply influenced by its predecessor – it has made the figure of David a central emblem of the Florentine Renaissance. From its very conception, however, the innovations in Donatello's work were startling. This was the first free-standing nude cast in metal in Europe since antiquity. Its naturalistic presentation of a young body helped define the ideal of human beauty for centuries. And its material, bronze, enhanced its impact by giving the statue a smoothness and a sheen that Donatello's previous medium, marble, could not have matched.

That this *David* embodies the humanists' ideal, a combination of the contemplative and the active, is unmistakable. He has just sliced off Goliath's head, and yet he stands relaxed, lost in thought (see fig. 26). He seems to embody timeless human perfection, and yet the original meaning was quite specific. The previous *David* had been refashioned into a patriotic declaration; this one was commissioned for that purpose from the outset, intended specifically as a statement about the war with the Visconti that had preoccupied the Florentines for more than thirty years.

It is only recently that this meaning has been uncovered, after decades of scholarly debate that interpreted the sculpture as representing, variously, a philosophic moral (truth is naked), the god Mercury, Christian humility, a general echo of the nude heroes of antiquity, erotic predilections, and other themes. Then, in a 1978 article, the distinguished art historian H. W. Janson made the connection with Donatello's own times that gives the statue a persuasive context and a believable meaning. He focused on two of its most puzzling features, neither of which had been satisfactorily explained: the unusual feathered wings that extend from Goliath's helmet, one around the base and the other along David's right leg; and the plaque on the visor of the helmet, which shows a chariot in a classical scene of triumph.

What these two details revealed was a *David* designed as a comment on Florence's struggle with Milan. That struggle had overlapped with a more fundamental conflict, which had split Italy and even individual cities into competing factions for centuries: the fight between German emperors and Roman popes for control of the peninsula. This fight had died down in Donatello's lifetime, largely

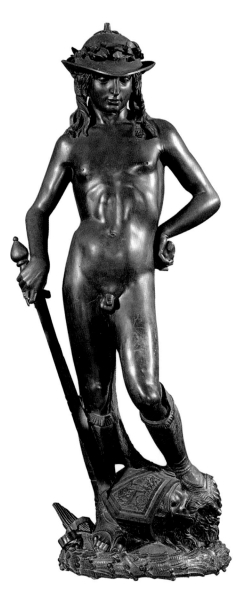

26 Donatello, *David*. David has just killed Goliath and stands over the severed head, but he seems calmly lost in thought. For Donatello, David is the perfect combination of the Renaissance's highest ideals, uniting the contemplative life of the mind with the active life of the warrior.

because of two developments: first, the papacy's departure from Rome to Avignon in 1305, followed by a schism in the Church (when two or more popes claimed the papal throne), events that sapped its authority between 1378 and 1417; and second, the growing weakness of the popes' chief rivals, the emperors in Germany. Italian princes had nevertheless continued to seek the support of one of these two sides, and the Visconti, who had received their ducal title from the emperor, were firmly in the German camp. It was therefore especially appropriate that, in an

echo of the eagle that symbolized imperial power, the family had as one of its emblems a crown adorned with huge feathered wings. Goliath's winged helmet, in other words, marked him as a Visconti warrior.

The point was driven home by the visor plaque, which shows winged putti pulling a commander in a chariot in a scene that was typical of scenes of military triumph in antiquity – an ironic comment on the Viscontis' own imperial ambitions in Italy. Thus, over the crushed representative of Milan (Goliath) stands the embodiment of Florence (David), clothed only in a soldier's boots and helmet, crowned with the laurel wreath of the victor, and holding in his hands the stone and sword with which he has destroyed his enemy. Contemplative David may be, but there is no hint here of the psalmist. He is the conquering warrior at the moment of triumph.

It was no coincidence that, when Florence was again embattled, the government commissioned a third large sculpture of David, by Michelangelo. By then Donatello's masterpiece had moved twice. It had first been placed by the city's dominant family, the Medici, as the centerpiece of their palace courtyard; and then transported, like the first *David*, to the Palazzo Vecchio. In the sixteenth century, however, as the Medici dukedom of Tuscany settled into a relatively peaceful existence, Donatello's bronze lost favor and was moved once more to a less prominent position. Not until the revival of classical ideals in the late eighteenth century did it attract renewed attention and come to be appreciated as one of the marvels of Renaissance art. And only recently has it again been recognized for what it was originally intended to be: a celebration of military prowess, and especially of the unexpected victory of the weak over the strong. To which we can add that the elegance of the sculpture also conveys that most unusual by-product of war: a flowering of delicacy, grace, and beauty.

Uccello's *Battle of San Romano*

The most remarkable depiction of warfare by an artist in the fifteenth century was the set of three paintings by Paolo Uccello commemorating the battle of San Romano. They were commissioned by a Florentine family (though they soon ended up in the hands of the Medici) in order to celebrate what by any standards was a fairly obscure occasion: the encounter, during yet another war involving Florence and Milan, when a Florentine force defeated (though this is disputed) Sienese troops on June 1st, 1432. This minor battle left little mark on the times, and even the place itself is obscure – a rural location about halfway between Florence and Pisa. Though we know only the barest outlines of what happened, we can assume that, as at the battle of Agincourt between the English and the French seventeen years earlier, there was no evidence that Europe had entered the

age of gunpowder. Uccello was therefore free to choose a lovely countryside setting and a clash of knights and archers that would have seemed appropriate for at least the previous half-millennium – except for the style of presentation.

Uccello, also a Florentine, was born about ten years after Donatello, and they appear to have been friends, since Uccello is said to have shown his work to the older man. And he, like the sculptor, had adapted a famous classical prototype to honor a military leader. His funerary portrait of the mercenary captain Sir John Hawkwood in the cathedral at Florence shows a mounted hero, reminiscent of Marcus Aurelius, whose splendid horse, like the emperor's, has one foot raised. It was an image of the valiant warrior that remained a favorite for Europe's rulers for centuries to come.

His masterpiece, however, consisted of three massive wooden panels, each approximately 6 by 10 feet, which commemorated the major events of the battle. Today the panels are divided among museums in London, Paris, and Florence, but when they were together they told three parts of a single story. On the left, in the London picture, the conflict begins with a charge by Niccolò da Tolentino, the captain of the Florentine mercenary troops (see fig. 27). In the center panel, now in Florence, the symbolic moment of victory comes when the Sienese commander,

27 Paolo Uccello, *Battle of San Romano*, Tolentino. In this panel by Uccello the center of attention is Niccolò da Tolentino, the victorious commander. But the viewer is soon distracted by other features in this busy scene: the lances, the banners, the horses, the setting, and the objects on the ground.

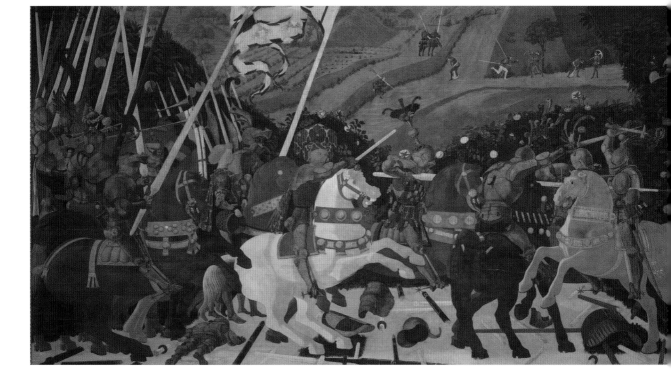

Bernardino della Carda, is thrust off his horse by a lance (an imaginary episode, since the Sienese believed they won the battle) (see fig. 28). Finally, the right-hand panel, in Paris, acknowledges the crucial role of Micheletto da Cotignola, whose unexpected arrival on the scene with his own troops – the Sienese had thought he was neutral – may have swung the fight (if one accepts their version of events) in the Florentines' favor (see fig. 29).

This may be the most unusual work ever painted that was inspired, not simply by war, but by recent conflict. As has been pointed out, Uccello seems to have turned a bloody real-life struggle into the colorful display of a knightly tourney. There is certainly no blood to be seen, and although there may be horses and riders lying on the ground, their postures make them distractions rather than exemplars of slaughter. Above all, the panels appear to be elaborate exercises in

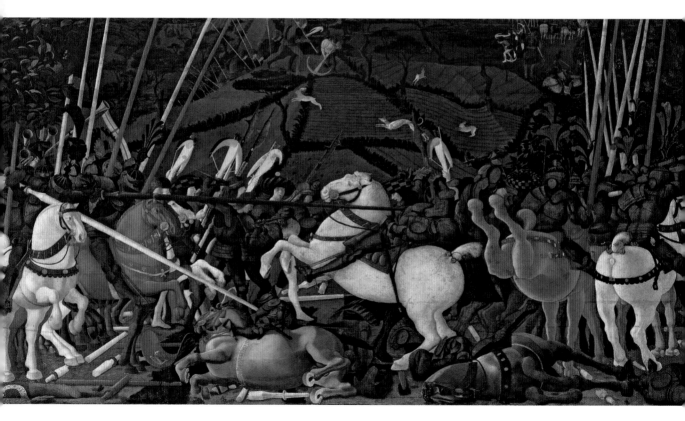

28 Paolo Uccello, *Battle of San Romano*, Carda. Here Uccello's attention shifts to the toppling of the Sienese commander, Bernardino della Carda, but the distractions only intensify: dead horses and knights, animals in the background, kicking and rearing horses, and a chaotic melee of warriors, colors, and lances pointing at all angles.

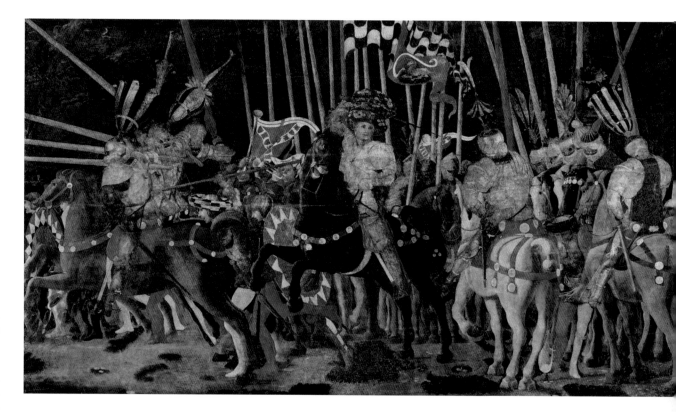

29 Paolo Uccello, *Battle of San Romano*, Cotignola. Finally, Uccello celebrates the arrival of Micheletto da Cotignola, whose troops determined the outcome of the battle. A more focused scene, it is still an extended exercise in perspective and the bright, pageant-like colors that make the combatants look like participants in a tourney.

the techniques of perspective that obsessed Uccello throughout his career. As his first biographer, Giorgio Vasari, related, "Uccello's wife told people that Paolo used to stay up all night in his study, trying to work out the vanishing points of his perspective, and that when she called him to come to bed he would say: 'Oh what a lovely thing this perspective is!'"

The most striking example of that obsession is the figure of Niccolò da Tolentino, and especially his peculiar hat. Sitting atop his orange-and-gold *mazzocchio*, the doughnut-shaped headgear that adorns at least ten of the soldiers in the painting, is a wide octagon of the same design, riveting the eye at the center of the scene. Both *mazzocchio* and octagon were severe tests of perspectival accuracy. They had to be mastered by art students, and we have two painstaking drawings of the torus (doughnut) shape from the hand of Uccello himself. It was

this hat that Uccello was said to have shown, with some pride, to Donatello. Micheletto da Cotignola, too, is fantastically adorned, with a hat that looks like a four-layered *mazzocchio*. What is clear is that the fanciful headgear of the two commanders reinforces the mingling of pageantry and perspective that sets the three paintings apart. Similarly the heraldic banners, familiar from chivalric tourneys, identify the protagonists and, together with the musicians and the magnificent harnesses of the horses, adorned with gold, lend the scene an almost festive air.

It is hard, for instance, to decide whom the three well-coordinated archers in the Florence panel are aiming at, or what role in the story is being played by the frolicsome animals in the background. Similarly, the bright colors of the feathers, lances, and saddles convey more of a sense of performance and display than of armed conflict. Even the pieces of armor and broken lances on the ground seem designed to multiply the diagonals that criss-cross each painting. Rearing and kicking horses provide a semblance of action, but basically these are static scenes. One could perhaps call them tableaux, filled with tricks of perspective, which serve to glorify only the two Florentine commanders.

The final giveaway is the young man riding behind Niccolò da Tolentino. He is not in armor and the helmet he is carrying looks, from its size, as if it is Niccolò's. This is not someone who is in the midst of a battle, and it is surely significant that, apart from the two captains, he is the only participant who is portrayed as a recognizable person. One has to assume that he was Niccolò's page or possibly a relative whom the Medici wanted to see in the picture. Given all the armor around him, one cannot avoid the conclusion that, although he might well have looked like this in the parade preceding a tourney, neither he nor Niccolò is shown as they would have appeared when entering a battlefield.

In terms of the interest Renaissance artists developed in nature, in modes of representation, and in human individuality, the *Battle of San Romano* is a painting of its time. But as a comment on warfare one has to say that Uccello, like Donatello, remained firmly within well-established artistic traditions.

Verrocchio's *Colleoni*

The four figures in heroic pose whom we have encountered in this chapter – Donatello's Gattamelata, and Uccello's Sir John Hawkwood, Niccolò da Tolentino, and Micheletto da Cotignola – were members of a breed of soldier that came to new prominence during the Renaissance: the mercenary captain. Soldiers who offered their services for pay had been familiar since earliest times. Xenophon's army of 10,000 had been hired by a Persian prince nearly two thousand years

before Gattamelata was born. There were differences, however, in the images that these varied types of military men summoned to mind.

If at one end of the spectrum the knight conjured up gallantry and honor, at the other end stood the mercenary, whose very name suggested the basest of motives for taking up arms. From David in the valley of Elah to the doughboy in the valley of the Somme, the reluctant and non-professional citizen-soldier has always had the best notices. We admire the Athenians, not the Spartans; the selfless patriot, not the soldier for hire. Even Machiavelli, adept in the pathways of power and force, preferred the volunteer to the mercenary. And yet he lived in a period when the citizen army had been unknown for centuries, and would not fully revive for a long time to come.

The invading tribes who destroyed the Roman Empire had fought for themselves; their successors, the medieval foot soldiers and squires who followed their lords, had gone to war either because they had no choice or, increasingly as the centuries passed, for pay. By the fourteenth century the communal groups led by knights that had made up the earliest form of the feudal army had long been supplemented or replaced by soldiers who earned their living on the battlefield. The transition was not always complete, but there was no escaping the reality that societies had become more complex, monetary transactions had transformed economies, and as a result military organizations had had to change. Although the old forms still received lip service, the relations of lords and vassals had been so permeated by financial considerations that historians have called the results "bastard feudalism." For the next four hundred years, as cash became the mainstay of war, the mercenary enjoyed a golden age.

There were exceptions. Gustavus Adolphus, the king of Sweden during the Thirty Years War, conscripted a significant number of his subjects into his army. But just about every other European commander until the French Revolution (when devotion to a national cause began to take over) depended on monetary inducements to raise troops. Polyglot armies were the norm, though occasionally specific regions or people went to war en masse. Swiss troops, for instance, were universally feared (and for rent) in the fifteenth and sixteenth centuries, a heritage still recalled by the Swiss Guard at the Vatican. And Cromwell's New Model Army certainly fought for a cause during the English Revolution in the 1640s and 1650s. But these armies were unusual. Whether it was Giangaleazzo Visconti's soldiers in Milan in the fourteenth century, Albrecht von Wallenstein's in Germany in the seventeenth, or the Hessians in America in the eighteenth, the standard practice was to recruit with money and accept all who joined up.

The outlook and procedures that shaped this age of mercenary warfare were given their first fully elaborated form, like so much else in European history, in Italy. The Italians even invented their own word for the commanders of the bands

of soldiers who dominated their peninsula in the late Middle Ages and Renaissance. These captains always served under a contract with their employers (a device, usually futile, to prevent them changing sides), and the contract they signed, known as a *condotta*, gave them the name: *condottiere*. Because so many of them founded princely dynasties, with descendants who ranked among the most venerable of Europe's aristocracies and even occupied the papal throne, the term *condottiere* has not seemed quite as pejorative as mercenary, but the distinction is solely semantic.

The Renaissance *condottieri* were also made more glamorous, in our eyes, by their discerning patronage of the arts. Some of the most famous families, such as the Gonzagas in Mantua and the Montefeltros in Urbino, created intellectual and artistic centers overshadowed only by the Florence of the Medicis. But even the commanders who failed to found a dynasty or a new principality gained a level of admiration that elsewhere in Europe mere mercenaries rarely attained. And this was true even in that most down to earth and practical of Italian states, the republic of Venice.

Thanks to its location on islands in a lagoon, Venice could rely primarily on naval might to maintain its power. It was the only city in medieval Europe that never had to build a fortified wall to protect its inhabitants. And at sea it trusted nobody but its own patricians to lead its forces into war. On land, however, it accepted the conventions of the time. To fight off rivals in northern Italy, and then, in the first decades of the fifteenth century, to carve out a large empire on the mainland, Venice employed a series of *condottieri*. With the ample resources of a thriving mercantile republic at their disposal, these *condottieri* did extremely well, extending the boundaries of the state into the Dolomites to the north and as far as Bergamo, just outside Milan, to the west. By the end of the fifteenth century, the Venetians were capable of paying for nearly 40,000 soldiers, and even in peacetime they kept in readiness an army of more than 10,000 men.

Among the many *condottieri* they hired, two achieved unique renown – not for their exploits in battle, which were unexceptional, but for the art they inspired. The first was Erasmo da Narni, a papal commander known by his nickname, Gattamelata (honeyed cat), who signed on with the Venetians in 1434 and served them for just six years, until old age and ill health forced him to retire. In this brief time, however, he became a revered figure, as was made abundantly clear by the Venetian Senate, which raised the sizable sum of 250 ducats to pay for a state funeral for Gattamelata in Padua in 1443. Even more telling was the Senate's decision to erect a public monument honoring the *condottiere*. Though paid for by his heirs, the result was an official work of art that ensured his fame for all time: the equestrian statue that, as we have seen (fig. 25), was commissioned from Donatello.

There had been paintings and sculptures honoring *condottieri* in Italy before, but nothing to compare with Donatello's monument. Bringing back to life the

celebration of imperial valor that was associated with ancient Rome, the figure of Gattamelata, astride his magnificent horse, dominates the approach to Padua's cathedral. The power of Donatello's work, not to mention his feat in casting a bronze of this size, has overwhelmed viewers ever since. It is true that the artist was a foreigner, a Florentine, but he was the most famous sculptor of his day. And although the location was a city that the Venetians ruled rather than Venice itself, they eagerly took credit for the glory of the art and its military subject. They probably even enjoyed the story about the project that soon circulated, which ascribed almost godlike powers to the artist – and which, appropriately amended, was later told about the Florentine sculptor who was Donatello's disciple and who repeated his feat, Andrea del Verrocchio.

As the story had it, while Donatello was working on the bronze statue of Gattamelata, he felt increasingly that he was being pressed too hard to finish. He therefore took a hammer and smashed the nearly finished head. When the rulers of Venice heard this, they summoned the artist and told him that his own head would be smashed like that of the statue. To which Donatello is said to have replied: "That's all right with me, provided you can restore my head as I shall restore that of your Captain."

During the three decades following the death of Gattamelata, Venice's chief military leader was Bartolomeo Colleoni, a member of a warrior family from the area around Bergamo. Starting as the captain of a small troop in the 1430s, he rose to be captain-general of Venice's armies in 1455, a position he held until his death twenty years later. Although the republic was at peace virtually the entire time he was captain-general, and in earlier years Colleoni – like many *condottieri* – had changed sides twice, the Venetians overlooked both the absence of battlefield action and his disloyalty in their determination to keep him happy, granting him lands, honors, and fabulous wealth. When he died, leaving a fortune to the government of Venice, with instructions for a stunning tomb in Bergamo as well as a statue to rival the *Gattamelata* – this time, however, in the Piazza San Marco, the very heart of Venice – the government took up the venture with enthusiasm, knowing that the glory would redound to the city as well as to Colleoni.

Three years later the Senate set up a committee to arrange for the monument. The winner of the commission was again a Florentine, Verrocchio, who defeated two other candidates, one of whom may have been his student Leonardo da Vinci. Verrocchio was then in his early fifties, the acknowledged inheritor of Donatello's mantle as the supreme sculptor of the age. He had fashioned the tombs of three members of the Medici family, including their patriarch, Cosimo, and his elegant depiction of David with the head of Goliath was said to have surpassed even Donatello's treatment of the subject. He now set to work on what was to be his

masterpiece. Sadly, though, Verrocchio suffered from increasingly poor health during the ten years it took to construct the statue. Eventually, as it was nearing completion, he decided to move to Venice to oversee the final stages, but just a few months later he died, in 1488.

The monument Verrocchio designed seems almost deliberately to try to surpass the *Gattamelata* (see fig. 30). It was again set on a high pedestal alongside a church (since the Venetians refused to honor an individual in the Piazza San Marco, it was placed next to the enormous and beloved church of Santi

30 Andrea del Verrocchio, *Colleoni*. Venice is adorned with an astonishing concentration of artistic masterpieces, but none of its public sculptures comes close to the force or majesty of this figure. Verrocchio's equestrian statue has never been outshone as an image of the warrior at his most powerful and determined.

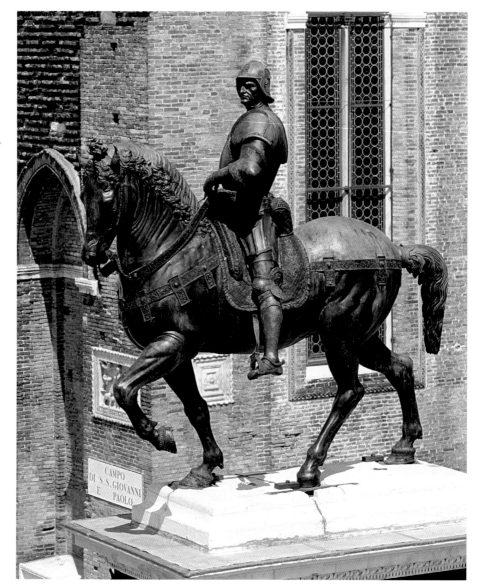

Giovanni e Paolo). But both horse and rider convey a fierceness and forward movement that is absent from the *Gattamelata*. To accomplish this impression, Verrocchio made Colleoni larger in relation to his horse, and made his whole body tense with purpose: his legs are taut and at full stretch, his left arm is flexed, and he looks to his left even as his body is turned to his right. At the same time, the horse, its muscles sharply defined, also looks to its left. The most noticeable feature of the horse, though, is its front left foot. Previous equestrian statues had shown one foot raised, but never so high, so flexed, and so free of physical support. This vigorous, unencumbered stride creates a sense of determination and energy that had never before been seen in such a monument.

Although Verrocchio died before the casting and the pedestal were complete, and never saw the statue that was put in place in 1495, the design is almost entirely his work. What he had done was bring to a climax the tradition that the knight in full armor was the embodiment of valor and nobility. Though some may have regarded the soldier for hire with disdain, Renaissance Italy was in general a time and place that admired individual achievement and set enormous store by those who turned Fortune to their own account. The archetypal Renaissance text on manners, Castiglione's *Courtier*, urged the fighting man to make sure that his acts of bravery on the battlefield were observed by the right people. It is thus no wonder that a centuries-old image of prowess should still have been considered the best means of glorifying a civic hero, or that it was conveyed so powerfully in the Colleoni monument by warrior and artist alike.

Hints of Change: Federico da Montefeltro

In one mercenary captain's dukedom, the first hints of a change in artistic treatments of war can be perceived. Federico da Montefeltro began his military career in the 1440s, when he was still in his teens, and spent much of the rest of his life (he died in 1482) on the battlefield. One of the most sought-after *condottieri* of the age, he fought both for and against the Pope; for and against the Florentines; for and against the Malatestas, the rulers of Rimini; and for the king of Naples and the Sforza rulers of Milan. Not surprisingly, one of his campaigns brought him up against Colleoni.

Yet this rough-and-ready soldier, who lost his right eye in a tourney, was also one of the most discriminating patrons of the arts and letters of his day. His magnificent palace in Urbino was both lavish and elegant, with a central courtyard framed by arches that inspired generations of architects. In one of the small rooms – it occupied less than 15 square yards – where he would retire to read, he placed portraits of famous writers on the upper walls, and below, a gallery of wood inlays, known as intarsia, whose *trompe-l'oeil* effects made it seem that he was surrounded by shelves

of books, cabinets, instruments, sculpture, birds in a cage, a squirrel, and decorations. This quiet study, or *studiolo*, is one of the marvels of Renaissance art. Federico also patronized humanist scholars, creating the finest library in Italy outside the Vatican. In one of the portraits he commissioned, he is shown attending a learned lecture together with his young son, Guidobaldo, who survived this intimidating upbringing and went on to maintain his father's commitments. It was because of his service at Guidobaldo's court that Baldassare Castiglione, some decades later, made the Urbino palace the setting for his book on manners, *The Courtier*.

Where painting was concerned, Federico's favorite was the Tuscan Piero della Francesca. He may have seen Piero's portraits of one of his antagonists, Sigismondo Malatesta, in Rimini, particularly one of Sigismondo kneeling, because he was to have Piero show himself in the same pose a number of years later. What seems clear is that he was not drawn to the artist because of his ability to suggest the heroism of the warrior. The two paintings of military scenes for which Piero was well known were *The Battle between Constantine and Maxentius* and *The Battle between Heraclius and Chosroes*, both of which were part of his "Legend of the True Cross" cycle in Arezzo. Although the second of these was unlike Uccello's *Battle of San Romano* in that it did depict combat, blood, and death, both scenes are animated by the same qualities the Florentine emphasized: pageantry, color, varieties of human gesture, slashing diagonals, and staged, almost impersonal effects. The frescoes recount two episodes in the story of the True Cross, the first when the Roman emperor Constantine won a victory by holding up a cross (see fig. 31), the second when, a few centuries later, the Byzantine emperor Heraclius recaptured Jerusalem from infidels. Not only are they full of inexplicable details, including soldiers both in and out of armor, odd columns, and tricks of perspective, but they strongly suggest that Piero was responding, not to the warrior as a subject, but rather to the demands of telling a sacred story. Although they are magnificent works, and in formal terms do take up the theme of battle, they give little sense of an artist grappling with the meaning of warfare.

That characterization makes all the more sense when we consider Federico's choice of portraitist for a pair of matching paintings of himself and his second wife, Battista Sforza. Here was one of the chief military figures of the age, who knew full well that the embodiment of glory was the superb knight, preferably mounted on a splendid horse – a representation for which he was almost uniquely suited. Yet he picked Piero because he was a master of the human face, of beautifully observed details, of distant landscapes, and of classical forms. And those were the very skills the painter brought to what became the most famous double portrait of the Renaissance. We see husband and wife in profile, with a vast vista behind them, and on the reverse side the couple sitting on two triumphal chariots.

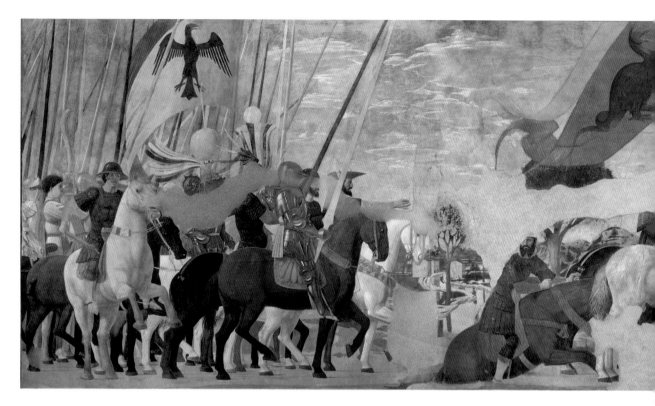

31 Piero della Francesca, *Constantine and Maxentius*. After Constantine, holding the cross, defeated Maxentius in 312, he ruled the Roman Empire from Constantinople (Byzantium). Piero's portrait is of a Byzantine emperor who had visited Italy, and the color and pageantry suggests (as did Uccello at about the same time) a tourney rather than a battle.

These second scenes, drawn from ancient models, might hint at military significance, but below them are inscriptions proclaiming the couple's virtues without any such reference. Federico has had the artist ignore the very aspect of his life that had brought him title, fame, and fortune.

Piero did show him in armor in another painting, the so-called *Pala Montefeltro*, an altarpiece of almost unworldly calm and grace that the duke commissioned for a chapel that was never built (see fig. 32). In front of a barrel-vaulted marble niche stand ten reverent saints around a seated Madonna and Child. Below them, in profile, kneels Federico, in full armor, though he has removed his gleaming helmet and also his gauntlets so that he can hold his hands together in devotion. He may be identified as a warrior, in other words, but that is not the point: what counts is his religious faith. To drive the point home, Piero hung an ostrich egg above the Madonna's head – a symbol (because the ostrich was thought to be unable to find her eggs) of the need constantly to remember the Savior.

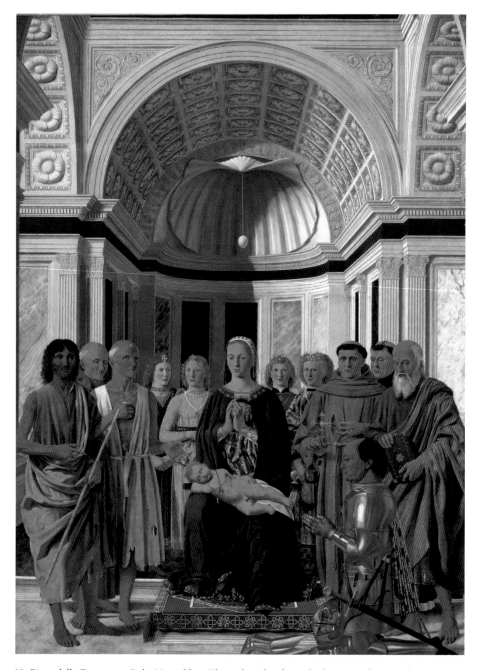

32 Piero della Francesca, *Pala Montefeltro*. The right side of Piero's altarpiece shows Federico Montefeltro kneeling in front of saints, the Madonna, and a sleeping Jesus. Federico has removed gauntlets as well as helmet, symbols of war, so that, together with the Madonna herself, he can clasp his hands in prayer.

Here, in other words, was a man of arms who, while not hiding his profession, emphasized his other qualities. And in one other portrait he had the artist make that argument beyond contradiction. It was the work of a Spaniard, Pedro Berruguete, possibly with the collaboration of a Fleming, Justus of Ghent, and shows Federico with his son Guidobaldo. Although we see the main subject sitting in a chair and reading a book, he is dressed in a manner that is virtually unique in the annals of portraiture (see fig. 33). Except for his helmet, which again he has

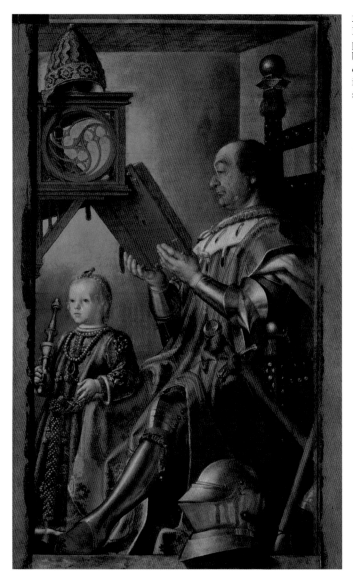

33 Pedro Berruguete, *Federico Montefeltro*. In Berruguete's portrait of Federico, he has put the symbols of war aside to read a book. There is no precedent for this depiction of a soldier deeply absorbed in intellectual activity, and it foretells a major shift in the image of the warrior.

set aside, Federico is in full armor. The effect is slightly softened by the magnificent cloak he wears over the armor, but there is no mistaking the message: this is a warrior in an off moment, relaxing with a volume from his library.

What we have here, from both Piero and Federico, is a crucial change of emphasis that was to have far-reaching implications in the years ahead. In the first place, war could be shown as an unheroic activity. The Arezzo frescoes present the two battles as merely episodes in a sacred story. Even a commander on his horse – the emperor Constantine – does not cut a dashing figure. He is prominent, but certainly not triumphant. And in *The Battle between Heraclius and Chosroes* there are no heroes at all. In the second place, and even more significant, a famous warrior, Federico, has sought to appear in non-heroic guise. Unlike Gattamelata or Colleoni, this veteran commander, while not disguising his vocation, has set the heroism aside in order to emphasize his piety and his commitment to the life of the mind. The active life is still there, but the contemplative has trumped it, and a door has opened for artists to propose very different understandings of warfare.

<p align="center">* * *</p>

These first signs of change may have had nothing to do with the technology of battle, but that determinant of military behavior would soon ensure that the tides of history could be held back only so long. As we move into the sixteenth century, we find gunpowder at last transforming warfare. Handguns come to dominate the battlefield; cannon, trenches, and explosions revolutionize sieges; and naval engagements pass a decisive milestone when the objective changes from boarding and capturing a ship to sinking it with firepower. Inevitably, as the possibilities for heroism shrank, and conduct became more impersonal and broadly lethal, the image of war began noticeably to shift. The traditional view, that battle ennobles, may have been able to survive even as it grew less plausible, but it was now joined by new ways of treating warfare in the arts. Painters and engravers, in particular, expressed views of combat and combatants that made the sixteenth and seventeenth centuries the central dividing point in the story of the artist and the warrior.

Traditions Transformed

THE SIXTEENTH AND SEVENTEENTH CENTURIES

The Military Revolution

Although it may have been invented long before, it was not until the sixteenth and seventeenth centuries that gunpowder at last wrought a fundamental revolution in the conduct of war. That revolution took many forms, but at its heart lay two vast expansions: in cost and in the size of armies. Never before had armaments cost so much to produce, and not since antiquity had Europe seen so many troops mobilized at one time. Entire new trades appeared in branches of metalworking and in the manufacture of guns, cannon, and their projectiles. At the same time, there was enormous growth in the crafts of masonry and brick-building, as massive walls and bulwarks had to be constructed to defend cities against gunpowder assaults. To make these weapons and defenses as effective as possible, the demand for manpower grew with unprecedented speed. By the reign of Louis XIV in the late seventeenth century, France had some 400,000 soldiers – plus perhaps five times that number of staff support and hangers-on – in permanent readiness: a scale of military endeavor that had far-reaching consequences throughout politics and society.

How did the application of a simple discovery – the explosive properties of gunpowder – have such profound effects? The crucial moment arrived when a way was found to put an effective firearm into the hands of an individual soldier. During the fifteenth century, the impact of handguns had been limited because they were heavy, difficult to fire, and inaccurate. On the battlefield, as we noted, even cannon served primarily as a scare tactic, though there were some occasions (at Castillon in 1453, for example) when, in conjunction with portable guns, they did play a significant role in a victory. Their main importance, however, was at sieges, where, despite the difficulties in firing them and the unpredictable results

of their blasts, they helped create holes in walls and other defenses. This situation, which gave gunpowder arms, in essence, an auxiliary role in warfare, changed dramatically around 1500 with the development of weaponry – notably the arquebus and the musket – that an ordinary soldier could carry without too much difficulty, and which some relatively simple training could teach him to fire. Once that breakthrough happened, the race to make guns increasingly effective ensured that warfare would never be the same again.

In their early days guns like the arquebus were both cumbersome and inefficient. They were so heavy that the barrel had to rest on a stand when in use. Its owner had to carry the stand with him, prop up his weapon, pack just the right amount of powder down the barrel, insert the projectile (usually a little lead ball, or shot), aim, and light the fuse. Then the process, which took at least two minutes, would have to be repeated. Within a few decades, not only had the gun become lighter, and thus easier to carry and aim, but firing mechanisms – especially the wheel lock and the flintlock – had been devised to apply a spark to the powder and thus shorten the interval between shots. The weapon's effective range probably did not exceed that of the longbow until the seventeenth century, but its use required far less skill, and long before then it had come to dominate the battlefield.

The effects were felt most immediately in the area of military tactics. In order to manage the new firepower, and bring it to bear on combat in disciplined fashion, the Spaniards devised a new formation that, because theirs was the most successful army of the sixteenth century, became the standard means of organizing troops. The Spanish formation was the *tercio*, a large square consisting of approximately 3,000 soldiers, armed with pikes, traditional swords and daggers, and guns. The pikemen, in disciplined lines on all sides of the square, could dig their weapons into the ground and, presenting a formidable array of sharp obstacles, hold off charging cavalry or infantry. Behind or alongside them stood rows of gunners: each row would fire a coordinated burst, and while it kneeled and reloaded, the row behind let loose its fire. If properly controlled, these gunners could unleash a barrage of steady shot. And if an attack came from a new direction, the square could change direction to meet the threat. The men armed with swords and daggers, meanwhile, were available for hand-to-hand combat. Kept intact by discipline and a chain of command, the *tercios* would march across a battlefield until it was cleared of the enemy.

Not until two military geniuses, the Dutchman Maurice of Nassau and the Swedish king Gustavus Adolphus, figured out counter-measures in the decades around 1600 did the invincibility of the *tercio* begin to falter. Their response was to emphasize speed, lightness, and flexibility against the lumbering progress of the *tercio*. Maurice created longer, thinner lines, modeled after Roman formations,

that were far more maneuverable than the *tercio*. Gustavus had his engineers devise smaller, lighter cannon, harnessed in leather, not metal, which could be moved around the battlefield and unleashed where needed. He also preferred the salvo, a single simultaneous blast rather than a steady barrage of fire, as a means of terrifying the enemy and breaking up formations. Gustavus even armed his cavalry with small arms, ordering them to end a charge with a salvo. And the innovations kept coming. The paper cartridge, which combined the right amount of powder charge with the ball, shortened the interval between shots. It became possible to create rapid coordinated firing, the fusillade, and by the late seventeenth century the musketeer had become the fusilier. During this period, too, the bayonet had become fixed to the gun, and the pikeman began to disappear.

That was the battlefield, but it was not alone in witnessing major change in response to gunpowder. During the Middle Ages, significant sieges tended to become ordeals of attrition. Since it was very difficult to capture a well-defended castle or city, an army would cut it off, settle down, and wait for starvation to resolve the issue. That is what happened at Kenilworth Castle in 1266, and also, despite the presence of cannon, at Rouen in 1419. There were occasions when a frontal assault succeeded, but on the whole, castle and city walls were impervious to long-distance projectiles. Gunpowder ended that invulnerability for castles, but cities were a different matter. With extensive earthworks, thick walls, and heavily armed, star-shaped bastions that dominated all approach routes, a town could still hold out, even against cannon, for many months. As a result, lengthy city sieges had become major elements of military campaigns by the sixteenth century, imposing a laborious, grinding existence on both sides. Because elaborate fortifications now became the norm, the only way to breach urban walls was to bring gunpowder to their base and set off an explosion. That could be done only by digging a complex web of trenches, protected from the lines of fire available on the bastions until the target was reached. Much of warfare thus came to consist of drawn-out, endlessly boring stalemates, as soldiers spent days and nights digging trenches and exchanging fire. The only notable innovation in these tedious affairs came from Gustavus, who realized that, by mixing small arms fire with cannonades, he could force defenders to keep their heads down so that they could not easily watch the besiegers from the commanding heights of a city wall. An indication of how difficult it was to penetrate the defenses that the engineers of this period built came in 1914, when one fortified town, Rocroi in north-eastern France, was able to hold off an invading German army for three days.

At sea, too, gunpowder changed the nature of combat. Until the sixteenth century one filled a ship with soldiers, grappled with and boarded the enemy vessel, and captured it in the same way as one overran territory on land. With the

advent of cannon, that course of action disappeared. Now the goal was to sink ships, not capture them. And the broadside – a coordinated blast from a row of cannon – became the naval equivalent of the salvo.

Given the new realities of warfare on both land and sea, the demands on manufacturing processes and on the recruitment of soldiers and sailors grew exponentially. Economies had to produce entire arsenals of new weapons each year; immense numbers of bricks for defenses; and tens of thousands of troops, as well as their support staff of bakers, grooms, tent-makers, and so forth. Where once the relatively small forces of a few thousand men assembled in the Middle Ages could be brought together by a combination of legal summonses, feudal obligations, and payments to mercenaries, now there was an unremitting effort of recruitment. The Spanish army in the Netherlands grew to around 80,000 men by the 1630s, but in the same decade Gustavus invaded Germany with a force of 130,000. Huge new bureaucracies had to be created to handle these needs, not to mention the payment, supply, and disciplining of soldiers and sailors; the administration of developing systems of military justice; and the control of civilians whose lives were transformed by the new forms of warfare.

What all these "advances" had in common was additional expense. It was no wonder that the most famous of the aphorisms attributed to a leading seventeenth-century commander, Count Montecuccoli, was: "Running a war requires money, money, and more money." The largest cost was in manpower and its equipment. If you were going to use smaller, mobile units on the battlefield, you needed more of them. They had to have better and lengthier training; they required more junior officers to lead them; and manufacturers had to produce more weapons for them. As the outlays necessary to maintain these commitments soared, warfare's impacts on civilian society multiplied. If on one side of the balance sheet there were new industries, on the other there were ever more crushing burdens of taxes, damage, and expropriations. It has been estimated that Germany lost a third of its population during the Thirty Years War – from the actions of troops, and the diseases and starvation they brought in their wake. Both Gustavus and his adversary, the Imperial general Albrecht von Wallenstein, relied on a system of "living off the land," appropriating cattle, crops, and housing to a degree that laid entire regions waste. And on the battlefield the slaughter, sometimes fueled by confessional hatreds, reached horrific levels. At the battle of Nördlingen in 1634, for example, about one in five of the 58,000 combatants was killed. Although estimates of the wounded are uncertain, one can assume that they were at least as numerous as those killed. The casualties, in other words, may well have reduced the two armies by as much as a third. Taking the larger view, it was not just that the techniques of war had changed and that the devastation

had mushroomed; warfare itself had assumed a new importance on the European scene.

It is true that governments did make some effort to mitigate the worst effects. They were the only authorities that could afford the rising costs of military activity, and one result of the surge in the taxation they demanded was that their officials, though more intrusive and visible throughout society, could also try to alleviate hardship. Rather than simply squeezing the populace, rulers attempted to use their resources to temper some of the most dire consequences of the fighting. By the late seventeenth century, for instance, drill grounds had begun to appear, a sign of growing attention to discipline. In a number of countries, special barracks were built so that troops did not have to be billeted among the civilian population. Food supplies were improved, and in general there was an attempt to shield non-combatants from the depredations of soldiers. In the late 1600s, there was also a dying away of the ferocious passions that had stoked the wars of religion for the previous century, and this too helped reduce casualties both on and off the battlefield.

With all that said, however, there is no escaping the conclusion that the gunpowder revolution transformed the enterprise of warfare and made Europe a very different place. The soldier was now a familiar figure, and since the insistence on distinctive uniforms was one of the innovations of the age, he was also imme-diately recognizable. He regarded his occupation as a career, even a profession, and in that respect he differed radically from his equivalent in earlier times, who was not only more of a rarity, but tended to melt back into society once his brief stints of combat were over. Because of this new omnipresence, and the intrusions into society of standing armies, warfare became an unavoidable element in daily life. Its proximity, especially in the regions around the Rhine, to the south of the Baltic, and in northern Italy and central Europe, meant that its brutality and destructiveness came to the fore. Trumpeting its glories was becoming less convincing, and strong denunciations of war began to appear, most notably from Erasmus, the leading scholar and author of his age. Although it took a while for the arts to follow suit, here too the cracks that we have already noticed were finally, in the sixteenth century, beginning to split apart the long tradition of unstinting praise for the warrior and his valor.

Pieter Brueghel the Elder

The bifurcation of the image of war into opposing visions – one traditional, evoking honor and triumph, the other critical, emphasizing horror and mayhem – made its first dramatic appearance in two masterpieces, painted within a decade of one

another in the mid-sixteenth century. What makes the juxtaposition especially telling is that the villain and the hero of both paintings is the same person, King Philip II of Spain. His antagonist, and the pivotal figure in the creation of anti-war art in the mid-1560s, was his subject in the Low Countries (modern-day Belgium), the Flemish painter Pieter Brueghel the Elder; his supporter, in the early 1570s, was a non-Spaniard whose work he prized, the longtime lionizer of the rich and the powerful, the Venetian painter Titian. Both were amongst the greatest artists of their age, but they could hardly have devoted their masterpieces to more different ends.

One reason that Brueghel could take the position he did was that gunpowder weapons rendered obsolete the traditional notion that valor was essential to success in battle. As humble gunners learned to bring down their enemies from afar, the notion of war as an opportunity for superior individuals to demonstrate their courage in hand-to-hand combat disappeared. Arrows had done some damage to the mounted knight, but they could not compare with the increasingly devastating effects of cannon and guns. It is no surprise that these were the years when an alternative means of demonstrating bravura, the duel, became a significant feature of aristocratic life. In 1516 the Italian poet Ludovico Ariosto had lamented the passing of this era. In his epic poem, *Orlando Furioso*, his protagonist, Orlando, throwing a gun into the sea, says: "To ensure that no knight will ever again be intimidated by you, and that no villain will ever again boast himself the equal of a good man because of you, sink here." It was precisely because of this shift in outlook that new attitudes to war could develop, and that new values could arise – especially the admiration for elegance and taste – which eventually replaced skill in battle as the mark of a gentleman.

Another of the changes of the period was also crucial in making Brueghel's outlook possible. For it is in the sixteenth century that one begins to notice a growing inclination to assert the special nature of a particular place or area. One of the reasons historical scholarship made major advances in the sixteenth and seventeenth centuries was the effort, related to this assertiveness, to demonstrate the distinctiveness of regions or countries. Though they also had other purposes, this quest for identity underlay Niccolò Machiavelli's *History of Florence* and his neighbor Francesco Guicciardini's *History of Italy*, both written in the early decades of the 1500s. A few years later, writers in France sought to distinguish their countrymen by reference to the character of the ancient Gauls, and in England there arose the belief that a Norman yoke had become a stifling influence after 1066. In some of these cases, imagination took over where evidence was lacking, but the very effort marked a new level of attachment to place – not yet to a nation, but certainly to a community larger than the locality, linked by a shared history and culture.

There had been hints of such feelings before. The polyglot Crusader armies had revealed diversities among people from different geographic origins – from their taste in beer to the language they spoke. Such encounters had drawn people of similar background together, even as the experience of strangers had also prompted (as it had since antiquity) the more unpleasant stirrings of xenophobia. What was different now was the greater breadth of these identifications, and the encouragement they were receiving from the investigation of common histories.

During the millennium since the fall of Rome, when the phrase *civis Romanus sum* (I am a Roman citizen) had united many of the people of Europe, wider allegiances, where they existed, had tended to be directed either to a fairly limited target – to a lord, to a locality – or else, in abstract terms, to Christendom. What emerged in the sixteenth century was a sentiment that scholars tend to regard as patriotism rather than the more elaborate nationalism of later times. Its presence is unmistakable, whether in the poetry of Ronsard in France or of Shakespeare in England. That John of Gaunt in the play *Richard II* could describe his native countrymen and land as:

This happy breed of men, this little world,
This precious stone set in the silver sea

was an indication of the feelings that were beginning to stir. And what also set the sixteenth century apart was the fact that those feelings were encouraged by a newly powerful and intrusive force, which had come to realize that it could benefit from them.

We have already noted how the gunpowder revolution fed the growth of central governments. Once they had gained a monopoly of military action, moreover, they entertained ever larger ambitions, which transformed their relations with their subjects as well as the very purposes of warfare. War became less personal and more a means of advancing larger goals: an assertion of authority, a claim to land, or (in the wake of the Reformation) an assault on a rejected faith. And in order to strengthen their claims, rulers and governments increasingly sought the support of their people for their causes. Queen Elizabeth of England was particularly adept at cultivating the allegiance of her subjects, especially in a time of war. Controlling the use of her image, traveling throughout the land, and drawing on the power of rhetoric – her speech to the troops as the Spanish Armada approached was a classic of patriotic propaganda – she strongly reinforced the larger loyalties that were beginning to emerge. Much the same was accomplished by Gustavus Adolphus when, on the eve of Sweden's entry into the Thirty Years War, he roused the Riksdag (the country's representative assembly) with a speech

whose culmination was "The fight will be for parents, for wife and child, for house and home, for the fatherland and faith."

But such campaigns for emotional support were double-edged swords. If, on the one hand, they enhanced loyalty to a ruler or a regime, they also aroused enemies. For it was obvious that, as armed conflict came more and more to serve territorial or religious aims, those who espoused a different cause, or who began to regard a leader as an outsider, would see the fight as destructive rather than ennobling. What to one was a valiant call to arms could appear to the victim as brutal repression. Thus loyalty to a land or to indigenous traditions could lead to hatred as well as devotion. The scene was being set for a new way of showing the warrior – a possibility that grew ever closer as feelings of attachment to regimes or geographic areas took hold.

One part of Europe where these changes were painfully visible was home to the remarkable painter who first challenged the centuries-old idealization of the soldier and suggested that there were no redeeming values in the carnage of war. The place was the Low Countries, and the painter was Pieter Brueghel the Elder. His break with the past helped create a new role for artists as critics of society.

The dominant state in Europe in the second half of the sixteenth century was Spain, the center of an overseas empire, rich in New World silver, equipped with a seemingly invincible army, and dominant in most of Italy and the Low Countries. The king from the mid-1550s, Philip II, was a devout Catholic and a relentless upholder of his own authority. A series of fortunate marriages and deaths had made him the heir to the provinces bordering the North Sea that made up the Low Countries, and he was as determined to exert his control there as in Spain itself. These provinces, however, cherished a long tradition of independence, which only intensified as Calvinism began to make inroads among the people.

To crush their defiance, Philip asserted his control over both Church and government in a series of measures in 1559. Six years later, he introduced the Inquisition to the Low Countries, and the following year the Calvinists, who regarded the Catholic reverence for sacred images as idolatry, responded with a wave of iconoclasm, smashing hundreds of religious objects and symbols. Philip now decided to resort to force, and in the spring of 1567 dispatched a small army under a ruthless commander, the duke of Alba, to destroy the resistance. Deploying thousands of troops, Alba began a reign of terror. During the first three months of 1568, for example, 113 heretics were burned in the main square of Brussels. On one day in March alone, 500 were arrested, and in June two of the territory's leading aristocrats were executed for defying Philip's authority. Although there had been civil wars provoked by religion during the previous twenty years in both Germany and France, this was the first time a prince had tried to stamp

out heresy and insubordination by using soldiers on this scale to fight – not against a rebel army, but against his own subjects.

Open revolt erupted in 1568, and for the next eighty years (until the Peace of Westphalia in 1648) seven of these provinces, united as the Netherlands, kept up the struggle until they gained independence from Spain. Yet the deterioration of relations between ruler and ruled during the late 1560s also left its mark on the way the soldier was seen. The merciless assertion of authority, and the waging of war against ordinary people, eventually prompted Brueghel, in his last years, to raise questions about military values that have never been answered.

Born in the 1520s, Brueghel had become known as a printmaker and land-scapist by the early 1550s, when he was admitted to the painters' guild in Antwerp. He traveled to Italy between 1551 and 1555, passing through France and Switzerland, and it was after his return that he moved on from landscapes to the scenes of daily life, religious belief, and allegory that became his trademark. Although he lived in the seat of government, Brussels, from 1563 and received the patronage of the Spanish governor and leading citizens, he was already showing his unease at the sharpening antagonisms that were mounting as a result of the political and religious conflicts in his native land.

In 1559 and 1560, for instance, he completed a series of drawings of the Seven Virtues. Both Hope and Charity are deeply pessimistic visions of the human condition: the former suggests that hope is no more than a last resort, while the latter is, if anything, an attack on the hypocrisy of the charitable. But Justice is unambiguous. She carries a huge sword and is surrounded by soldiers who implement her decrees. We see an accused prisoner being tortured and various other grim punishments. Indeed, some of the executions Brueghel showed were to be echoed in the devastating *Triumph of Death* that he painted within a couple of years. Justice, in other words, is an instrument of force and power, and the role of religion in death's victories was to be symbolized in the *Triumph* by a huge cross on the gate to hell.

That Brueghel regarded religious intolerance as the root of the troubles in his homeland is suggested by his gruesome depiction of the parable of *The Blind Leading the Blind* (see fig. 34). It was painted in 1568, during Alba's first year in the Low Countries, and although the message may be hidden by the biblical theme, Brueghel's distress is obvious. Six of his most unfortunate countrymen, feeling their way across the Flemish countryside, head inexorably toward a fall into a ditch. Nor would it have taken his contemporaries long to realize that the passage he illustrated, from Matthew 15: 14 – "If the blind lead the blind, both shall fall into the ditch" – was Jesus' condemnation of the intolerance of the Pharisees.

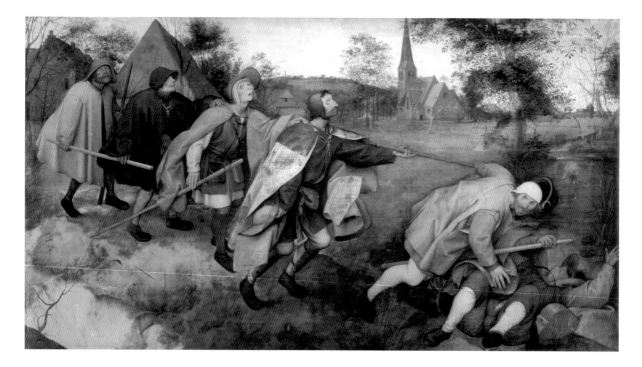

34 Pieter Brueghel, *Blind Leading Blind*. This disturbing painting exemplifies Brueghel's interest in the shocking as well as the pleasant features of the daily life of his time. This sensitivity to helplessness and misery was essential to his ability to capture the brutality of war.

The year before, as Alba crossed the Alps on his way to the Low Countries, Brueghel had painted a *Conversion of Paul* taking place in an Alpine setting, filled with soldiers, and presided over by a mysterious figure dressed in black (the color that Alba was known always to wear). Scholars have not been able to decide whether Brueghel intended to evoke the Spanish commander or what such a reference would have implied. Was he bringing the true faith? Was he standing aside from true faith? But in two other paintings of these years – both of which, once again, were ostensibly biblical scenes – the contrast between the actions of Spain's government and the simple humanity of the inhabitants of the Low Countries is inescapable.

The first was an unusual painting of the event that brought the heavily pregnant Mary to the town where Jesus was to be born, the *Census at Bethlehem*. The conduct of a tax inquiry was about as unlikely a subject as an artist could have imagined. And yet it gave Brueghel a perfect opportunity to show, by implication, the heavy hand of Spain on the Low Countries. His village is deep in its hardest season, an icy winter, but its inhabitants have to leave their chores, stand in line, and subject themselves to the inspection of a scruffy and shadowy group of officials. The scene is magically invoked, though it cannot have been unintentional that everyone in it seems indifferent to the huddled figure of the patient Mary in the foreground. Who has time for such attention when the cold is so harsh and the government so demanding?

The next episode in the biblical story was vastly more bitter. Following the census and the birth of Jesus, Joseph and his family had to flee to Egypt because, hearing of the Nativity, Herod ordered all infants in Bethlehem killed. The Massacre of the Innocents that ensued has never been shown in more anguished terms than in Brueghel's masterpiece, of that name, which seems to have been painted at about the time Alba reached Brussels. Possibly a companion piece to the earlier *Census*, it shows a scene of undisguised horror (see fig. 35). Spanish soldiers break their way into Flemish villagers' houses, tear babies from their grieving, pleading parents, and slaughter them without mercy. In the background, watching impassively, is a detachment of Spanish cavalry led by a bearded figure in black. Although the beard and the outfit suggest Alba, and a copy of this picture by Brueghel's son makes the portrait unmistakable, one hardly needs a reference to the commander to recognize

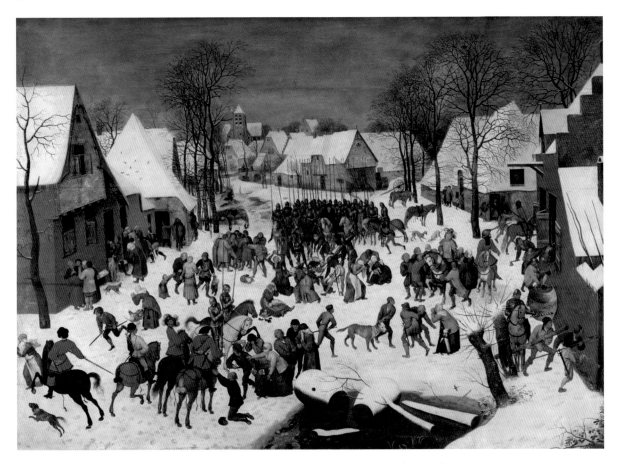

35 Pieter Brueghel, *Massacre of Innocents*. In this version of his painting, Brueghel emphasizes the viciousness of soldiers. His village is in the midst of a harsh winter, and despite the pleas of parents, troops break into houses and slaughter helpless children, totally indifferent to the suffering they cause.

the artist's savage indictment of the soldier's trade. Gone is all vestige of heroism; what remains is the vicious cruelty of those who resort to arms.

Brueghel painted more than one version of the picture, and the clearest evidence of the stir it caused can be seen in the one now owned by Queen Elizabeth II, which was once in the collection of Rudolf II, the Habsburg emperor who was a nephew of Philip II. Rudolf was no distant relative. He had spent his childhood at the Spanish royal court, and it was probably there that he gained a fondness for the arts. Brueghel was one of his favorite painters, but the *Massacre* evidently came too close to the bone. As one can see to this day, he had all the babies painted out, and replaced by animals, apparently being slaughtered (see fig. 36). Patrons were not yet ready for the jaundiced view of war that Brueghel had pioneered.

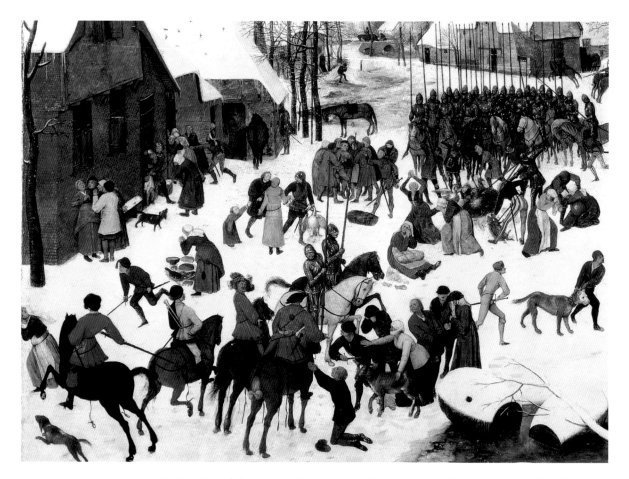

36 Pieter Brueghel, *Massacre of Innocents*, detail. An admirer of Brueghel, Emperor Rudolf II bought this version of the biblical scene; but since it shows soldiers who served the Spanish king (a relative) killing Flemish children, he had it repainted. Now they kill animals, presumably for food, yet the supplicants still plead for them to stop.

The artist himself realized the danger. On his deathbed he made his wife burn some of his works "for fear that she might get into trouble and have to answer for them." Nobody knows what canvases vanished into the flames, but those that have survived give us cause to appreciate Brueghel even more as a brave and unprecedented social commentator. His exposure of the dark side of military prowess not only started the refashioning of the image of warfare, but marked him as the prophet of a new and increasingly more compelling vision of the inhumanity of war.

Titian's *Allegory of the Battle of Lepanto*

A fissure may have opened in the depiction of war, but the heroic tradition was still in vigorous health, as the most famous artist of the day demonstrated just a few years after Brueghel painted the *Massacre*. Asked to celebrate a notable naval victory, won by a combined Venetian and Spanish fleet, Venice's renowned son, Titian, created an allegory that offered a new way of celebrating the glory of battle.

The underlying motive was one of the most driving passions in the history of warfare. Few causes have prompted such self-righteous contempt for an enemy, or such martial ferocity, as religious fervor. And rarely has that emotion reached the heights it scaled in the sixteenth century, when protagonists of the Reformation and the Counter-Reformation would feel so threatened by the very existence of their opponents that, after a massacre, they would toss the victims' dead bodies into the nearest river in order to cleanse the countryside of the pollution of heresy. It was not surprising, therefore, that the dehumanization of religious antagonists should have been reinforced by claims of grandeur and piety when it became time to commemorate a victory for the cause.

If religious hatred put Europeans at each other's throats in the sixteenth century, there was nevertheless one article of faith that could unite them: their fear of the Ottomans. Few of the world's confrontations over belief have matched the durability or the animosity of the struggle between Christendom and Islam that began in the age of Charlemagne, hardened during the Crusades, and persists to this day. The intensity of the conflict may have varied over the centuries, but one of its peaks was reached following the Ottomans' capture of most of the Balkans, and their attack on Vienna, in the 1520s.

The Turks' thrust along the Danube and into German-speaking territory brought the troops of Sultan Suleyman close to the heart of Europe and sent a shudder throughout the West. All of the eastern and most of the southern shores of the Mediterranean, not to mention many of its strategic islands, were already ruled by the Ottomans. And a counter-offensive begun by the Holy Roman

Emperor Charles V into North Africa during the 1530s had ended in defeat in 1541. Thereafter the Ottomans' advance, undeterred by the failure of their siege of Vienna in 1529, seemed increasingly ominous. In the 1550s they captured Tripoli and overran Corsica; in the 1560s they destroyed half of Spain's galleys in battle, and, although assaults on Malta and Oran failed, by the end of that decade they seemed on the brink of renewed success.

That the Ottomans were seeking to expand further became evident in 1570 when they took control of Tunis and invaded Cyprus. At that point the Mediterranean's often divided Christian regimes at last agreed to unite in a major effort to hurl back the infidels. The first move came from the Venetians, who, despite the profits they gained from their trade with the Ottomans, were determined to resist the Sultan's demand that they hand over Cyprus. Seeking allies, they turned to the papacy which, though often opposed to Venice in Italian affairs, now set about creating a Holy League that included not only much of Italy but also the most redoubtable monarchy of the day, Spain.

Court advisers warned the Spanish king, Philip II, that he was over-committed elsewhere. His devout piety, however, complemented by his hopes for conquest in North Africa, swept all such objections aside. Here was a chance to strike a blow for the faith and serve Spain's strategic interests at the same time. He therefore entered the complex negotiations that eventually forged an alliance in May 1571, when the three main partners (Venice, the papacy, and Spain) agreed to assemble a massive fleet to attack the Ottomans in the eastern Mediterranean. Spain was to provide half the funds and forces – 100 fully manned galleys – a contribution that earned Philip the right to nominate the commander of the armada. Though the young man was only in his mid-twenties, Philip chose his half-brother, Don John of Austria.

The expedition that set sail from Sicily for the eastern Mediterranean in September 1571 was to win one of the most famous naval victories in European history. Indeed, for centuries the day of the battle, October 7th, would be a national holiday in Venice, marked by a special procession. The joy was so exuberant partly because it was so unexpected, since none of the allies had been able to defeat the Turks in a major engagement at sea.

The anxiety had been high as Don John's armada moved toward the main Turkish fleet, waiting in the harbor of the small town of Lepanto on the Gulf of Patras in present-day Greece. As the ships of the Holy League approached, the Turks came out of their harbor and formed a gigantic crescent that filled the gulf, apparently hoping to tighten a noose around Don John's force. The tactic misfired, however, when Don John unleashed two fierce assaults, led by the experienced Venetians, who broke through the Turkish line. The result was disaster for the

Muslims as their ships were isolated and then destroyed or captured. Among the thousands who died was the Ottoman admiral, Ali Pasha. The material losses were equally devastating: of the 230 vessels in the Turks' fleet, only thirty-five escaped, more than half of the rest were sunk, and the remainder were taken in triumph by the Holy League. It was a shattering defeat.

All of Christian Europe rejoiced at the news, even though the immediate effects of the victory were limited. Within two years, the Venetians had lost control of Cyprus, the Ottomans had rebuilt their fleet, and the Spanish capture of Tunis (one of the few tangible gains) had been reversed. Yet the battle's long-term consequences were by no means negligible. Increasingly the Ottomans looked eastward and the Spaniards westward, leaving the Mediterranean uneasily divided but never again in danger of falling under the domination of either side. Meanwhile, the Venetians resumed their commerce, although their control of eastern trade was to be undermined within half a century by two intruders from the north, the Dutch and the English. Thus, if the decisive shifts could not be appreciated for decades to come, the immediate, unrestrained jubilation seemed entirely appropriate.

Philip II, as the dominant partner in the Holy League, had special cause for exultation. Spanish interests in North Africa were not unimportant, but Philip prided himself on his role as champion of the Church. No major Catholic state was as free of heresy as Spain, none had a more vigilant Inquisition, and none took so seriously the mission of defending the faith against its enemies. It seemed fitting that the news of Lepanto should have reached Philip as he was attending vespers on the eve of All Saints' Day. Yet piety and sobriety did not prevent Philip from becoming the most discerning patron of the arts in his day. His love of beauty embraced gardens, books, and sculpture; he built himself a magnificent Renaissance palace, the Escorial; and he bought the works of the finest painters of the time. A particular favorite, even though they never met, was Titian, who had already gained fame across Europe through the patronage of Philip's father, the emperor Charles V.

It had been for Charles that Titian had celebrated another victory by producing an equestrian portrait that helped set the pattern for the future portraiture of rulers and generals. The victory had been the battle of Mühlberg in 1547, at which the emperor had defeated Protestant rebels in Germany (see below, fig. 52). Although the outcome had been ambiguous, because a few years later the German Lutherans were granted toleration for their faith, Titian celebrated Mühlberg with a portrait of Charles as a mounted warrior, in full armor, that brought into paintings the ideal of valor that had been established in sculpture by Donatello and Verrocchio. Titian never portrayed Philip on horseback, but among his depictions of the king was one

in armor, a reflection of the artist's mastery of the heroic that made him the natural choice for a commission to commemorate a moment of military triumph. By the time of Lepanto, Titian was nearly ninety years old, but Philip recognized that he was still Europe's supreme artist and that he would be eager, as a Venetian, to honor a victory in which his city had played so notable a part.

To contemporaries, Titian's *Allegory of the Battle of Lepanto* was known simply as *The Battle*, but it obviously served a purpose larger than the mere recording of a naval encounter. After all, the battle is only dimly recognizable as a blur of ships, fire, and smoke in the background (evoking, it has been suggested, firework displays in the Venetian lagoon). The focus of attention is, instead, Philip himself, dressed for the occasion in armor (his regular absence from battlefields notwithstanding), towering over a defeated Turk, and holding a baby up toward a figure flying down from heaven.

This puzzling subject matter was first fully explained by the art historian Erwin Panofsky, who showed that Titian had created a celebration that extended beyond Lepanto to include his patron and his faith. For there had come into Philip's life late in 1571, just before he commissioned the painting, a second blessed event: the birth of a son, the Infante Don Fernando. Sadly, the child was to die seven years later (Philip's life was marked by the funerals of his wives and children), but at the time the double stroke of good fortune seemed God-given, and Titian was therefore asked to commemorate both battle and birth in a single canvas. The painting would be his largest portrait of Philip (deliberately designed to be the same size as Titian's largest portrait of Charles V), and, responding to the instructions, it became a remarkable apotheosis of king, family, and victory.

The picture did not reach Madrid until September 1575, nearly four years after Lepanto and just a few months before Titian's death. Its edges were apparently damaged and required major restoration fifty years later, but we can easily appreciate the aims and achievements of Titian's work. We see the ostensible subject of the picture, the battle, in the background, behind the armored king, and – especially vividly – the powerful yet defeated and mournful Turk crouching at his feet (see fig. 37). This was a famous and intimidating enemy, yet he has to sit in shame, half clothed (possibly to emphasize his barbarity), at the feet of his conqueror, with his weapons and turban scattered on the floor around him.

It is the second theme, however, that takes the painting out of the realm of simple self-congratulation. Philip holds his son up to a woman, usually identified as the angel Winged Victory, who flies downward holding a laurel wreath (symbol of victory) in one hand and with the other gives the baby a palm branch (symbol of peace). To the palm is attached a banner with the motto *maiora tibi* (you will do even better). Significantly, an early Spanish mention of the picture described

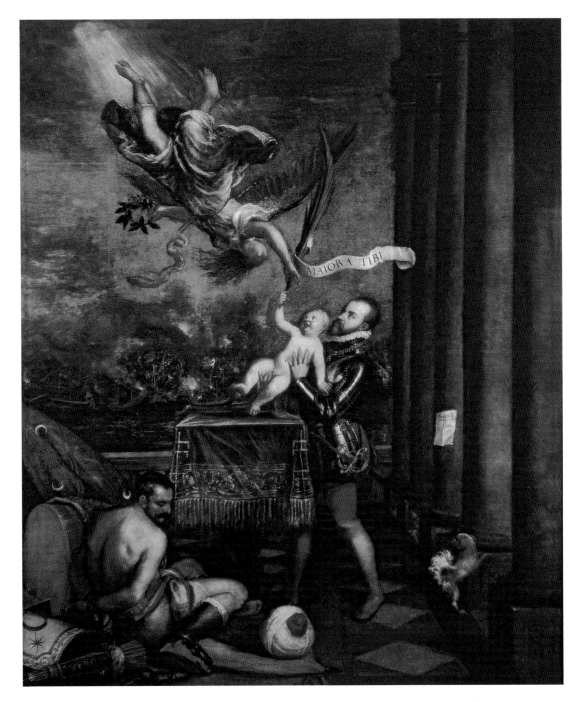

37 Titian, *Lepanto*. This large painting combines allegoric references to the mass and to the birth of Philip II's son with its evocation of the battle in the background. And yet, despite its serious themes, Titian could not resist adding a light touch: the little dog on the right.

the winged figure as an angel, though not Victory, and this clue led Erwin Panofsky to uncover the painting's much broader propagandist purpose.

As he pointed out, the gesture of a priest raising a nude baby heavenward over his altar was the standard means of illustrating the phrase from Psalm 24: 1 "Unto thee, O Lord, do I lift up my soul," in the liturgy for the first Sunday of Advent. That we are meant to be reminded of that phrase and of God's grace toward the innocent baby, symbol of the soul, is shown by the table over which Philip holds his son – it stands exactly where the altar appears in illustrations of the liturgical phrase. To emphasize the connection, the divine light of heaven, shining from above in Titian's painting, casts its grace on both the birth of the child and the destruction of the infidel. The Turk has thus been vanquished and cast down not merely by Spain but by God himself. In other words, success in religious war had earned the victors no ordinary glory; it had enabled Titian to align the very will of God with Philip, his military cause, his family, and his faith. No masterpiece in the long history of artistic images of war has ever exalted so many ambitions to such dazzling effect.

Artemisia Gentileschi's *Judith Slaying Holofernes*

As we enter the seventeenth century, the split in the approaches to war begins to widen. The decisive decade proved to be the 1630s, when the Thirty Years War was at its most ferocious. Nothing like its long-lasting relentless fury had been seen before, and for the next two and a half centuries, until World War I, it was regarded as the grimmest example of desolation and destruction in history. By the end of the 1630s the carnage and the pillaging, an almost constant presence in large areas of central Europe, had entered their third decade, and many observers despaired that they could ever be brought to an end. Seven years of negotiation in the Rhineland province of Westphalia did finally restore peace, but by then it was no longer unusual for questions to be raised about the nobler qualities of warfare.

Before that fateful decade, however, there were still artists – indifferent to or perhaps unaware of Brueghel's message – who could present warriors as ideals. One combatant in particular seemed to appeal strongly to the practitioners of the highly theatrical style of the Baroque that began to transform artistic representations around 1600. And one depiction produced in these years exhibits a level of personal feeling that makes it an exemplar, for this period, of the genre we have been following for two millennia.

To set the context for the painting, one must stress that only rarely does a work of art evoke its ostensible subject matter alone. Whether or not artists intend it – and often they do – portraits take on allegorical, psychological, or political

purposes; landscapes embody philosophical or religious principles; dramatic scenes tell hidden stories; inanimate objects such as dead birds, pieces of fruit, or buildings reflect elusive meanings; and even abstract sculptures or paintings become comments on form or on art itself. Nor is warfare, even when most vividly represented, free of symbolic reference. A general's portrait stands for his nation's destiny, a heroic deed for a larger struggle, an act of violence for human suffering or glory. There are few themes that the tumultuous details of war cannot represent, whether an episode be taken from one's own times, from history, or from legend. It was thus natural that artists, looking for incarnations of their larger purposes, should so often have sought out famous moments in battle and conflict from the past.

A favorite source in the West, for obvious reasons, has been the Bible. Second only to classical antiquity as a fertile subject for the art and literature on war is the heroism recounted in the Old Testament and Apocrypha, from Joshua and David to Samson and the Maccabees. And when, in this overwhelmingly male pantheon, a rare heroine appears, she easily becomes invested with heavy significance.

The two most noted female warrior figures of biblical times were both celebrated not for feats in battle (which were hardly likely), but for their bravery in killing an enemy general. Strictly speaking, neither was enlisted in an army, but their actions marked them as warriors nonetheless. The first episode appeared in the Book of Judges, which tells a story from the days of the prophetess Deborah. At that time a woman named Jael, whose tent was near the site of a battle between the Israelites and Canaanites, hammered "a nail of the tent" into the temple of a sleeping Canaanite commander, Sisera, and "so he died." Since Sisera was fleeing after having lost the battle, he hardly posed a threat, but Jael's courage inspired even Rembrandt to produce a potent drawing of the event.

More widely remembered – and certainly more clearly cast in the role of military savior – was a heroine to whom an entire book of the Apocrypha was dedicated: Judith. It is known to us only in the Septuagint, the Greek translation by a body of Jewish scribes, though most scholars agree that it was originally written in Hebrew. Of the various dates of composition that have been proposed, the most likely appears to be the second century BCE, because of its echoes of the failed assault on Judea in the 160s BCE by the Seleucid Empire, centered in Syria. Yet the work is obviously a fiction and can even be regarded as the first ever war novel. Among its sources may have been the story of Jael, Herodotus' *History*, and the most gruesome event of the Seleucid invasion when the head of the defeated general, Nicanor, was hung near the Temple in Jerusalem. But the Book of Judith transforms these materials, and others, into a tale of courage and triumph that has moved the devout and creative ever since.

The narrative takes place in the sixth century BCE, at the time of Nebuchadnezzar, notorious for his destruction of Jerusalem in 586. Though he was a Babylonian, the Book of Judith calls him king of the Assyrians, the most vicious of the empire-builders of the ancient world. And the aura of wickedness is intensified by giving him as his capital a city that in fact had been in ruins when he reigned, Nineveh, target of the prophet Jonah's mission of redemption. Furious at the Judeans and their neighbors for not joining him in a war, Nebuchadnezzar sent his finest general, Holofernes, and a huge army "to slay with the sword all the inhabitants of the land." As the army approached Jerusalem from the north, the people of Bethulia, a fictional fortified hill town, closed off (as did the Spartans at Thermopylae) a crucial pass into the Judean hills. Enraged, Holofernes brought his "very great multitude" to besiege Bethulia and cut off its water supply. After thirty-four days, the parched townsfolk wanted to surrender, but their leader, Ozias, pleaded for five more days to give the Lord a final chance to save them. It was at that point that Judith, a beautiful widow, entered the story.

She had heard the talk of surrender, and she came to Ozias to pour scorn, in fine prophetic invective, on these signs of weakness. He asked her to pray for rain, but she told him that she would leave town that night with her servant, and Bethulia would be saved within the prescribed five days. "But enquire ye not of mine act, for I will not declare it unto you, till the things be finished that I do." She prayed, changed from her widow's weeds into splendid jewelry and clothing, and headed for the Assyrian camp as Bethulia's elders "wondered at her beauty very greatly."

It did not take her long to persuade the smitten Assyrian soldiers that she had come to show Holofernes a path into Bethulia, and the general himself told her she was "both beautiful in thy countenance, and witty in thy words." He allowed her to have her own tent and go out to pray, but on the fourth night he told his men, as delicately as he could, that "it will be a shame for our person, if we shall let such a woman go, not having had her company." He called her to his tent and, "ravished with her," drank himself into a stupor. Whereupon Judith took his sword, "and she smote twice upon his neck with all her might, and she took away his head from him." Dropping the trophy into "her bag of meat," Judith's servant returned with her mistress to Bethulia.

The next morning, the townsfolk displayed the head on their battlements and ventured forth to do battle with the besiegers. Rushing to inform their general, the Assyrians discovered Holofernes "cast upon the floor dead, and his head was taken from him." Panic ensued, the army fled, and Bethulia, Jerusalem, and Judea were saved. Judith herself became "in her time honorable in all her country."

This vivid account of the weak, the pure, and the holy overcoming, in war, the mighty, the wicked, and the cruel would capture the imagination of Europe. The

book was repeatedly translated, and Western and Byzantine visual representations have survived from the eighth and ninth centuries. During the high Middle Ages, Judith appeared over the portal of Chartres cathedral, and since the Renaissance she has been a continual inspiration. Her literary admirers stretch from Hans Sachs, the Meistersinger, in the sixteenth century, to the English novelist Arnold Bennett and the French playwright Jean Giraudoux in the twentieth; in music from Vivaldi and Mozart to Honegger. She has stood in for Florence in that city's struggles with Milan, for Maria Theresa in her wars with Frederick the Great. But the richest use of her story has been in the visual arts, where she has inspired a Who's Who of sculptors and painters, from Donatello and Botticelli, via Michelangelo and Rubens, to the contemporary American Leonard Baskin.

Of the many who took up the theme, none returned to it so often or so chillingly as Artemisia Gentileschi. Born in 1593 to a successful Roman painter, Artemisia grew up amidst artists, notably Caravaggio, a friend of her father who was a pioneer of baroque theatricality, and who brought an unprecedented and disturbing sense of immediacy and drama to his own depiction of Judith. Artemisia studied with her father, Orazio (because formal apprenticeship was forbidden to a woman), and later forged a highly successful career as a female court painter in Florence, London, and Naples. More than two-thirds of her works were portrayals of women from myth or the Bible. But no subject drew her so insistently as did Judith, whom she painted with a frequency probably unique in art history: five times within fifteen years.

There was a level of meaning for Artemisia in this subject that the vast majority of its delineators could not share. At the age of seventeen she had completed her first known painting, *Susannah and the Elders*, and was alone, hard at work, when one of her father's artist friends stopped by. Calling out, "Not so much painting, not so much painting," he forced her into a bedroom and raped her. Whether lust alone, or anger at female intrusion into his profession, was at work we cannot know, but the rapist, sued by Artemisia's father, did have to serve eight months in prison. Artemisia was then able to put her life back together, marry and have children, and embark on her distinguished career.

The paintings of Judith date from the years following the court case. Their intensity and their blood-soaked viciousness suggest not so much the nature of war itself as the unswerving hatred that drives individuals when they are consumed by its violence (see fig. 38). Those who succumb to the sword, whether victim or victor, remain forever under its relentless sway. The watchfulness and determination of Judith and her servant, and the sickening death inflicted on Holofernes, expose aspects of human nature that become visible only under the

38 Artemisia Gentileschi, *Judith Slaying Holofernes.* This is the most famous of Artemisia's five paintings of the story of Judith. It shows the central moment when her heroine, helped by a maid, decapitates the Assyrian general Holofernes. In graphic and dramatic fashion, Artemisia demonstrates the power of violence.

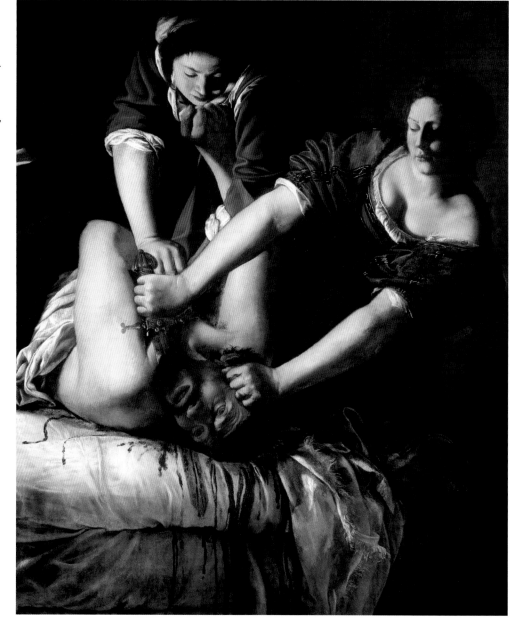

pressure of brutal conflict (see fig. 39). But there is no question that Judith is a heroic figure, striking a decisive blow for her people. That Artemisia could convey that understanding, fraught as it was with her own experiences, testifies to the power inherent in the image of the warrior.

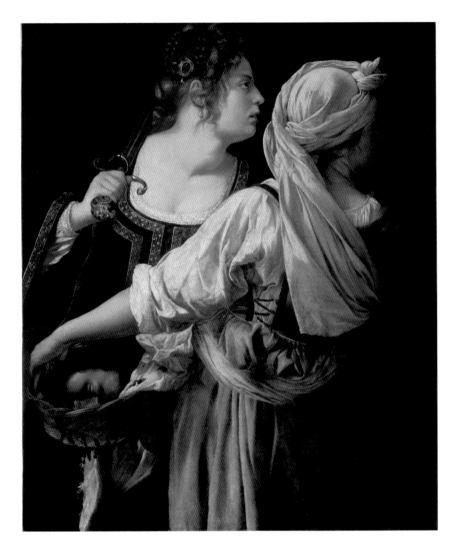

39 Artemisia Gentileschi, *Judith and Maidservant*. In this painting, Artemisia changes the scene to show the aftermath of the decapitation of Holofernes. The severed head is now in a basket, the sword has done its work, and Judith and her maid look ahead as they prepare to escape from the Assyrians' camp.

Jacques Callot

When we come to the decisive decade of the 1630s, the rise of the new, critical approach to warfare becomes indisputable. Three artists, in particular, broke with tradition in ways that ensured the bifurcation we have described would persist. For these were not mordant outsiders like Brueghel, who, notwithstanding his wealthy patrons and his later appeal to a monarch like the emperor Rudolf II, never moved in court circles or occupied a privileged position in society. All three attracted princely patronage, attained high status, and enjoyed close connections with the very leaders of government who were responsible for the wars of the time. When insiders of this caliber presented war in less than favorable terms,

they heralded the end of the unquestioned, centuries-long association in the arts of combat with nobility.

The first blow was struck by a Frenchman, Jacques Callot, who may be the least well known of the three, but was famous in his own time as the leading engraver of the age. The son of a wealthy, and possibly aristocratic, family, and a native of the border province of Lorraine – which meant that he probably witnessed the Thirty Years War at first hand – Callot worked at the Medici court in Florence, and then, back in France, became known for his mastery of martial scenes. He depicted a French victory at the battle of Avigliana in Savoy; he produced documentary etchings of cavalry combats and military exercises; and he executed commissions for vast panoramas of two well-known sieges. For the Spanish capture of the Dutch city of Breda in 1625, seen in a bird's-eye view, Callot in 1628 and 1629 created six huge engravings, each over 2 feet long and more than a foot and a half wide, which fitted together to present a panoramic record of the victory. Two years later, he produced a similar set of six engravings, of the same size, to celebrate France's successful defense of the city of La Rochelle from an English siege in 1628. Callot thus seemed firmly categorized as a kind of official recorder of military achievement.

The scale may have been larger, and the quest for accuracy more persuasive, but this kind of enterprise was by no means new, for the documentary style of representation of military events had a long history. Many manuscript illuminators during the Middle Ages, for instance, had taken specific battle scenes as their subjects. The pictures had given only the vaguest idea of what warfare actually looked like, but they sustained a practice (parallel to the celebrations of valor) that one might call the reportage of war. The most famous example from the early sixteenth century was Albrecht Altdorfer's *Battle of Alexander at Issus*, an enormous vista in which the victorious commander is barely visible, and which perfectly exemplified the tradition of treating armed conflict as an opportunity for a colorful panorama rather than a moral lesson. This relatively dispassionate and neutral vision of warfare gathered increasing numbers of adherents in the sixteenth century, and their work created the context out of which not only Callot but also a quite specific genre of painting, "the battle without a hero," were to develop. Though casualties, gore, and brutality appeared in these pictures, they were included more to suggest what war looked like than to comment on it.

If these works of art receive only passing mention here, it is because their focus remained largely descriptive and, as a result, one is hard put to find a masterpiece among them. Nevertheless, it is important to acknowledge the role the "documentary" artists of the sixteenth century played in making scenes of warfare familiar to those who never ventured near a battlefield. One of the most talented was the

Swiss Urs Graf, himself a soldier, who portrayed military men both as types and in action, showing corpses, hanged men, and dead horses as well as the general melees that he himself must have witnessed. Yet he was but one of a number of Swiss artists who, in the first quarter of the sixteenth century, took war as their subject. A fellow soldier, Nikolaus Manuel Deutsch, and a chronicler who illustrated his own texts, Diebold Schilling the Younger, were both skillful recorders of the military world, though neither can be regarded as a particularly compelling artist. The same is true of the Flemish engraver Frans Hogenberg, who was famous for his prints of Europe's cities but who also produced detailed bird's-eye views of battles and sieges. His younger contemporary, the Dutchman Jacques de Gheyn, though clearly more accomplished and wide-ranging as an artist, made his principal contribution to this enterprise not with scenes of battle, but with meticulous illustrations of the various individual types in an army. His musketeers, pikemen, and standard-bearers constitute a priceless record of the soldiery of the time – but again, this is more documentation than art.

In France the mantle was picked up primarily by the Huguenots, the Protestant minority that won a degree of toleration after thirty years of bitter civil and religious wars. Yet even though their pictures were intended to stir the conscience of their persecutors, the documentary nature of their work places it firmly within the tradition of reportage. It is true that a painting of the *St Bartholomew's Day Massacre* by François Dubois offers a Brueghel-like emphasis on the cruelty and viciousness of the assault, but this is not a scene of war. Moreover, the fame of the picture rests on its subject matter, not its artistic excellence. More relevant to our theme are the engravings of Jacques Tortorel and Jean Perrissin, whose depictions of the battles of the French religious wars are much closer to the Hogenberg model than to Dubois. The most comprehensive historian of their work, and of the tradition to which they belonged, Philip Benedict, has called their pictures "moderately partisan," but that is largely because of the executions and massacres they also record. The battles and sieges, on the other hand, appear essentially as records of events: detailed, impartial, and if not major works of art, certainly well-executed examples of an ever-growing genre which Callot was to bring to new heights. That is indeed the role he seemed to be filling as he produced his vast illustrations of the sieges of Breda and La Rochelle (see figs. 40 and 41).

It must have come as something of a shock to his patrons, therefore, when, in 1633, he published – as his last major work – a collection of seventeen etchings entitled *The Miseries of War* (see figs. 42–4). In case the message might be lost, Callot added captions that left no doubt about his purposes. The description of *Plundering a Large Farmhouse* (see fig. 43), for example, reads:

40 Jacques Callot, *Siege of Breda*. One of Callot's specialties was the enormous panorama. Fitting together six large engravings, he created this record of one of the most famous sieges of the Thirty Years War, when the Spanish commander Spinola captured the Dutch city of Breda.

41 Jacques Callot, *Siege of La Rochelle*. Although he had no vantage point from which to see this aerial view of the French king's siege of the Huguenot stronghold of La Rochelle, Callot certainly examined the site. Combining imagination and realism, he was able to produce a documentary record of an important military event.

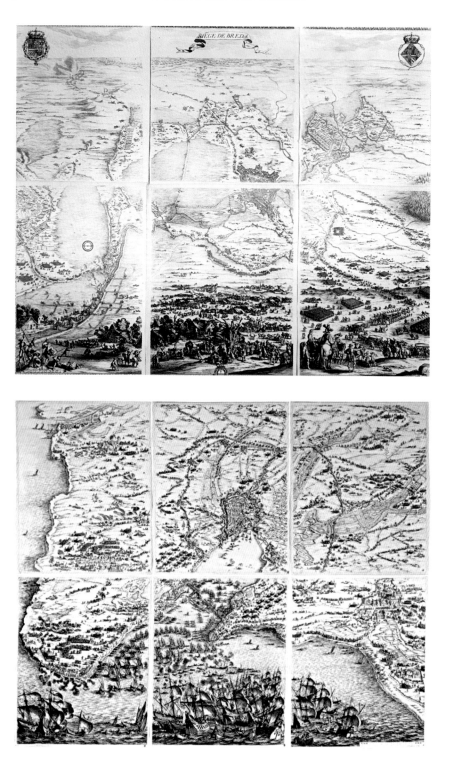

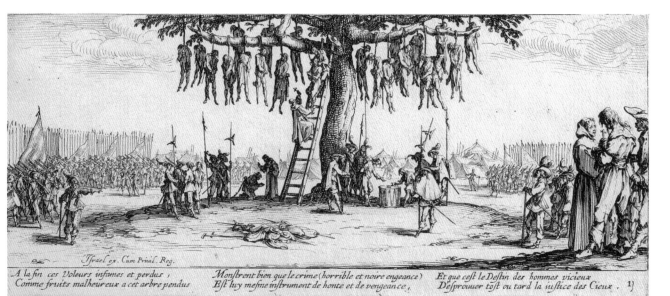

A la fin ces Voleurs infames et perdus,
Comme fruits malheureux a cet arbre pendus

Monstrent bien que le crime (horrible et noire engeance)
Est luy mesme instrument de honte et de vengeance,

Et que c'est le Destin des hommes vicieux
Desprouuer tost ou tard la iustice des Cieux. 1)

42 Jacques Callot, *Miseries of War: The Hanging.* The most famous engraving in Callot's *Miseries* shows a mass punishment for looters, but emphasizes, in the abandoned crutches, the irony that these, too, are victims of war. The lances in the background are a recurring element in the series.

43 Jacques Callot, *Miseries of War: Plundering a Farmhouse.* There are no holds barred in Callot's depiction of warfare's day-to-day agonies. Once set loose on ordinary civilians, soldiers terrorize their victims. Here they loot a chest of valuables, hang a man upside down and burn him, and kill at will, even the bedridden.

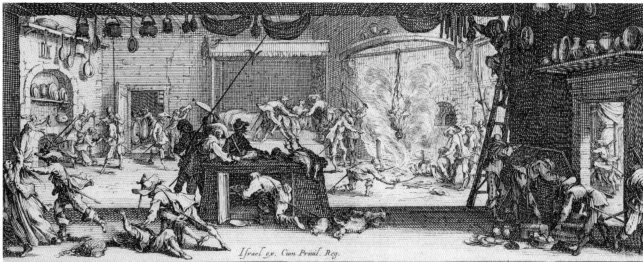

Voyla les beaux exploits de ces cœurs inhumains
Ils rauagent par tout rien nechappe a leur mains

L'vn pour auoir de l'or, inuente des supplices,
L'autre à mil forfaicts anime ses complices;

Et tous d'vn mesme accord commettent méchamment
Le vol, le rapt, le meurtre, et le violement. 5

Here are the fine exploits of these inhuman hearts. They range everywhere. Nothing escapes their hands. One invents tortures to gain gold, another encourages his accomplices to perform a thousand heinous crimes, and all with one accord variously commit, theft, kidnapping, murder and rape.

Another scene, *Plundering and Burning a Village* (see fig. 44), has the label:

Those whom Mars supports with his evil deeds, serve in this manner the poor country people. They take them prisoner, burn their villages and even wreak havoc on their livestock. Neither fear of the Commandments, nor sense of duty, nor tears and cries can move them.

Even the ancient god of war does not escape censure. The indictment of the military is unsparing and complete.

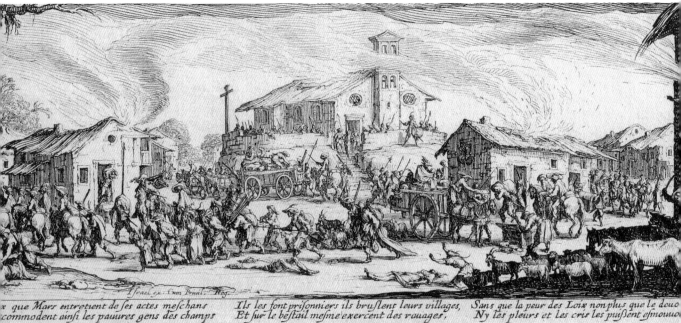

x que Mars entretient de ſes actes meſchans *Ils les font priſonniers ils bruſlent leurs villages,* *Sans que la peur des Loix non plus que le deuo*
commodent ainſi les pauures gens des champs *Et ſur le beſtail meſme exercent des rauages,* *Ny les pleurs et les cris les puſſent eſmouuo*

44 Jacques Callot, *Miseries of War: Plundering a Village*. The soldiers have arrived, and already flames are pouring out of the cottages. Men are carrying sacks of goods they have stolen, while the dead lie on the ground. Soon nothing of value will remain. Devoid of mercy, the troops spread death and destruction wherever they go.

Diego Velázquez, *The Surrender of Breda*

Two years later, one of the encounters that Callot had recorded, the capture of Breda, became the subject of a questioning of the heroism of war that was much subtler than *The Miseries of War*, but in other respects seems more significant, since it was put forward by a figure far closer to the heart of the military enterprises of the 1630s: Diego Velázquez, the chief painter at the court of Philip IV of Spain. The Spaniards were still regarded as the leading military power of the age, and their troops had now been regularly in combat, with just a few intervals, for well over a century. In the 1630s they were deeply embroiled in the Thirty Years War, and it was at this point that Velázquez was asked to celebrate one of their most notable victories. The result, however, was not what one might have expected just a few decades before.

Essential to Spanish success over the years had been a stream of superb military leaders. The duke of Medina Sidonia, commander of the ill-fated Armada in 1588, had been an exception. But the victor of Breda, Ambrogio Spinola, was one of the finest generals who ever served Spain. Born in 1571 to a great banking family of Genoa, he had decided on a military career, and soon displayed both tactical and strategic brilliance, notably in the Spanish struggle against the revolt of the Netherlands, where he had made his mark by taking the port of Ostend in 1604. When Spain entered the Thirty Years War in 1620, he occupied the Rhine Palatinate, and he seized the city of Jülich in 1622; but it was his capture of Breda in June 1625, following the expiration of a twelve-year truce with the Dutch in 1621, that was widely seen as one of the classic sieges of the age. It took nearly ten months, and included an extraordinary response by Spinola when the Dutch dammed the river Mark in order to flood the area and relieve Breda by water: he diverted the waters right back to the city. The fame of the engineering works attracted visitors from throughout Europe.

Three years later, however, despairing of the possibility of Spain's winning a war it was now fighting on many fronts, Spinola traveled to Madrid to argue for peace before the Council of State. That same year, 1628, the Spaniards suffered a calamity that in the long run may have been the decisive setback to their hopes. After decades of trying, a Dutch fleet finally managed to seize the greatest prize afloat: a Spanish treasure fleet carrying home silver from the New World. It was a devastating blow not only to the finances of the king, Philip IV, but also, by extension, to his military capacity. "Whenever I speak of the disaster," he later said, "the blood runs cold in my veins." Nevertheless, Spinola's advice was rejected, and two years later the great general was dead. Spain was now under ever intensifying pressure, and her last truly able commander was gone.

Because of his arguments for peace, Spinola became the symbol of an anti-war sentiment that had to remain muted and low-key in this absolutist age. Yet it was as that symbol that he was to appear in Velázquez's painting of the siege of Breda, which the king commissioned in 1634. Velázquez had been born in 1599 to a respectable Seville family and apprenticed to the master of a well-known painting academy, Francisco Pacheco. Astutely, Diego married Pacheco's daughter and then, in his early twenties, used his Seville connections to seek patronage at the royal court. Philip's chief minister, the Count-Duke of Olivares, had extensive lands near Seville, knew the city well, and was delighted to advance someone he could regard as his protégé. He was also a man of refined taste who recognized the young artist's talent. Olivares arranged for Velázquez to paint a portrait of Philip IV, which he did in a single day, and the result was so universally admired that henceforth Velázquez alone was allowed to portray the king. Ten years later, Olivares was in charge of building and decorating a new palace in Madrid, the Buen Retiro (Happy Retreat), and he naturally turned to Velázquez to produce one of the major works that were to adorn its walls.

The painting was to hang in the central room of the Buen Retiro. This Hall of Realms was designed as the principal setting for official functions: here the king received ambassadors and important ceremonies were held. To enhance these events, the hall was decorated with works that paid homage to the glory of the Habsburg royal dynasty, its power, its rule over far-flung territories, and its renowned military achievements. The latter occupied the dominant place in the decorative scheme: twelve scenes of heroic victory, including Spinola's capture of Jülich and five great successes from the particularly good year of 1625 at Genoa, Cádiz, Puerto Rico, Bahia, and Breda.

The most famous of these triumphal paintings is Velázquez's masterly evocation of human emotion and individuality within a scene of epic grandeur (see fig. 45). In Spain the picture is popularly known as *Las Lanzas* (The Lances), a reference to the disciplined Spanish lances, in contrast to the drooping spears of the Dutch. But even that detail hints at its anti-war theme, because the most familiar pictures of arrayed lances at the time – and possibly a model for Velázquez – were in Jacques Callot's *Miseries of War* series, where seven out of the seventeen engravings feature lances in disciplined formation.

Could doubts about the endless war – which would continue for another thirteen years – have infected even this salute to one of its triumphs? Apparently they did, as a closer look at the painting reveals.

The scene shows the Dutch commander, Justin of Nassau, the illegitimate son of William the Silent and thus a member of the leading family of the Netherlands, handing over to the Spanish general, Spinola, the key to the city of Breda. Breda itself is in the background, its fortifications and waterworks visible through the

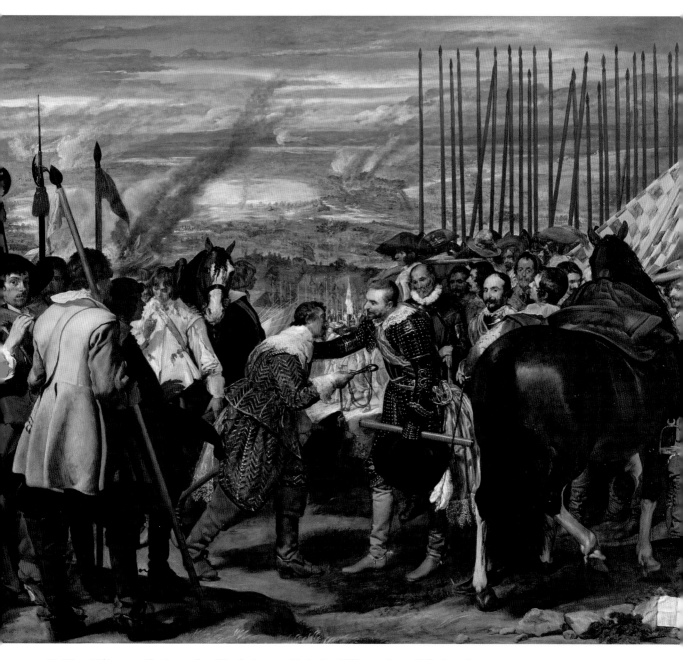

45 Diego Velázquez, *The Surrender of Breda*. It seems likely that Velázquez knew Callot's work, because this vast aerial view of Breda is similar to the Frenchman's vista. And the lances recall Callot's *Miseries*. But the central scene offers a level of psychological insight into the combatants that is unique to Velázquez.

smoke of the fighting that has decided its fate. Velázquez has chosen the dramatic moment of actual surrender, when the key of the city is transferred to its new ruler, to mark the occasion. The struggle is over, and its consequences are now clear to all the participants.

But what feelings do they convey? The Dutch, shabby and disconsolate under their orange-and-blue flag, reflect the despair of defeat. Yet there is little sign of corresponding joy on the Spanish side, where not a smile is to be seen. And the central gesture of the painting, to which one's eyes inexorably are drawn, seems almost out of place in a celebration of military victory. Rather than relishing his triumph, Spinola leans over and comforts Justin in a gesture well known to represent magnanimity. His action seems to mute the satisfaction the victors must have felt. Instead of drawing a sharp contrast between winners and losers, Velázquez has created an atmosphere of gentleness and reconciliation.

There was no historical justification for this treatment. As the victor, Spinola undoubtedly remained on his horse to accept the surrender. That is how he appears in another painting in the Hall of Realms, Jusepe Leonardo's *Surrender of Jülich*. But it was well known that Spinola had offered generous terms in 1625. The garrison of 3,500 troops was allowed to depart from Breda unharmed, with banners flying, and the city's inhabitants were left unmolested. Combining the general's reputation for clemency with his later advocacy of peace, Velázquez has made him into an embodiment of solace and generosity amidst the sufferings of war.

By the time the painting was completed, ten years after the surrender, conditions were sufficiently changed to give force to this interpretation. Spain's financial situation had deteriorated, and there had been few further victories. In Germany, Gustavus Adolphus of Sweden had put an end to Austrian Habsburg advances; in Italy, the Spaniards had sustained a series of reverses; and the French had joined their enemies. The Dutch had continued to struggle for their independence, and Spain had remained unable to put an end to their revolt. When Velázquez completed his painting, the capture of Breda had lost its significance. In a final irony, the city was to be recaptured by the Dutch only two years later, in 1637, this time for good.

The change in Spain's mood in the mid-1630s was almost tangible. Celebrations of stirring events became a thing of the past, and Velázquez turned his attention to depictions of the internal life of the court that were to reach their climax, twenty years later, in another masterpiece, *Las Meninas*. In the interim, his only painting connected with military affairs was an extraordinary portrayal of the god of war, Mars, as a sad, weary, and humbled figure (see fig. 46). It was further testimony to the disillusion that may have been a crucial element in the alchemy that transformed what was billed as a celebration of battle into an indirect, but unambiguous, statement of the view that compassion was a finer human quality in war than those traditional virtues, valor and heroism.

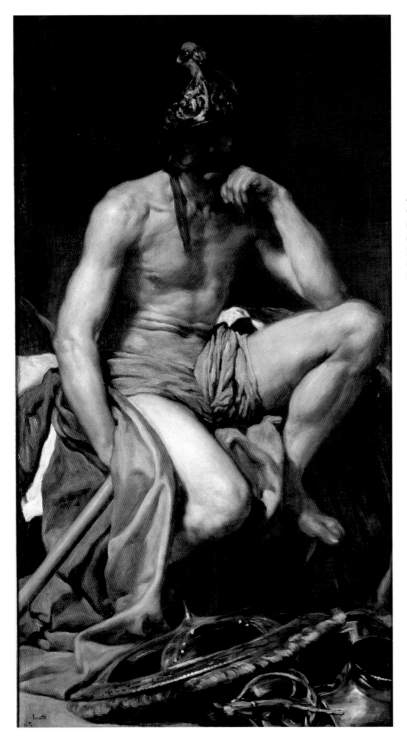

46 Diego Velázquez, *Mars*. Disconsolate, and with his weapons discarded, the god of war scarcely resembles the embodiment of valor and martial fury that he is supposed to personify. He may be weary after being surprised with Venus, but the disillusion seems also to extend to his role as a warrior.

Peter Paul Rubens, *The Horrors of War*

The argument could be made that our final example from the 1630s was the most explicit denunciation of warfare of the three. It certainly came from the most famous artist, and the most powerful celebrator of the martial spirit, of the age: Peter Paul Rubens.

Rubens was raised in Antwerp, and spent much of his twenties, in the early 1600s, in Italy. By the time he returned to Antwerp he was already well known in court circles both in Italy and in Spain, and in 1609 he was appointed court painter to the rulers of the Low Countries. Over the next twenty-five years he became recognized as the premier artist of his time. Even as he was painting kings and queens and their families and advisers, though, he also served in diplomatic missions for the rulers of the Low Countries and other Habsburgs who were their relatives. It has been suggested that it was his experience in diplomacy that inclined Rubens, after many canvases that glorified wars and their protagonists, toward advocacy of peace. For King Charles I of England, for example, who managed to avoid most of the fighting of the time, he painted *Allegory of Peace and War* in 1629 or 1630 (see fig. 47). This

47 Peter Paul Rubens, *Peace and War*. Bathed in light, the tranquil scene that dominates this painting emphasizes Rubens' advocacy of peace. England's king, who commissioned it, had stayed out of the Thirty Years War, and Rubens underlines the message by portraying a friend's children as recipients of the fruits of peace.

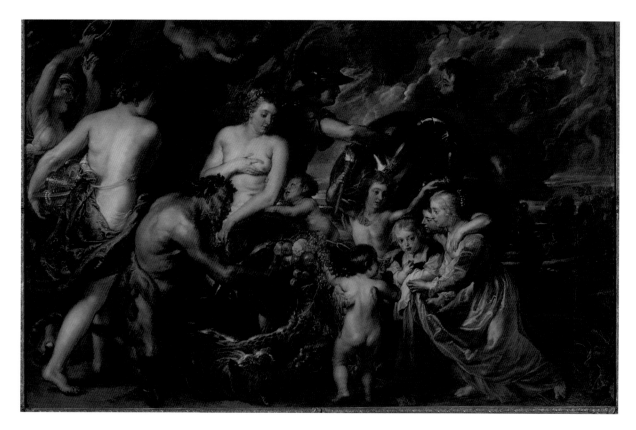

certainly showed peace in a favorable light, glowing with fecundity and embracing children as well as a benevolent satyr. The basic presentation, however, is an elaboration of a story about the ancient gods that the Venetian artist Tintoretto had painted a few years earlier; in that story Minerva, the goddess of wisdom, symbolically pushes Mars, the god of war, away from Pax, the goddess of peace. The effect of the painting, therefore, is as an allegory, not a work of passion. The moral was clear, as it was in a series of decorations promoting peace that Rubens designed for the entry into Antwerp of a new ruler in 1635. But neither the allegory nor the highly sophisticated decorations, full of obscure classical references, constituted anti-war statements to compare with Brueghel's. For that one has to wait until 1638 and a painting that Rubens described at length, emphasizing that, as had been true of Callot, it was the viciousness and destruction he had witnessed that were primarily responsible for his new-found anguish and dismay (see fig. 48).

 The painting in question was commissioned by the Grand Duke of Tuscany, Ferdinando de' Medici, through his court painter, Justus Sustermans. The two artists knew one another, because both came from Antwerp, and Rubens had high regard for Sustermans's command of symbolism and meaning. Nevertheless, to make quite sure that his intentions were understood, Rubens sent Sustermans a

48 Peter Paul Rubens, *Horrors of War*. In a letter to a friend, Rubens explained in detail how this painting made the case for its title. Every inch of the large canvas is dedicated to the aim of demonstrating the devastating effects of war on a civilized society.

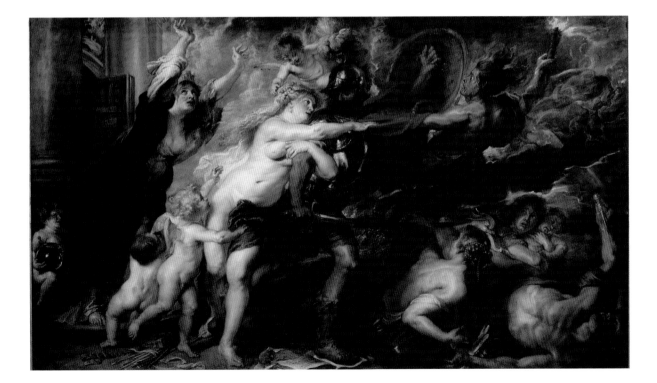

letter explaining the content of his work. We know that one of his models had been a mythological painting of Mars and Venus by the Italian artist Giulio Romano in Mantua, where Rubens had spent a number of years. But unlike the *Allegory of Peace and War*, this was not just an expansion and elaboration of a mythological composition by an Italian predecessor. It had an urgent and programmatic purpose, prompted by the atrocities of the age, as he explained in the letter to Sustermans. Its central paragraph deserves to be quoted in full, as the elaboration of a view of war that was to win ever more disciples in the years that followed:

> The principal figure is Mars, who has left the open temple of Janus [which, in time of peace, according to Roman custom, remained closed] and rushes forth with shield and blood-stained sword, threatening the people with great disaster. He pays little heed to Venus, his mistress, who, accompanied by her Amors and Cupids, strives with caresses and embraces to hold him. From the other side Mars is dragged forward by the Fury Alekto, with torch in her hand. Nearby are monsters personifying Pestilence and Famine, those inseparable partners of War. There is also a mother with her child in her arms, indicating that fecundity, procreation, and charity are thwarted by War, which corrupts and destroys everything. In addition, one sees an architect thrown on his back with his instruments in his hand, to show that that which in time of peace is constructed for the use and ornamentation of the City, is hurled to the ground by the force of arms and falls to ruin. I believe, if I remember rightly, that you will find on the ground under the feet of Mars a book as well as a drawing on paper, to imply that he treads underfoot all the arts and letters. There ought also to be a bundle of darts or arrows, with the band which held them together undone; these when bound form the symbol of Concord. Beside them is the caduceus and an olive-branch, attribute of Peace; these also are cast aside. That grief-stricken woman clothed in black, with torn veil, robbed of all her jewels and other ornaments, is the unfortunate Europe who, for so many years now, has suffered plunder, outrage, and misery, which are so injurious to everyone that it is unnecessary to go into detail. Europe's attribute is the globe, borne by a small angel or genius, and surmounted by the cross, to symbolize the Christian world.

It is hard to imagine a more poignant or comprehensive account of the transformation in the traditional image of warfare.

"The Battle without a Hero"

Two other subjects that were favorites of seventeenth-century artists reflected the bifurcation that allowed alternatives to the standard equation of glory and warfare. One was a genre in painting, known as "the battle without a hero," whose origins

we also noted in the background to Callot. The other was a shift in portraiture that heralded an end to the long-standing assumption that a man was at his most noble when most valorous.

"The battle without a hero" emerged out of a tradition of documentary-style reportage, which now took the form of scenes of combat for their own sake, without any pretense that they might represent specific battles. This development was also, however, the result of a growing interest among artists in creating a recognizable and realistic everyday world.

In that world, there was no escaping the presence of military combat, driven by the soaring numbers of soldiers and the sustained violence of the Thirty Years War. But what made that reality so interesting as subject matter was an unprecedented fascination with the mundane and with material things. The seventeenth century was when still lifes – foods of various kinds, objects on a tabletop, flowers, and similar everyday objects – became popular. It was also when simple scenes of daily life – the tavern, the road full of travelers, skaters on a frozen pond, a city street, or a herdsman with his cows – found a growing clientele. Even a major figure like Caravaggio, famous for his powerful biblical scenes, enjoyed painting card sharps, musicians, fops, or a saint with dirty feet. Given this trend, it was no wonder that painters should have begun to explore in greater depth than ever before the soldier's daily existence, thus bringing to new prominence, if not to the highest levels of artistic distinction, the documentary tradition in depictions of the warrior. What we find are neither heroes nor villains, but rather a neutral presentation, shorn of both praise and condemnation.

The Dutch, the richest people per capita in this period, and the most taken by the material realities of their lives, led the way in this new genre. There were antecedents among German artists of the sixteenth century, but these were nearly always drawings (probably intended for personal use) rather than finished paintings. With the Dutch the subject matter came into full flower. Since theirs was the largest art market of the age – it has been estimated that a million pictures were sold in the Netherlands in a decade – they could support specialists of all kinds, and the life of the soldier and the battle without heroes could flourish. Guardhouse scenes; troops in camp or asleep; detachments on the march; or soldiers in civilian settings, reading a letter or talking to a young woman; all these can be found in Dutch art (see fig. 49). Implications of valor or brutality were gone: these were men no different from their civilian neighbors. Even when one moves to the battlefield, the grandeur remains absent. The best-known of the Dutch painters of combat, Philips Wouwermans, wonderfully evoked the smoke and the chaos of a cavalry sortie, for example, but there was not a hint of glamor associated with the event or its participants (see fig. 50). These are anonymous warriors, simply going about their business, as would a peddler or a blacksmith.

49 Jacob Duck, *Soldiers and Women*. The tools of their trade cast aside, these Dutch soldiers are simply part of an everyday scene. Like young men anywhere, they relax over a pipe and a drink in the company of young ladies. The distinction between the warrior and the rest of society has dissolved.

50 Philips Wouwermans, *Cavalry Sortie*. For centuries, paintings of battle scenes focused attention on the principal warriors. Wouwermans, however, allows no individuals to stand out. He is a prolific recorder of the smoke, the surging bodies, and the upheaval of military conflict, but this is war without heroes.

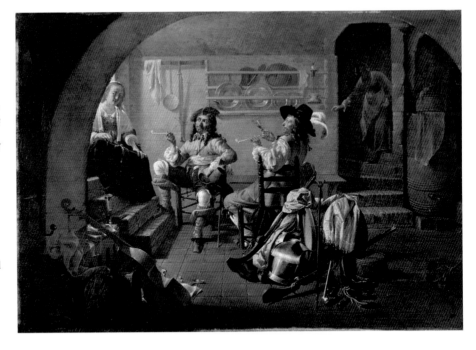

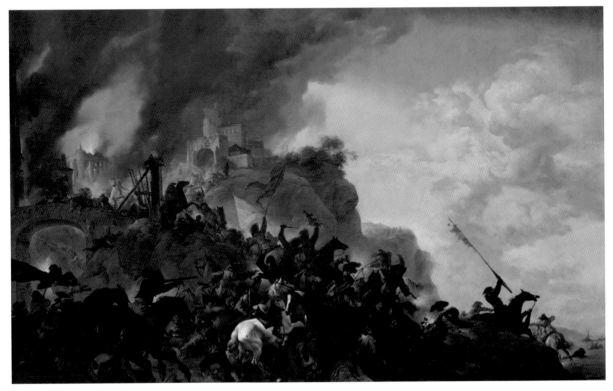

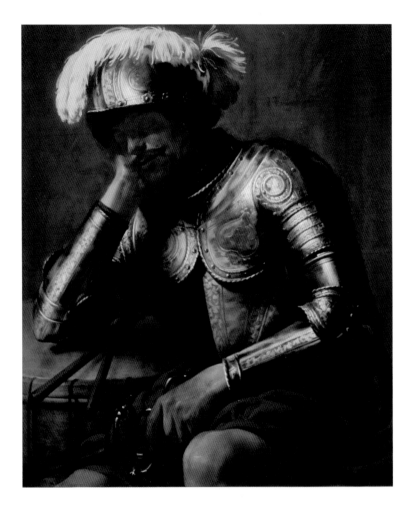

51 Hendrick Terbrugghen, *Sleeping Mars*. The subject of Mars fast asleep attracted a number of artists in the seventeenth century. He was portrayed as a soldier, and his somnolence suggested the quieting down of conflict. For the Dutchman Terbrugghen, this was a natural hope in a country fighting an eighty-year war.

Only one of these themes slid over into an anti-war statement: pictures of a sleeping soldier which were intended as portraits of a quiescent Mars (see fig. 51). It was a subject taken up in both engraving and paint, and one can surmise that even when the god was not identified the recumbent figure of a soldier might have been thought of as an indirect yearning for peace. The caption to an engraving by Jacques de Gheyn, produced in the early years of the Thirty Years War, makes the point unmistakably: "Mars rests after crowning himself with glory; may he rest more gloriously from now on for the good of the people." These works may not have been masterpieces, but their subject matter indicates how thoroughly artists of the seventeenth century had undermined the traditional identification of the warrior with valor. And in their link to a painting we have already mentioned, the portrait of Mars by Velázquez, these representations also suggest that, at the very

highest levels of society, the image of war had lost the elevated status it had enjoyed for millennia.

Portraiture

There was one other artistic enterprise that changed as a result of the devaluation of the traditional equation of valor and virtue: the portrait. As we saw earlier, it was already a commonplace in antiquity for leaders of society to have themselves shown in the figure of the warrior. Augustus in armor and Marcus Aurelius on horseback were the models, and although in the Middle Ages individual portraits gave way to representations of religious scenes, the genre came roaring back during the Renaissance, abetted by a renewed emphasis on the qualities that made for personal nobility and what Machiavelli called *virtù* (a kind of life force, embracing prowess, adaptability and determination). As in ancient times, so during the Renaissance the highest respect was accorded to bravery and leadership. Piety was certainly admired, but it was not what set the upper levels of society apart. For them the ideal was the dashing warrior, whose finer qualities were summed up by a word that Castiglione made famous in his *Book of the Courtier*: *sprezzatura*, the ability to do everything well and to make it seem easy.

The consequences were immediately apparent. The Marcus Aurelius model, in particular, emulated by Donatello and Verrocchio in sculpture and by Uccello in paint, became a standard means of displaying a great man at his most admirable. Thus, although Titian painted the emperor Charles V a number of times, when he had to show him at his most glorious he produced a huge canvas of his subject, on horseback, as the epitome of knighthood at the battle of Mühlberg (see fig. 52). And the list of participants in this tradition includes monarchs – even Queen Christina of Sweden appeared on a rearing horse, sitting side-saddle (see fig. 53) – as well as the aristocrats who surrounded them. The Count-Duke of Olivares, the chief minister of Philip IV of Spain, never went near a battlefield, but it was on a rearing horse, with a battle in the background, that he was shown by Velázquez. Even as a little boy the son of Spain's king Philip IV, Prince Baltasar Carlos, had to be painted in this pose, the commander's baton in his hand (see fig. 54). This was a mode of representation that was to continue for centuries, but by the end of the seventeenth century it had lost its force as the embodiment of nobility and virtue. In a bifurcation that echoed the split in the view of war, a new means had arisen to suggest royal or aristocratic magnificence.

It is true that many a prince's portrait had shown just a head, a bust, or a figure standing or seated in a chair. They may have worn fine clothes, but unless

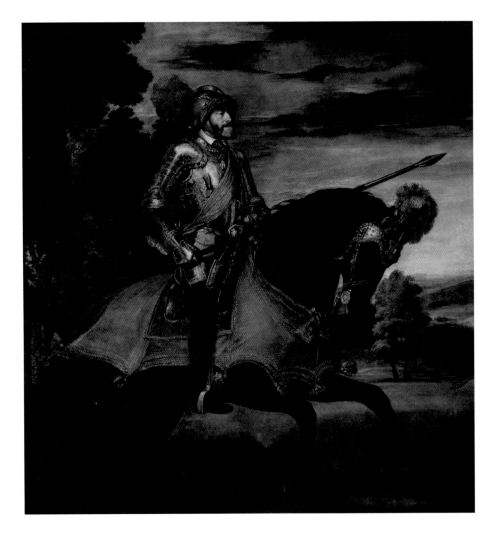

52 Titian, *Charles V*. Titian's large-scale portrait set a pattern in painting that Donatello and Verrocchio had established in sculpture. The emperor is shown in command, a knight on a resplendent horse. His heroism is self-evident, even though the battle he has just won is nowhere to be seen.

they were accompanied by symbolic appurtenances like a suit of armor, a sword or a crown, they did not obviously exude the aura of superiority that was immediately apparent in equestrian portraits. The latter were so appealing to the likes of Olivares because they made their point without any need for a detailed understanding of iconography. As that genre lost its élan, however, artists began to set their subjects apart by emphasizing the elegance and splendor of their persons, their garments, and their surroundings.

A decisive figure in this development was Rubens's student Anthony van Dyck. He did paint Charles I of England on horseback, but his most celebrated portrait showed the king as a splendid and lordly figure at a hunt, dismounted (the horse

53 Sébastien Bourdon, *Queen Christina*. So potent was the image of the great leader on horseback that it was adapted for queens. Since Christina of Sweden could not join a battle, her court painter, Bourdon, put her on a rearing horse going hunting, with a falcon and dogs behind her.

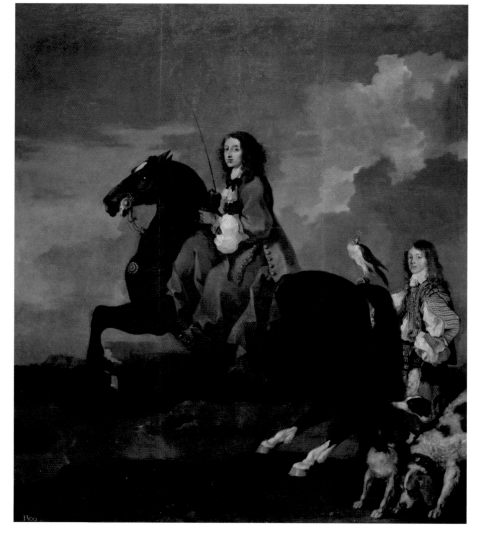

in the background) but no less grand for that (see figs. 55 and 56). And even though the king's cousins, John and Bernard Stuart, were to die in battle, their pose for Van Dyck was not as warriors, but rather as aristocrats of sumptuous appearance, cynosures of taste and grace, disdainful of those who did not measure up to their elevated status. The classic instance of this new form came seventy years later, when Hyacinthe Rigaud painted the most famous of the many portraits of France's Louis XIV. Although he was the main promoter of warfare of his age, the king appeared in a pose that echoed Van Dyck's *Charles I at the Hunt*, even down to the position of the legs, but now dressed in a robe and placed in a

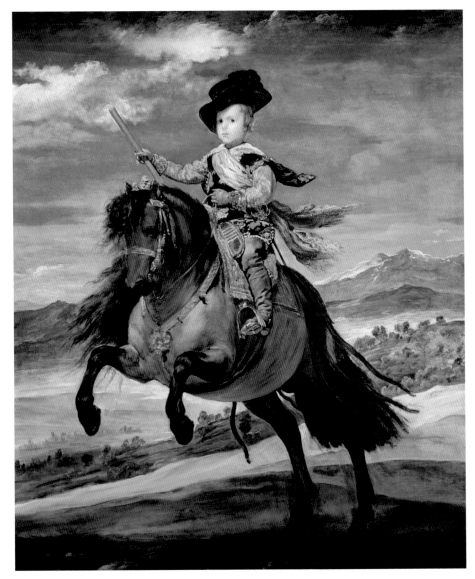

54 Diego Velázquez, *Baltasar Carlos*. If the heroic equestrian portrait seemed appropriate for a woman, it also served to glorify a child. Emulating portraits of aristocrats and the young prince's father, the king of Spain, Velázquez showed Baltasar Carlos astride a rearing horse and holding the commander's baton.

setting of lavish magnificence – without, however, a hint of his role as a warrior (see fig. 57). Ironically, when the greatest sculptor of the time, Gianlorenzo Bernini, fashioned a powerful equestrian portrayal of Louis, on a rearing horse climbing the mountain of glory, it was coolly received at Versailles. Exactly what displeased the king we will never know, but he soon had it altered into a depiction of the Roman hero Marcus Curtius riding his horse into flames. As a

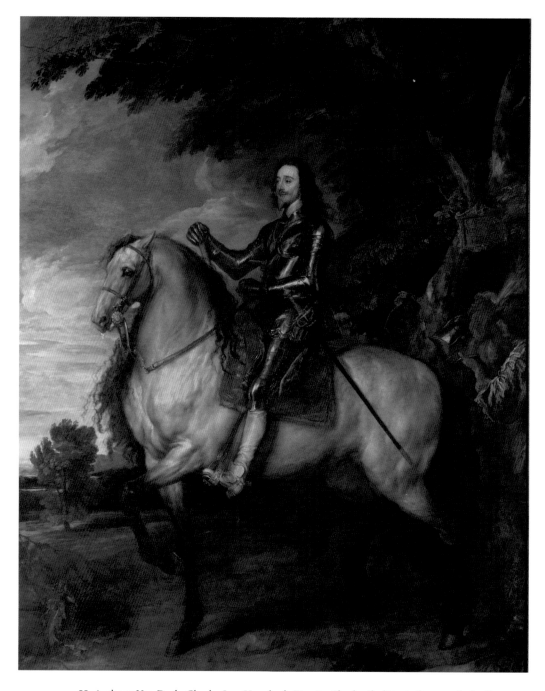

55 Anthony Van Dyck, *Charles I on Horseback*. Despite Charles I's distaste for war, the leading
portrait painter of the age, Van Dyck, showed him in a classic heroic pose as a knight in shining
armor on a splendid horse. Yet Van Dyck's earlier portrait of Charles (fig. 56) helped revolutionize
such images.

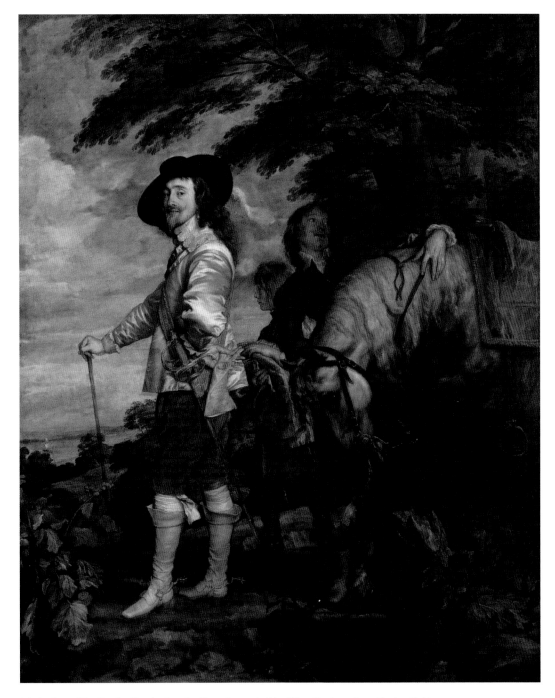

56 Anthony Van Dyck, *Charles I at the Hunt*. It was bold of Van Dyck to show England's king, not
as a heroic warrior, but as a fine gentleman, dismounted from his horse, a walking stick in his hand.
Yet this image inspired a new emphasis on elegance in aristocratic portraiture.

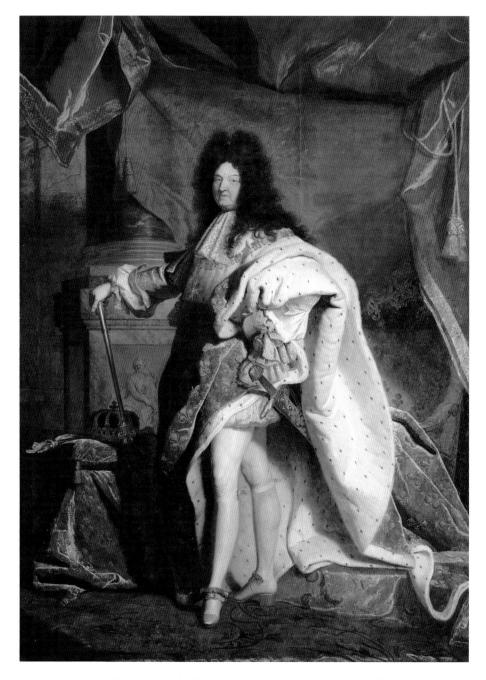

57 Hyacinthe Rigaud, *Louis XIV*. The legacy of Van Dyck is apparent in Rigaud's portrait of Louis XIV. Though this is a formal pose, with a crown on the table, it is hardly a warrior who stands before us. Even the sword, the mark of a gentleman, is largely hidden.

result, it was Rigaud's scene of magnificence, not Bernini's evocation of the warrior, that came to personify the most bellicose ruler of the years around 1700.

* * *

As our story enters the eighteenth century, it has passed its central turning-point. In the wake of radically new representations, first by Brueghel, and then by the leading artists of the 1630s, the image of war had lost irrevocably its singular association with nobility and grandeur. It might still imply such virtues, but it also could convey the inhumanity of man toward man. That division remained in place thereafter and, indeed, it was to inspire almost contradictory masterpieces in the years around 1800. Before we come to that further exemplification of the two-sided meaning of warfare, however, we need to examine yet another way in which military combat inspired the arts in this period.

War as Decoration

SULEYMAN, PALLADIO, AND AKBAR

As a result of the challenge to the traditional reverence for the warrior, the image of war had undergone profound changes in the sixteenth and seventeenth centuries. It was now possible to make the protagonists of military conflict villainous as well as virtuous, and scenes of reportage and "battles without heroes" had brought the soldier's occupation out of the realm of moral statement and into daily life. Equally noteworthy is the elaboration, in this period, of yet another kind of artistic response to the battlefield. Even a brief look at this work, created in Muslim as well as Christian lands, indicates that artists had become skilled at treating warfare as a colorful, elegant, and carefully structured human activity. The subject might be conflict, but the ends it served were decorative and aesthetic.

The *Süleymanname*

Military history has long been one of the most popular forms of reading about the past. It has taken many guises, but a favorite has always been the story of a battle. Not surprisingly, given the predilection for compilations of lists, a common exercise has been to identify "The Decisive Battles of World History." Among these, a perennial contender has been the encounter that sealed the fate of the Balkans for generations, the battle of Mohács in 1526. What made this contest unusual was not just that it was relatively unfamiliar – nowhere nearly as well known as, say, Hastings or Waterloo – but that 161 years later, in 1687, another battle of Mohács undid the effects of its predecessor and again settled the fate of the Balkans for a long time to come.

The outcomes of these clashes were so decisive because of geography and topography. Mohács (pronounced mohatch) is a small town in southern Hungary, situated at the edge of a plain between the Danube and Drave rivers, which join

together some thirty miles to the south. For any army heading either north toward Vienna or south toward Belgrade, the river crossings in the area of Mohács are crucial to the control of the western Balkans. And so it was that the turning point for the Ottomans, as they sought to expand their empire to the west and advance through Hungary in 1526, and conversely (though to a lesser extent) as the Austrians pushed the Ottomans back to the east in 1687, was a victory at Mohács. In both cases, both the fate of Hungary and the future of a major empire were determined in a few hours of bitter struggle.

We have seen that Hastings inspired a major work of art, but not every major battle has had such effect. Indeed, the Austrian triumph at Mohács in 1687 was but one stage in a long advance, and its chief visual record is a large engraving by Jean Moncornet from a French calendar for 1688 that shows the victorious general, the Frenchman Charles of Lorraine, in the traditional equestrian pose in front of a distant scene of battle – it is a standard, almost boilerplate rendition of what warfare was supposed to look like. But the events of 1526 had a different impact. In the eyes of the victor here, the Ottoman sultan Suleyman, Mohács was a major moment in the creation of his legacy as an empire-builder, and it required artistic commemoration. The result, however, bore little resemblance either to Moncornet's later effort or to the examples of heroic celebration that we have seen elsewhere in Europe.

The reason why the 1526 battle was so important was that it determined the fate of the ever-sharpening struggle between the Ottomans and their Hungarian neighbors in the 1520s. Some thirty years earlier, the largest territorial state in Europe had been the kingdom ruled by Matthias Corvinus, king of Hungary. From his capital in Vienna he had controlled Moravia, Silesia, parts of Austria and Bohemia, and an enlarged Hungary that extended through Croatia to the Adriatic. He had been one of the great soldier-patrons of his day, the creator of a powerful standing army as well as a famous library of more than 10,000 manuscripts and books. But the power he amassed drained away after his death in 1490. His crown was elective, and Hungary's nobles, jealous of royal authority, made sure that the next two occupants of the throne were ineffective men. As a result, the Habsburg rulers of nearby areas were able to take over territories outside Hungary to the north and west, and the homeland itself came under pressure from the aggressive Ottomans to the south.

Their ruler at the time, the formidable sultan Suleyman – known to his people as "the Lawgiver" but to the West as "the Magnificent" – succeeded to his throne at the age of twenty-five, in September 1520. Almost at once he went on the attack against the shaky kingdom to the north. In February 1521 he left his capital, Constantinople, to join his troops, and in July, in the words of his diary, "Suleyman

sets forth for Belgrade. July 31 he arrives before the walls of Belgrade amid the cheers of his army." Within four weeks the great citadel had fallen, and the road lay open to the heart of Hungary.

First, however, Suleyman had other business on his mind. The island of Rhodes, just off the southern coast of Turkey, had been an aggravation to the Ottomans for more than two hundred years. Ruled by the crusading order of the Knights Hospitaller of St. John, the island was the base for constant attacks on the nearby Muslims, and Suleyman was determined to capture it. After a bloody and costly six-month siege, the knights surrendered in December 1522, but for the next three years the sultan licked his wounds and turned his attention from war to the administration of his lands and the pleasures of the hunt.

The relative lull in Hungary was not entirely peaceful. There were regular border skirmishes, gains and losses of fortresses, and even a minor Ottoman defeat in battle in 1524 – followed by the gruesome gesture of a celebration in Buda, the new capital of Hungary, when the head of the decapitated Turkish commander arrived. But what finally galvanized Suleyman into action was trouble at home. Early in 1525 his crack troops, the elite corps of soldiers known as Janissaries, revolted, largely because of their enforced inaction; resentful that there was no prospect of a major campaign, they demanded a resumption of full-scale war. Threatened in his own palace (Suleyman killed three of the rebels himself), the sultan agreed and spent the rest of the year planning an advance up the Danube, from Belgrade toward Buda and Vienna.

In April 1526, he left Constantinople at the head of his army, and by August he had reached the junction of the Drave and the Danube. This would have been the place to stop him, but in Buda the Hungarian king, Louis II, was unable to make his wrangling nobles join together long enough to send a force to guard the river crossings. Within a few days, Suleyman had built a bridge of boats and advanced into the plain of Mohács. Here, at last, King Louis was able to make his stand. His army, consisting of fewer than 30,000 men, combined professional soldiers from much of central Europe, hastily assembled artillery, and cavalry units made up of the headstrong Hungarian nobility. Against them were arrayed some 45,000 Turks, led by 8,000 superbly trained Janissaries and disciplined units of artillery and cavalry. It was not a promising matchup, and the outcome was to be total disaster.

The battle was joined on August 29th and was decided in less than two hours. The crucial maneuver was the opening charge by the Hungarian cavalry. It seemed entirely successful, forcing the Ottoman troops to give way rapidly. But the withdrawal was a trap. When the Hungarians reached the line of Janissaries, they were halted and then destroyed by artillery fire into their crowded ranks. As

at Agincourt in 1415, where the advancing French knights at the rear prevented the soldiers at the front from escaping the rain of destruction, the result was havoc and rout. In the words of the contemporary Turkish historian Kemalpasazâde: "At the order of the sultan the fusiliers of the Janissaries, directing their blows against the cruel panthers who opposed us, caused . . . thousands of them, in the space of a moment, to descend into the depths of Hell." It has been estimated that three-quarters of the Hungarian army, including King Louis himself, were casualties.

By September 10th, the Ottomans were in Buda, which they burned to the ground, and from which Suleyman took Matthias Corvinus's library back to Constantinople. Three years later, moreover, he was back at the scene of his triumph, ready to march onward to Vienna. Here, however, after a vicious and unsuccessful siege, his advances came to an end. Unable to capture the city, he retreated in October 1529, never to threaten Vienna again.

But the fame of Suleyman's triumphs was to be recorded for all time. Twenty years after his expeditions into the Balkans, there arrived at his court a poet named Fethullah Arif Çelebi, commonly called Arifi. He soon impressed the sultan, who commissioned him to produce a history of the Ottoman dynasty; this work, written in Persian, turned out to be an epic poem of well over 100,000 verses. A team of calligraphers and artists was assembled to create a fitting rendition of Arifi's work, which eventually became a sumptuous five-volume manuscript that took the story from Adam and Eve to the year 1555. Although half of the text has vanished, the 30,000-verse final volume survives, and it remains one of the most glittering tributes a monarch has ever received.

This volume, known as the *Süleymanname*, the history of Suleyman, was illustrated by five artists. We know none of their names, and they have been called simply Painter A, Painter B, and so forth. Two of them, A and B, were clearly the major artists, notably Painter A, whose forty-one illustrations are the most original in the manuscript. Painter B, also a consummate artist, was responsible for twenty-two of the text's sixty-nine paintings. His contributions are splendid in their own way, but never as compelling as those of his colleague. And the masterpiece is Painter A's depiction, on two facing pages, of the battle of Mohács (see figs 58 and 59).

On the right-hand page are the splendidly disciplined troops of the Ottoman army. At the center, on a superb black horse with a jeweled harness, sits Suleyman himself. Around him, in their distinctive hats, are the Janissaries. In the back row are mounted musicians, playing pipes and drums, and in front of him are two rows of Janissaries, loading and firing the small arms and cannon that destroyed the Hungarian cavalry. Dead horses and knights, at the bottom of the painting, give a hint of the slaughter that has just occurred.

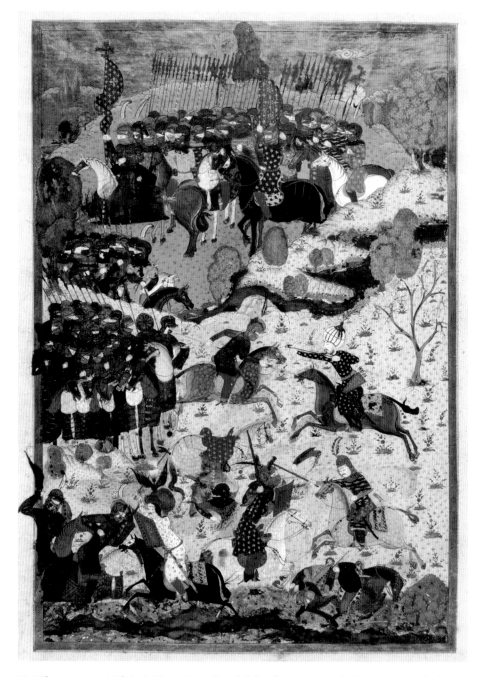

58 *Süleymanname*, Mohács I: Hungarians. On a left-hand page we see the Hungarians at the battle of Mohács. One of their knights, charging forward, is about to be killed by a Turkish archer. And in the background a detachment of soldiers is already leaving the battlefield.

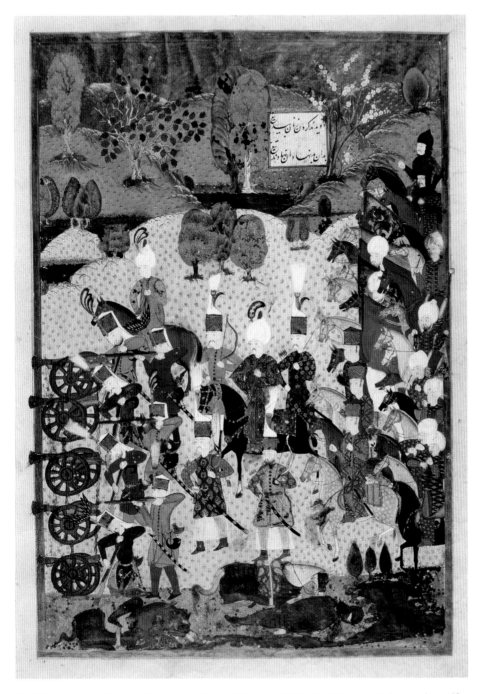

59 *Süleymanname*, Mohács. Ottomans. On the facing page is the Turkish army. Suleyman himself, in a white turban in the center, is in command. Gunmen and cannon fire at the Hungarians, some of whose dead lie below – without, however, disturbing the colorful elegance of the painting.

On the opposite page are the Hungarians. A large detachment of cavalry with a Christian banner, at the top, is already fleeing the field. Another detachment, disorganized, faces both front and rear, with one soldier shooting a charging knight with bow and arrow, and two others smashing swords into their armored foes. A dead knight, his golden visor drooping toward the ground, lies astride his brown horse, while another knight, oozing blood, seems to have been hacked in two. The whole scene is placed in a pink and green landscape of delicate beauty.

None of the other illustrations matches the elegance or drama of those that are devoted to Mohács. Painter A created a charming but more subdued double-page illustration of the siege of Belgrade, and Painter B filled three successive scenes of the siege and fall of Rhodes with a kaleidoscope of colors and graceful designs. But Mohács was the great moment in the Ottoman advance, the decisive blow that established the Turks' control of the Balkans for more than 150 years, and it was appropriate that it should have been commemorated by one of the finest works of Ottoman art.

Yet the overwhelming impression from the paintings is of the artist's delight in finding a subject so rich in ornamental possibilities. After all, these pictures are only a few among the sixty-nine in this volume whose purpose was to lend visual beauty to a poem celebrating the sultan. By their very nature, the images were secondary to the text, designed primarily to enhance the delight of the reader. Not surprisingly, therefore, it is the brilliant hues, especially the pinks that pervade both scenes, that first strike the viewer as the pages on Mohács open. Their impact is little different from the illustrations of the ceremonies and other events that marked Suleyman's reign. That the subject matter is a battle seems almost secondary to the demands of colorful decoration. War, in other words, is merely backdrop to the prime purpose of the commission: to adorn a manuscript with lush interludes that will bring pleasure and delight.

Palladio on Caesar and Polybius

Andrea Palladio, a citizen of the Ottomans' main trading rival, Venice, was a somewhat younger contemporary of Suleyman. Although, like Leonardo da Vinci, he did give some thought to the design of fortifications, his name does not immediately spring to mind when one thinks of artists and warfare. He was an enormously influential architect, but his fame derives from his revival of ancient styles and models in churches and villas in northern Italy. His buildings served religious or aristocratic needs; their air of harmony and balance, and their frequent pastoral settings, bear no relation to the military life. Yet Palladio did have one passion that brings him into our story.

Its roots lie in the transformation that shaped his career. Born in 1508 to a Paduan miller, the future architect (whose original name was Andrea di Piero della Gondola) was apprenticed at the age of thirteen to a stonemason. Clearly unhappy, he tried to run away, and finally, in 1524, managed to make his way to nearby Vicenza, where he found employment in the workshop of two of the leading stonecutters and sculptors of the city. He remained with them for fourteen years, and might well have taken over the enterprise had he not been brought into contact with the city's leading scholar, Giangiorgio Trissino, in 1538. Sent to work on an addition to Trissino's villa, the thirty-year-old must have shown special talents (he was helping to construct a loggia in the new classical style of the Renaissance), for his employer decided to take him under his wing – an entry into the world of patronage that transformed the protégé's career.

What absorbed Trissino was the legacy of ancient Rome. True to the credo of Renaissance humanism, he believed that antiquity provided the models, the ideals, for all endeavors, and he set about training his young acquaintance to believe the same. He took him to Rome at least twice, and even renamed him Palladio – in a reference to Pallas Athena, the goddess of wisdom. Thanks to this tutelage, the young architect (who was to visit the Eternal City five times) became a learned student of antiquity, and in particular of the work of the most famous Roman theorist of architecture, Vitruvius. The latter's *Ten Books on Architecture* had been rediscovered only in the previous century, and their illustrations had been lost. It was appropriate, therefore, that Palladio should have joined the efforts, during the sixteenth century, to provide the missing diagrams and plans. By then Trissino had died, and Palladio had moved to Venice at the behest of a new patron, Daniele Barbaro. Barbaro was preparing a commentary on Vitruvius and translating the Latin books into Italian, and he asked Palladio to produce the illustrations. The result was published in 1556, and in 1570 Palladio paid an even more direct homage to his great predecessor by publishing his own *Four Books of Architecture*.

Although it was a secondary interest, one must not minimize the attention to military affairs displayed both by Vitruvius and by his sixteenth-century disciple. Vitruvius was himself a soldier, and probably a military engineer, for he discusses in his tenth book siege engines and other warlike constructions. His attention to city walls, too, reflects a soldier's concern for the principles of defense. The connection between architecture and war was by no means unusual. A predecessor of Palladio who lived in Venice in the 1530s and wrote a treatise on architecture, Sebastiano Serlio, had been particularly taken by the ancient historian Polybius, and his descriptions of the methods used to organize a

camp "to lodge an army in splendid order." There seemed a natural kinship between the structures and designs that shaped an army and those that shaped a building. It was a connection that Palladio was to explore even more closely.

The original stimulus came once more from Trissino. Among the humanists of Vicenza the interest in ancient authors often focused on accounts of the Roman army and its battles, and one concern was to illustrate what the texts merely described. Thus, in one of Trissino's books the very first illustration shows the layout of a military encampment. It was derived from a description by Polybius, and was almost certainly the work of Palladio. A similar interest animated one of Trissino's plays, *Sofonisba*, based on a passage in Livy which required accurate depictions of Roman soldiers. Palladio himself produced the play – yet another engagement with the components of ancient warfare that seems to have fed a lifelong interest in the subject. For in his last years he undertook two new projects in this area that demonstrated his continuing creativity and revealed how powerfully the visible elements of military activity appealed to his aesthetic sensibilities.

The two projects were editions of Caesar's *Commentaries*, published in 1575, and of Polybius' *Histories*, which remained incomplete at Palladio's death. Such undertakings were quite familiar in scholarly circles. For example, an illustrated edition of one of the best known theorists of ancient war, Aelianus Tacticus, had been published in Venice in 1552, and an Italian translation had come out in Venice the previous year. But Palladio took such efforts to a new level. What made his version of Caesar a highly innovative enterprise were the 42 plates, which illustrated the text with an accuracy and level of detail that were unprecedented. The plates were on separate pages, but closely related to the narrative, unlike earlier illustrations, which had been incorporated into the text itself. Reprinted twice in the next half-century, the publication was one of the high points of sixteenth-century book production. The Polybius, however, remained essentially unknown until recent scholarly discoveries brought it back into view. This, too, had 42 plates, and was intended as a continuation of the Caesar, although the focus of the illustrations was somewhat different, concentrating on cavalry formations and ship designs.

What is unmistakable in all these illustrations, and links them to the painters of the *Süleymanname*, is their devotion to the aesthetic properties of military scenes. As one of the pioneers in the study of this side of Palladio, Guido Beltramini, put it when describing some of the earliest illustrations: "in the young architect's mind the forms of . . . battalions could be superimposed like the plans of complex buildings. Soldiers become bricks and vice versa."

While it is true that Palladio's main impulse was to improve the understanding of ancient warfare by adding a visual dimension to the famous works that described the Roman army, there is no question that the most conspicuous feature of the enterprise was its aesthetic qualities. As Beltramini noted, the parallels between the pictures of, on the one hand, formations, battles, and encampments, and, on the other, buildings, ornaments, and architectural details are too striking to miss. This was an artist who sought harmony, coherence, symmetry, and shape in his subject matter, whether it be a military exercise or a construction project. And the two were linked by one particular attribute of Palladio's work: they are non-perspectival. At a time when mastery of perspective was a signature accomplishment of painting and drawing, this was an architect whose overriding concern was the plan. His studies of the antique, which dealt with proportions and measurement, show his materials in flat projection. One cannot tell if a column is a rounded pillar or a slightly raised pilaster. It is the design, the orthogonal projection, that counts – as in buildings, so also, to a major degree, in military formations.

The unity of the vision is apparent throughout the engravings for Caesar and Polybius. These may seem among Palladio's lesser accomplishments, by comparison with his *Four Books of Architecture*, his exquisite country villas, or his imposing churches. Yet the precision, the love of detail, and the imaginative reconstruction of the look of the Roman scene mark these works as supreme exemplars of their genre. They also reveal an aesthetic in the very contours of warfare that no other artist so determinedly or so elegantly explored.

The examples range from a perfect little rhombus, made up of tiny cavalrymen holding pikes and astride their horses, in a plate for the Polybius, to studies of huge infantry formations, sieges, and battles that were prepared for both works (see figs. 60–62). Most striking, perhaps, is a moment when Palladio's two interests coalesced. An earlier effort to lay out the plans of military structures was a book that Palladio must have known, because it was so clearly a simpler version, and a forerunner, of his own undertakings. This was Battista della Valle's *Vallo*, published in Venice in 1539. One of its plates showed how 300 pikemen could be organized into two lunettes (presented as semicircles) joined by a square, a configuration which could fend off attacks from all sides (see fig. 63).

If we turn to Palladio's *Four Books of Architecture*, we see that the second book ends with a description of the villa on the river Brenta that he designed for the Venetian patrician Leonardo Mocenigo. And here, in an echo of Battista della Valle, is the same plan: two lunettes (though not quite semicircular), linked by the square that contained the main house (see fig. 64). There could be no clearer example of an artist taking from warfare its decorative possibilities, and adapting those elements to his own uses.

60 Andrea Palladio, cavalry formation. This is hardly likely to have been a formation used on the battlefield or on the march. Yet it enabled Palladio to create a perfect rhombus, made up of tiny horsemen, each one of whom is individually drawn and aligned.

61 Andrea Palladio, battle formation. Palladio's fascination with regular shapes pervades this illustration of a military formation. A close look at the perfect lines reveals meticulous drawings of all the chariots and horses in their six rows, the horsemen surrounding the spear holders, and the smoking chimney in the background.

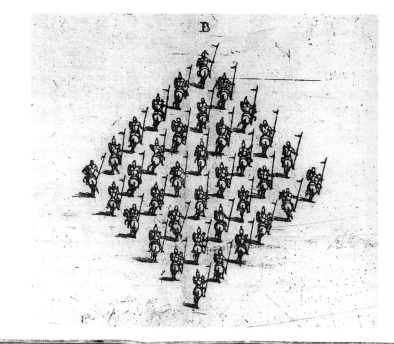

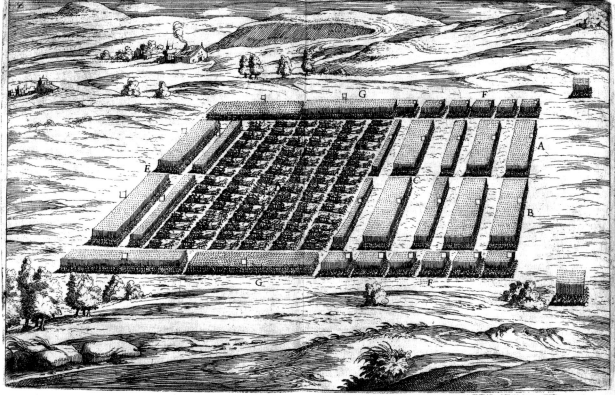

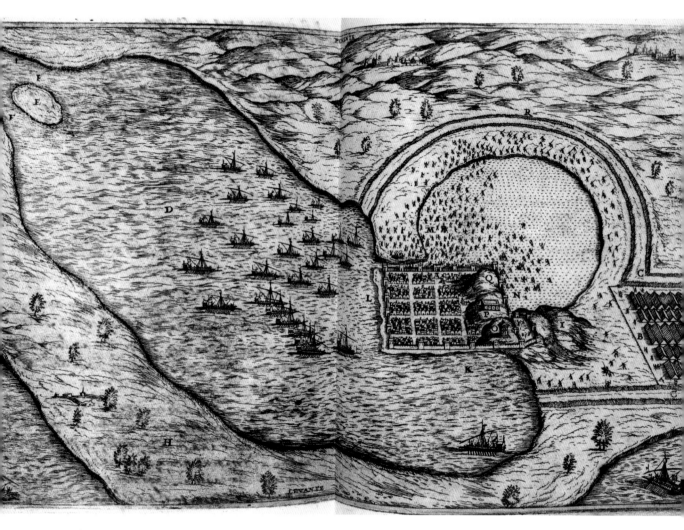

62 Andrea Palladio, siege layout. In this enormous scene, Palladio draws every house in the
besieged town, every oar on the ships in the harbor. Contrasting with the symmetry of the camp on
the right and the circular pool are the scattered attackers, many with ladders, wading toward the
town walls.

63 Battista della Valle, battle formation. Because of his interest in the subject, Palladio would have been familiar with this earlier volume, compiled by Della Valle, of ancient battle formations. Though more sketchy than Palladio's work, this layout shows troops organized into two crescents, linked by a square.

64 Andrea Palladio, Villa Mocenigo. The connection that arose from the interest in shapes, whether of military formations or of architecture, is made manifest in Palladio's design of a villa for the Mocenigo family. The plan, for two crescents linked by a square, reflects directly the battle formation depicted by Della Valle.

The *Akbarnama*

Our third example from this period was a product, again, of a slightly younger generation. And, as with the *Süleymanname*, the inspiration was a ruler famous for his victories on the battlefield. Indeed, its subject has come to be recognized as one of the supreme warriors of world history. Countless leaders have linked their destinies to war, but only a few are described as conquerors. Whether they gained the title after just one battle, as did William of Normandy, or – more commonly – spent much of their adult lives in the acquisition of the territory that gave them their fame, they form an exclusive company of historical figures, remembered as much in legend and the popular imagination as in the record of their actual deeds. The very concept of the conqueror conjures up visions of derring-do that overwhelm sober accounts of campaigns organized, strategies formulated, or individual victories won. And the arts almost always give a brilliant edge to this image. Poets and painters, architects and musicians, are drawn to the heroic themes conquerors offer, and stories of death and suffering give way to glittering evocations of splendor and power. In representations of Augustus, Trajan, England's William I, and the *condottiere*, we have already seen a number of examples of this encounter of the artist with the warrior.

Yet there could hardly have been a more vivid instance of this connection than the career of Akbar, the Mughal emperor who dominated the north of the Indian subcontinent in the second half of the sixteenth century. The Mughals – the Persian version of the word Mongols, to be transformed by the British into Moguls – had first swept into the subcontinent from the north under the leadership of Akbar's grandfather, Babur. Descended from both Tamerlane and Genghis Khan, Babur lived up to his conqueror ancestry by carving out a huge empire across what is now northern India and the adjacent lands, from Bengal to the Punjab, Afghanistan, and Pakistan.

Just like Alexander the Great, Babur made his name by winning three great battles against fearsome odds in the space of four years. When he died in 1530, it seemed that the Mughal Empire he had founded would go from strength to strength. Over the next twenty-five years, however, his son Humayun, a romantic dreamer, would lose everything Babur had won; only in the last year of his reign, 1555–56, thanks to help from the shah of Persia (ruler of what is now Iran), was he able to regain much of his father's territory and return in triumph to the cities of Agra and Delhi. A few months later, he fell down a flight of stairs and was killed – "stumbling out of life," in the words of one commentator, "as he had stumbled through it."

Humayun's death left his own son, the thirteen-year-old Akbar, heir to a large but still shaky domain. Over the next four decades, however, military success, administrative acumen, and a policy of toughness tempered by religious tolerance

established Akbar as the most redoubtable conqueror and ruler of the Mughal age. Ranging from Kashmir in the far north to the edge of the Deccan in the south, Akbar virtually doubled the size of his inheritance: by the end of his reign in 1605 his empire extended to well over half of the Indian subcontinent. A master of political compromise, and an astute manager of the loyalty of the country's diverse elites, he was able steadily to tighten his hold on his realm – not just by victories in the field, but also by shrewd alliances and policies. Thus, although Muslim himself, Akbar allowed full toleration to his Hindu subjects; and he sought to keep his regime's harshness to a minimum.

Essential to his cultivation of authority was Akbar's patronage of the arts. Unlike Babur, who was a fine poet, Akbar could neither read nor write, but that did not interfere with his passion for literature – which he had others read to him – architecture, and painting. He had an abiding interest in philosophy and religious thought, which may well have inspired his tolerance of non-Muslim faiths. On a number of occasions, for instance, he sponsored discussions with Jewish and Christian as well as Hindu scholars. If Akbar took pleasure in plunging into the worlds of thought and the arts, he nevertheless seemed wryly aware of his limitations. A story he liked to tell had to do with his shortcomings when he was learning to paint at the age of ten. He had produced a rather poor piece of work, "a form whose parts were all separated from each other and scattered." When asked who had painted the picture, he gave the name of an enemy general. Yet his own lack of talent did not prevent him from becoming a significant patron of intellectuals and artists, or from demanding the highest aesthetic standards in the ceremonies, buildings, and artifacts that came to embody his reign.

Among his favorites was the son of Sheikh Mubarak, a teacher and religious leader who was already a revered intellectual figure in Agra when Humayun returned to the city. Mubarak became one of Akbar's closest advisers, and in 1574 he presented at court his son Abul Fazl, a child prodigy who had grown into an exceptionally learned young man. Abul Fazl offered the emperor two commentaries on verses from the Koran – works of such scholarly accomplishment that he was rapidly established as a fixture at court. He received a series of military and administrative posts, but in 1589 Akbar drew on his literary talents to commission a history of the reign.

The result, the *Akbarnama*, a massive, multi-volume work written over the next ten years, is one of the masterpieces of the age: a deeply researched, carefully constructed account of the rise of the Mughals that culminates in a stirring portrayal of Akbar and his achievements. It was to be a shattering blow – the emperor apparently fainted when he heard the news, and remained inconsolable for days – when Akbar learned that his own son and successor, Jehangir, fearful of Abul Fazl's influence and the doubts he had expressed about Jehangir's capacity for rule, arranged for the historian to be assassinated in 1602.

From the first, it was understood that the history would be a splendid produc-
tion, commensurate with the greatness of its subject. Accordingly, even as the text
of the *Akbarnama* was being prepared, an art workshop that had been established
at the royal court swung into action to illustrate the manuscript. Humayun had
brought two painters with him from Persia, Mir Sayyid Ali and Abdus Samad, and
Akbar used their leadership to develop what became a distinctive Mughal school
of painting. We know the names of those who worked on the *Akbarnama*, and
that in itself is an indication of the new status of their art. As Akbar himself put it,
rejecting the traditional Muslim prohibition of depictions of creation, "a painter
in sketching anything that has life [is] . . . forced to think of God." The miniatures
that resulted – now preserved in the Victoria and Albert Museum in London – are
masterpieces in paint that rival Abul Fazl's attainments in prose.

Among the 116 miniatures, many show scenes of battle, as could have been
predicted in the life of a conqueror. But only one encounter, the capture of
Ranthambore of 1569, inspired sufficient attention to require five detailed paint-
ings and the talents of seven artists, all of whom are named: Miskina, Paresh,
Khim Karan, Bhurah, Mukund, Lal, and Sankar. In military terms, Ranthambore
had hardly been the most significant of Akbar's successes. It was the second, and
less difficult, of the two victories that brought about the first major expansion of
the territories he had inherited: the conquest of Rajasthan, a largely barren and
rocky region to his south. Yet the siege was a highly dramatic affair, requiring
cannon to be hauled up a steep slope, and it went through a succession of stages
that offered artists opportunities for imaginative reconstructions of distinct
scenes. Thus did historical importance give way to aesthetic imperatives.

The area that Akbar now conquered was ruled by the Rajputs, who were Hindus.
For the first years of Akbar's reign their most prestigious leader, Udai Singh, had
lived in uneasy cordiality, and occasional tension, with his neighbor to the north.
Finally, in 1567, the emperor decided to assert his authority, and did so by invading
Rajasthan. Udai Singh took flight, leaving strong garrisons in fortresses at the tops
of two massive rock formations, both rising some 500 feet from the plain below:
Chitor and Ranthambore. By October, Akbar was able to lay siege to Chitor, keeping
up a steady bombardment (one huge cannon was cast at the site) and organizing
sappers to bring explosives, through trenches and tunnels, to the walls. But not until
late February 1568 did the fortress fall, whereupon Akbar ordered the 5,000
defenders and their families killed, followed by a savage slaughter of more than
20,000, and perhaps as many as 30,000, civilians from Chitor and the surrounding
area. This was the exemplary and decisive victory of the Rajasthan campaign; it took
only a month for Ranthambore to surrender (without mass slaughter) a year later.

Nevertheless, it was Ranthambore that offered the illustrators of the *Akbarnama*
the visual excitement to inspire five glowing miniatures. At this siege a neighboring

hill overlooked the fortress, and by hauling his cannon to its summit Akbar was able to unleash a far more devastating and effective barrage than at Chitor. Thus the first miniature does not even show Ranthambore, but rather the startling sight of the heavy cannon dragged up the steep incline by teams of bullocks and then firing away from the summit. The Mughal painters' love of nature and bright hues comes through even in this crowded, improbable scene, where the eye is caught by the fantastic shapes of trees growing out of rocks, and the colors of robes and tents. The oranges, reds, greens, and blues enliven every area of the miniature, while a lone goat, a bird in one of the gravity-defying, rock-bound trees, and a gunner peeping around another tree add light touches to the forbidding landscape and toiling soldiers.

The second miniature pulls back, and we see the larger setting: the besieged fortress on the left, firing back; the distant plain in the middle; and, on the right, Akbar himself, who takes command of the assault, directing the attack while dressed in white and carrying a handgun (see fig. 65). By using a brilliant white for his robe, the illustrator has made him the focal point of the action. Although the perspective requires that he be a small figure, he is impervious to the cannon firing at him, and as a result he seems to dominate the battle. To protect his cannon, Akbar had to put up walls, and the task of building continues below (carried out by the blacksmith and his assistant and the splendid figure in blue wielding a rock-breaking ax-cum-scythe), but it is now the stony landscape that defines the battle.

In the third scene the perspective changes. We look from above into a panicky Ranthambore – an implausible elephant on its streets – as the siege intensifies (see fig. 66). The depiction of nature, with striking rocks and trees, remains essential to the illustrator's work, but now the assault has come closer. The attackers, wearing helmets and armor, have come to the point where they can reach the fortress with smaller cannon. Already the bodies of defenders are beginning to crash headlong down the rocks, and the entire scene has been darkened by the ominous clouds above.

The final two illustrations of the siege of Ranthambore celebrate the aftermath of Akbar's overwhelming victory. Although the smoke of battle has died away, the splendor of these scenes reinforces the aura of power that surrounded the emperor, and emphasizes the magnificence that his artists always convey. Two more miniatures were needed, however, to document Akbar's triumph. First, the gates of the conquered fortress are shown open in the background as the defeated general submits to the enthroned Akbar, elegantly clad in gray, in his gorgeously decorated tent. Even here, the painter cannot resist the distracting animals that reflect imperial power: the lavishly decorated horses, a falcon, and just part of an elephant's head. Then we pull back yet farther, in the final miniature, to show how the entire fortress was surrounded (see fig. 67). Akbar, astride a fine black horse,

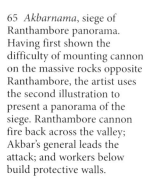

65 *Akbarnama*, siege of Ranthambore panorama. Having first shown the difficulty of mounting cannon on the massive rocks opposite Ranthambore, the artist uses the second illustration to present a panorama of the siege. Ranthambore cannon fire back across the valley; Akbar's general leads the attack; and workers below build protective walls.

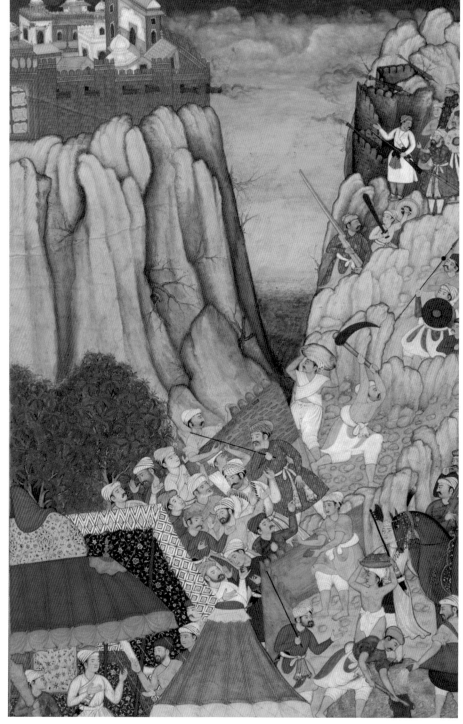

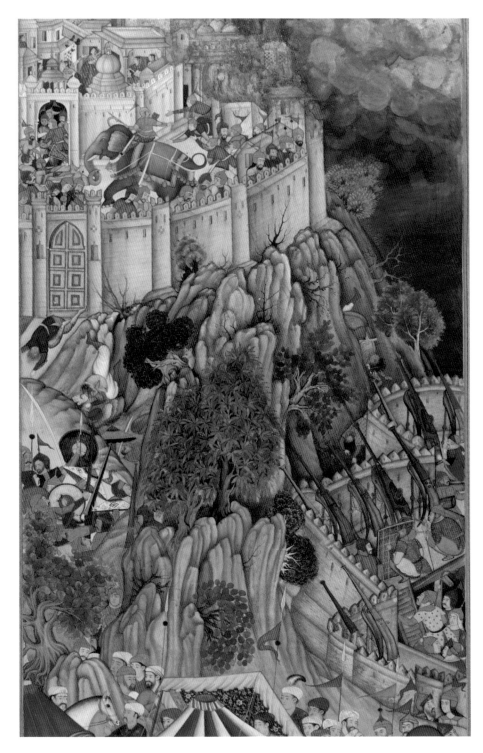

66 *Akbarnama*, last stages of siege of Ranthambore. As the siege enters its last stages, there is chaos within Ranthambore, while defenders' bodies, in large scale, fall headlong from the walls. Yet it is the array of colors, the marvelous rocks and trees, and the beauty of the depiction that catches the eye.

67 *Akbarnama*, entry of Akbar into Ranthambore. Akbar himself, in yellow and on a fine black horse, has now entered Ranthambore. The evidence of the battle is still there in the cannon, but the focus now seems entirely on the lush colors of the scene and the fantastic evocations of the terrain.

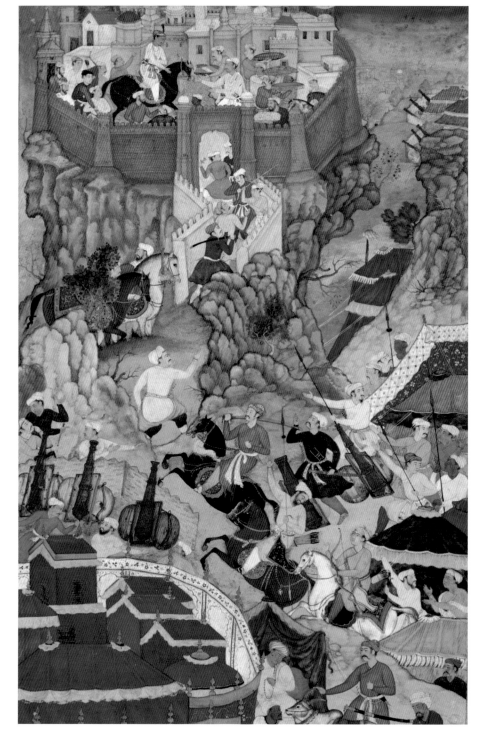

has at last entered Ranthambore. With its siege works and implements of war, this may still count as a battle scene, but the painters have transformed it into a fantasy of color and shapes that gives little hint of the harsh reality it recalls.

To a significant degree, this last miniature merely reflects the commitments of the artists who illustrated the *Akbarnama*. The emperor may have been a powerful ruler, a successful commander whose military victories were landmarks of his reign. And any history was bound to celebrate his career as a warrior. Yet the principal impression one takes from the miniatures is of a determination to bring as much grace and delight into the story as possible. Even as we see the dead or the bellicose, our attention is drawn away to the vibrant evocations of nature. The painters want readers to enjoy the manuscript, and so, while the text emblazons the glories of the emperor's reign, they provide the aesthetic appeal that transforms the manuscript into far more than a striking narrative. The *Akbarnama* may give us the story of a conqueror, but its art has conquered war.

* * *

The decorative purposes that military affairs could serve offer an unusual sidelight in a story that has emphasized the ways in which artists were inspired first to glorify and eventually to condemn the warrior. The more neutral treatments of the theme, whether documentary or aesthetic, inevitably play a subsidiary role, because they downplay the passions that tend to drive a masterpiece. Yet the more ornamental approach deserves attention, not least because three such distinct exemplars all appeared within a few years of each other, and in widely separated settings. The commonality that links the *Süleymanname*, Palladio, and the *Akbarnama* is testimony, yet again, to the far-reaching influence of the world of battle on the world of the artist.

David Versus Goya

Stability and Change in Warfare

During most of the eighteenth century the patterns established by the gunpowder revolution retained their sway over military tactics. But as religious passions died away, and powerful central governments became increasingly concerned to limit the destructiveness of war, both battlefields and contested territories became less bloody and less damaged. From their high point in the Thirty Years War, casualty rates steadily declined, and sometimes commanders would try to avoid engaging with an enemy so as to preserve their armies. One did not want to ravage a region one hoped to conquer, because the costs of reconstruction would be so great. And at home, the building of barracks to minimize contacts with civilians; the development of sophisticated mechanisms to ensure deliveries of food and equipment (Louis XIV set up saltworks just to supply his troops); and the insistence on drilling and discipline to train soldiers and prevent the rampages that had been common in the Thirty Years War; all contributed to a more orderly integration of the military into the structures of the state.

Of course, violent confrontations did not cease, and the age produced famous generals in the English duke of Marlborough, the Austrian Prince Eugene, the German king Frederick the Great, and others. Yet the few changes in tactics and in weaponry did not result in a significant alteration in the shape of battle between the end of the Thirty Years War in 1648 and the beginning of the Napoleonic era in 1789.

It is true that the block formation of infantry that had been so potent in Spanish hands had gradually given way to a reliance on advancing lines or columns of troops. But that shift had begun around 1600, as the Dutch, led by Maurice of Nassau in their War of Independence, had sought to emphasize flexibility and

smaller units to counter the trundling weight of the Spanish *tercios*. The superiority of this approach had been demonstrated by Gustavus Adolphus in the 1630s, especially as a result of his introduction of mobile field artillery to the battlefield. During the next century, there remained two schools of thought: one stressed the weight represented by the block of troops (impervious to cavalry charges because horses would shy away from pikes or bayonets), while the other pointed to the dash and maneuverability made possible by the column or line. The second approach gradually won out, but because the new tactics required strict discipline and tight coordination, the importance of drilling and the instruction provided by military academies became paramount. Since the officer ranks, which had to impose the discipline and determine the tactics, were filled primarily from the upper levels of society, they often disdained the ordinary soldier (one commander referred to him as "swill"). Yet both cohesion and bravery were essential to success, and those qualities depended on the ranks as well as the leadership. Thus, while the battlefield may have looked different – with an ever greater reliance on organized lines and columns of infantry than in 1600 – victories were still won when, as a result of superior tactics and determination, enemy formations were broken up either by flanking movements or by breaches in their lines. That remained the standard practice until the era of Napoleon at the end of the eighteenth century.

In weaponry, too, there was little new in the eighteenth century except a refinement of traditional methods of production. The basic weapons remained the cannon and the musket, now fitted with a bayonet. The musket did become lighter to carry, but not appreciably easier to fire when the flintlock replaced the matchlock as the standard firing mechanism. One of the puzzles of military history is why one major improvement that had been known since the sixteenth century was not applied. This was rifling, the cutting of a spiral groove into the barrel so that the shot would be set spinning and could be aimed far more accurately. Specialty pistols, often lavishly decorated, and hunting weapons were rifled, as were the carbines used by cavalry units that were manned by horsemen of some social standing. For the average infantryman, though, this did not become a regular feature of guns until the nineteenth century. One theory is that it was not worth the added expense. Another is that, in an age of strict social divisions, it would have been inappropriate to put into the hands of common soldiers a weapon that could have been used to pick off aristocratic enemy officers. This is not to say that accuracy was deemed unimportant. The principal technological advance of the period was a major improvement in the area of cannon manufacture. Instead of casting a hollow barrel, metalworkers learned to cut the bore into a solid barrel, thus making possible standardization and much more accurate

firepower. As with tactics, however, these small improvements in weaponry had minor consequences for the nature of battle.

The major transformation was to come in the era of the French Revolution and the Napoleonic Wars. That the nature of warfare remained essentially stable for a century and a half, and that conflict in these years was primarily about high politics and territorial jockeying, is the main reason why, from the 1640s until around 1800, there is no significant work of art that seems to deserve a place in our story. Depictions of battles and commanders continued to appear in steady numbers, of course, and some distinguished artists did lend their talents to scenes of war – notably Charles Le Brun, a favorite of Louis XIV – but neither passion nor originality is conspicuous. Instead, one finds a muted, standardized homage to the warrior and his works, and a documentary instinct in the presentation of scenes of conflict.

Indeed, in one exceptional case, Le Brun, whom Louis had ennobled and appointed "Painter to the King", harked back to Rubens's *Horrors of War* even in a painting that was intended to commemorate France's declaration of war on the Dutch in 1670. Here was the court's most important artist, honoring what was called *The Decision for War* by his warlike monarch, and yet what is portrayed is a king enthroned between symbolic representations of war and peace that by no means favor bellicosity (see fig. 68). On Louis's left the god of war points to the promise of the victor's laurel, but on his right a seated goddess of wisdom opens up a dark scene of tempest and prone bodies straight out of Rubens. It was hardly a stirring endorsement of the glory of military conflict. In fact, it was not until a different kind of warfare erupted in the last years of the eighteenth century that an artist was again inspired by the clash of armies to create a masterpiece that continues to stir the emotions.

The new atmosphere that arose in the era of the French Revolution and Napoleon, between 1789 and 1815, was the result of a new source of passionate commitment: revolutionary nationalism. Both those who fought for a radical reshaping of society and those who resisted them were driven by animosities of an intensity that had not been seen since the end of the wars of religion. Because these causes seemed so urgent – the drive to export the ideals of the French Revolution versus the determination to defend national autonomies or to stamp out the specter of social upheaval – warfare dominated the European continent during these years, from Moscow to Madrid and beyond, at a level that had not been experienced in a century and a half.

Armed conflict also involved many more people. Here the catalyst was the threat to their revolution from abroad that prompted the French to invent mass conscription. The so-called *levée en masse* (literally, mass rising), which called on

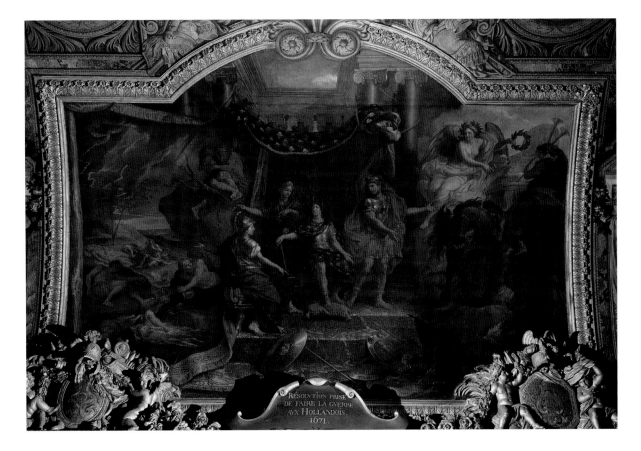

the entire nation to take up arms, produced an army of one million men by 1794. Penny-pinching by the government resulted in those numbers falling to less than half by 1796, but Napoleon's electrifying appearance on the scene started a turna-round. He made conscription the law of the land, and by 1815 he had an army of two million under his command. Nothing like it had ever been seen before. It drew from all levels of society, and created an officer corps that gave no heed to birth, the buying of commissions, or the other hierarchical concerns that had been in force for centuries. In fact, many officers were elected by their men (though in the early 1790s they were still watched carefully by political agents). One conse-quence was the disappearance of social distinctions. Although in later years they were to make a comeback, aristocrats in the French revolutionary armies repre-sented a tiny fraction of the officers – little more than 2 percent. And it is clear that the premium placed on talent and cohesion was a major reason for the victo-ries won both by the revolutionaries and by Napoleon. The ferocity and depend-ability of the soldiers became legendary, and made possible a reduction in the

68 Charles Le Brun, *Decision for War*. The effects of the shift in artistic treatments of warfare are visible in Le Brun's commemoration of France's declaration of war against the Netherlands. Both the glory and the misery of war beckon King Louis XIV of France as he makes his decision.

traditional dependence on cavalry. Horses were often used to give speed and flexibility to artillery units, an element of battle in which the French showed great skill, but it was their infantry that provided the tactical versatility and the panache and determination in combat that set their army apart.

To this foundation of success Napoleon brought a use of cavalry as a shock tactic and as an expansion of artillery units, but his reliance on the infantry remained paramount. What he added was an emphasis on speed, surprise, and a cool strategic eye that made the French seem almost invincible for nearly two decades. He was a master, above all, at misleading his enemy. Sometimes he would feign a retreat or a weakness that would entice his opponents to commit their forces, only to have them destroyed in a powerful counter-strike. On other occasions he would threaten a flank, drawing attention to one side while his troops cut off escape routes on the other. Perhaps most devastating of all was his uncanny ability to sever supply and communication routes, and to surround enemy armies – the classic means of securing victories.

That was one side of the balance sheet. On the other was a dismaying return to the civilian suffering that much of eighteenth-century warfare had sought to avoid. In the early 1790s French armies, often short of supplies, were already resorting to pillaging to support themselves. Napoleon, moreover, regarded foraging for food and materials as an important element in rapid movement. If troops did not have to wait for support, they could advance more quickly, and he gave little thought to the effects of the policy on the populations his men despoiled. It was this that turned the Germans against him; that helped fuel a draining guerrilla war in Spain; and that finally brought the disaster of the Russian campaign. For all the admiration Napoleon's originality and brilliance inspired, it is well to remember that about a million men died in his wars.

The return of ideological strife – revolution and French hegemony on one side, conservatism and local patriotism on the other – meant that the two-pronged response to armed conflict (glory vs inhumanity) also returned. With the alternatives now so starkly visible, it was perhaps inevitable that two of the most formidable artists of the era should have put forward, in compelling fashion, radically contrasting visions of warfare. The division that had begun with Brueghel, some 250 years earlier, attained what was perhaps its last powerful airing when these two contemporaries created diametrically opposed visions of the meaning of war.

David's *Bonaparte Crossing the Great St. Bernard Pass*

The new fervor for social and political change that was associated with the French Revolution, and the rise of national pride that soon followed, affected the arts

almost immediately. Alongside operas celebrating the heroism, the virtue, and the honor of rulers and aristocrats, there were now stories of valiant commoners, rescues from evil authorities (notably Beethoven's *Fidelio*), and exhortations to patriotism – the last appearing even in one of Rossini's comic operas, *L'Italiana in Algeri*, in the aria "Pensa alla Patria" (Think of the Fatherland). The visual arts experienced a similar transformation, which was to reach a climax in Delacroix's remarkable *Liberty Leading the People* of 1831, where the single figure of Marianne served to represent both France and freedom.

Long before Delacroix, however, a powerful artist had become caught up by the spirit of revolution. Jacques-Louis David, born in 1748, came from a privileged background, but had joined the many intellectuals of this generation who (like the American revolutionaries) saw the Roman Republic as the ideal government. Bringing that commitment to his work, he took subjects from antiquity, such as the death of Socrates and the oath of the Horatii, and depicted them in a hard classical style that rejected the soft, decorative rococo taste of the previous generation. His talents attracted royal patronage, but he made no secret of his republican sympathies, and when the French Revolution erupted he became a prominent figure on the national scene. He voted for the execution of the king, Louis XVI, and painted two crucial moments in the history of the revolution: an oath sworn by representatives who had been forced to meet in a tennis court, and the death in his bath of a leading politician, Jean-Paul Marat. A friend of both Marat and Maximilien Robespierre, the dominant revolutionary of the early 1790s, David was imprisoned after the fall of Robespierre, but his fortunes revived with the rise of Napoleon, an admirer of his work.

What is notable about this career is the fact that an artist was once again able to bring passion as well as skill to political and military events. It was because he believed so enthusiastically in the aims of the revolution, in the destiny of France, and in the ability of Napoleon to bring both causes to a new height, that David felt impelled to celebrate success on the battlefield. And the way he did so revealed for the last time that there was still life in an image that went back at least to Alexander the Great: the fearless commander astride a triumphant horse. Since no later masterpiece glorifies the warrior in this fashion, it has to be seen – at least for our purposes – as the final exemplar in a tradition that began with the Assyrians and received such notable adherents during the Renaissance. For this role, moreover, it is particularly fitting, because it arose from a circumstance – the ordeal of crossing a mountain – that allowed David to link his hero with heroes across the ages.

For most of Western history, mountains had been regarded as fearful and dangerous. To the dark mystery of Mount Sinai, Moses climbed alone. On the

summit of Olympus only gods could walk. Even the goatherds and remote villagers who settled on rocky heights seemed alien and strange to those who lived below. A Dante, a Petrarch, or a Pascal could make memorable ascents, but it was a foolhardy leader who took troops into a mountain fastness. Were not those Alpine dwellers, the Swiss, already known as redoubtable soldiers by the fifteenth century? Did the ruggedness of the Valtelline not make mighty French and Habsburg armies struggle in the seventeenth? Even in modern times, with jeeps and helicopters at their disposal, commanders have not been able to bring their firepower effectively to bear in such terrain, as Afghanistan has demonstrated. In fact, it is not until quite recently – the past two hundred years or so – that mountains have gained the broad appeal that has drawn climbers, hikers, and skiers to their grandeur. For generals, by contrast, they have remained places to avoid. That is, unless the general is a genius.

If Hannibal's crossing of the Alps with elephants is not the most famous single episode in the history of war, one is certainly hard put to think of an equivalent (though it is worth adding that a slightly humorous depiction by Nicolas Poussin is the closest the episode has come to stimulating an artistic masterpiece). Nor is it easy to surpass, as evocations of the bravery of battle, the heroism of the Spartans at the pass of Thermopylae, the resilience of Xenophon's 10,000 as they crossed the snowbound peaks of Asia Minor, or, even more celebrated, the legendary last stand of Roland high in the Pyrenees, defending the rear of the army of Charlemagne. It was only because the Austrians made so little of his subsequent victories that Prince Eugene's crossing of the Alps in 1701 has never received the same attention as these other feats. A century later, though, the comparisons with the towering military figures of Europe's past, and especially their conquest of the mountains, became a standard trope in discussions of Napoleon, because his successful campaign of 1800 turned out to be a public relations coup that revived his flagging fortunes. It happened also to inspire the last great work of heroic equestrian art.

What is known as Napoleon's second Italian campaign was the make-or-break moment of his career. He had reached the rank of general in 1793, and after various ups and downs he was given command of an army in 1798 whose aim was to establish a French presence in Egypt and the Middle East. In late August 1799, however, he slipped ignominiously out of Egypt, abandoning troops who, though victorious in the field, had had their communications cut and their mission thwarted by the British admiral Horatio Nelson, who had destroyed the French fleet the previous year. When Bonaparte reached France in October, his future was in peril, but his response, as always, was to attack. Helped by his brother and by disaffected leaders of the Directory, France's current revolutionary government,

he engineered a bloodless coup in November – executed, Thomas Carlyle wrote, with "a whiff of grapeshot" – and, evoking ancient Rome, made himself first consul. In December, France's new constitution (essentially a dictatorship) was approved by more than three million voters in a quick referendum, but it was obvious that Napoleon's hold on power remained shaky, especially as news filtered back about the humiliating negotiations, continuing through January, to rescue the soldiers he had abandoned in Egypt and allow them to return to France.

Even more ominous was the progress of another enemy, the Austrians, much closer to home. Advancing across northern Italy, they defeated a French army under General André Masséna near Genoa in early April 1800, forced him into the city, and began a horrendous, starving siege that was to last two months. Their main force then moved on to Nice and beyond, coming to within 30 miles of Fréjus, the port where Napoleon had landed the previous October. If his faltering regime (let alone his military reputation) was to survive, he had to repel this mortal danger. What he decided on was a strike into Lombardy: an attack from the rear that would cut the Austrians off from their base of operations. To do that, however, he had to cross the Alps.

The route he chose, for its unexpectedness and safety from detection, was the Great St. Bernard, the higher and longer of the two passes that bear that name. Opened up for Julius Caesar nearly 2,000 years before, the pass, more than 50 miles long (including 10 miles of narrow mountain track) and 8,000 feet high, linked Martigny in Switzerland with Aosta in Italy. At its summit was a monastery, whose monks had been revered since the eleventh century for their help to travelers, and for their famous St. Bernard dogs. Here, in mid-May, Napoleon rested for three days, read about Hannibal in the monastery library's copy of Livy, and hurried on when he heard that his advance guard, which had traversed the pass in just four days, was having difficulty beyond Aosta. For part of the descent he had to ride a mule, and for part, impatient to get ahead, he slid "sur le derrière." He reached Aosta on May 24th, captured Milan and Pavia, and moved south-westward along the Po valley.

Although the besieged French in Genoa finally capitulated on June 4th, the main body of the Austrian army, led by Baron Melas, was already heading east to face the threat from its rear. The decisive encounter took place on the 14th near the village of Marengo, south of the Po. For a change, it was Napoleon who was taken by surprise. Believing Melas to be in Turin, and in any case not likely to cross the Bormida river, which, running northward to the Po, lay between them, he had allowed his army to become widely scattered. He now found himself with some 22,000 men facing more than 30,000 under Melas, who had suddenly and boldly crossed the Bormida. By early afternoon on June 14th, with the French

falling back, the Austrians seemed on the point of victory. But one of Napoleon's commanders, Louis Desaix, was racing to the scene with 6,000 men. When they led a counterattack, in the early evening, they swept Melas from the field.

Napoleon had come to the brink of defeat, and, indeed, Desaix had lost his life in the crucial engagement. Fifteen years later, in an ironic reversal, Napoleon's final downfall was to be sealed by another commander, Blücher, arriving late on the field of battle at Waterloo. Now, however, there was only triumph, glory, and myth-making. Italy lay at Napoleon's feet, fears of disaster were banished, and although he himself hurried back to Paris, he postponed the entry of his troops into the capital to create a theatrical climax for a rapturous Bastille Day, July 14th, 1800. Even the simple chicken dish with tomatoes, mushrooms, and garlic that his cook had prepared the night of the engagement (because he could find no other ingredients) became one of Europe's classic recipes, Chicken Marengo. Carefully cultivated, an aura of invincibility began to surround Napoleon, even in the view of hard-headed warriors. To an early student of his campaigns, Baron Jomini, who would later be a general in Bonaparte's army and a distinguished theorist of war, the crossing of the St Bernard pass was one of the most impressive feats in the annals of war: a supreme example of the power of surprise, an incredible logistical achievement, and a strategic masterstroke unsurpassed in military history.

As the fame of the Marengo campaign spread, it naturally attracted the attention of the 52-year-old David, who by now was France's leading artist. In fact, he was soon to be appointed by Napoleon as "First Painter," the very title Louis XIV had bestowed on his favorite artist, Charles Le Brun. Yet it was France's ally, Charles IV, the king of Spain, who first asked David to commemorate the crossing of the Alps. The result, a huge canvas, just under 9 feet high and nearly 8 feet wide, is the most heroic of the many portraits Napoleon's career inspired (see fig. 69).

One can see immediately that the painting is intended as an allegory. The impossibly acrobatic pose of the rearing horse (even though the ride was actually on a mule) continued the tradition we have followed since the time of Marcus Aurelius in Rome, showing military heroes as larger-than-life equestrians. To heighten the drama, Napoleon points upward, perhaps toward his destination, or possibly to indicate the trajectory of France herself, as he prepares confidently to scale the forbidding mountains that loom around him. And his historic role is engraved in the very rocks he crosses, where his name appears above those of two famous predecessors, Hannibal and Charlemagne.

Yet David did not ignore the reality of the scene. Since Napoleon refused to pose for him, he persuaded the general's valet to lend him the sword and uniform Bonaparte had worn at Marengo, from hat to boots, and he dressed up a dummy as his model. The windblown cloak and horse's tail, also pointing ahead, may be a

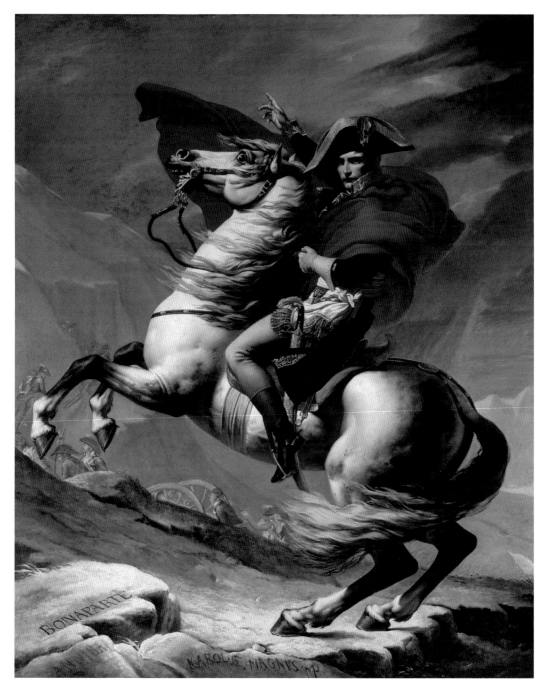

69 Jacques-Louis David, *Bonaparte Crossing the Great St. Bernard Pass*. This may have been the last masterpiece in the long tradition of heroic portraits of warriors on horseback, but the vigor is undimmed. As soldiers labor in the background, the commander rears up and even his cloak seems to fly forward.

poetic touch, but the wide-eyed steed and its elegant harness are painted as meticulously as the horseman himself – and so, too, are the toiling troops, dragging their cannon, in the background.

The portrait was an immediate success. Napoleon ordered three copies; by September 1801, one was completed, as was Charles IV's original, and in the following months David and his students produced three more. Highly prized, the five paintings were sold for a total of more than 100,000 francs, a gigantic sum.

But the days when a commander could be convincingly portrayed as a heroic warrior on his horse, echoing the image of the chivalric knight, were almost over. In fact, David himself – like another admirer of Napoleon, Beethoven – was to regard it as a betrayal when his subject, once the embodiment of the spirit of the French Revolution, became increasingly consumed by ambition and self-glorification. *Bonaparte Crossing the Great St Bernard Pass* turned out to be the last masterpiece of this genre in Western art, the final flourish of a tradition that had inspired, among others, Donatello, Verrocchio, Leonardo da Vinci, Titian, Rubens, Bernini, and Velázquez. Even before the horse vanished from the battlefield, the superhuman equestrian figure, towering over his army and over history, had lost his grandeur. When David's younger contemporary, Théodore Géricault, painted cavalry officers, he did so in elegiac mood, using them as a way to lament the end of Napoleonic military glory. Leaders were still to be shown in bellicose pose well into the twentieth century, whether the peaceful Edward VII of England, in public statuary in London, Liverpool, and Toronto, or the World War I general Earl Haig, in London and Edinburgh, the depictions no longer had the energy or the élan of their predecessors. In the mechanized age that soon dawned, with its complex logistics and death from great distances, there was little room for the verve of a Napoleon, and certainly not for the grandiose vision of a David. The mountains remained, but the conquerors were gone.

Francisco de Goya: *The Third of May 1808*

We have seen that the ancient tradition of the artist lionizing the warrior was first breached during the Renaissance, and in particular by Brueghel's response to the brutalities of religious conflict. The creation of a counter-tradition gathered pace during the Thirty Years' War, notably in the work of Callot and Rubens, but the power of these two traditions to inspire clashing masterpieces was still at work in the age of Napoleon. Not long after David celebrated France's victories, his Spanish contemporary, Goya, just two years older, offered a very different vision of military conflict. Responding to the French invasion of Spain in 1808, he fashioned a searing indictment of the cruelty of war.

Ironically, it was the same new and rising passion that lent fervor (and thus artistic brilliance) to both sides. Just as David had been stirred by his ardor for France, so too was Goya moved by his feelings for his fellow Spaniards. Nationalism in the late eighteenth and early nineteenth centuries was sweeping writers, composers, and painters alike into rousing advocacy of patriotic themes. But the effects of such commitment to a large cause were no longer one-sided, and the future (at least in the creation of masterpieces) was to belong to the Goyas, not the Davids. If the great equestrian figure was coming to the end of its long and distinguished history, concern about the harm inflicted by war was gathering force. And Goya's denunciation of violence had a power that the hymns to courage of the previous millennia could no longer muster.

It was not as if the Spanish regime of the late eighteenth century had had much to recommend it. The Bourbon dynasty that had ruled the country since the early 1700s had presided over the economic decline and loss of prestige of a proud former superpower. Charles IV, who reigned from 1788 to 1808, admired the French (and indeed commissioned David's portrait of Napoleon crossing the Alps). But he was petrified by the republican sentiments their revolution had stimulated. He had tried desperately to save the life of Louis XVI up until his execution in Paris in January 1793, and he had paid the penalty when, a few months later, he found his realm invaded by France. Thanks to the astute maneuvering of his chief minister, Manuel Godoy, Charles had recovered by 1795 what he had lost on the battlefield, and the following year he finally decided to throw in his lot with France against its chief enemy, Britain. Despite the defeat of Spain's chief military asset, its navy, at the battle of Trafalgar in 1805, this alliance held firm, although within the country opposition to the pro-French policies of Charles and Godoy grew ever stronger, led by the heir to the throne, Ferdinand.

It was this tension that intensified Spanish nationalism and provoked the bloodshed of the years that followed. Determined to exclude Britain from European trade, Napoleon had taken control of much of the continent by mid-1807, and his last major target was Portugal. In October, having decided to partition that country and divide its rule between Charles and Godoy, he dispatched an army that was able to capture Lisbon by the end of November. Within a few months, however, popular resentment of Spain's subordination to Napoleon's ambitions (and the continued presence of his troops) boiled over. A popular uprising in March 1808 prompted Charles to abdicate, but Ferdinand did not inherit the crown for long. A French army, commanded by Joachim Murat, marched into Madrid, and Charles and Ferdinand were summoned to meet Napoleon in Bayonne, just across the border, on April 30th. Ten days later Charles and Ferdinand had both abdicated, allowing Napoleon to place his brother,

Joseph, on the Spanish throne. By then, however, rebellion was under way in Spain itself, and guerrilla tactics (so named for the first time), abetted by a British army, continued until the French were forced to retreat in 1813.

Two episodes in the early days of the popular resistance soon came to occupy a special place in Spanish memory: an uprising in Madrid in the first days of May 1808, even as the Bayonne meeting was taking place; and the seven-week defense of Saragossa, headed by the patriotic leader José de Palafox, in which 50,000 died before the besieged city surrendered in late February 1809. Yet the intensity of these memories, and their reverberations throughout Europe, were the result not so much of what happened during a few violent days and months, but rather of the way they were evoked by Goya, the leading Spanish artist of the day.

Goya had been First Court Painter under Charles IV, and was renowned for his portraits of the aristocrats who populated the royal entourage. He was in Madrid in May 1808, but it is unlikely that he witnessed the events of May 2nd and May 3rd that he was to commemorate, six years later, in two remarkable canvases. The first records the initial uprising on May 2nd, which started with a crowd at the royal palace trying to prevent the departure of Ferdinand's baby brother to France, and reached a bloody climax in the late afternoon, when a detachment of Mameluke cavalry, brought into Napoleon's army after his conquest of Egypt, charged into a protesting mob at the Puerta del Sol and slaughtered men and women armed with little more than cudgels and knives (see fig. 70). If a single work of art could epitomize the futility of civilian resistance in the face of the ferocity of soldiers, it is this one. As a sullen crowd watches, the rebels are ruth-lessly cut down. They may succeed in unhorsing a few cavalrymen, but it is clear that the Mamelukes' discipline and swordsmanship will carry the day.

This viciousness inflicted on ordinary civilians became a major theme in Goya's art in 1808. For it was in that year, when the resistance to Napoleon began, that he was invited by Palafox to come to the besieged city where he had spent his childhood, Saragossa, "to see and study the ruins of that town," (in Goya's words) "for the purpose of painting the glorious exploits of its inhabitants." An important public figure, accorded respect by both sides, the artist was allowed to travel through the countryside, where he must have witnessed some of the events that began to give new subjects to his work. He did depict one heroic event, when a young woman named Augustina, who had been bringing food to the Spanish soldiers in Saragossa, had taken over firing a cannon when all the artillerymen had been killed. But Goya's major preoccupation now came to be the grimness of war: scenes of soldiers shooting and assaulting women, omni-present corpses, women trying vainly to attack soldiers, and the agonies of the wounded.

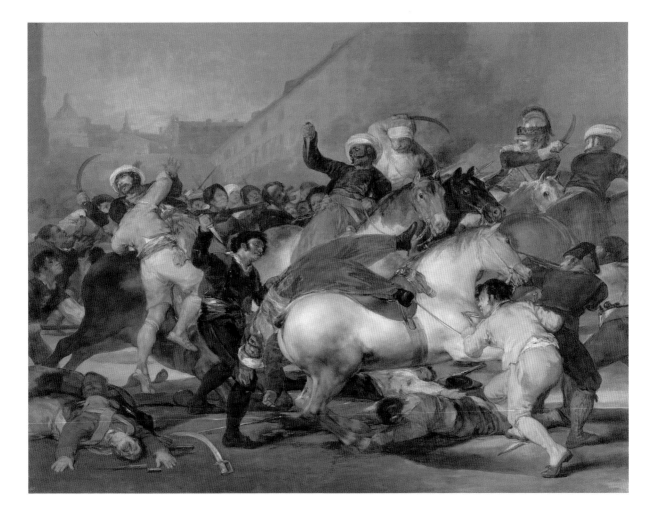

To do justice to the many episodes he wanted to portray, Goya embarked on a large series of etchings – eighty-two prints in all – which he continued during the devastating famine in Madrid during 1811 and 1812. They were completed in the 1820s with searing attacks on the Spanish clerics and politicians who had presided over the agonies of his countrymen. Called *The Disasters of War*, these engravings, produced in multiple copies and recollecting Jacques Callot's famous etchings of *The Miseries of War* in the 1630s, show little heroism or fine qualities. Instead, the combatants are described, in one title, as being "like wild beasts" (see fig. 71); in another, even the wounded are pressed into battle, for they, too, "can still be of use"; the dead are treated callously by both sides; and if the execution of a rebel by the French receives the title *Barbarians!* (see fig. 72), other scenes of the mutilated bodies of guerrillas show that there are no redeeming values in death or war. The

70 Francisco Goya, *Second of May*. The events of May 1808 that Goya recorded began with France's Mameluke cavalry, imported from Africa, charging into a crowd that had gathered at the royal palace in Madrid. The disparity in weaponry and training between soldiers and civilians had inevitably brutal consequences.

71 Francisco Goya, *Disasters of War: Wild Beasts*. The title of Goya's etching suggests his unease over violence, even if inflicted on French soldiers by civilians driven to murderous fury. This scene shows that women, too (one of them carrying a naked baby), fought with whatever weapons they could find.

72 Francisco Goya, *Disasters of War: Barbarians!*. A monk has been tied to a tree, and two French soldiers shoot him while a group of their colleagues calmly watch. Although Goya illustrated atrocities committed by both sides, it was the indifference to the savagery that he called barbaric.

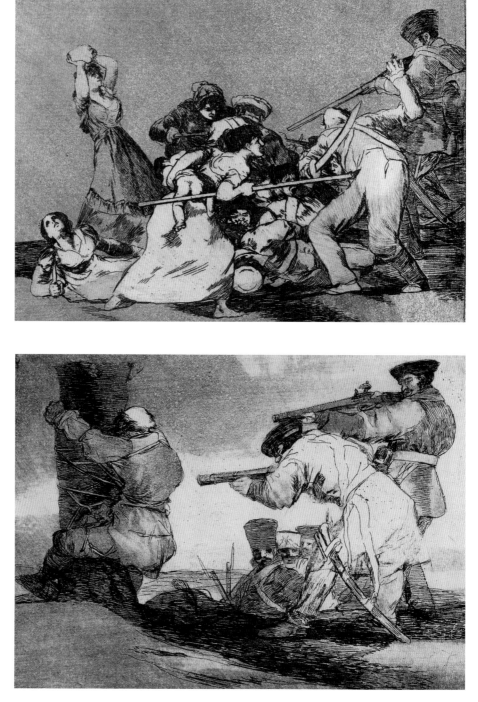

target, in other words, was not just the atrocities of the invader, but the brutality of war itself. If the victims are everyday Spanish men and women, their suffering is the consequence of soldiery in general, not of particular, identifiable troops. It is in the very nature of armed conflict to cause the cruelties Goya portrays.

Although the etchings are an essential element in any assessment of Goya's fame and influence, one has to recall that they were not published until the 1860s, thirty-five years after his death in 1828. He was well into his seventies when they were completed, and by then the aging artist had opted for the comfort of continued royal service under the Bourbon dynasty, restored to the Spanish throne in 1813. He even produced a standard equestrian portrait of General Palafox in 1814. Having chosen to remain a solid member of the establishment, Goya kept to himself his deeply disturbing engravings of the callousness of man toward man.

But this is not to say that his unsparing vision of war was unknown. For it was during the same year as the portrait of Palafox, 1814, that Goya painted two bleak but widely admired commemorations of the bloody events of 1808 that offered a sharp contrast to the celebration of the warrior that was David's *Napoleon*. We have already taken note of the painting of the Mameluke cavalry's charge into civilians on May 2nd. But the most remarkable masterpiece was its chilling companion piece, inspired by what happened the following day: *The Third of May 1808 in Madrid: The Executions on Principe Pio Hill* (see fig. 73). For it was in the hours after the Mamelukes' suppression of the original uprising that the French general, Murat, had his men round up anyone in Madrid whom they found carrying a weapon. The prisoners were then taken to an execution site on the Principe Pio Hill, now known as the Moncloa district. That night, and into the following morning, forty-three were executed, and Goya made the scene the central means of illuminating both the terror and the meaning of the uprising of May 1808. It was certainly a nationalist statement, recording the ordeal Spain suffered at the hands of the French; but it was also an anguished tribute to the plight of the ordinary citizen in a time of war.

With the darkened city as a backdrop, a line of prisoners climbs the hill to their doom. Ahead of them stand six men who are about to die, and beyond them, their blood still soaking into the soil, three newly dead corpses lie sprawled on the ground. Filling the right half of the canvas is a detachment of French soldiers, their backs to the viewer, their rifles raised: anonymous instruments of war, they concentrate on the task of execution. They have set up a lantern to help them see what they are doing, and its light rivets our attention on the front row of those climbing the hill, especially the central figure, a moment from death, who dominates the scene. If those around him cower in despair, cover their faces in dread,

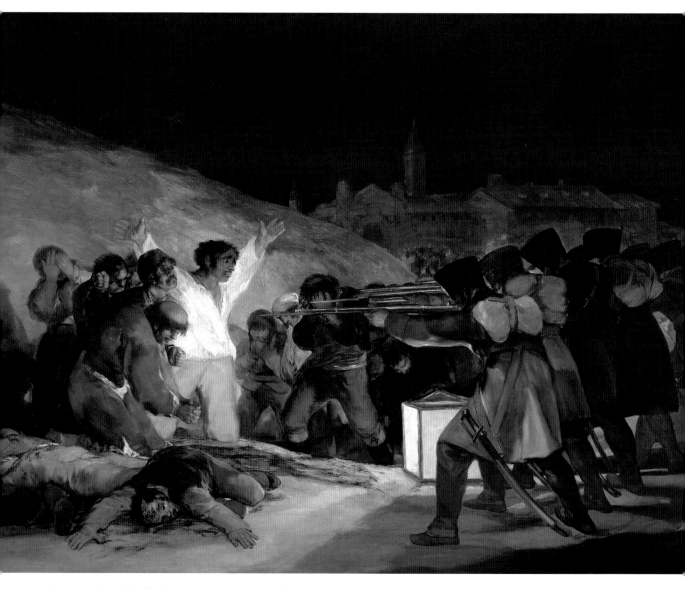

73 Francisco Goya, *Third of May*. The blaze of white and yellow at the center of this painting rivets our attention on a man who has become a symbol of the victims of war. Goya's Christ-like figure represents the Spaniards executed by French troops following an uprising in May 1808.

or stare impassively at their executioners, he stares at the soldiers as if almost willing them to fire.

This anonymous martyr to the Spanish cause has become one of the most famous images in Western art. Unlike the painting of May 2nd, where horses, Mamelukes, and protesters compete for attention, all eyes here move toward the one man whose pale clothes light up an otherwise dark and somber scene. Even though one of the corpses also has his arms thrust apart, it is this gesture, combined with his penetrating, almost sorrowful gaze, that draws us back, again

and again, to the man in white and yellow. What is he doing? Can he be welcoming the bullets that will kill him?

And why not? The most famous martyr of them all, Jesus himself, did not shrink from the death he knew awaited him, and indeed sought forgiveness for his executioners. The acceptance in the expression of this central figure seems a deliberate echo of Christ's martyrdom, a connection that Goya underlined with a stance that recalled the Crucifixion. And, just in case the reference might still elude the viewer, he painted in the man's hands indentations that recall the nails that attached Christ to the Cross – the stigmata, whose miraculous appearance in the hands of St. Francis and others in Christian history has always denoted the saintliness of the sufferer.

To heighten his effects, Goya moved toward a new kind of art, ignoring the rules of perspective and flattening and foreshortening the distances between the figures. To the distinguished art historian Enrique Ferrari, moreover, the "discordant cry, desperate and plaintive," that issues forth from the painting and its companion piece signals a basic change in the way painters (and mankind) confront the world. Here, he suggests, lies the beginning of modern art. If so – and, as we shall see, Picasso's quotation of the outstretched arms with the stigmata in his *Guernica* strengthens the claim – then it was the pressure of warfare, and his angry response to its savagery, that drove Goya's art in directions that he probably would have thought unimaginable before 1808.

For he made his case, as did Brueghel, Callot, and Rubens during the wars of religion, not with heroes or villains. Instead, he showed us nameless victims and executioners, who may symbolize Spain and its defiance of conquerors, but ultimately convey the terror and inhumanity of war itself.

<p style="text-align:center">* * *</p>

The ancient tradition of bravery did not end with the Napoleonic Wars, but in the generations that followed it no longer seemed capable of summoning the best from artists who were drawn to the subject of warfare. Instead, as in Tennyson's poem, "The Charge of the Light Brigade," written a few years before Goya's *Disasters* were published, it was the futility and chaos of battle that fed the highest creative impulse. The balance had finally been reversed and, henceforth, as we enter the modern age, it would be the heritage of Brueghel, Callot, Rubens, and Goya that inspired the most potent images of war.

The Pity of War
MODERN TIMES

War Becomes Impersonal

Warfare in the nineteenth and twentieth centuries was increasingly conducted at a distance. The rifling of gun barrels, the development of machine guns and tanks, and the use of airplanes, rockets, laser-guided bombs, car bombs, and roadside bombs were but stages in the growing resort to death delivered from afar – a progression that has been called the industrialization of war. For the first time in the history of warfare, hand-to-hand combat began to lose its significance. Casualties rose astronomically as weapons became ever more devastating as well as indiscriminate, and it may be that the killing of millions rather than thousands would not have been possible had the slaughter remained personal and immediate. But that was not to be.

Even when soldiers did find themselves face to face, as they did in the trench warfare of World War I, or in some subsequent engagements, the overriding image came to be the anonymity of combat. Gone were the notable warriors whose names and valor had resonated so stirringly down the ages. Now there were nameless enemies and friends, many of whom died unknown deaths. Such faceless troops had of course toiled in every army since antiquity, but by the twentieth century they, rather than the heroes, gave identity to battle. If attention was paid to the exceptional bravery of ordinary soldiers – recognized by newly devised medals like Britain's Victoria Cross – it seemed noteworthy precisely because it was so unusual. The overall impression was of bleakness, a mood that was captured by Wilfred Owen, one of a remarkable group of British poets who responded powerfully to their experiences on the front line in World War I. In a poem entitled "Strange Meeting," Owen imagined himself, like Homer, Virgil, and Dante before him, in the underworld, with the ghosts of the dead. Unlike those

predecessors, however, he encountered someone he did not know. The two men talked, and in the last lines of the poem the ghost chillingly explained who he was:

> "I am the enemy you killed my friend.
> I knew you in this dark: for so you frowned
> Yesterday through me as you jabbed and killed.
> I parried; but my hands were loath and cold.
> Let us sleep now . . ."

The indiscriminacy that was the dominant feature of the new warfare was here laid bare.

Matters had come to this point by steady increments. Though of minor consequence militarily, the Crimean War of 1853–56 had started the process on its inexorable path. This was not because its most famous encounter, the Charge of the Light Brigade, demonstrated how pointless traditional notions of courage had become on a battlefield ruled by artillery, but rather because of the new equipment issued to British and French troops. Not only were the barrels of their guns rifled, but they were given specially designed bullets that fitted the rifling. The result was a range of accurate fire that extended to 300 yards or more, an advantage used to telling effect in a number of battles. This was also the first war when steamships were used to carry troops at new speeds, and when telegraph communication permitted close coordination both among the commanders and with their home governments. Mechanization and industrialization were on their way.

A few years later, the American Civil War of 1861–65 added the railroad and the machine gun as instruments of strategy and tactics. Although the earliest versions of a weapon that could maintain a steady stream of fire, the Agar gun and the Gatling gun, were used sparingly, their appearance heralded an entirely new means of delivering multiple deaths, at random and at a distance. Moreover, the relentless pressure and attrition whereby the North eventually defeated the South marked a new willingness to cause civilian suffering that was to reach unimagined levels over the next century. Fraternal conflict unleashes intense passions, and it was no surprise that the war proved to be the bloodiest in American history: in just four years, more were killed than in all the nation's other wars combined.

Even that record, however, paled by comparison with the next major conflagration, fifty years later. Again lasting just four years, from 1914 to 1918, World War I caused the largest loss of life in history, only to be surpassed by World War II in the 1940s. The twentieth century brought such dizzying changes to the organization, conduct, and technology of war as to make the enterprise unrecognizable even to its practitioners of the 1880s, let alone the 1860s. To quote just

one example, from Williamson Murray's account of the prelude to World War I in *The Cambridge History of Warfare*:

> The admirals who led the fleets into battle in 1914 had entered navies in the 1880s whose traditions and technology were closer to Nelson's day than to the twentieth century. From primitive steam-driven and partially metalled ships of 1880, many still possessing sails, navies had progressed to great oil-powered dreadnoughts with weapons that could throw projectiles over twenty miles and could move at speeds of over twenty knots (cruisers and destroyers could reach speeds of thirty knots). With radio, navies could control and deploy ships around the world. By the end of World War I the introduction of submarines, aircraft, and aircraft carriers underlined the extraordinary technological changes that affected the conduct of naval war.

Much the same was true of land battles and that entirely new dimension, war in the air. It is sometimes noted that cavalry on horseback were still deployed in World War I, but far more indicative of the nature of the combat was the appearance of two devastating new assault weapons, both the products of technological invention: the tank and mustard gas.

Moreover, the scale of the fighting went far beyond all previous bounds. Best estimates suggest that over 70 million men were put into uniform, of whom close to 15 percent were killed. That number was probably more than doubled by the maimed and wounded, who became a common sight in the years that followed. What makes the torrent of casualties and the ghastly consequences of the fighting especially dismaying is the joy with which the antagonists entered the war. Where once religious commitment and revolutionary fervor had driven a citizenry enthusiastically into battle, now the spurs were nationalism and imperialism. Aroused by newspapers and politicians to believe in the special destinies of their native lands, and turned against their neighbors by the competition for colonies overseas, the people who lived in the major states of Europe had been expanding their armed forces and equipment for years before the war broke out. Their expectation was that the fighting would be over in months, if not weeks. When, instead, the murderous struggle dragged on for years, destroying the cream of their youth, it shattered illusions as well as bodies. World War I left a wound in Europe's consciousness from which it has never fully recovered.

Nevertheless, the lust for battle did return. A traumatic civil war tore Spain apart less than twenty years later, and in 1939 the continent was plunged into World War II by the quest for vengeance and by new and implacable ideological hatreds. There may have been passions at work among both leaders

and ordinary soldiers in both those conflicts, but they were overwhelmed by the technology that eventually proved to be the difference between victory and defeat. Though there might still be heroic deeds and the camaraderie generated by a small body of men who depend on one another for their lives, the growing sophistication of the weaponry and the remoteness and impersonality of the killing were giving warfare an aura of abstraction and distance. It was not surprising that, for decades after World War II, fierce rivalries and even open hostilities were tamed by calling them a Cold War; nor that more traditional local wars, and even the revival of religious fundamentalism as a *casus belli*, did little, except for a few true believers, to restore earlier notions of warfare as grand or ennobling.

For artists, the old ways were gone, never to be revived. They were still commissioned to depict leaders and combatants as valiant, especially in the war posters that proliferated in the twentieth century. And there were certainly individual heroes aplenty, such as the English seaman Jack Cornwell or the American sergeant Alvin York, both of whom received their nation's highest military honor in World War I. But those who fashioned masterpieces of art were no longer able to suggest that inspiration could cut both ways. One looks in vain for a successor to David. Instead, it became evident in the nineteenth century that the effects of what Wilfred Owen called "The pity of War" had overcome, at the highest levels, the enthusiastic artistic responses to warfare of earlier times. Nonetheless, the remaining works that we will explore remind us that the versatility of the creative mind, even in pursuit of a single theme, can astonish even as it draws on the deepest wells of emotion.

Mathew Brady and Antietam

The bloodiest and most agonizing conflict of the nineteenth century, after the defeat of Napoleon, was the American Civil War. Such wars sear a nation's soul, and the two such torments that we will discuss in this chapter – in the United States and Spain – are among the most anguished in the long history of these self-destroying encounters. It may be a cliché to speak of brother turning against brother, son against father, but no deaths in battle reverberate as long as those inflicted by kin upon kin. Grand opera can suggest the emotional power of such confrontations: The last scene of Verdi's *Il Trovatore*, when the Count di Luna discovers that he has killed his brother, gives a hint of the despair caused by the shedding of what is virtually one's own blood. In the Bible such unnatural behavior marked Cain for life. It is no wonder that societies that are torn apart by fratricidal war bear the scars for generations.

For Americans the trauma came not when their British cousins and ancestors were cast off in a war of independence – that was a time of glory, of self-definition, of a common struggle for freedom – but when their nation divided into two bitter camps, separated by the issue of slavery. It has been noted that the north of any sizable nation often differs from the south. Thus is Germany divided between Protestant Prussia and Catholic Bavaria, Italy between industrial Lombardy and rural Calabria, France between the Burgundy and the Languedoc of old, England between the formerly industrial north and the administrative south. And thus was the young United States split between the free states of the North and the slave states of the South until, amidst growing tension, civil war seemed to be the only way to settle unbridgeable and irreconcilable differences.

When the guns burst forth on Fort Sumter in April 1861, little blood was spilled and no one was killed, but the fort's surrender became the opening act of an increasingly vicious and bitter struggle between the secessionist Confederacy in the South and the Union forces of the North. Within days a Confederate mob had attacked Northern troops passing through Baltimore, and by July there had been a major battle in Virginia. This first battle of Bull Run, not far from Washington, had already created a war hero, General Thomas J. Jackson, whose indomitable stand transformed a likely Southern defeat into victory and won him the nickname "Stonewall." Three days later, President Abraham Lincoln gave command of the Union troops around Washington, the Army of the Potomac, to a new general, George B. McClellan.

McClellan was a highly professional choice. He had graduated from America's military academy, West Point; he had distinguished himself in war with Mexico; he had driven secessionists out of West Virginia; and he was to transform the ragged Army of the Potomac into a disciplined fighting force within a few months. But caution was his watchword. To Lincoln, who wanted to take the battle to the enemy, McClellan's preference for slow movement and the avoidance of danger, and his perennial requests for reinforcements, were a source of increasing frustration and annoyance. The President expressed his feelings with his customary humor, but his attitude was clear. "If McClellan does not want to use his army," he was reported to have said, "I wonder if I might borrow it."

In March 1862, McClellan began a campaign that, in a little more than three months, brought the peninsula between the James and York rivers in Virginia under Union control, at a cost of some 50,000 casualties, more than 20,000 of them on his side. But in late June he was prevented from moving toward the Confederacy's capital, Richmond, by the new commander of its Army of Northern Virginia, Robert E. Lee. Like McClellan, Lee had graduated from West Point and had fought against Mexico. Trained as a military engineer, he had also served for

three years as Superintendent of the West Point academy. Though reluctant at first
to join the Confederacy, Lee accepted the command of the Army of Northern
Virginia, his native state, and after the Peninsula Campaign he won a major
victory at the second battle of Bull Run. Then, in September, he decided to strike
north into Maryland to try to isolate Washington. Here, on September 17th, he
was confronted by McClellan at Antietam Creek, near the small town of
Sharpsburg. What ensued was the bloodiest single day of the entire war. In five
successive assaults by McClellan, whose 75,000 men vastly outnumbered Lee's
40,000, 20 percent of the combatants became casualties: more than 6,000 killed or
mortally wounded, and more than 18,000 wounded. The battle was a standoff,
with each army losing roughly the same number of men, but Lee had to withdraw
to Virginia, and as a result the French and British postponed their recognition
of the Confederacy and Lincoln felt confident enough to issue a preliminary
Emancipation Proclamation for the slaves – followed three months later by the
full proclamation.

These enormously important political consequences of Antietam, however,
have long been overshadowed in the popular mind by the unprecedented destruc-
tion of human life during the few hours of fighting. And that image was largely
the creation of a figure who was a new phenomenon on the field of battle: the
photographer.

Experiments with photoelectric chemical processes that made it possible to
capture images of people and scenes on metal or glass, and to print them on paper,
had led, during the second quarter of the nineteenth century, to the creation of a
profession that hovered between reportage and art. At the time, its practitioners
regarded themselves as simply reflecting fact, offering a window into the real
world; but modern scholars have emphasized the choices that shaped composition,
lighting, and timing – the artifice that brings photography into the realm of art.

The artistic impulse was certainly at work in a young man from upstate New York,
Mathew Brady, who moved to Saratoga Springs in 1839, at the age of sixteen, to learn
a trade and ended up studying design and painting. He so impressed his mentor,
William Page, that in 1841 he was sent on to work with the great inventor Samuel
Morse at the Academy of Design in New York City. Morse also offered training in
one of the early forms of the photograph, the daguerreotype, and it was here that
Brady found his métier. By 1844 – still only twenty-one years old – he had opened a
gallery and studio in New York; three years later he opened a branch in Washington,
and in 1851 he won first prize in the international daguerreotype competition at
London's Crystal Palace Exhibition. His growing fame, enhanced by publications
and his photographs of the leaders of American society, enabled him in 1860 to open
his largest gallery in New York, appropriately named the National Portrait Gallery.

Brady continued to try out new techniques, notably the "wet plate" process – so called because its light-sensitive solution, collodion, had to be exposed and developed within an hour, or its sensitivity was lost. Yet the result became Brady's favorite, because it produced a negative image from which multiple prints could be produced on paper. He had discussed these collodion glass images in London in 1851 with one of their early advocates, a Scotsman named Alexander Gardner. Five years later, Brady persuaded Gardner to come to Washington to run his gallery, and gradually his studio became home to a team of photographers. He was thus ready when, in 1861, he made the fateful decision that transformed his career and his reputation.

There had been individual photographers at previous wars, notably the Mexican War in the 1840s and the Crimean War in the 1850s. But when the American Civil War erupted, Brady conceived a much larger ambition: to put together a group of photographers who would create a systematic visual record of this major historical event. Accordingly, he abandoned his lucrative portrait practice – which had reached such heights that Lincoln himself, made famous by an enormously successful picture Brady took in New York when Lincoln spoke at the Cooper Institute in 1860, said that "Brady and the Cooper Institute made me president" – and led his team, including Gardner and another talented figure, Timothy O'Sullivan, into the field to document the struggle between North and South.

Brady had increasingly poor eyesight, and the most famous battle and camp photographs were often taken by Gardner and O'Sullivan, though Brady himself took the incisive studio portraits of the chief protagonists, notably one of Robert E. Lee after his final defeat (see fig. 74). The dangers of this enterprise were very real. Following the first battle of Bull Run, a journalist wrote, "Brady has shown more pluck than many of the officers and soldiers," and on one occasion O'Sullivan was ordered to leave an area "lest he join the list of casualties." Yet their sense of purpose was undimmed. As Gardner noted about the "harvest of death" that O'Sullivan revealed at Gettysburg: "Such a picture conveys a useful moral: . . . [to] aid in preventing such another calamity."

Although by the time of Antietam Gardner had left Brady's Washington gallery and was serving as the official photographer to McClellan's army, it was Brady who published Gardner's pictures and made them famous in an exhibition, later that year, at his New York gallery. The show was entitled "The Dead of Antietam," and it caused a sensation. Two of the photographs, in particular, fixed the horror of that day in the public mind. The first, *On the Antietam Battlefield*, suggests that the bodies of the dead soldiers, sprawled where they had fallen, might stretch to the far horizon (see fig. 75). The Hagerstown road to the left, and the fence on the right, emphasize the perspective and force our eyes to follow the destruction across what seems an infinite distance. A similar immensity beckons at the end of the more

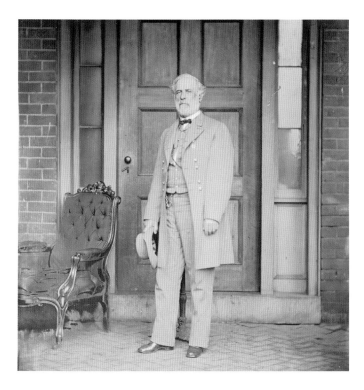

74 Mathew Brady, *Robert E. Lee*. Brady's photograph of the dignified commander of the Confederacy's troops was taken in Richmond, Virginia a week after the end of the American Civil War. Back in civilian clothes, the general shows no sign of the grueling years that have just ended.

75 Mathew Brady, *On the Antietam Battlefield*. Heroism is absent from this record of the legacy of Antietam. Not only are bodies strewn about, but the ground is covered with the litter that accumulated during the battle. Many Americans were awakened to the reality of the Civil War by this photograph, taken by Alexander Gardner.

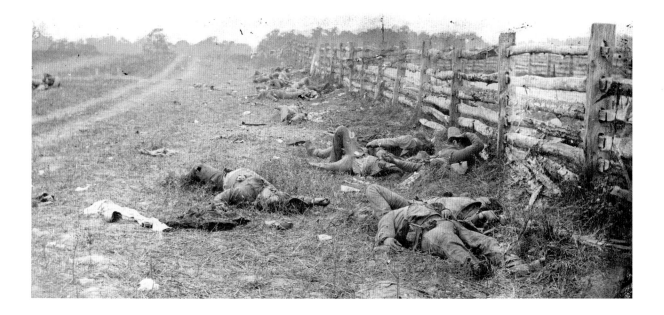

orderly parade of corpses laid out in *Confederate Dead Gathered for Burial* (see fig. 76). No hint of value redeems the desolation of the scene. And when, two weeks later, Lincoln came to see the site for himself, Gardner recorded the visit in one of the most famous documents of the war, a staged photograph in which the army officers are dominated by the top-hatted figure of the President – the military men unmistakably subservient to the civilian (see fig. 77). Unmistakable, too, is the absence of joy; there is only grim determination in the wake of massive slaughter.

Of all the Civil War photographs in Brady's studio, none was more powerful than *On the Antietam Battlefield.* For the first time, thanks to Brady, the public could ponder, as virtual eyewitnesses, the horrors of war. But this achievement soon proved hollow for the artist himself. Although the photographs established him as one of the defining figures of nineteenth-century American culture, and a notable exemplar of the response of a gifted creative figure to war, Brady's venture turned out to be a personal disaster. He sank the enormous sum of $100,000 into his Civil War efforts, but the market for his photographs was ruined by the combatants'

76 Mathew Brady, *Confederate Dead Gathered for Burial.* This desolate scene represents the aftermath of the battle of Antietam. The bodies of the dead soldiers have been laid out for burial, and even the bleak setting seems to reinforce the grim message of this photograph by Alexander Gardner.

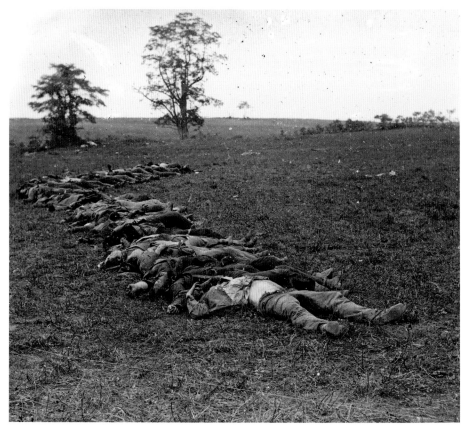

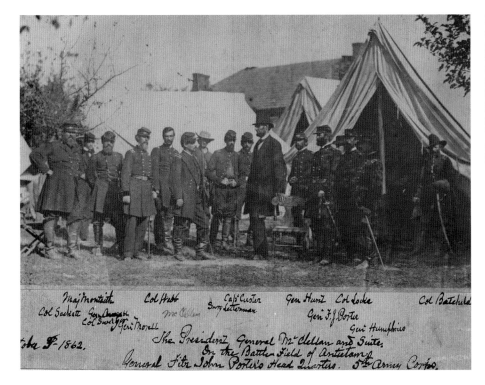

77 Mathew Brady, *Lincoln and his officers.* This official photograph, by Alexander Gardner, documents Lincoln's visit to the officers of the Union army following the battle of Antietam. In front of him (with three men between them) is General McLellan. The "last stand" of George Custer, on the far right, came fourteen years later.

determination to put the trauma behind them. As is often the case when a time of terrible agonies comes to an end, those who lived through it want to focus their attention elsewhere, and it can be decades before they are willing fully to confront the past. This was true of the Holocaust after World War II, which did not figure in school curricula or university departments until a wave of new interest appeared in the 1970s and 1980s. So, too, it was with the Civil War. The fighting was over, and people no longer wanted Brady's photographs to remind them of their ordeal.

In the end, it was the federal government itself that stepped in, and bought the full collection of photographs in 1875; by then, however, Brady was near poverty, barely able to maintain one small gallery in Washington, which he was forced to sell in 1895, the year before his death. It is wrenching to contemplate his life in his forties and fifties, when he was rarely able to spend time with his beloved camera. Yet his place in history was secure, both as America's most noted pioneer in a new art form, and as the nation's most vivid documenter of truths too easily forgotten. In the words of a deeply moved *New York Times* reporter, following a visit to Brady's exhibition just a month after Antietam:

Mr. Brady has done something to bring home to us the terrible reality and earnestness of war. If he has not brought bodies and laid them in our dooryards

and along the streets, he has done something very like it. [At his gallery, crowds] of people are constantly going up the stairs; follow them, and you find them bending over photographic views of that fearful battlefield. There is a terrible fascination about it that draws one near these pictures. . . . You will see hushed, reverent groups standing around these weird copies of carnage . . . to look in the pale faces of the dead, chained by the strange spell that dwells in dead men's eyes.

Manet on War

In the history of Western art, France during the second half of the nineteenth century and the early years of the twentieth has come to be seen as the birthplace of a revolution that overturned centuries of tradition and created a new visual aesthetic. Like much of the eighteenth century, however, it was not a time when warfare loomed large among the interests of painters who were struggling to create new ways of seeing the world. A partial exception was Edouard Manet, an immensely influential figure who, though drawn to the theme of war mainly as a reflection of the political issues of the day (about which he felt strongly), eventually responded to the violence and suffering that warfare brought.

Manet was born in 1832 in Paris to a prominent and prosperous family. He set up as an artist in his mid-twenties, and was soon a familiar figure in circles critical of the imperial regime of Napoleon III. He became particularly well known when the official Paris Salon rejected his *Déjeuner sur l'herbe* (Luncheon on the Grass) for their annual exhibition in 1863. This picture of a nude woman and two fully dressed men at a picnic, with the figures and food painted sharply and precisely, but much of the background sketchily and indistinctly, has come to be seen as one of the breakthrough moments in the development of modern art. It was to be followed by evocations of everyday life, adaptations of the masters of the past, and a boldness of composition and technique that made Manet a major inspiration for his fellow artists.

His first venture into the world of battle was in the year after *Déjeuner sur l'herbe*, when the American Civil War, though taking place 3,000 miles away, unexpectedly staged a European sideshow. The *Alabama*, a sloop commissioned by the Confederacy that had raided the Union's commercial shipping around the world, from the Pacific to South Africa, since 1862, had come to the French port of Cherbourg for a re-fit. As an ally of the South, the France of Napoleon III was a natural destination for the *Alabama*. But the sloop was being chased by a corvette from the North, the *Kearsarge*, which took up a position outside the Cherbourg harbor and summoned reinforcements. To avoid being trapped, the captain of the *Alabama* chose to fight, and in the engagement his ship was sunk, with a loss of over forty lives.

There is no evidence that Manet witnessed the battle off the French coast, but it was the sensation of the day, and he recorded the event in a dramatic canvas. Amidst a vast stretch of beautifully painted dark green, grey-flecked sea, the *Alabama* is sinking in a cloud of smoke in the middle distance, with the *Kearsarge*, flying the American flag, barely visible just beyond. The doomed vessel is surrounded by rescuers and perhaps spectators, notably a sailing ship in the foreground that seems to be a pilot vessel that is about to rescue two sailors clinging to a spar in the water. Despite the act of war that is its ostensible subject, though, this is hardly an evocation of death or destruction. If it had to be categorized, its most appropriate pigeonhole would probably be the seascape. Indeed, most commentators agree that Manet picked the subject, not as a battle scene, but because the episode was an embarrassment to Napoleon III's government; he used it to indicate the kinship he and his friends felt for the progressive forces of the North.

The same purpose may well have animated his next foray into a distant civil war. This time the conflict had erupted in Mexico, where the emperor, the Habsburg Maximilian I, brought from Europe and backed by the French, was overthrown by a republican revolt in 1867. The new government decided to execute Maximilian, and the event inspired Manet to produce, over the next two years, five different versions of the scene: three large canvases, a sketch, and a lithograph. Yet his involvement with the subject, which resulted in some of his finest work, seems again to have been prompted by political commitment rather than an interest in war. That the authorities prohibited publication of the lithograph is a clear indication of what was involved. For in every one of the depictions, except for the first painting, Manet showed the firing squad, not as the Mexicans who in fact carried out the execution, but as French soldiers (see figs. 78 and 79). The commentary on the government of Napoleon III was obvious, as Émile Zola pointed out in typically sarcastic fashion in *La Tribune* in February 1869:

> On examining a proof of the condemned lithograph, I noticed that the soldiers shooting Maximilian were wearing a uniform almost identical to that of our own troops. . . . You can understand the horror and anger of the gentlemen censors. What now! An artist dared to put before their eyes such a cruel irony: France shooting Maximilian!

A final indication of Manet's intentions may be the deliberate echo, in the composition, of Goya's *The Third of May 1808*. Once again, it is the foreign invaders who are the executioners.

But warfare came much closer to home a few years later. In July 1870 growing tensions with Prussia led to the outbreak of war, and by September Napoleon III's

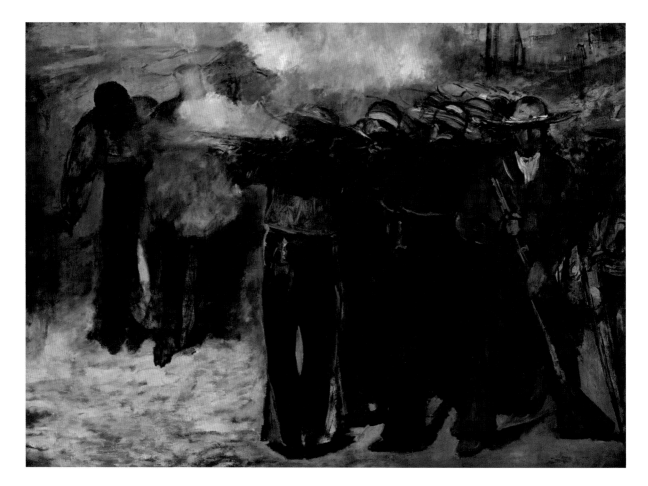

78 Edouard Manet, *Execution of Maximilian.* Manet's original painting shows the Mexican troops in the act of executing Emperor Maximilian. Much of the picture remains hazy and indistinct, as the artist seeks to convey the atmosphere, rather than the specifics, of the scene.

armies had surrendered and the emperor himself had been captured. Undeterred, his domestic opponents declared France to be a republic, recruited new troops, and refused to accept Prussian demands. The result was a siege of Paris, which finally fell in late January 1871, and eventually the signing of a humiliating peace treaty in May. Manet lived through the siege, but left for the far south-west of France as soon as it was over. He was still away when radical forces took over the government, the Commune, of Paris in March, and defied the National Assembly that assembled at Versailles. The response from Versailles was to besiege Paris again, and for most of April and May an increasingly bitter civil war raged. The Assembly's troops finally entered the capital on May 21st, and what followed came to be known as the "Bloody Week," when fierce resistance was crushed, barricades erected by the leaders of the Commune were overcome, and harsh reprisals began. Tens of thousands died, and tens of thousands were imprisoned or went into exile.

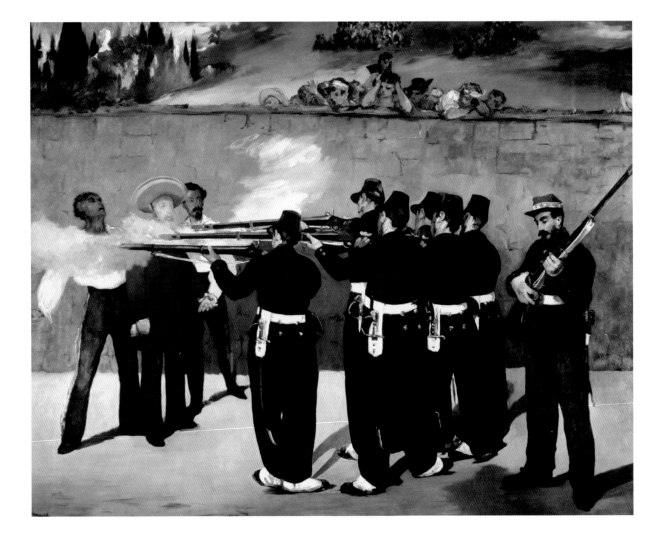

Manet returned to Paris at the end of "Bloody Week," and it was at this time that he produced two lithographs, *Civil War* and *The Barricade*, that, unlike his earlier works, represent a direct encounter with military conflict. The Prussian siege had prompted an etching of women in a line outside a butcher's shop that is dominated by their billowing umbrellas, but the only reminder of war is a bayonet in the background rising above the umbrellas. The agonies of civil war, on the other hand, inspired three haunting images. The first recalled a scene he apparently witnessed while walking through a devastated Paris with his friend, the art critic Théodore Duret, who reported that they had come upon a body lying in the street. Manet had made a quick sketch, and it was on this that the lithograph was based, though the

79 Edouard Manet, *Execution of Maximilian*. In a later version, more sharply focused, Manet changes the uniforms of the firing squad from Mexican to French. The sharpness suggests that this is how the scene looked, but in fact the painting is a thinly disguised attack on French policy.

artist seems also to have had other references in mind. The body echoes the one in his famous painting, *The Dead Matador*, as well as that picture's model, *The Dead Soldier*, long considered a Velázquez, though more recently attributed to an unknown artist. The engraving was also an opportunity for Manet to make a commentary on the consequences of war (see fig. 80). It may be, too, that he was recalling an earlier moment when he had come face to face with death in battle. When Napoleon III took power in 1851, there was a brief revolt in Paris, crushed by troops who killed more than a hundred people. Manet witnessed part of the struggle with a friend, Antoine Proust, who reported that the artist did a sketch of one of the corpses, though this has not survived. And he may well have known a famous lithograph by an older contemporary, Honoré Daumier, *The Empire Means Peace*, a bitter political comment on the collapse of Napoleon III's government in 1870, which showed a Paris street littered with bodies (see fig. 81).

Manet's *The Barricade* is no less pointed (see fig. 82). The original pen and ink sketch, reversed in the lithograph, seems to quote directly both Goya's *The Third of May 1808* and his own *Execution of Maximilian*, in that it shows a line of soldiers, rifles raised, firing directly, in foreshortened perspective, at the rebels who are manning the barricades. The echoes of scenes in which well-equipped troops gun down hapless victims are unmistakable.

80 Edouard Manet, *Civil War*. Manet's stark depiction of dead bodies that have been left lying in the street summons up the devastation of civil war more bluntly than any elaborate composition. That the lithograph was inspired by a sight that Manet himself had seen merely adds to its impact.

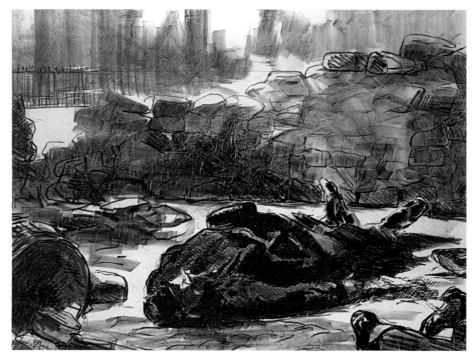

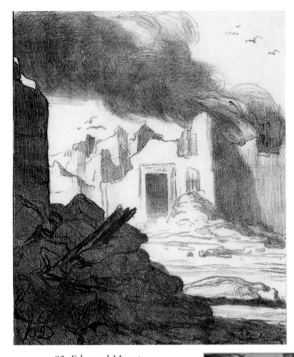

81 Honoré Daumier, *Empire Means Peace*. A brilliant satirist, Daumier was a master of irony. Hence the title of this lithograph, which shows the consequences of Napoleon III's ambitions: corpses in the street, rubble, and smoke rising from huge fires – in other words, desolation and ruin.

82 Edouard Manet, *Barricade*. Echoing both Goya and his own *Execution of Maximilian*, in this ink and watercolor sketch Manet captured the helplessness of Paris's civilians in the face of ruthless troops. When the barricades they had built proved to be futile defenses, their ability to resist trained soldiers soon collapsed.

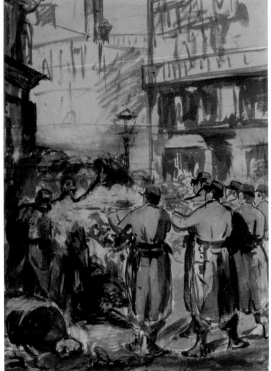

And Manet was to convey one more reminder of the nature of war. Unlike Daumier, whose weapon was satire – his last lithograph, in 1872, showed a group of angry skeletons as *The Witnesses* outside a meeting of the Council of War – he focused on the poignancy and suffering inherent in his subject. When the government decided to celebrate the establishment of the new Republic with a special festival in June 1878, Manet painted the scene near his home, *Rue Mosnier Decorated with Flags* (see fig. 83). But the street seems almost empty, its few pedestrians faint and indistinct, with one notable exception. In the foreground is a one-legged man on crutches, a vivid reminder of the consequences of the fighting earlier in the decade. As was the case with the other major artists of modern times, it was its pity that Manet recalled when, going beyond politics, he felt compelled to address the subject of war.

John Singer Sargent Visits the Front

There are many ways to win a war, and most of them require hard and relentless work – what Winston Churchill called "blood, toil, tears and sweat." But the dream of a short cut has always dazzled armies and their commanders. Military

83 Edouard Manet, *Rue Mosnier*. Manet's final comment on warfare came in this painting of his street. The largest figure is the one-legged man on crutches, clearly a victim of recent conflicts, though the reference is much subtler than the use of cripples by other artists such as Otto Dix.

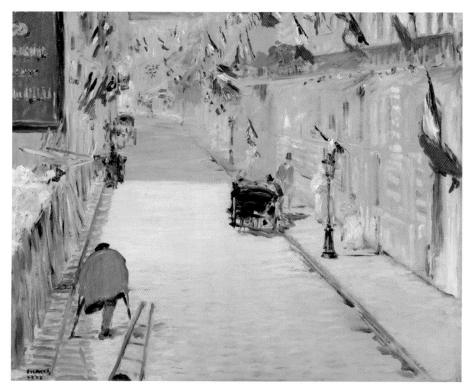

history is dotted with attempts at tactical masterstrokes designed to turn slow progress into sudden, convincing victory. Even more enticing, however, and equally uncertain in its effects, has been the hope for a technological break-through that could give one side unquestioned superiority over its opponents.

The quest for a decisive invention is as old as the experiments with tactics. Whether it was Archimedes' use of shields as mirrors to focus sunlight and burn enemy ships, or the development of the stirrup to help stabilize horsemen in battle, or the ingenuity lavished on weapons to hurl projectiles – from the crossbow through the multifarious applications of gunpowder – generals looking for an extra edge have been among history's most inventive and persistent experimenters. And whenever a new lethal device proved effective, it was quickly imitated, countered, refined, and ultimately made standard equipment until the next invention appeared. As we have seen, this has been one of the themes of modern warfare, with improvements in technology accelerating at an unprecedented rate. Apart from the atomic bomb, however, the impact of the inventor and the engineer on warfare has never been as spectacular as it was during World War I.

Three innovations in particular made the soldier's experience between 1914 and 1918 radically different. First was the airplane, which leaped from the Wright brothers' drawing board to the front line in little more than a decade. It rarely takes the military long to find a way to apply a technological breakthrough, and they had been interested in aerial weaponry for some time. During a revolt against the Austrian Empire in 1849, for instance, Venice was assaulted by an unmanned balloon carrying incendiary devices. Inevitably, therefore, airplanes quickly came to serve as weapons. By the end of World War I some could carry more than a ton of bombs. And, thanks to a clever invention – a synchronizing gear that permitted the firing of a machine gun through a whirling propeller – planes were able not only to shoot one another down more easily but also to strafe troops on the ground.

The second innovation was the tank, an armored vehicle conceived by an Englishman, Ernest Swinton, as a result of the marriage of two inventions: the internal combustion engine and the caterpillar-type tractor. Their combination created the first piece of weaponry that could resist machine-gun fire amid the rigors of trench warfare, and it was soon a common sight in France. In late 1917 the English launched the first massive tank assault – nearly four hundred smashed through enemy lines – in the battle of Cambrai, and its initial success transformed ground combat.

But it was the third of the technological advances that caused the most profound horror and fear: poison gas. The idea of such weaponry was not new – the ancient Greeks had used sulphur fumes to disperse enemies – but the progress of chemistry had made the danger more far-reaching, and in the nineteenth

century adversaries had agreed not to use it. Those agreements fell apart, however, when the Germans, frustrated by the stalemate of unmovable, entrenched positions, launched a huge greenish-yellow cloud, filled with chlorine, toward Canadian troops near Ypres in April 1915. The attack opened a four-mile gap in the lines, but by the next day the Allies had identified the gas and begun to take counter-measures. Ever more lethal varieties, notably mustard gas, were produced during the next three years by both sides, but for all the menace these chemicals posed, their delivery (mainly by wind, shell, and bomb) was too uncertain to achieve a decisive effect on the battlefield.

No artist could have seemed more unlikely to produce the most haunting image of this war than the American painter John Singer Sargent. Born in 1856 in Florence to a surgeon who had given up his Philadelphia practice to travel in Europe, Sargent had a pampered but peripatetic childhood. The family was nearly always on the move, and he spent his first eighteen years traveling among the principal European cities and resorts. Cosmopolitan and fluent in four languages, Sargent began drawing at a young age, encouraged by his mother, who herself had taken up watercolors. His talent was obvious, and in 1874 he began the serious study of art in Paris. By the 1880s he was a well-known figure in Parisian artistic and literary circles, exhibiting at the Salon and receiving commissions from the socially prominent.

In his twenties and thirties, Sargent visited America a number of times, and it was there that he began to win wide renown as a portrait painter, a reputation that grew when he settled in England in the 1890s. In London he became a fixture in high society, was elected to the Royal Academy, and cultivated friendships that ranged from aristocratic families to the novelist Henry James and the composer Percy Grainger. During these years Sargent created his trademark work – dreamy landscapes and seascapes, beautifully observed city scenes, and, above all, portraits of elegant, ethereal females, appealing children, and keen-eyed, often languid men. In his early fifties, though, he decided to cut back on the portrait commissions and the social whirl and to devote himself primarily to larger-scale works and to depictions of the places he visited during his many travels, especially his beloved Italy.

This was the figure from the *haut monde*, the master of grace and delicacy, whom the British government implausibly asked, in the spring of 1918, to travel to the front lines to record his impressions of a ghastly war. The Memorials Committee of the Ministry of Information offered the commission at a nominal fee, and the Prime Minister, David Lloyd George, personally wrote to Sargent to persuade him to accept. He agreed, left in July with his fellow artist and friend Henry Tonks, and remained in France for a few months, sketching and working extensively in the medium his mother had loved, watercolor.

The encounter with the war inspired a depth of feeling in Sargent for which there was little precedent in his earlier work. It is noticeable, for example, that the qualities associated with his art – soft colors and attention to architectural detail – are overwhelmed when he finds himself compelled (as in an urban scene called *A Street in Arras*) to comment on the effects of combat. If ever an artist was transformed by the experience of warfare it was Sargent. He was housed for a while in Arras, and his almost documentary record of the time and place is a study in contrasts: between the wreckage in the foreground and the elegance of the entrance to a fine house further down the street, or between the interesting varieties of the setting and the boredom of the troops who take what rest they can from the fighting (see fig. 84). The destruction of beauty has become a matter of complete indifference to the soldiers who are its cause.

Sargent was also aware of the new weaponry, and two of his watercolors suggest, at least implicitly, its ultimate futility. *A Wrecked Tank* shows little

84 John Singer Sargent, *A Street in Arras*. This may be a moment of lull in the war, but Sargent's watercolor does not let us forget the consequences of the fighting. Not only has a house been destroyed, but somehow a car has been hurled through the shattered wall.

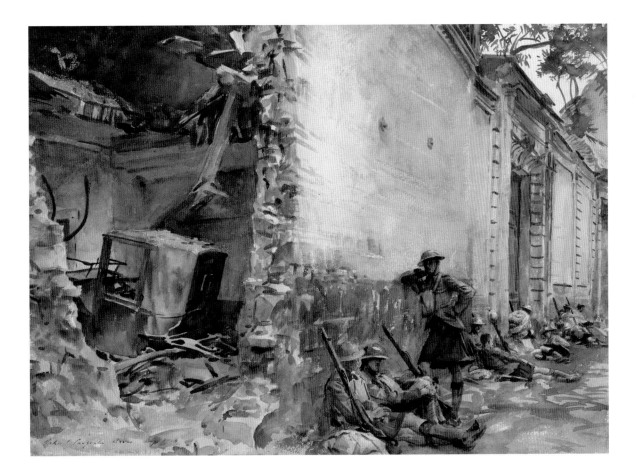

evidence of a once formidable machine (see fig. 85). Abandoned in the country-side are a few twisted pieces of metal, relics of an explosion and now no more than a rusting testimony to the devastation it could cause, reflected in a small row of crosses, probably grave markers, behind the tank.

In *Crashed Aeroplane* the message is hard to miss (see fig. 86). The wreckage is in the background, ironically surveyed by soldiers on foot and on a horse, the

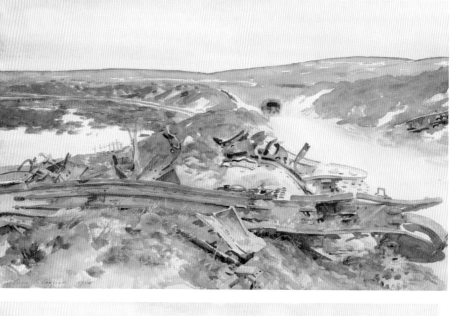

85 John Singer Sargent, *A Wrecked Tank*. It was not often in World War I that a tank could be destroyed. It was a dramatic enough subject, therefore, to prompt Sargent to produce a sketchy watercolor when he came across this scene of abandoned wreckage.

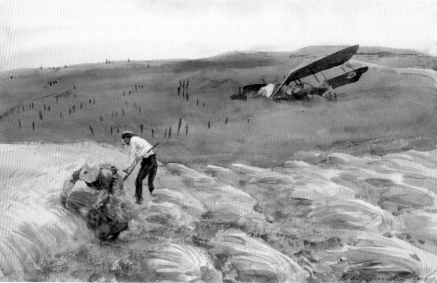

86 John Singer Sargent, *Crashed Aeroplane*. The farmer and his wife continue their labors while the plane in the background is examined. The watercolor could be an ordinary panorama of life in the countryside, except that the presence of an instrument of war, and its destruction, indicate Sargent's very different purpose.

one-time exemplar of speed and mobility. But in the foreground the life of the farmer goes on, unaffected by the destruction in the adjacent field. The scene recalls the famous canvas by Pieter Brueghel, *The Fall of Icarus*, which hangs in the Musée des Beaux-Arts in Brussels, and in which, as W. H. Auden wrote in a poem named after the museum,

> . . . everything turns away
> Quite leisurely from the disaster; the ploughman may
> Have heard the splash, the forsaken cry,
> But for him it was not an important failure.

For Sargent, too, life had to triumph over death.

Yet it was the third of the new weapons that stirred Sargent to create his masterpiece. He did not complain when he came under fire or shared the harsh conditions of the front, but he did write in September 1918, in a letter to a friend, of "a harrowing sight, a field full of gassed and blindfolded men." He made sketches of what he saw, and when he came back to London, he agreed with the Memorials Committee that the major work from his commission would be an enormous canvas – it turned out to be 20 feet long and 9 feet high – entitled *Gassed* (see fig. 87).

The painting evokes the misery and anguish of World War I, and it does so – as was so often the case with this highly cultivated artist – by drawing on historic imagery. For a start, *Gassed* echoes the military processions so familiar in ancient and Renaissance art. But it also resonates with the medieval theme of the Dance of Death and quite specifically with another poignant painting by Brueghel, *The Blind Leading the Blind* (see fig. 34), the powerful visualization of the biblical parable about futility and intolerance. Henry Tonks described the scene they had encountered on the Arras road in August 1918: "The Dressing Station . . . consisted of a number of huts and a few tents. Gassed cases kept coming in, led by an orderly. They sat or lay down on the grass, there must have been several hundred, evidently suffering a great deal." This was the scene, caused by a surprise mustard gas attack, that Sargent decided to commemorate.

Under a sky whose color is reminiscent of the gas, a line of blindfolded soldiers staggers toward the tent on the right. Around them lie other victims, and a second group approaches. In the sky, above a pale sun that also recalls Brueghel, tiny planes are engaged in combat, while in the distance some soldiers who escaped the attack relax in a game of soccer, ignoring the agony that surrounds them. Yet it is the central tableau of nine sightless men, still carrying their gear and their guns, that rivets our attention. They are being helped along by two orderlies, one of whom warns of a small step, and in response the third soldier, in a gesture that marks this

87 John Singer Sargent, *Gassed*. This huge painting by Sargent conveyed a powerful statement about the impact of the new weapons of World War I. In addition to the procession of blinded soldiers, the bodies of the wounded in the foreground emphasize the terrible cost of warfare.

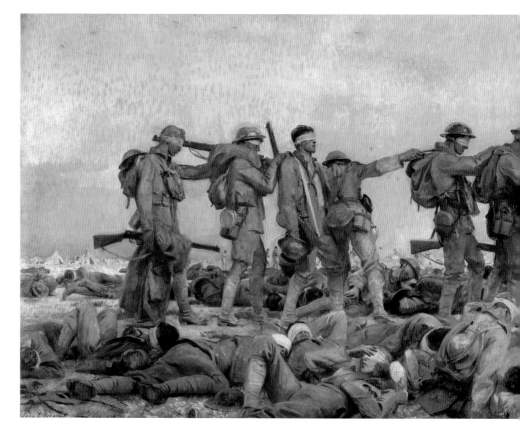

as a moment frozen in time, lifts his foot to exaggerated height to avoid tripping. The monumental scale of the procession gives it a heroic cast, and there seems little doubt that the artist is both documenting the torment caused by a gruesome form of warfare and creating a deeply moving tribute to the men who fought on amidst the suffering. The painting transforms one's appreciation of Sargent; no other work of art conveys more forcefully the fury and the fortitude of World War I.

The Artists of World War I

Because of its shattering impact on the consciousness of the time, the war remained a central subject for artists, poets, and writers long after it ended. If I focus on just one witness, and examine his most important work in some detail, it is not to dismiss his contemporaries, but rather to choose what I regard as the supreme masterpiece inspired by the conflict. That said, it still seems necessary briefly to suggest the range of artistic responses that these years provoked. On the 80th anniversary of the peace settlement, 100 paintings were assembled on a

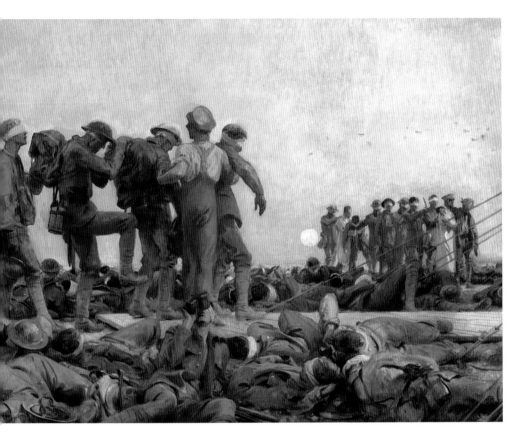

website, http://www.art-ww1.com/gb/peintre.html, which gives an indication of
the variety and extent of the works that were created, many by the most famous
figures of the time. If we pay special attention to just two of these artists, one an
Englishman and the other a German, it is because they can be taken to represent
the spectrum of commentary that the fighting inspired.

Christopher Nevinson, the son of two radical activists, started his training for
a career as an artist in his teens (Henry Tonks was among his teachers). In 1914,
when he was twenty-five years old, he declared himself a pacifist and volunteered
to work for the Red Cross, serving as an ambulance driver and a medical orderly
at the front. He later joined the Army Medical Corps, but was eventually invalided
out of uniform by rheumatic fever and appointed an official artist by the War
Propaganda Bureau. A firm believer in seeing his subjects at first hand, and
committed to the Futurist movement, a new influence on the art of the time,
Nevinson produced dozens of images of the war, both in realistic style and in the
fragmented representation that was characteristic of the Futurists. Among his
subjects were machine-gunners, aerial combat, marching and resting troops,

stretcher-bearers, dead soldiers, barbed wire, explosions, convoys, and even airplane mechanics. At times his work seemed to come straight out of the reportage tradition, showing what battle was like. This was what the Bureau required (as had governments for centuries), and although he was not always comfortable in the role, one should point out that some of his earlier paintings had also been of this kind. At least the Bureau never asked him to romanticize what was happening. In the end, however, his feelings about the war did come through.

The best example of the emotions the war aroused in Nevinson is a meticulously rendered portrayal of two dead soldiers, lying on barren, littered, muddy ground in front of rows of barbed wire (see fig. 88). Painted in painfully realistic fashion the painting brings the viewer right up to the front line. The stillness of the two young men, helmets off and faces down, is almost palpable. One of them continues to clutch his rifle, and on his left is a large hole in the ground that may have been left by the shell that killed him. The serene blue sky seems almost to mock these lost young lives. Most telling of all is the title Nevinson gave the painting: *Paths of Glory* (an ironic phrase we will encounter again). The point was not lost on the military censors, who refused to allow it to be displayed until after the war ended.

If reportage was at one end of the spectrum, denunciation was at the other. Here the archetype was the German artist Otto Dix. The son of working-class parents, Dix

88 Christopher Nevinson, *Paths of Glory*. The reference in the title of Nevinson's painting to Gray's "Elegy" suggests the relevance to these unburied soldiers of the poet's epitaph: "Here rests his head upon the lap of Earth/A youth to Fortune and to Fame unknown."

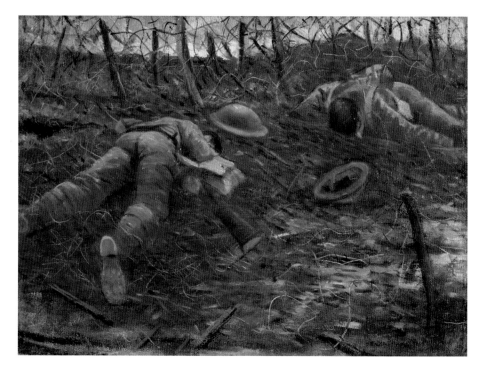

was in his early twenties when the war broke out, and, like so many of his contemporaries, joined the army with alacrity. He was to serve on both the eastern and western fronts (including the battle of the Somme) and suffered a number of wounds before he was discharged in 1918. As a soldier, he had made dozens of sketches, and these were to result in a series of fifty etchings entitled *The War* published in 1924. These have been compared with Goya's *Disasters*, though it has to be said that the unrelenting gruesomeness of the images – typical is a picture of a skull, with worms wriggling in and out of its every cavity – gives the series a sameness of tone that serves to arouse revulsion and dismay rather than admiration for the artist. That is not to deny the power of Dix's castigations of war. But his indictments were so savage that it was difficult to apply to them the aesthetic judgments that art usually evokes. A particularly troubling painting, *The Trench*, showing decomposing bodies after a battle, had to be hidden by the museum that bought it in 1923. Two years later the sale was canceled and the museum director dismissed. When the Nazis took over Germany in the 1930s, they denounced Dix as "degenerate," showed *The Trench* as an example of his debased work, and then had it burned.

As the creator of a distinctive vision of war, and as a martyr to artistic freedom, Dix is a major figure. But it is difficult to acknowledge any of these etchings or paintings as a masterpiece. And the same is true of the subjects he and a number of his German contemporaries took up in the 1920s, when peace returned. What these works offer is painful testimony to the omnipresence of the crippled and mutilated in the aftermath of the war. In one picture, Dix shows three card players festooned with artificial body parts (see fig. 89). A 2006 exhibition of this period of German portraiture at the Metropolitan Museum in New York, entitled "Glitter and Doom," was almost too distressing to absorb. The wounded in war had, centuries earlier, served Brueghel, whose cripples are a wrenching reminder of the maiming caused by combat, and we saw the theme recur in Manet; but it was never so dominant or so overwhelming as in post-World War I Germany. In the end, one is driven to the conclusion that it is the unremitting horror, rather than the virtuoso mastery, that draws the eye. Unlike Sargent, these artists created statements that, although overwhelming, derive their power from their message, not because they are exemplary achievements of art.

Edward Lutyens's *Memorial to the Missing of the Somme*

There has been an attempt in this survey to include as many as possible of the media through which artists fashioned images of war, yet one major form of expression has eluded us in fully realized form: architecture. There is no doubt that buildings and construction designs make statements. And we saw how, in

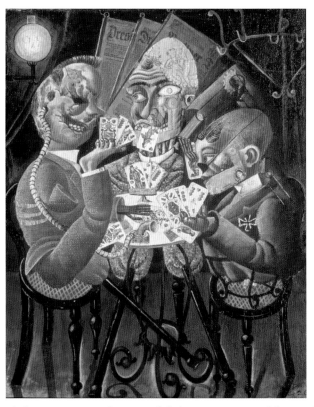

89 Otto Dix, *Card Players*. Dix seems almost to relish the gruesomeness of the casualties that were caused by World War I. It is hard to look more than briefly at the ghastly injuries that these three veterans of the fighting have suffered.

Palladio's hands, an architect was influenced by warfare as he set about his work. Moreover, the border between sculpture and architecture blurs in such cases as the Triumphal Arches and the Victory Columns of ancient Rome. But we have not so far seen an architectural masterpiece that in and of itself conveys what its creator wished to say about the world of military combat. It took the unprecedented horrors of World War I to inspire such a work.

Most of the time, architects are concerned with buildings where people live, work, or congregate. These may include barracks, homes for retired soldiers, military academies, and other buildings connected with warfare. But for direct responses to war itself one must look to structures that, instead of being habitable, are intended as celebrations or recollections of armed struggle. These have taken various forms, of which by far the most common and well known has been the Triumphal Arch. Invented in ancient Rome as the setting for the return to the city of a victorious army and its commander, the shape recurred over the centuries in

countless elaborations: higher, lower, wider, narrower, single arches, multiple arches, and crossing arches, all in virtually endless variations. Many are splendid monuments, essential focus points for cities – most notably, perhaps, the Arc de Triomphe that commemorates Napoleon's victories, at the intersection of twelve massive avenues and boulevards in Paris. If none of these arches strikes one as a masterpiece of architecture, it may well be because the elements seem so familiar and straightforward, and thus an unlikely stimulus to great inspiration. Moreover, it is in their surfaces and decorations, rather than their overall shape, that they refer to combat – in sculptured depictions of victories, similar to the Assyrian carvings, or in inscriptions that record battles or warriors. Not until the twentieth century did an arch itself become a way of commenting on military conflict.

Its architect was Sir Edward Lutyens, one of the most prolific practitioners of his trade in history. Born in 1869 into a distinguished family, noteworthy for its soldiers, he was set apart from his twelve brothers and sisters by an illness that prevented him gaining a formal education. Instead, he developed a deep interest in the buildings of the countryside surrounding his home. He would roam widely by bicycle and on foot, studying their appearance and the materials with which they were made. From a family friend, Randolph Caldecott, a well-known illustrator of children's books, he learned to sketch. Increasingly, his trips became opportunities to draw and to talk to carpenters, glaziers, and other craftsmen, as he prepared himself for his lifelong passion. When he was sixteen he was sent to what is now the Royal College of Art to study architecture, and from then on he remained devoted to his profession until his death in 1944.

In his early years Lutyens was much in demand for additions to country houses, homes for the gentry in the countryside, and public buildings as far afield as Johannesburg, Washington, and Rome, not to mention plans and buildings for a new suburb in London. Versatile as well as prolific, he gained worldwide fame in his early forties, on the eve of World War I, when he was appointed as the principal designer of an entire city: New Delhi, the new capital of India. This was a commitment that was to continue for many years, marked by the completion of an enormous government complex, Viceroy's House, and a huge India Gate that has become a national monument. The Gate, formally the All-India Memorial, is an arch nearly 140 feet high, built in the 1920s to honor the Indian troops who died in World War I. Its construction reflected a new interest that increasingly preoccupied Lutyens during the war, and eventually led to the masterpiece that we will consider below.

The new preoccupation was the campaign to honor all those who had given their lives in the war. Its four years had witnessed slaughter on a scale unknown in human history. Estimates suggest that, combining dead and wounded, both military and civilian, total casualties exceeded 30 million. Of those who lost their lives,

about a million came from Britain alone. As the magnitude of the losses became apparent, a major initiative, unprecedented in the history of war, was launched by a unit of the British Red Cross to locate and identify the graves of those who had died. In 1917 this effort became formalized, under royal charter, as the Commonwealth War Graves Commission, and Lutyens was appointed as one of its three official architects, charged with the task of designing cemeteries and memorials.

Over the next decade he became more closely identified with these tributes to the dead than any other architect. More than twenty memorials, from Colombo to Manchester, bear his name within the former British Empire, and his memorials and cemeteries remain, to this day, a major feature of the recollections of war that are scattered across north-eastern France. In addition, he designed for the War Graves Commission a solemn tomb-like structure, the so-called Great War Stone, or Stone of Remembrance, which has been placed in more than a hundred cemeteries, wherever more than 1,000 combatants are buried. Always inscribed with a line from Ecclesiastes, "Their Name Liveth for Evermore," the stones, which evoke the coffin-like structures used, since antiquity, as funeral decorations, make Lutyens an almost universal presence at sites that recall the casualties of World War I. He also designed a cross for the Commission, but it was primarily his memorials and cemeteries that made him the exemplar of his nation's determination to remember the sacrifices of the war. For all of the far-ranging variety of his enterprises – and they included banks, cathedrals, tombstones, fountains, bridges, castles, colleges, an embassy, and even an immense hotel, Grosvenor House, in London – his single most consistent commitment after 1917 was to the genre that makes him a unique figure in the history of architecture.

The assignment that established his special role as an artist of commemoration arrived in mid-1919, a few months after the end of the war. Britain's Prime Minister, David Lloyd George, aware that France's victory parade reached its climax at the Arc de Triomphe, wanted Britain's celebration to have a similar focal point. Returning to London from the peace negotiations in Paris, he summoned Lutyens, and asked him to devise an appropriate monument. With the parade scheduled for July 19th, Lutyens had just two weeks to comply. The Prime Minister suggested a catafalque, a coffin-like shape, but the architect preferred a cenotaph, an empty tomb raised on a high plinth (see fig. 90). In an astonishing burst of speed, he designed it within a day, and had it built of wood and mortar in time for the parade. Erected in the middle of Whitehall, a broad avenue surrounded by government buildings, the memorial captured the nation's attention, and by the time of the second anniversary of the armistice, on November 11th, 1920, the temporary version had been rebuilt in stone. To this day, the Cenotaph, a model of simplicity, its elevated tomb adorned only by a carved wreath, two sets of flags (which Lutyens had wanted carved in stone), and the

inscription "The Glorious Dead," remains Britain's most cherished site for solemn occasions, especially the recollection of war.

Although elegantly conceived, widely admired, and much imitated, the monument is by no means Lutyens's chief claim to fame. It has been much analyzed – especially its use of a slight curvature, learned from the Greeks, to fool the eye into thinking the lines are straight. (Thus the verticals would converge about 1,000 feet in the air, while the horizontals would expand into a circle whose center would be 900 feet below ground.) But amongst the many commemorative undertakings, one in particular stands out. It has been called an act of pure architecture, and what makes it so unusual is that its very structure proclaims the artist's response to warfare.

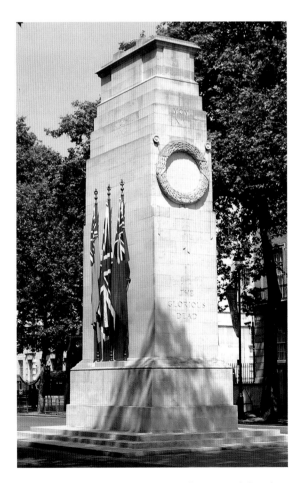

90 Edwin Lutyens, *Cenotaph*. This simple stone memorial is Lutyens's best-known work, standing in the middle of Whitehall, at the heart of London's governmental buildings. Although constructed as a World War I memorial, it serves as the center of all commemorations of Britain's war dead.

91 Edwin Lutyens, *Memorial to the Missing of the Somme.* The complex design of Lutyens's *Memorial* resolves itself, when seen from a distance, into a grim but imposing structure. There is nothing quite like it on this or any other battlefield – an overpowering reminder of the agony of war.

The structure in question is the *Memorial to the Missing of the Somme*, erected in the village of Thiepval, at the heart of the Somme battlefield, and dedicated in 1932. Although it is an extraordinary feat of architecture, it suffered from exactly the same disregard we have already noted in the case of Mathew Brady: the determination, during the first generation after terrible devastation, to avoid reminders of horrors now past. No architectural journal took serious note of the dedication, even though the memorial is the largest such British structure in the world. Doubts were also raised about its cost, and it may well have been the tepid reaction that persuaded the War Graves Commission to make this their last significant British memorial for the dead of World War I.

The original idea for what was to become the Thiepval monument was approved by the Commission as early as 1921, but various objections by the French (including a demand that the arch be lowered so that it would not be taller than the Arc de Triomphe) meant that consent for the location and the design was not finalized until 1929. Among the changes that happened over these years was a move of the site from the city of St. Quentin, one of the main strategic points in the Somme front lines, to the bleak rural setting of Thiepval; a shift in purpose, from recalling an advance to recalling the missing; and a reduction in the number of names to be commemorated from 60,000 to 30,000, a decision that was reversed – the number has since risen to 73,000 as new information has emerged. Given this fraught history, it was no small achievement that Lutyens was eventually able to realize his vision in 1932.

The memorial is 145 feet high, and is essentially a set of variations on the theme of the arch (see fig. 91). Depending on how one counts them, there are more than twenty arches, of varying heights and shapes, piled on top of one another, which together constitute the monument. On every side of the sixteen piers on which the arches rest are the panels engraved with the names of the missing. It may be, as architectural historians have argued, that the plan was necessary in order to provide space for so many thousands of engraved letters, all legible from ground level. But one cannot help feeling that Lutyens picked the arch theme as a way of making a memorial for those who had been killed in battle out of a structure that for 2,000 years had served as a means of celebrating military prowess. If so, the reversal was an astonishing coup.

His own feelings about the tragedy of 1914–18 were unambiguous. His great-granddaughter, Jane Ridley, quotes him as saying: "The magnitude of that host of boys that lie fearfully still, quickens the sense of unspeakable desolation." To drive the lesson home, the dominant color of the monument is the blood red of its so-called French bricks – small, rough-surfaced bricks, which he used for a number of his structures, such as Folly Farm in Hampshire. The highlights are of white Portland stone. When viewed as a totality, it seems almost a piece of

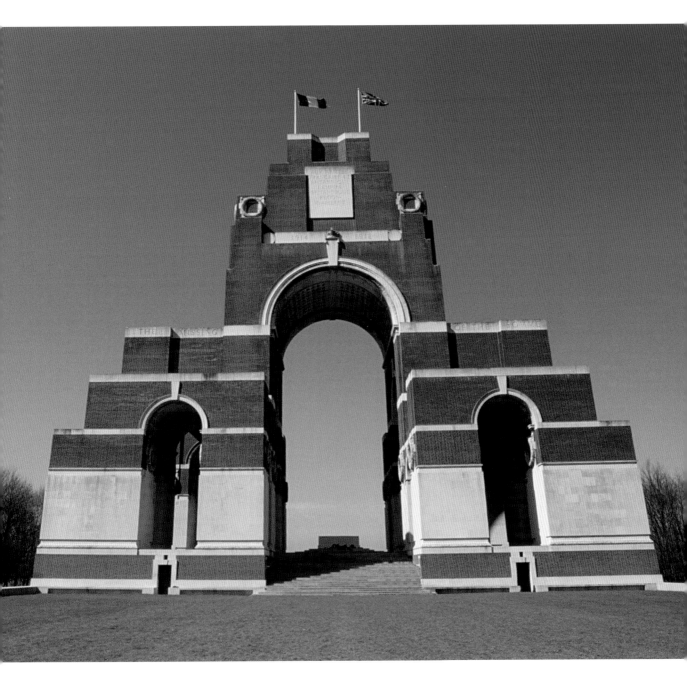

sculpture, and yet its highly complicated proportions, which have been shown by various analysts to comprise precise geometric relations, mark it unequivocally as a work of architecture. It was the architectural historian Christopher Hussey who called it a "great abstraction of pure architecture," and that is indeed what it is.

But how, beyond the blood-red color and the recording of the names of the dead, is it a statement about war? On this question two distinguished architectural historians strongly disagree. The first, Vincent Scully, has suggested that the answer emerges when one looks at the monument head-on. The second, Gavin Stamp, has called the ensuing conclusions "over-emotional," consisting as they do of a diatribe against "insatiable war" and an attribution to Lutyens of menace and ferocity that is hard to connect to the architect himself. Nevertheless, if one recalls the powerful image that had been created in various media, including lithographs, by the Norwegian artist Edvard Munch, one can see why Scully could argue that Lutyens had fashioned, out of brick and stone, an agonized response to the fate of the young men who had fallen in war: a gigantic scream.

Picasso's *Guernica*

The invention of the airplane was the first breakthrough in the twentieth century's discovery of a new human sensation: speed. Within fifteen years of the Wright brothers' momentous journey in December 1903, planes were flying at over 100 miles an hour and promising to transform not only travel but dozens of other areas of life, from geographic exploration to postal services. Nor was it long before nations realized that aviation could also be applied to war.

By the time World War I began in 1914, some 2,000 aircraft were available to fly sorties in support of the opposing armies; by the end of the war in 1918, more than 11,000 were operational. The damage they caused, except to one another, was not extensive, but their value in expanding the possibilities of reconnaissance was obvious. And it would not be long before designers and manufacturers of armaments provided them with the capacity to rain death and destruction on a massive scale from the skies.

The earliest major opportunity to display this prowess after World War I arose during the next significant armed conflict in Europe: the Spanish Civil War, which erupted in July 1936. The previous February, a new government had been elected that was strongly opposed to Spain's growing fascist movement, the Falange (meaning "phalanx"). In response to governmental efforts to suppress fascist activity, a number of army units revolted, and the result was civil war. General Francisco Franco, who soon became the leader of the insurgents, won active support from the fascist governments of Benito Mussolini in Italy and Adolf Hitler in

Germany, while the legal government of Spain attracted thousands of volunteers but little effective help from its natural allies in leftist circles throughout Europe.

The government's supporters, known as Loyalists, were particularly strong in the north-eastern province of Catalonia, including its capital, Barcelona; around the nation's capital, Madrid; and in the territory of the Basques, in the north. Gradually, however, over the course of nearly three years of devastating onslaughts, Franco's well-equipped armies crushed all resistance, and by March 1939 he ruled supreme in Spain. Ever since, one episode amidst the carnage has stood out as the embodiment of the slaughter that Franco was willing to inflict on his fellow Spaniards in pursuit of his ends.

Early in 1937, his armies were advancing through the Basque country and closing in on Guernica, a town of some 7,000 inhabitants near the city of Bilbao. There was a small armament factory on the edge of town, but it was scarcely a significant military target. Yet for the Basques Guernica was a holy place, the site of the province's parliament and also of an oak tree under which, each year for centuries, their leaders had stood and sworn to uphold their liberties. On April 26th, Guernica was about ten miles from the front, and at 4.30 that afternoon a single bell tolled a warning of approaching aircraft. What followed was unspeakable horror.

Over the next three hours, forty-three aircraft, piloted and commanded by Germans, dropped 100,000 pounds of incendiary and high-explosive bombs on Guernica and machine-gunned inhabitants who fled through the streets from the flames that were gutting the town. Miraculously, both the parliament house and the oak tree survived, but over 1,500 civilians, about a fifth of the inhabitants, did not. And the armament factory was untouched. The commander of the squadron, Wolfram von Richthofen, was a distant cousin of the swashbuckling Manfred von Richthofen, the "Red Baron," the most famous of the flying aces of World War I; but Wolfram now created a far different image for his family, for German fliers, and for the Spanish fascists.

Franco's propagandists claimed that the Basques had blown up their own town (a lie that the Germans' own accounts have exposed). And many of the opponents of leftist politics elsewhere in Europe tried to minimize what had happened. When local priests went to Rome to try to get the Church to condemn the bombing, they were dismissed by Cardinal Pacelli, soon to become Pope Pius XII, who noted that "the Church is persecuted in Barcelona." But one Spaniard did manage to stir Europe's conscience.

The artist Pablo Picasso, born in Spain in 1881, had left his native land in 1904 in order to move to Paris, the nerve center of new ideas in art. He had been a crucial figure in the transformation of painting and sculpture during the three

decades that followed, notably in the creation of Cubism and in the revolt against representational and figurative art.

Picasso's sympathies were always with the left, and though he remained in Paris, in 1936 he was delighted to accept from the Spanish Republican government the honorary post of director of the Prado, Spain's most famous museum. His anger and despair over Franco's victories mounted during 1936, and when he heard the news of the bombardment of Guernica he determined to use his art to protest the barbarity of the assault.

Picasso had been commissioned to paint a mural for the Spanish Pavilion at the Paris World's Fair of 1937, but for months he had been unable to settle on a theme. Now the questions vanished, and in little more than a month he completed what is perhaps the most famous painting of the twentieth century. From this burst of creativity there emerged a huge canvas, more than 11 feet high and 25 feet wide, and also more than fifty austere and compelling preparatory studies. There have been dissenters from the accolades that followed, but most people regard the fevered achievements of May 1937, seen as a whole, as Picasso's masterpiece.

The power of *Guernica* may at first sight seem surprising (see fig. 92). In an age when many believed that visual propaganda had to be simple, immediately understandable, and even crude if it was to be effective, Picasso's difficult, allusive, and allegorical images must have seemed an unlikely vehicle for the transmission of a clear or even comprehensible message. It is true that he had been drawing and painting rampaging bulls for a number of years, and that it did not require much interpretive insight to make the analogy with the bullfight and see the animal as the embodiment of Spain. But what about the rest? The horse, the gestures, the light bulb, the disconnected objects and body parts?

Picasso himself is said to have realized the difficulty, and to have pointed out that he meant the bull to represent brute irrationality, whereas the horse stands for civility and decency. Indeed, the horse is adjacent to, and illuminated by, the lantern and the lamp, traditional symbols of the light of reason. And the elucidations have not stopped there. Scholars have identified dozens of sources for the images, including paintings by Picasso's Spanish forebears Velázquez and Goya, and Rubens's *Horrors of War*. Also telling are the upraised arms, which refer to a favorite gesture of the Republicans; the broken sword; and the traditional association of women with the quest for peace.

Among Picasso's many inspirations, however, is one that stands out: the connection with a painting, completed over a hundred years before, that had long been famous as a response to the brutalities of warfare. In the Prado, Picasso had seen, and doubtless knew well, Goya's *The Third of May 1808*, the second of the two pictures that had commemorated the uprising against the Napoleonic troops

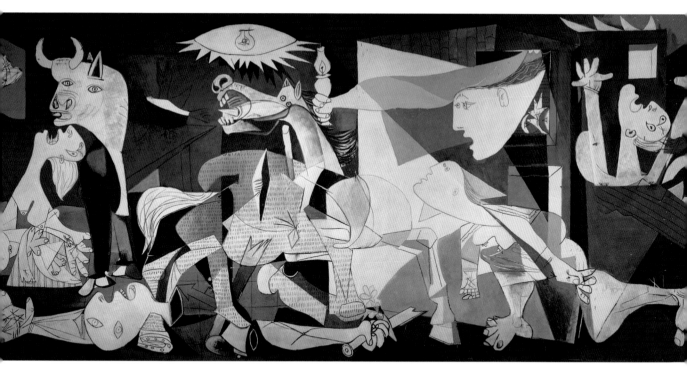

occupying Spain. During that episode, too, the heavily outgunned Spaniards had been brutally repressed by foreign soldiers, a bitter foretaste of the events of the 1930s. In particular, the references in Goya's painting to the Crucifixion seem to have had special meaning for Picasso in 1937: both the outstretched arms and the hint, on the outstretched hands, of the stigmata.

As some commentators have noted, the outstretched arm at the lower left of *Guernica* seems deliberately to recall Goya's martyr. What drives the connection home is the large dot that appears amidst the markings of the hand – a reference to Christ's stigmata not visible on the other hands in the painting. Picasso, in other words, used every artistic resource available to him in order to express his anguish. The avowedly secular leftist was prepared to draw even on Christian traditions and iconography. The reference may be obscure, but it reveals how completely the message of martyrdom, innocence, and self-defeating violence dominates *Guernica*.

And yet, few among the hundreds of thousands who have flocked to see the painting have needed such detailed explanations. The screaming woman holding her dead infant on the left, the agonized and crushed figures, the flames, the somber colors dominated by grays, and the distortions, all of which merely intensify the anguish and violence of the scene, have been more than sufficient to convey the meaning and the force of the painting. One cannot stand before the

92 Pablo Picasso, *Guernica*. The absence of color in Picasso's masterpiece connects it to earlier examples of art critical of warfare by Callot, Goya, Brady, and Manet. It seems fitting that *Guernica* can be viewed as the culmination of that heritage, and possibly the last example of a distinguished tradition.

huge canvas without experiencing the senselessness, the destruction, and the loss that defined the bombing of Guernica.

* * *

If the most moving responses of artists to war since the time of David seem united in condemnation, that is perhaps no surprise. After all, for millennia, from the Assyrians until the Renaissance, the unanimity had served a contrary end. What is remarkable in our story is that the consensus shifted gradually from one pole to its opposite. The progression has not been unbroken, but the rise of unanimity has been accompanied by a sparsity of masterpieces. Given the multitude of depictions of war in the past two hundred years, it has been necessary to set austere requirements for inclusion in a chapter that might otherwise have doubled the size of this book. Yet the aim has remained to honor not only major achievements but also works that can be taken to represent, at the most challenging level, the range of artistic engagements with warfare.

One of the ways to set manageable limits has been the decision not to venture beyond the 1930s. One can argue that more than seventy years have to pass before a masterpiece can be recognized, but there are also other justifications. First, as will be emphasized in the Afterword, a new visual medium, film, has inherited the mantle of its fellow arts as a means of making powerful statements about war. Film is a huge subject in itself, well beyond the scope of this small book, particularly since the message in this medium is no longer one-sided. There are notable achievements on both sides of the pro-war/anti-war divide, a topic that has generated a considerable literature, and one that would take us too far afield.

Second, as the arts have become more abstract and personal, they have become less likely to treat military conflict. Even when the style is representational, though, war seems to have become a less gripping theme. The most haunting images are, not of combat, but of a pervasive malaise or, when more specific, of the subject that is taken up by one of George Segal's most famous sculpture groups: *The Holocaust*. The focus, in other words, is on the horror of man's inhumanity whether on the battlefield or far from it, rather than on any particular war where that horror has loomed large. Moreover, when the subject is addressed, as it is, for example, in Samuel Bak's *War Games*, the theme is the perpetual recurrence of warfare, not a response to its specifics. In this regard, such treatments belong in a large family of post–World War II paintings (the *oeuvre* of Francis Bacon is an obvious example) that have cast a searching light on violence and anguish, but not on the actual events that are their cause.

Of course, the subject has not disappeared from view. There were "war artists" like Eric Ravilious in World War II, and many others who have addressed the dozens of

subsequent explosions of violence, including terrorism, around the world. But it is difficult to find in these works a new direction, let alone a new chapter, in the story we have told. Future historians may decide otherwise, but that prospect merely reinforces the conviction that in the year 2011 it makes sense not to move beyond a painting completed in 1937 in the search for a final exemplar for our narrative.

It seems appropriate to end with *Guernica*, finally, because the sea change in warfare that came about in World War II – not only the unprecedented scale of the hardship and the loss of life but also the birth of the atomic age – made the subject almost too titanic for a single work of art. If there were new approaches to be explored, they tended to be generic meditations on the human propensity for violence rather than reactions to particular acts of war. Those who sought to continue the traditions we have been exploring often turned, instead, to the new art form of film. Here – where vision, sound, and movement could blend together; where complex narration was possible; and where the transition from individual feeling to the large-scale and the universal was both easy and natural – was the most effective means, in a changing world, for the artist to respond to the warrior.

Afterword

FILM

The atrocity that Picasso evoked was soon to be overshadowed by bombings on a much larger scale in World War II, and by acts of inhumanity in Nazi Germany that descended to depths far lower than any that had been reached before. Europe was entering a time when it became hard to imagine a single painting encompassing monstrosities that made a mere thousand or so victims pale into insignificance. It seemed almost inevitable, therefore, that creative masters should turn to a new art form, film, to respond to this new kind of warfare – both its barbarity and its ability, nevertheless, to draw willing accomplices into its fervor. What is surprising, as war has threatened for the first time to obliterate all mankind, is the continued determination of artists, through moving pictures, to arouse and capture deep feelings that have long been tapped by their predecessors in stone, metal, ceramic, cloth, paper, and paint. To do minimal justice to the varieties of responses to warfare in film would be to write a new book in an area that has already been widely explored. Yet it may be useful to indicate briefly some of the ways in which filmmakers have echoed the themes and concerns that animated sculptors, painters, and architects for over three millennia. That will at least suggest how the story that we ended at Guernica continues to arouse artistic responses, albeit of a very different kind. The aim, however, is the same: to outline some basic categories and to suggest what is no more than an armature – an underdrawing that sketches the structure of the field, leaving it to more detailed studies to elaborate.

Definitions of a masterwork are as personal in this new medium as in all the arts, but a few exemplary cases can again indicate how the belief in warfare as a positive force could be as stirring as it was for the sculptors of Nineveh or the weavers of Bayeux, or how a director could convey a vision no less grim than that of Goya or Sargent. What follows, therefore, is a sampling drawn from a number

of countries and periods, designed to document how the traditions we have examined of artistic responses to war have been inherited by the makers of films.

Sergei Eisenstein was born in Latvia in 1898, but moved at the age of seven to St. Petersburg, where he planned to follow in his father's footsteps as an engineer. Then, however, the revolution of 1917 intervened; he was caught up in its passion; and in its aftermath he settled in Moscow, where he was drawn to the theater and then to film. His first full-length feature, the silent *Battleship Potemkin*, celebrating a naval mutiny in 1905, made him world famous. Its mastery of powerful images, of the narrative technique known as montage, and of crowd scenes made it not only extremely effective as political propaganda but also profoundly influential as a pioneering piece of filmmaking. What followed were years of international wandering and projects that came to naught until, in the mid-1930s, he returned to the Soviet Union and spent two years on a film, *Bezhin Meadow*, that was subject to constant interference from Stalin's regime, went through a number of versions, and in the end was never completed or released. The government finally ordered production to stop in March 1937. Eisenstein at that point fell seriously ill, which made it all the more impressive that he was able to complete in 1938 his first fully realized feature film with sound.

This work, *Alexander Nevsky*, is as rousing a tribute to valor and the glory of war as any of the celebrations we encountered in ancient Rome or medieval times (see fig. 93). Appropriately, it recounts an episode from the thirteenth century, when one of the redoubtable military orders founded during the Crusades, the Teutonic Knights, who had turned their attention to the conquest of lands around the Baltic after they lost their foothold in the Holy Land, invaded the Republic of Novgorod, a territory that eventually became part of Russia. The decisive battle, fought on a frozen lake and known as the Battle on the Ice, took place in 1242 and ended the threat from the Teutonic Knights. Eisenstein in 1938 doubtless had the looming threat of German invasion in mind as he chose his subject, and he was able to combine the austerity of the setting with the emotions of the protagonists to devastating effect. Not only is his hero, the Novgorod commander Alexander Nevsky, an iconic representation of bravery and determination, but the climactic scene – a half-hour-long recreation of the Battle on the Ice – is an irresistible trumpeting of what military ardor can achieve. To that end, Eisenstein commissioned a musical score from Russia's leading composer, Sergei Prokofiev, which is essential to the film's impact. The inexorable pressure that carries the audience along is a testament to Eisenstein's ability to compel admiration for the virtues of the warrior.

A more nuanced advocacy, but one that remained firmly committed to the importance of heroic deeds in battle, characterized the 1954 film by the Japanese

93 Sergei Eisenstein, *Alexander Nevsky*. In this scene from the battle on the ice that is the climax of Eisenstein's film, the array of lances recalls Callot and Velázquez. Although the reference is fleeting because of the movement the new medium made possible, it reflects the force of artistic tradition.

Akira Kurosawa: *The Seven Samurai*. Kurosawa was born in 1910 to a family descended from Samurai, a warrior class that had been prominent in Japan since the Middle Ages but had lost its military role by the nineteenth century. He had hoped for a career as a painter, but by his mid-twenties he began working in film and in the 1940s gradually built his reputation as a director. His breakthrough came in 1951, when a film that had done only moderately well in his native land, *Rashomon*, was entered without his knowledge into the competition at the Venice Film Festival. Kurosawa won the top prize, the Golden Lion, and from then on his work was eagerly awaited throughout the world.

It was not until 1954, however, that the next project to win international acclaim appeared. This was *The Seven Samurai*, an epic that ran for nearly three and a half hours, and on which he had been working since December 1952. Kurosawa was to explore combat and its effects in the Samurai era in many of his movies, notably *Yojimbo*, *Kagemusha*, and two adaptations of Shakespeare plays, but it was in *The Seven Samurai* that he most clearly explored both the nobility of the warrior and the ultimate disillusion that the fighting man has to face (see fig. 94).

The story, as one might expect in so long a film, is many-sided and complex. It begins when a group of bandits are overheard planning to attack a village once its harvest is gathered and loot will be plentiful. Having already suffered from the assaults of the same gang, the villagers decide that their only chance of survival is to hire some Samurai to defend them. Their initial efforts fail, but eventually they find a Samurai who gradually assembles a team of seven to plan the defense of the village. There are a number of sub-plots in the interim, notably an episode when the chief Samurai shaves off his identifying topknot of hair in order to pose as a priest. Unarmed, he then overcomes a sword-wielding kidnapper who has taken a child hostage. The nobility of the warrior is repeatedly emphasized, not least when a brash young man challenges a Samurai, and insists they use real swords. "What a waste," says the chief Samurai, just before the inevitable death of the young man.

Kurosawa used a cast of hundreds, and insisted that a real village be built, rather than a studio set. This expanse made possible a sweep and a sense of movement that could never have been achieved indoors. In scene after scene, we see crowds of villagers running as they follow the action or join in the fighting, and it is the choreography that creates some of the film's most powerful effects. Crucial, too, was the decision to shoot in black and white rather than color. This had been true of *Rashomon*, and it seemed more appropriate for the world of the Samurai too, for it underlined the stark contrasts that were at the heart of the film's dualities: between the warrior and the farmer, between bravery and cowardice, between refinement and barbarity.

94 Akira Kurosawa, *Seven Samurai*. The horseback charge, with spears raised, is a basic way of envisioning the warrior. Its appearance in Kurosawa's *Seven Samurai* indicates how persistent, for artists, has been an image that resonated in the Bayeux Tapestry, the *Heiji Monogatari Emaki*, the *Süleymanname*, and Titian's *Charles V*.

The long scene that marks the climax of the movie, as in *Alexander Nevsky*, is the battle. In this case it is not a clash of two armies, but a contest pitting the Samurai and their villagers against the bandits. Once again, though, it is the valor and the high skills of the victors that are highlighted. A small band of heroic figures defends the right and crushes the schemes of villainy. In the course of the battle, four of the seven Samurai are killed, but both the gang and its chieftain are wiped out. As a result, the village can resume its peaceful ways.

The final remark of the film, however, is telling. As the Samurai leader watches the local population return to work, planting the next rice harvest, he compares the loss of his four colleagues with the benefits that have been brought to the villagers. "Again we are defeated," he says. "The farmers have won. Not us." There is no question that Kurosawa has shown, with some power, how battle promotes exceptional human achievement. Yet the tinge of disillusion at the end adds a dimension that is absent from *Alexander Nevsky*.

If these two films represented the continuing inclination of artists to glorify the warrior, they are nevertheless exceptions in a century that brought out the best from its creative figures when they expressed their antipathy to combat. To suggest how this outlook was reflected in cinema is to be overwhelmed by candidates for inclusion. In America alone, from *All Quiet on the Western Front*, on World War I, shot in the early days of sound, to *In the Valley of Elah* and *The Hurt Locker*, on the Iraq War in 2007 and 2008, the drumbeat of anti-war movies is unrelenting. With such abundance, selection is invidious, and so I shall focus on just one masterly treatment that suggests how films have taken up the message conveyed by Goya, Brady, Lutyens, and their contemporaries.

Paths of Glory, completed in 1957, bears (as did the Nevinson painting) an ironic title which gains its point from its origin, a line in Thomas Gray's *Elegy*: "The paths of glory lead but to the grave." Built around an episode from World War I, it is an unsparing examination of the futility and the brutalizing effects of war (see fig. 95). Its director, Stanley Kubrick, was in his late twenties at the time, and the film was the first full indication of the original and compelling vision he was to bring to the cinema over the next forty years. The son of a New York doctor, Kubrick came to the movies via photography and short documentaries. He had begun making feature films in the 1950s, but *Paths of Glory* proved to be the first of ten astonishingly varied masterworks that he directed over the following decades, including *Lolita*, *Dr Strangelove*, *2001: A Space Odyssey*, and *The Shining*.

The inspiration for *Paths of Glory*, and the novel by Humphrey Cobb on which it is based, was the mass mutiny by French soldiers in May 1917. Convinced that the incessant artillery barrages, the assaults they had to launch, and their mounting casualties served no useful purpose, some 30,000 French troops abandoned their trenches on the front lines and refused to return. Army commanders responded with thousands of court-martials, at which over 20,000 men were convicted of mutiny. Punishments varied, but some forty or so were executed. It was these death sentences, and the maneuverings by officers that they reflected, that suggested the subject for both novel and film.

Like Kurosawa in *The Seven Samurai*, Kubrick shot *Paths of Glory* in black and white in order to achieve a harshness and bleakness that accorded with his subject. Much of the story centers on the corruption of the officers, who order a senseless attack for their own reasons, and then execute three scapegoats to divert attention from their failures. Although Kubrick was opposed to all forms of organized religion, he drew on the image of Christ's Crucifixion (as had Goya and Picasso before him) in the execution scene, where the three figures (as in the biblical story) are put to death. Everything, in other words, served the purpose of an unremitting denunciation of war. Its perpetrators are corrupt, its

95 Stanley Kubrick, *Paths of Glory*. The suffering Christ has provided artists with a powerful symbol for the agonies of war. Both Goya and Picasso (a professed atheist) used the reference in their work, and Kubrick (no Christian) likened the execution in *Paths of Glory* to the Crucifixion scene.

victims helpless and innocent, and even the one decent, honest participant – an officer who sees through his colleagues' deceits – is unable to avoid disillusion and disgust. It is a wrenching story, austerely conveyed; even a touch of humanity in a final scene, when the music of a German girl's song overcomes the hostility of the soldiers, is overshadowed by a reminder that the men will soon have to return to the front. Although Kubrick was to come back to the subject of combat, in *Barry Lyndon* and *Full Metal Jacket*, there is no question that, among his films,

the one that is the most potent successor to Goya's *Disasters of War* is *Paths of Glory*.

There are, of course, many other candidates for such a title. The German G. W. Pabst's *Westfront 1918*, the Frenchmen Abel Gance's *J'Accuse!* and Jean Renoir's *Grand Illusion*, the Japanese Masaki Kobayashi's trilogy, *The Human Condition*, and the growing number of movies that focus on the hardships of the individual soldier – the German *Das Boot*, set in a submarine, or the Israeli *Lebanon*, set in a tank, are good examples – leave little doubt about the writers' or directors' unhappy response to combat. It is true that there are many varieties in the spectrum of war films. Occasionally, for instance – as in the final scene of the American Leo McCarey's Marx Brothers comedy *Duck Soup*, in Kubrick's *Strangelove*, or in the Englishman Richard Attenborough's *Oh! What a Lovely War* – directors have adopted a satiric stance that is all too rare in the visual arts. In a kind of middle ground, too, have been historical epics set in the distant past, such as Gance's *Napoléon*, where there has been greater willingness to celebrate military virtues, though these have rarely reflected contemporary concerns. And there have been many movies that rejoice in heroic exploits, not to mention a relish for the explosions and mayhem available through special effects. World War II, in particular, with its strong claim (unlike World War I) to have been a struggle against evil, produced a succession of celebratory films, from the British *In Which We Serve* to the American *Guns of Navarone*. Yet the tendency in recent years has clearly been toward productions that treat the world of the soldier with the same unease that we have seen in other forms of modern artistic expression.

The story that began with the Assyrians, the Greeks, and the Romans has thus reached a stage, as the third millennium dawns, that these forebears could never have envisioned. The one-time ally of the warrior, the artist, has turned to the skepticism, and even antagonism, that, as was implied at the very outset of this narrative, seemed the natural relationship between these two very different professions. What remains unequivocal, though, is the dazzling range of the galaxy of masterpieces that has been inspired by the interaction of the artist and the warrior.

Bibliography

Ancient and Medieval Warfare

David S. Bachrach, *Religion and the Conduct of War, c. 300–1215* (Rochester, NY, 2003)
Brian Campbell, *War and Society in Imperial Rome, 31 BC–AD 284* (London, 2002)
Philippe Contamine, *War in the Middle Ages,* tr. Michael Jones (Oxford, 1984)
Stephen English, *The Army of Alexander the Great* (Barnsley, 2009)
John W. I. Lee, *A Greek Army on the March: Soldiers and Survival in Xenophon's Anabasis* (Cambridge, 2007)
Stephen Morillo, *Warfare under the Anglo-Norman Kings 1066–1135* (Rochester, NY, 1994)
Helen Nicholson, *Medieval Warfare: Theory and Practice of War in Europe, 300–1500* (New York, 2004)
Bustenay Oded, *War, Peace and Empire* (Wiesbaden, 1992): on Assyrian warfare
Michael Prestwich, *Armies and Warfare in the Middle Ages: The English Experience* (New Haven, CT, 1996)
Philip Sabin, Hans van Wees, and Michael Whitby, eds., *The Cambridge History of Greek and Roman Warfare*, 2 vols. (Cambridge, 2007)
Pat Southern, *The Roman Army: A Social and Institutional History* (Santa Barbara, 2006)
J.F. Verbruggen, *The Art of Warfare in Western Europe during the Middle Ages: From the Eighth Century to 1340*, 2nd edn. (Rochester, NY, 1997)
Robin Waterfield, *Xenophon's Retreat: Greece, Persia, and the End of the Golden Age* (Cambridge, MA, 2006)

Assyria

Mehmet-Ali Ataç, *The Mythology of Kingship in Neo-Assyrian Art* (Cambridge, 2010)
Paul Collins, *Assyrian Palace Sculptures* (London, 2008)
Stephanie Dalley, *Esther's Revenge at Susa: From Sennacherib to Ahasuerus* (Oxford, 2007)
Eva Strommenger, *The Art of Mesopotamia*, tr. Christina Haglund (London, 1964)

Greek Vases

P. E. Arias, *A History of Greek Vase Painting,* tr. and rev. B. B. Shefton (London, 1962)
Diana M. Buitron-Oliver, *Douris: a Master-painter of Athenian Red-figure Vases* (Mainz am Rhein, 1995)
Erika Simon, *Die griechischen Vasen*, 2nd edn. (Munich, 1981)

The Alexander Mosaic

Bernard Andreae, *Das Alexandermosaik aus Pompeji* (Recklinghausen, 1977)

Augustus, Marcus Aurelius, and Trajan

Filippo Coarelli, *The Column of Trajan,* tr. C. Rockwell (Rome, 2000)

Werner Eck, *The Age of Augustus* (Malden, MA, 2007)

Ronio Hölscher, "Images of War in Greece and Rome: Between Military Practice, Public Memory, and Cultural Symbolism," *Journal of Roman Studies*, 93 (2003), 1–17

Diana E. Kleiner, *Roman Sculpture* (New Haven, CT, 1882)

Frank Lepper and Sheppard Frere, *Trajan's Column: A New Edition of the Cichorius Plates* (Gloucester, 1988)

Frank McLynn, *Marcus Aurelius: Warrior, Philosopher, Emperor* (London, 2009)

Ian Richmond, *Trajan's Army on Trajan's Column* (London, 1982)

Lino Rossi, *Trajan's Column and the Dacian Wars,* tr. J. M. C. Toynbee (London, 1971)

Francesco Silverio, *Trajan's Column,* tr. R. Amen (Rome, 1989)

Manuscripts from St. Gall

Melanie Holcomb, *Pen and Parchment: Drawing in the Middle Ages* (New Haven, CT, 2009)

Adolf Merton, *Die Buchmalerei in St. Gallen: Vom neunten bis zum elften Jahrhundert* (Leipzig, 1912)

Peter Ochsenbein, ed., *Das Kloster St. Gallen in Mittelalter: Die kulturelle Blüte vom 8. bis 12. Jahrhundert* (Stuttgart, 1999), esp. pp. 167–205: Anton von Euw, "St. Gallen Kunst im frühen und hohen Mittelalter."

http://commons.wikimedia.org/wiki/Category:The_Leiden_1_Maccabees_manuscript_/_Codex_PER_F_17

The Bayeux Tapestry

George Beech, *Was the Bayeux Tapestry Made in France? The Case for Saint-Florent of Saumur* (New York, 2005)

Pierre Bouet, Brian Levy, and François Neveux, *The Bayeux Tapestry: Embroidering the Facts of History* (Caen, 2004)

Martin Foys, Karen Overbey, and Dan Terkla, eds., *The Bayeux Tapestry: New Interpretations* (Rochester, NY, 2009)

Lucien Musset, *The Bayeux Tapestry,* tr. Richard Rex (New York, 2005)

Sir Frank Stenton, ed., *The Bayeux Tapestry: A Comprehensive Survey* (London, 1957)

Hugh M. Thomas, *The Norman Conquest: England after William the Conqueror* (Lanham, MD, 2008), esp. Part 1

Japan

William W. Farris, *Heavenly Warriors: The Evolution of Japan's Military, 500–1300* (Cambridge, MA, 1992)

John Hall and Marius Jansen, eds., *Studies in the Institutional History of Early Modern Japan* (Princeton, NJ, 1968)

George B. Sansom, *A History of Japan*, 3 vols. (Stanford, 1958–63), Vol. 1

http://learn.bowdoin.edu/heijiscroll/ and http://learn.bowdoin.edu/heijiscroll/viewer.html

The Early Renaissance

Franco and Stefano Borsi, *Paolo Uccello,* tr. E. Powell (New York, 1999), esp. pp. 212–31.

A. G. Dickens, ed., *The Courts of Europe: Politics, Patronage and Royalty, 1400–1800* (London, 1977), esp. Chapter 2: "The Courtier" by Sydney Anglo

Dietrich Erben, *Bartolomeo Colleoni: die künstlerische Repräsentation eines Condottiere im Quattrocento* (Sigmaringen, 1996)

J. R. Hale, *Artists and Warfare in the Renaissance* (New Haven, CT, 1990)

——, *Renaissance War Studies* (London, 1983), esp. Chapter 14

——, *War and Society in Renaissance Europe, 1450–1620* (New York, 1985)

Bert S. Hall, *Weapons and Warfare in Renaissance Europe: Gunpowder, Technology, and Tactics* (Baltimore, MD, 1997)

H. W. Janson, "La signification politique du David en bronze de Donatello," *Revue de l'Art*, 39 (1978), 33–38

——, *The Sculpture of Donatello*, 2 vols (Princeton, NJ, 1957)

Marilyn A. Lavin, *Piero della Francesca* (London, 2002)

Michael Mallett, *Mercenaries and their Masters: Warfare in Renaissance Italy* (London, 1974)

Bernd Roeck and Andreas Tönnesmann, *Die Nase Italiens: Federico da Montefeltro, Herzog von Urbino* (Berlin, 2005)

Christine M. Sperling, "Donatello's Bronze 'David' and the Demands of Medici Politics," *Burlington Magazine*, 134, no. 1069 (April 1992), 218–24

Jeryldene M. Wood, ed., *The Cambridge Companion to Piero della Francesca* (Cambridge, 2002)

The Sixteenth and Seventeenth Centuries

Alessandro Barbero, *Lepanto: La battaglia dei tre imperi* (Laterza & Figli, 2010)

Philip Benedict, *Graphic History: The Wars, Massacres and Troubles of Tortorel and Perrissin* (Geneva, 2007)

Robert W. Berger, "Bernini's Louis XIV Equestrian: A Closer Examination of its Fortunes at Versailles", *Art Bulletin*, 63, no. 2 (June 1981), 232–48

Christopher Brown, *Van Dyck* (Ithaca, NY, 1982)

Jonathan Brown, *Velázquez, Painter and Courtier* (New Haven, CT, 1986)

Jonathan Brown and John Elliott, *A Palace for a King: The Buen Retiro and the Court of Philip IV*, 2nd edn. (New Haven, CT, 2003)

Peter Burke, *The Fabrication of Louis XIV* (New Haven, CT, 1992)

Niccolò Capponi, *Victory of the West: The Story of the Battle of Lepanto* (London, 2006)

Roger Crowley, *Empire of the Sea: the Siege of Malta, the Battle of Lepanto, and the contest for the Center of the World* (New York, 2009)

Pia Cuneo, ed., *Artful Armies, Beautiful Battles: Art and Warfare in Early Modern Europe* (Leiden, 2002)

John Elliott, *Europe Divided, 1559–1598*, 2nd edn. (Oxford, 2000)

Stanley Ferber, "Peter Bruegel and the Duke of Alba", *Renaissance News*, 19 (1966), 205–19

Mary D. Garrard, *Artemisia Gentileschi: The Image of the Female Hero in Italian Baroque Art* (Princeton, NJ, 1989)

Felix Gilbert, "On Machiavelli's Idea of Virtu," *Renaissance News*, IV (1951), 53–55 [the title in the original does not have the accent over the "u" of "virtu"]

William P. Guthrie, *Battles of the Thirty Years War: From White Mountain to Nördlingen, 1618–1635* (Westport, CT, 2002)

Craig Harbison, "A Note on Terbrugghen's 'Sleeping Mars,'" *Burlington Magazine*, 116 (1974), 35–38

Julius Held, "Le Roi à la Ciasse," *Art Bulletin*, 40 (1958), 139–49

Paul Hills, "Titian's Fire: Pyrotechnics and Representations in Sixteenth-Century Venice," *Oxford Art Journal*, 30 (2007), 185–204

Amelie Ishmael, *Images of Violence: Jacques Callot's Misères et les Mal-Heurs de la Guerre* (Academic.edu, 2008): http://saic.academia.edu/AmeliaIshmael/Papers/233768/Images_of_Violence_Jacques_Callots_Miseres_et_les_mal-heurs_de_la_guerre

Ruth S. Magurn, tr. and ed., *The Letters of Peter Paul Rubens* (Cambridge, MA, 1955), esp. letter 242.

R. H. Marijnissen, *Bruegel* (New York, 1984)

Stephen Murillo and Michael Pavkovic, *What Is Military History?* (Malden, 2006), esp. Chapter 4

Erwin Panofsky, *Problems in Titian, Mostly Iconographic* (New York, 1969)

Geoffrey Parker, *The Army of Flanders and the Spanish Road, 1567–1659: The Logistics of Spanish Victory and Defeat in the Low Countries' Wars*, 2nd edn. (Cambridge, 2004)

——, *The Military Revolution: Military Innovation and the Rise of the West, 1500–1800*, 2nd edn. (Cambridge, 1996)

Theodore K. Rabb, "Artists and Warfare: A Study of Changing Values in Seventeenth-Century Europe," *Transactions of the American Philosophical Society* (1985), 79–106

——, *The Struggle for Stability in Early Modern Europe* (New York, 1975)

Michael Roberts, *Essays in Swedish History* (London, 1967), Chapters 3 and 7

H. Diane Russell, ed., *Jacques Callot: Prints & Related Drawings* (Washington, 1975)

Fritz Saxl, "The Battle Scene without a Hero: Aniello Falcone and his Patrons," *Journal of the Warburg and Courtauld Institutes*, 3 (1939–40), 70–87

Roy Strong, *Van Dyck: Charles I on Horseback* (London, 1970)

Frank Tallett, *War and Society in Early-Modern Europe, 1495–1715* (London, 1992)

Peter Wilson, *The Thirty Years War: Europe's Tragedy* (Cambridge, MA, 2009)

War as Decoration

James S. Ackerman, *Palladio* (Baltimore, MD, 1966)

Esin Atil, *Süleymanname: the Illustrated History of Süleyman the Magnificent* (New York, 1986)

Guido Beltramini, ed., *Andrea Palladio and the Architecture of Battle: With the Unpublished Edition of Polybius' Histories*, tr. David Kerr (Venice and New York, 2009)

Sheila S. Blair and Jonathan M. Bloom, *The Art and Architecture of Islam 1250–1800* (New Haven, CT, 1995)

J. R. Hale, "A Humanistic Visual Aid: The Military Diagram in the Renaissance," *Renaissance Studies*, 2 (1988), 280–98

Roger B. Merriman, *Suleiman the Magnificent* (Cambridge, MA, 1944)

Ferenc Toth and Janos B. Szabo, *Mohács, 1526: Soliman le magnifique prend pied en Europe centrale* (Paris, 2009)

Som Prakash Verma, *Interpreting Mughal Painting: Essays on Art, Society, and Culture* (New York, 2009)

André Wink, *Akbar* (Oxford, 2009)

David versus Goya

Philippe Bordes, *Jacques-Louis David: Empire to Exile* (New Haven, CT, 2005)

Owen Connelly, *The Wars of the French Revolution and Napoleon, 1792–1815* (London and New York, 2006)

Enrique Lafuente Ferrari, *Goya: El dos de mayo y Los fusilamientos; estudio critico* (Barcelona, 1946)

——, *Goya, Complete Etchings, Aquatints, and Lithographs*, tr. Raymond Rudorff (London, 1963)

Pierre Gassier and Juliet Wilson, *Vie et oeuvre de Francisco Goya: l'oeuvre complet illustré, peintures, dessins, gravures*, ed. François Lachenal, preface by Enrique Lafuente Ferrari (Paris, 1970)

David Gates, *The Napoleonic Wars, 1803–1815* (London and New York, 1997)

Louis Marchesano and Christian Michel, *Printing the Grand Manner: Charles Le Brun and Monumental Prints in the Age of Louis XIV* (Oxford, 2010)

Warren E. Roberts, *Jacques-Louis David, Revolutionary Artist: Art, Politics, and the French Revolution* (Chapel Hill, NC, 1989)

Gunther Erich Rothenberg, *The Napoleonic Wars* (London, 1999)

Peter-Klaus Schuster and Wilfried Seipel, with Manuela B. Mena Marqués, *Goya: Prophet der Moderne* (Cologne, 2005)

Hugh Thomas, *Goya: Third of May 1808* (New York, 1972)

The Pity of War

Rudolf Arnheim, *Picasso's Guernica: The Genesis of a Painting* (Berkeley, 1962)

Antony Beevor, *The Battle for Spain: The Spanish Civil War, 1936–1939* (New York, 2006)

Beth Archer Brombert, *Edouard Manet: Rebel in a Frock Coat* (Chicago, 1996)

S. G. Butler, with George Stewart and Christopher Hussey, *The Architecture of Sir Edwin Lutyens*, vol. III (Woodbridge, 1950), pp. 41–42

Alex Danchev, *On Art and War and Terror* (Edinburgh, 2009)

M. R. D. Foot, *Art and War: Twentieth Century Warfare as Depicted by War Artists* (London, 1990)

On Alexander Gardner: http://www.indianahistory.org/library/manuscripts/collection_guides/ P0420.html#BIOGRAPHICAL

James D. Horan, *Mathew Brady, Historian with a Camera* (New York, 1955)

Christopher Hussey, *The Life of Sir Edwin Lutyens* (London and New York, 1950)

John Keegan, *The Face of Battle* (New York, 1978), esp. Chapter IV: "The Somme"

——, *The First World War* (London, 1998)

——, *The Second World War* (London, 1989)

Elaine Kilmurray and Richard Ormond, eds., *John Singer Sargent* (Princeton, NJ, 1998)

Lawrence L. Langer, *In a Different Light: The Book of Genesis in the Art of Samuel Bak* (Boston, 2001); see also the images available from www.puckergallery.com

James McPherson, *Battle Cry of Freedom: The Civil War Era* (New York, NJ, 1988)

Roy Meredith, *Mr Lincoln's Camera Man: Mathew B. Brady*, 2nd edn. (New York, 1974)

Philip Nord, "Manet and Radical Politics," *Journal of Interdisciplinary History*, 19 (1989), 447–80

Stanley Olson, *John Singer Sargent, his Portrait* (London, 1986)

Mary Panzer, *Mathew Brady and the Image of History* (Washington, 1997)

Geoffrey Parker, ed., *The Cambridge History of Warfare* (Cambridge, 2005), esp. Part Four

Olaf Peters, ed., *Otto Dix* (New York, 2010)

Carter Radcliff, *John Singer Sargent* (New York, 1982)

Sabine Rewald, *Glitter and Doom: German Portraits from the 1920s* (New York, 2006)

Jane Ridley, *The Architect and his Wife: A Life of Edwin Lutyens* (London, 2002), pp. 316–17 & 352–53

Marianne Ruggiero, "Manet and the Image of War and Revolution: 1851–1871," in Bell Art Gallery, *Edouard Manet and the Execution of Maximilian* (Providence, RI, 1981), pp. 22–38

Vincent Scully, *Architecture: The Natural and the Manmade* (New York, 1991), Chapter 11

Tim Skelton and Gerald Gliddon, *Lutyens and the Great War* (London, 2008)

Gavin Stamp, *The Memorial to the Missing of the Somme* (London, 2006)

Alice D. Tankard, *Picasso's Guernica after Rubens's Horrors of War* (Philadelphia, PA, 1984)

Anne Ullmann, ed., *Ravilious at War: The Complete Work of Eric Ravilious* (Upper Denby, Huddersfield, 2002)

Gijs van Hensbergen, *Guernica: The Biography of a Twentieth-century Icon* (New York, 2004)

Nigel Viney, *Images of Wartime: British Art and Artists of World War I* (Newton Abbot, 1991)

Michael Walsh, *C.R.W. Nevinson: This Cult of Violence* (New Haven, CT, 2002)

Aterword

James Goodwin, *Eisenstein, Cinema, and History* (Urbana, IL, 1993)

Thomas A. Nelson, *Kubrick: Inside a Film Artist's Maze* (Bloomington, ID, 2000)

Mitsuhiro Yoshimoto, *Kurosawa: Film Studies and Japanese Cinema* (Durham, NC, 2000)

Index

Note: Page references in bold refer to figures.

Abel 3
Achaemenid dynasty 15
Achilles 1, 12
Adam and Eve 129
Adriatic Sea 31, 127
Aelianus Tacticus 134
Aeneas 1, 2
Aesop's Fables 44, 45
Afghanistan 140, 154
Africa 92, 93
Agar gun 167
Agincourt, battle of 64, 129
Agra 140, 141
aircraft 166, 183, 186, 187, 198
Ajax 12, 13, 14, 21
Akbar, Mughal emperor 126, 140–43, 147
Akbarnama 140–43, **144, 145, 146,** 147
Alabama 176, 177
Alba, Fernando, duke of 86–89
Alexander Mosaic xvi, 14, 17, **18–19,**
 20, 21
Alexander the Great 6, 14–20, 24, 37, 102,
 140, 153
Ali, Mir Sayyid 142
Ali Pasha 93
allocution 25, 28, 29
All Quiet on the Western Front 209
Alps 88, 154–56, 159
Altdorfer, Albrecht 102
 Battle of Alexander at Issus 102
Amalekites 2
America and Americans 69, 99, 153, 167,
 169–77, 184, 209, 211
 American Civil War 167, 169–76
 Confederacy forces 170, 171, 176, 177
 Union forces 170, 176, 177

Andreae, Bernard 17, 19
Anglo-Saxons 43, 44
Antietam, battle of 169, 171, 172, 175
Antietam creek 171
Antiochus IV Epiphanes, emperor 37,
 38, 40
Antony, Mark 25
Antwerp 87, 112, 113
Aosta 155
Apelles 17
Aphrodite (*see also* Venus) 12, 21
Apocrypha *see* Bible
Apollo 13, 25
Apollodorus of Damascus 29, 30, 31
Arabic 38
Arabs 8
archeologists 7, 17
archers 5, 8, 9, 23, 31, 35, 37, 38, 55, 65, 68
Archimedes 183
architecture 132, 133, 135, 191–98
Arezzo 74, 78
Arifi *see* Fethullah
Ariosto, Ludovico 84
 Orlando Furioso 84
Aristotle 17
Armada, Spanish 85, 107
armor 5, 8, 13, 26, 28, 31, 36, 44, 68, 73, 74,
 75, 78, 94, 118, 119, 132, 143
Army of Northern Virginia 170, 171
Army of the Potomac 170
Arras 185, 187
artist, nature of xv, xviii
Asia 15, 34, 35
Asia Minor 6, 15, 16, 154
Assur 4
Assurbanipal, king of Assyria 7–11

Assyria, Assyrians xv, 4, 5, 6, 7–11, 12, 20, 21,
 24, 42, 48, 153, 193, 202, 211
 Assyrian army 4, 5, 8–10
Athena 12, 13, 21
Athens and Athenians 5, 6, 11, 12, 69
Attenborough, Richard 211
 Oh! What a Lovely War 211
attitudes to war (*see also* warrior) xv–xvi, 74,
 78, 83, 96, 97, 114, 125, 202
 anti-war 89–90, 91, 101, 103, 106, 108,
 112, 158 *ff.*, 202, 204, 207–11
 celebration 12, 20, 21, 33, 48, 56, 64, 91,
 94, 96, 127, 153, 158, 168
 decoration 126–47
 idealization 37, 49, 50, 204, 209
 pathos 12, 21, 48
 reportage xv, 33, 102, 114–18
Auden, W. H. 187
Augustina 160
Augustus, Roman emperor 2, 23–26, 27, 28,
 29, 34, 118, 140
 Augustus of Prima Porta 24, **25, 26**
Austria and Austrians 110, 127, 148,
 154–56, 183
Avigliana, battle of 102
Avignon 63

Babur, Moghul emperor 140, 141
Babylonia and Babylonians 37, 97
Bacon, Francis 202
Bahia 108
Bak, Samuel 202
 War Games 202
Balkans 91, 126, 127, 129, 132
Baltasar Carlos, Spanish prince 118, 121
Baltic Sea 83, 205
Baltimore 170
Barbaro, Daniele 133
Barcelona 199
barracks 83
Baskin, Leonard 99
Basques 199
Bastille Day 156
Battle on the Ice 205
"battle without a hero" 102, 114–18, 126
Bavaria 170
Bayeux 42–48, 204
 Bayeux Tapestry 42, 44, **45–47**
Bayonne 159, 160
Beethoven, Ludwig van 153, 158
 Fidelio 153
Belgium *see* Flanders and Low Countries
Belgrade 127, 128, 132
Beltramini, Guido 134, 135

Benedict, Philip 103
Bengal 140
Bennett, Arnold 99
Bergamo 70, 71
Bernini, Gianlorenzo 121, 125, 158
Berruguete, Pedro 77
 Federico da Montefeltro **77**
Bethlehem 89
Bethulia 98
Bhurah 142
Bible 1, 2, 3, 37–41, 88, 89, 97, 99
 Apocrypha 97
 Old Testament 37, 97
Bilbao 199
Black Sea 6
Blücher, Gebhard Leberecht von 156
Bohemia 127
Bologna 59
bombs 166, 183, 184, 199, 202, 204
Bormida river 155
Botticelli, Sandro 99
Bourbon family 159, 163
Bourdon, Sébastien 120
 Queen Christina **120**
bows 8, 9, 13, 36, 55, 80, 183
Brady, Mathew 169, 171–76, 196, 209
 Confederate Dead Gathered for Burial **174**
 Lincoln and his Officers **175**
 On the Antietam Battlefield 172, **173**
 Robert E. Lee 172, **173**
Breda 102, 103, 107, 108, 110
Brenta river 135
Britain and British *see* England
Brittany 45
Brueghel, Pieter 83–91, 96, 101, 103, 113,
 125, 152, 158, 165, 187, 191
 Blind Leading the Blind 87, **88**, 187
 Census at Bethlehem 88, 89
 Conversion of Paul 88
 Fall of Icarus 187
 Massacre of the Innocents **89, 90**
 Triumph of Death 87
Brunelleschi, Filippo 59
Brussels 86, 87, 89, 187
 Musée des Beaux-Arts 187
Bucephalus 17
Buda 128, 129
Buddhism 50
Bull Run, battles of 170, 171, 172
Burgundy 170
Byzantium and Byzantines 74, 99

Cádiz 108
Caelus 25

Caesar, Julius 132, 134, 135, 155
 Commentaries 134
Cain 3, 169
Calabria 170
Caldecott, Randolph 193
Callot, Jacques xv, 101–6, 107, 108, 113, 115,
 158, 165
 Miseries of War 103, **105–6**, 107, 108, 161
 Plundering a Large Farmhouse 103, **105**
 Plundering a Village **106**
 Siege of Breda 102, 103, **104**
 Siege of La Rochelle 102, 103, **104**
 The Hanging **105**
Calvinism 86
Cambrai, battle of 183
camel 8
Canaanites 97
Canadians 184
cannon 57–58, 79, 81, 84, 129, 142,
 143, 149–50
cannonballs 58
Canterbury 42
Canute, English king 43, 44
Caravaggio 99, 115
Carda, Bernardino della 66
Carlyle, Thomas 155
Castiglione, Baldassare 73, 74, 118
 Book of the Courtier 73, 74, 118
Castillon, battle of 57, 79
castles 35, 81
Catalonia 199
Catholicism 86, 93, 170
cavalry 6, 16, 22, 35, 36, 46, 80, 81, 128, 129,
 132, 134, 149, 152, 158, 160, 163, 167
Channel, English 43, 44, 45
Charge of the Light Brigade 165, 167
chariots 5, 9, 11, 16, 17, 18, 20, 25, 74
Charlemagne, emperor 34, 36, 50, 91,
 154, 156
Charles I, king of England 112, 119, 122, 123
Charles IV, king of Spain 156, 158, 159, 160
Charles V, Holy Roman Emperor 34, 92, 93,
 94, 118, 119
Charles of Lorraine 127
Chartres 99
Cherbourg 176
Chester 23
China 35
Chitor 142, 143
chivalry 35
Christianity and Church, 21, 27, 34–35, 36,
 38, 48, 49, 62, 63, 85, 91, 92, 93, 126,
 132, 141, 165, 199, 201
 schism 63

Christina, queen of Sweden 118
Chronicles, Book of 4, 7
Church *see* Christianity
Churchill, Winston 182
Cleopatra, queen of Egypt 25
cloister government 50
Cobb, Humphrey 209
Cold War 169
Colleoni, Bartolomeo 71, 73, 78
Colombo 194
Commonwealth War Graves Commission
 194, 196
condottieri 70–71, 73, 140
Confederacy *see* American Civil War
conscription 69, 150–51
Constance, Lake 38
Constantine the Great, Roman emperor 27,
 74, 78
Constantinople 33, 34, 127, 128, 129
Cornwell, Jack 169
Corsica 92
Corvinus *see* Matthias
Cotignola, Micheletto da 66, 68
Counter-Reformation 91
Crimean War xvi, 167, 172
Croatia 127
Cromwell, Oliver 69
 New Model Army 69
Crusades xvi, 34, 37, 49, 85, 91, 205
Cubism 200
Cupid 25
Cyprus 4, 92, 93
Cyrus, Persian emperor 6

Dacia (Romania) and Dacians 28, 29, 30, 31
Dance of Death 187
Danelaw 43
Dante Alighieri 154, 166
Danube river 14, 22, 27, 29, 31, 91, 126, 128
Danuvius 29, 30
Darius I, Persian emperor 15
Darius III, Persian emperor 15, 16, 17, 18, 20
Das Boot 211
Daumier, Honoré 180, 181, 182
 The Empire Means Peace 180, **181**
 The Witnesses 182
David, king of Israel 3, 38, 60, 61, 62, 64, 69,
 71, 97, 169
David, Jacques-Louis 148, 152–53, 156–58,
 159, 163, 202
 *Bonaparte Crossing thd Great St. Bernard
 Pass* 156, **157**, 158, 159, 163
da Vinci, Leonardo xv, 71, 132, 158
Deborah 97

Deccan 140
Decebalus, king of Dacia 29, 30
decisive battles, 42, 126
Delacroix, Eugène 153
 Liberty Leading the People 153
Delhi 140
Demeratus of Corinth, 16
Denmark and Danes 43
Desaix, Louis 156
Deutsch, Nikolaus Manuel 103
Dix, Otto 190–91
 Card Players 191, **192**
 The Trench 191
 The War 191
Dolomite mountains 70
Domitian, Roman emperor 24
Donatello 59–64, 65, 68, 70, 71, 93, 99,
 118, 158
 David 60, 62, **63**, 64
 Gattamelata **61**, 68, 70, 71, 72, 73
Douris **12**, 13, **14, 15**
Drave river 126, 128
drill grounds and drilling 83, 149
Dublin 34
Dubois, François 103
 St. Bartholomew's Day Massacre 103
Duck, Jacob 116
 Soldiers and Women **116**
duelling 84
Duret, Théodore 179
Dutch *see* Netherlands
Dyck, Anthony van 119, 120, 122, 123
 Charles I at the Hunt 120, **123**
 Charles I on Horseback **122**

Ecclesiastes, Book of 194
Edinburgh 158
Edward VIII, king of the United Kingdom 158
Edward the Confessor, English king 43, 44,
 45, 47
Egypt 4, 7, 25, 89, 154, 155, 160
Eisenstein, Sergei 205
 Alexander Nevsky 205, **206**, 208
 Battleship Potemkin 205
 Bezhin Meadow 205
Elah, valley of 69
Elam 7, 8, 9
Eleazar 40
elephants 5, 40, 143, 154
Elizabeth I, queen of England 85
Elizabeth II, queen of the United Kingdom 90
Emancipation Proclamation 171
England and English 22, 36, 42, 43, 44, 46,
 64, 84, 85, 93, 99, 102, 112, 119, 148,

154, 158, 159, 160, 166, 167, 169, 170,
 171, 183, 184, 189, 194, 195, 211
Army Medical Corps 189
Ministry of Information Memorials
 Committee 184, 187
War Propaganda Bureau 189, 190
Eos 12, 21
equestrian portraits (*see also* horses and
 horsemen), 26–29, 59–68, 71–73, 93,
 118–22, 127, 153, 154, 156, 159
Erasmus, Desiderius 83
Esther, Book of 7
Ethiopian army 12
Eugene of Savoy, prince 148, 154
Euphrates river 3, 4
Exodus, Book of 1, 2

Fazl, Abul 141, 142
Febbraro, Flavio xvi
Ferdinand VII, king of Spain 159, 160
Fernando, Infante Don, Spanish prince 94
Ferrari, Enrique 165
Fertile Crescent 3, 4
Fethullah Arif Çelebi 129
feudalism 35, 49, 50, 69, 82
film 202, 204–11
Finns 38
Flanders and Flemings 77, 84, 87, 89, 103
Florence and Florentines 59, 60, 61, 62, 64,
 65, 66, 68, 70, 71, 73, 74, 99, 102, 184
 Palazzo Vecchio 60, 61, 64
 Piazza della Signoria 62
Folly Farm 196
fortifications xv, 9, 30, 31, 36, 81, 133
Fort Sumter 170
France and French 34, 38, 42, 43, 44, 64, 79,
 81, 84, 85, 86, 87, 99, 102, 103, 110,
 127, 129, 150–56, 158, 159, 160, 164,
 167, 170, 171, 176–82, 183, 184,
 194–96, 209, 211
 French Revolution 69, 1, 50, 151, 152,
 154, 158
 National Assembly 178
 Third Republic 182
Franco, Francisco 198, 199, 200
Franks 34
Frederick the Great, king of Prussia 99, 148
Froissart, Jean 42
 History of France 42
Futurism 189

Gance, Abel 211
 J'Accuse! 211
 Napoléon 211

Ganges river 14
Gardner, Alexander 172
gas, poison 183, 184, 187–88
Gatling gun 167
Gattamelata (Erasmo da Narni) 61, 69, 70, 71, 78
Gaugamela, battle of 15, 16, 20
Gauls 84
Genghis Khan 140
Genoa 107, 108, 155
Gentileschi, Artemisia 96, 99–101
 Judith and her Maidservant **101**
 Judith Slaying Holofernes 96, **100**
 Susannah and the Elders 99
Gentileschi, Orazio 99
Géricault, Théodore 158
Germany and Germans 23, 34, 62, 63, 69, 81, 82, 86, 91, 93, 110, 115, 148, 152, 170, 184, 189, 190, 191, 199, 204, 205, 211
 Nazis 25, 191, 204
Gettysburg, battle of 172
Gheyn, Jacques de 103, 117
Giraudoux, Jean 99
Godoy, Manuel 159
Godwin, earl 43
Goethe, Johann Wolfgang von 19
Golden Psalter 38
Goliath 3, 60, 62, 64, 71
Gonzaga family 70
Go-Shirakawa, emperor of Japan 51, 53
Goths 34
Goya, Francisco, 158–65, 177, 180, 191, 200, 201, 204, 209, 211
 Disasters of War 161, **162**, 165, 191, 211
 Second of May **161**
 Third of May 1808 xvi, 158, 163, **164**, 177, 180, 200, 201
Graf, Urs 103
Grainger, Percy 184
Granicus, battle of 15, 16, 20
Gray, Thomas 209
 Elegy 209
Great Palace 51, 55
Great St. Bernard Pass 152, 155, 156
Greece and Greeks 1, 2, 5, 6, 7, 11–20, 24, 26, 61, 92, 183, 195, 211
 Greek army 5, 6, 15, 16, 68, 154
 Greek language 38, 97
 Greek pottery 12
guerilla tactics 160
Guernica 199, 200, 202, 204
Guicciardini, Francesco 84
 History of Italy 84

gunpowder (*see also* Military Revolution) 33, 36, 48, 57–58, 65, 78, 79–83, 84, 183
Guns of Navarone 211
Gustavus Adolphus, king of Sweden 69, 80, 81, 82, 85, 110, 149

Habsburg family 90, 108, 110, 112, 127, 154, 177
Hadrian, Roman emperor 29
Hagerstown road 172
Haig, Douglas, earl 158
Halley's Comet 45
Hamanu 7, 9, 10
Hampshire 196
handguns 58, 78, 79–80, 84, 143, 149, 166, 167, 187, 190
 rifling 149, 166, 167
Hannibal 154, 155, 156
Hannukah 38
Hardrada, Harold, king of Norway 44
Harold, English king 43–47
Hastings, battle of 42, 44, 46, 126, 127
Hawkwood, Sir John 65, 68
Hebrew 37, 38, 97
Hebrews 2
Hector 12, 13, 14
Hecuba 21
Heiji Monogatari Emaki 52, **53–55**, 56
Heiji Uprising 51, 52, 53
Helen of Troy, queen of Sparta 12
Hellenistic era 24
Heraclius 74
Herod 89
Herodotus 97
 History 97
Hessians 69
Hindus 141, 142
Hitler, Adolf 198
Hogenberg, Frans 103
Holocaust 175
Holofernes 62, 98, 99
Holy League 92, 93
Holy Roman Empire 34, 62–63, 91–92
Homer 12, 13, 21, 166
 Iliad 12, 13
 Odyssey 1
Honegger, Arthur 99
Horatii 153
Horatius 2
horses and horsemen 5, 9, 18, 20, 27, 31, 35, 36, 39, 53, 56, 66, 68, 73, 74, 93, 103, 110, 118, 129, 143, 152, 153, 156, 158, 164, 168, 183, 186, 200

Huguenots 103
humanism and humanists 60, 62, 133
Humayun, Mughal emperor 140, 141, 142
Hungary and Hungarians 38, 126, 127, 128, 129, 132
Huns 34
Hussey, Christopher 198

Iberian Peninsula 34
Iceland 43
India and Indians 15, 17, 50, 140, 141, 193
Indian Ocean 14
infantry 5, 16, 22, 35, 36, 37, 46, 80, 148–49
Inquisition 86, 93
In the Valley of Elah 209
In Which we Serve 211
Iran 140
Iraq 7, 16, 209
 Iraq War 209
Islam *see* Muslims
Israel and Israelis (*see also* Palestine) 211
Israelites 37, 38, 39, 41, 62, 97
Issus, battle of, 15, 16, 20
Italy and Italians 34, 38, 59, 62, 63, 69, 70, 83, 87, 92, 110, 112, 132, 133, 134, 154–56, 170, 184, 198

Jackson, Thomas J. ("Stonewall") 170
Jael 97
James, Henry 184
James river 170
Janissaries 128, 129
Janson, H. W. 62
Japan and Japanese 49–56, 205, 207, 211
Jehangir 141
Jerusalem 5, 24, 37, 39, 74, 97, 98
Jesus 87, 88, 89, 165
 Crucifixion 165, 201, 209
 stigmata 165, 200
Jews 37, 38, 39, 97, 141
Johannesburg 193
John of Austria, Don 92
John of Gaunt, duke of Lancaster 85
Jomini, Antoine-Henri, baron 156
Jonah 7, 98
 Book of 7, 98
Joseph 89
Joseph Bonaparte, king of Spain 160
Josephus 24
Joshua 97
Judea and Judeans 37, 38, 97, 98
Judges, Book of 97
Judith 62, 97–100
 Book of 97, 98

Jülich 107, 108
Jupiter 30
 see also Zeus
Justin of Nassau 108, 110
Justus of Ghent 77
 Federico da Montefeltro **77**

Kalliades 12
Kamakura 52
Karan, Khim 142
Kashmir 140
Kearsarge 176, 177
Kemalpasazâde 129
Kenilworth Castle 81
Kent 42
Kiev 34
Kiyomori, Taira 51, 52
knights 33 *ff.*, 49, 65, 66, 69, 73, 74, 84, 129, 132
Knights Hospitaller of St. John 128
Kobayashi, Masaki 211
 The Human Condition 211
Koran 141
Kubrick, Stanley 209–10
 2001: A Space Odyssey 209
 Barry Lyndon 210
 Dr. Strangelove 209, 211
 Full Metal Jacket 210
 Lolita 209
 Paths of Glory 209, **210**, 211
 The Shining 209
Kurosawa, Akira 207–8, 209
 Kagemusha 207
 Rashomon 207
 The Seven Samurai 207, **208**, 209
 Yojimbo 207
Kyoto, 51, 52

Lal 142
Languedoc 170
La Rochelle 102, 103
Latin language 133
Latins 1
La Tribune 177
Latvia 205
Lebanon 211
Le Brun, Charles 150, 156
 Decision for War 150, **151**
Lee, Robert E. 170–73
Leonardo, Jusepe 110
 Surrender of Jülich 110
Lepanto 92
 battle of 92–93, 94
levee en masse see conscription

Lincoln, Abraham 170, 171, 172, 174
Lisbon 159
Liverpool 158
Livia, Roman empress 24
Livy, 2, 134, 155
 History 2
Lloyd George, David 184, 194
Lombardy and Lombards 34, 59, 155, 170
London 65, 99, 142, 158, 171, 172, 184,
 187, 194
 British Museum 7
 Crystal Palace Exhibition 171
 Grosvenor House 194
 Royal Academy 184
 Royal College of Art 193
 Victoria and Albert Museum 142
 Whitehall 194
Lorraine 102
Louis II, king of Hungary 128, 129
Louis XIV, king of France 79, 120, 121, 124,
 148, 150, 156
Louis XVI, king of France 153, 159
Louvre 7, 12
Low Countries 84, 86–88, 112
Luna, Count di 169
Lutherans 93
Lutyens, Edward 191–198, 209
 Cenotaph 194, **195**
 Great War Stone (Stone of
 Remembrance) 194
 Memorial to the Missing of the Somme 191,
 196, **197**

Maccabees 37–39, **40, 41**, 97
 Judah 39
 Mattathias 39
McCarey, Leo 211
 Duck Soup 211
McClellan, George B. 170, 171, 172
Macedonians, 15
Machiavelli, Niccolò 59, 60, 69, 84, 118
 History of Florence 84
machine gun 166, 183
Maciejowski Bible 37
Madrid 94, 107, 108, 150, 159, 160, 163, 199
 Buen Retiro 108
 Hall of Realms 108, 110
 Moncloa district 163
 Prado Museum 200
 Principe Pio Hill 153
 Puerta del Sol 160
Magyars 38, 39
Malatesta family 73
 Sigismondo 74

Malta 92
Mamelukes 160, 163, 164
Manchester 194
Manet, Edouard 176–82, 191
 Civil War, 179, **180**
 Déjeuner sur l'herbe 176
 Execution of Maximilian 177, **178,
 179**, 180
 Rue Mosnier Decorated with Flags **182**
 The Barricade 179, 180, **181**
 The Dead Matador 180
Mantua 70, 114
manuscripts 37 *ff.*
Marat, Jean-Paul 153
Marcus Aurelius, Roman emperor 24, 26, **27**,
 28, 29, 61, 65, 118
Marcus Curtius 121
Marathon, battle of 5, 6, 15
Marengo, battle of 155–56
 Chicken Marengo 156
Maria Theresa, empress of Austria 99
Mark river 107
markets xvii
Marlborough, John, duke of 148
Mars 33, 106, 110, 113, 114, 117
Martigny 155
Marx Brothers 211
Mary 88
Maryland 171
Masaccio 59
Masséna, André 155
Matthew 87
Matthias Corvinus, king of Hungary 127, 129
Maurice of Nassau, prince 80, 148
Maximilian I, emperor of Mexico 177
Medici family 60, 64, 68, 70, 71, 102, 113
 Cosimo de', duke 71
 Ferdinando de', duke 113
Medina Sidonia, Alonso, duke of 107
Mediterranean sea 3, 4, 14, 22, 91, 92, 93
Meistersinger *see* Sachs
Melas, Michael von, baron 155, 156
Melians 11
Memnon 12
Menelaus, king of Sparta 12, 14, 21
mercenaries 68–71, 82
Mercury 62
Mesopotamia 3, 4, 6
Mexico and Mexicans 170, 172, 177
 Civil War 177
 Mexican War 172
Michelangelo 28, 64, 99
Milan and Milanese 59, 60, 62, 64, 69, 70, 73,
 99, 155

Military Revolution (*see also* gunpowder)
 79–83, 148
military strategy and tactics 4, 5, 6, 15–17,
 22–24, 35, 36, 148–52, 166–69
Minamoto, Tameyoshi 51
Minamoto, Yoritomo 52
Minamoto, Yoshitomo 51, 56
Minamoto clan 51, 52, 55
Minerva (*see also* Pallas Athena) 113, 133
Miskima 142
Mithridates 16
Mocenigo, Leonardo 135
Mohács 126–28, 132
 battle of 1526 126, 127, 129–32
 battle of 1687 126, 127
monasteries 34–35, 37–41, 48, 155
Moncornet, Jean 127
Mongols *see* Mughals
Montecuccoli, Raimondo, prince 82
Montefeltro family 70
 Federico da, duke 73–78
 Guidobaldo, duke 74, 77
Mont-Saint-Michel 45
Moravia 127
Morse, Samuel 171
Moscow 150, 205
Moses 2, 153
Mosul 7
Mozart, Wolfgang Amadeus 99
Mubarak, Sheikh 141
Mughals 140–43
Mühlberg, battle of 93, 118
Mukund 142
Munch, Edvard 198
Murat, Joachim 159, 163
Murray, Williamson 168
music 33, 129, 153
Muslims and Islam 34, 91, 93, 126, 128,
 141, 142
Mussolini, Benito 198

Naples 19, 73, 99
 Archeological Museum, 19
Napoleon Bonaparte, emperor 148–58, 159,
 160, 163, 165, 169, 193, 200
Napoleon III, emperor 176, 177, 180
nationalism 150, 159, 168
naval warfare 78, 81–82, 92–93, 94, 154, 159,
 167, 168, 176–77, 205
Nebuchadnezzar, Babylonian king 98
Nelson, Horatio, lord 154, 168
Neolithic age 3
Netherlands and Dutch 80, 82, 87, 93, 102,
 103, 107, 108, 110, 115, 148

Nevinson, Christopher 189, 209
 Paths of Glory **190**
Nevsky, Alexander 205
New Delhi 193
 India Gate (All-India Memorial) 193
 Viceroy's House 193
New York 171, 172, 209
 Academy of Design 171
 Cooper Institute 172
 Metropolitan Museum 191
 National Portrait Gallery 171
New York Times 175
Nicanor 97
Nice 155
Nijō, emperor of Japan 51
Nile river 4
Nineveh 7, 8, 98, 204
 Nineveh reliefs 7, **8–11**, 21
Nördlingen, battle of 82
Normandy and Normans 42–45, 84
North Sea 86
Norway and Norwegians 44, 45, 198
Novgorod, Republic of 205

Odo of Bayeux, bishop 42, 44, 46, 47
Odysseus 1, 12
Old French 43
Old Testament *see* Bible
Olivares, Gaspar, count-duke 108, 118, 119
Olympus, Mount 2, 154
Oran 92
origins, stories of 1–3
Ostend 107
O'Sullivan, Timothy 172
Ottomans 91, 92, 93, 127–29, 132
Owen, Wilfred 166–67, 169
 "Strange Meeting" 166–67
Ozias 98

Pabst, G. W. 211
 Westfront 211
Pacelli, Giovanni, Cardinal *see* Pius XII
Pacheco, Francisco 108
Pacific ocean 176
Padua 61, 70, 71, 132
Page, William 171
Pakistan 140
Palaeolithic age 3
Palafox, José de, duke 160, 163
Palatinate 107
Palestine (Holy Land) 15, 205
Palladio, Andrea 126, 132–35, **136, 137, 139**,
 147, 192
 Four Books of Architecture 133, 135

Pallas Athena (*see also* Minerva) 133
Panofsky, Erwin 94, 96
papacy 62–63, 70, 73, 82
Paresh 142
Paris (city) 34, 37, 65, 66, 156, 159, 176–82,
 184, 193, 194, 196, 199, 200
 Arc de Triomphe 193, 194, 196
 "Bloody Week" 178, 179
 Commune 178
 Paris Salon 176
 siege 177, 179
 World's Fair 200
Paris (person) 12, 21
Parthians 25–26
Pascal, Blaise 154
Patras, Gulf of 92
patriotism 85
patrons xvii, 37, 47–48, 101
Pavia 155
Pax 113
Peloponnesian War xvi, 11
Peninsula Campaign 171
Perrissin, Jean 103
Persia and Persians 5, 6, 15, 22, 50, 68, 140, 142
Persian army 6, 15, 16, 18, 20
Persian Gulf 7
Perugia 59
Petrarch 59, 60, 154
phalanx 6, 16, 198
Pharaoh 2, 3
Pharisees 87
Philadelphia 184
Philip II, king of Spain 84, 86, 90, 92, 93, 94
Philip IV, king of Spain 107, 108, 118
Philippoteaux, Henri xvi
photography 171–176
Picasso, Pablo 165, 198, 199–201, 204, 209
 Guernica xvi, 165, 198, 199, 200, **201**, 203
Piero della Francesca 74–78
 Battle between Constantine and Maxentius
 74, 75
 Battle between Heraclius and Chosroes
 74, 78
 Legend of the True Cross 74
 Pala Montefeltro 75, **76**
Pinarus river 16
Pisa 59, 60, 64
Pius XII, pope 199
Plataea, battle of 15
Pliny 61
Polybius 132–35
 Histories 134
Pompeii xvi, 17
 House of the Faun 17

Po river 155
 valley 155
portraiture 118–25, 191
Portugal 159
Poussin, Nicolas 154
Prokofiev, Sergei 205
Protestantism 93, 103, 170
Proust, Antoine 180
Prussia and Prussians 49, 170, 177, 178 179
Puerto Rico 108
Punjab 140
Pyrenees 154

Rajasthan 142
Rajputs 142
Ranthambore 142, 143, 147
Ravenna, battle of 57
Ravilious, Eric 202
Red Cross 189, 194
Reformation 85, 91
Reichenau, Abbey of 38
Rembrandt van Rijn 97
Remus 2
Renoir, Jean 211
 Grand Illusion 211
Rhine river and Rhineland 22, 23, 34, 83,
 96, 107
Rhodes 128, 132
Rhoisakes 16, 20
Richmond 170
Richthofen, Manfred von 199
Richthofen, Wolfram von 199
Ridley, Jane 196
Rigaud, Hyacinthe 120, 124, 125
 Louis XIV 120, **124**
Riksdag 85
Rimini 73, 74
Robespierre, Maximilien 153
Rocroi 81
Roland 154
Roman army 22–33, 134, 135
Romania *see* Dacia
Romano, Giulio 114
Rome and Romans, 2, 21, 22–33, 34, 35,
 38, 59, 61, 62, 63, 69, 71, 74, 80,
 85, 121, 133, 135, 153, 155, 192,
 193, 199, 205, 211
 Capitoline Hill 28
 Forum 24
 Pantheon 29
 Triumphal Arches 192
 Victory Columns 192
Romulus 2
Ronsard, Pierre 85

Rossini, Gioachino 153
 L'Italiana in Algeri 153
Rouen 81
Rubens, Peter Paul 99, 112–14, 119, 158,
 165, 200
 Horrors of War 112, **113**, 150, 200
 Allegory of Peace and War **112**, 114
Rudolf II, Holy Roman Emperor
 90, 101
Russia and Russians 152, 205

Sachs, Hans 99
St. Bernard dogs 155
St. Francis 165
 stigmata 165
St. Gall, Abbey of 37–41, 48
St. Petersburg 205
St. Quentin 196
Salamis, battle of 15
Samad, Abdus 142
Samson 97
Samurai 207, 208
Sanjō Palace 51, 52
Sankar 142
San Romano, battle of *see* Uccello
Sansom, George, 49, 51
 History of Japan 49
Saragossa 160
Saratoga Springs 171
Sargent, John Singer 182–88, 191, 204
 A Street in Arras **185**
 A Wrecked Tank 185, **186**
 Crashed Aeroplane **186**
 Gassed **188**
Savoy 102
Scandinavia 34
Schilling, Diebold 103
Schwetje, Burkhard xvi
Scotsman 172
Scully, Vincent 198
sculpture 7, 59–64, 71–73
Segal, George 202
 The Holocaust 202
Seleucid Empire 37, 39, 97
Sennacherib, king of Assyria 4, 7
Septuagint 97
Serlio, Sebastiano 133
Seville 108
Sforza family 73
 Battista, duchess 74
Shakespeare, William 85, 207
 Richard II 85
Sharpsburg 171
Sicily 17, 20, 34, 92

sieges and siegeworks xvi, 5, 7, 9, 23, 30, 31,
 36, 37, 39, 40, 58, 78, 81, 102, 103,
 107, 108, 128, 133, 135, 142, 143, 160,
 177, 178, 179
Siena and Sienese 59, 64, 65, 66
Silesia 127
Sinai, Mount 153
Singh, Udai 142
Sisera 97
Socrates 20, 153
Sol 25
soldier *see* warrior
Somme, battle of the 190, 196
Somme, valley of 69
South Africa 176
Spain and Spaniards 77, 80, 82, 84–94, 96,
 102, 107, 108, 110, 112, 118, 148, 149,
 152, 156, 158, 159–65, 168, 169, 198,
 199, 200, 201
 Civil War 168, 169, 198, 199
 Falange 198
 Loyalists 199
 Republican Government 200
 treasure fleet 107
Sparta and Spartans 2, 6, 12, 49, 69, 98, 154
spears 8, 9, 13
Spinola, Ambrogio, marquis 107, 108, 110
stained glass 37
Stalin, Joseph 205
Stamp, Gavin 198
stirrup 35
Stoicism 28
Suleyman the Magnificent, Ottoman
 emperor 91, 126–29, 132
Süleymanname 126, 129, **130, 131**, 134, 140,
 147
 Painter A 129, **130, 131**, 132
 Painter B 129, 132
Susa 7, 10
Sustermans, Justus 113, 114
Sweden and Swedish 69, 80, 85, 110, 118
Swinton, Ernest 183
Switzerland and Swiss 36, 37, 38, 40, 69, 87,
 103, 154, 155
Syria 97
Syriac 38

Tacitus 22
Taira clan 51, 52
Tamerlane, khan 140
tanks 166, 183, 185, 186, 211
telegraph 167
Tennō, Shirakawa, emperor of Japan 50
Tennō, Toba, emperor of Japan 50, 51

Tennyson, Alfred, lord 165
 "Charge of the Light Brigade" 165
Terbrugghen, Hendrick 117
 Sleeping Mars **117**
tercio 80, 81, 149
Teutoburg Forest 23
Teutonic Knights 205
The Dead Soldier (Velázquez?) 180
The Hurt Locker 209
"Theory" xvi–xvii
Thermopylae 2, 6, 98, 154
Thiepval 196
Thirty Years War 69, 82, 85, 96, 102, 107,
 115, 117, 148, 158
Thucydides 11
Tiber 2
Tiberius, Roman emperor 26
Tigris river 3, 4, 7, 16
Tintoretto 113
Titian 84, 91, 93, 94, 96, 118, 119, 158
 Allegory of the Battle of Lepanto 91,
 94, **95**
 Charles V at Mühlberg **119**
Titus, Roman emperor 24
Tolentino, Niccolò da 65, 67, 68
Tonks, Henry 184, 187, 189
Toronto 158
Tortorel, Jacques 103
Trafalgar, battle of 159
Trajan, Roman emperor 28–33, 140
 Commentarii 29
 Trajan's Column 28, 29, **30–32**, 33,
 42, 46
 Trajan's Forum 29
trenches 81, 142
Tripoli 92
Trissino, Giangiorgio 133, 134
 Sofonisba 134
Triumphal Arch (*see also* Paris, Arc de
 Triomphe) 192
Triumphal Painting 24
Trojan War 3, 12
Troy and Trojans 1, 2, 12, 13
Tunis 92, 93
Turin 155
Turkey and Turks 91–94, 96
Turnus 2
Tuscany 59, 60, 64, 113

Uccello, Paolo 64–68, 74, 118
 Battle of San Romano 64, **65, 66, 67**, 74
Ukraine 43
underdrawing xvii, 204
uniforms 83

Union *see* American Civil War
Urbino 70, 73–74
 palace 73–74
 studiolo 73–74
Uruk 3

Valle, Battista della 135, **138**
 Vallo 135, **138**
Valtelline 154
Vasari, Giorgio 67
Vatican 69, 74
Velázquez, Diego 107–11, 117, 121, 158,
 180, 200
 Baltasar Carlos **121**
 Las Meninas 110
 Mars 110, **111**, 117
 Surrender of Breda 107, 108, **109**
Venice and Venetians 57, 60, 70–73, 84,
 91, 92, 93, 94, 113, 132–35,
 183, 207
 army 70
 arsenal 57
 Film Festival 207
 Golden Lion 207
 Piazza San Marco 71, 72
 Santi Giovanni e Paolo, church of 72–73
Venus 25, 114
 see also Aphrodite
Verdi, Giuseppe 169
 Il Trovatore 169
Verrocchio, Andrea del 68, 69, 71–73, 93,
 118, 158
 Colleoni 71, **72**, 73
Versailles 121, 178
Vesuvius, Mount 17
Vicenza 133, 134
Victoria Cross 166
Vienna 91, 92, 127, 128, 129
Vikings 34, 43, 47
Virgil 2, 24, 47, 166
 Aeneid 2, 24, 47
Virginia 170, 171
Visconti family 62, 63, 64
 Filippo Maria, duke 60
 Visconti, Giangaleazzo, duke 59, 60, 69
Vitruvius 133
 Ten Books on Architecture 133
Vivaldi, Antonio 99

Wallenstein, Albrecht von, duke 69, 82
War Graves Commission *see* Commonwelath
 War Graves Commission
warrior 9, 13, 20, 21
 churchman as, 34

image of (*see also* attitudes to war) 24–28,
 36, 73, 74, 86, 87, 96, 97, 103, 108,
 110, 115, 149, 160, 166
nature of xv, xviii, 1–3, 166
warrior society 49–50
wars of religion 83, 91, 150
Washington (city) 170, 171, 172, 175, 193
Waterloo, battle of 126, 156
weaponry (*see also* aircraft, bombs, bows,
 cannon, gas, handguns, machine guns,
 spears, tanks) 5, 7, 9, 13, 14, 16, 17, 20,
 22, 35–37, 46, 54, 55, 57–58, 68,
 79–81, 82, 84, 132, 149–50, 166–69,
 183, 184, 198, 199, 202, 204, 211
Wessex 43
Westminster Abbey 47
Westphalia 23
 Peace of 87, 96
West Point 170, 171
West Virginia 170
William I (the Conqueror), king of England
 43–47, 140

William the Silent, prince 108
Winged Victory 94
World War I 96, 158, 166, 167, 168, 169, 183,
 187, 188–98, 199, 209, 211
World War II 167, 168, 169, 175, 202, 203,
 204, 211
Wouwermans, Philip 115, 116
 Cavalry Sortie **116**
Wright brothers 183, 198

Xenophon 6, 68, 154
 Anabasis 6
Xerxes, Persian emperor 15

Yorinaga, Fujiwara 51
York, Alvin 169
York river 170
Ypres 184

Zeus 12, 13
 see also Jupiter
Zola, Émile 177